WILD SPACES, OPEN SEASONS

THE CHARLES M. RUSSELL CENTER SERIES ON
ART AND PHOTOGRAPHY OF THE AMERICAN WEST

B. Byron Price, *General Editor*

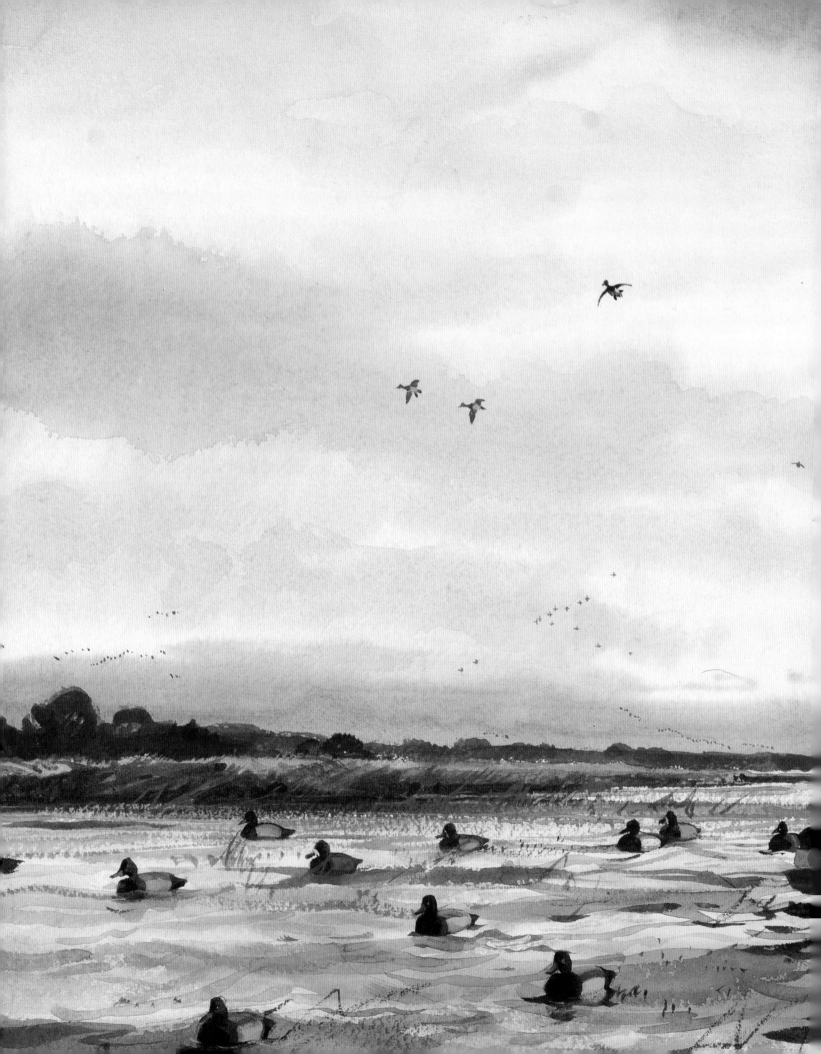

WILD SPACES, OPEN SEASONS
Hunting and Fishing in American Art

Edited by **Kevin Sharp**

Introduction by **Stephen J. Bodio**

Contributions by **Margaret C. Adler, Shirley Reece-Hughes,
Kory W. Rogers** *and* **Adam M. Thomas**

UNIVERSITY OF OKLAHOMA PRESS : NORMAN

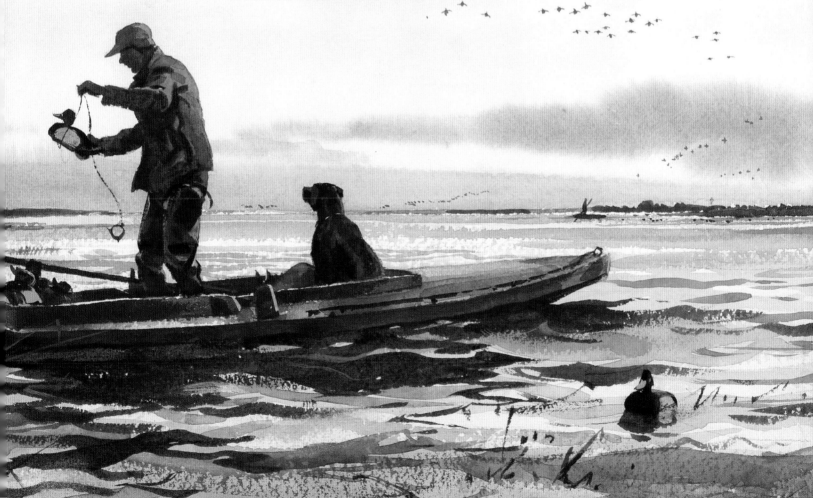

Published in cooperation with the Amon Carter Museum of American Art, Dixon Gallery and Gardens, Joslyn Art Museum, and Shelburne Museum, and in conjunction with the exhibition *Wild Spaces, Open Seasons: Hunting and Fishing in American Art.*

This exhibition is supported by an indemnity from the Federal Council on the Arts and the Humanities.

DIXON GALLERY AND GARDENS, Memphis, Tennessee
October 23, 2016–January 15, 2017

JOSLYN ART MUSEUM, Omaha, Nebraska
February 12–May 7, 2017

SHELBURNE MUSEUM, Shelburne, Vermont
June 3–August 27, 2017

AMON CARTER MUSEUM OF AMERICAN ART, Fort Worth, Texas
October 7, 2017–January 7, 2018

Library of Congress Cataloging-in-Publication Data

Names: Sharp, Kevin, 1957– editor. | Amon Carter Museum of American Art, organizer, host institution. | Dixon Gallery and Gardens, organizer, host institution. | Joslyn Art Museum, organizer, host institution. | Shelburne Museum, organizer, host institution.
Title: Wild spaces, open seasons : hunting and fishing in American art / Edited by Kevin Sharp ; Introduction by Stephen J. Bodio ; Contributions by Margaret C. Adler, Shirley Reece-Hughes, Kory W. Rogers, and Adam M. Thomas.
Description: Norman : University of Oklahoma Press, 2016. | Series: Charles M. Russell Center series on art and photography of the American West ; volume 27 | "Published in conjunction with the exhibition Wild Spaces, Open Seasons: Hunting and Fishing in American Art, organized by the Amon Carter Museum of American Art, the Dixon Gallery and Gardens, Joslyn Art Museum, and Shelburne Museum." | Includes bibliographical references and index.
Identifiers: LCCN 2016006826 | ISBN 978-0-8061-5462-6 (hardcover : alk. paper) | ISBN 978-0-8061-5463-3 (pbk. : alk. paper)
Subjects: LCSH: Hunting in art—Exhibitions. | Fishing in art—Exhibitions. | Art, American—Themes, motives—Exhibitions.
Classification: LCC N8250 .W54 2016 | DDC 704.9/4979929—dc23
LC record available at http://lccn.loc.gov/2016006826

Wild Spaces, Open Seasons: Hunting and Fishing in American Art is Volume 27 in The Charles M. Russell Center Series on Art and Photography of the American West.

The paper in this book meets the guidelines for permanence and durability of the Committee on Production Guidelines for Book Longevity of the Council on Library Resources, Inc. ∞

1 2 3 4 5 6 7 8 9 10

The following images appear uncaptioned on the pages noted:

Pages ii–iii:
(detail) Cat. 52
Ogden Minton Pleissner, *The Broadbill Gunner,* 1957. Watercolor on paper, 19⅜ × 29⅛ inches. Collection of Shelburne Museum, Shelburne, Vermont. Gift of Ann M. Leonard, 2013-14.1

Page vi:
(detail) Fig. 2.10 [Cat. 39]
Alfred Jacob Miller, *Buffalo Hunt,* ca. 1838–42 (See page 71)

Pages xiv–1:
(detail) Fig. 2.19 [Cat. 25]
Philip R. Goodwin, *The Northwood King—Calling the Moose,* n.d. (See page 81)

Lenders to the Exhibition

Amon Carter Museum of American Art

Brooklyn Museum

Buffalo Bill Center of the West

The Butler Institute of American Art

Cincinnati Art Museum

Crystal Bridges Museum of American Art

Detroit Institute of Arts

Davis Museum at Wellesley College

Fenimore Art Museum

Fine Arts Museums of San Francisco

Gilcrease Museum

High Museum of Art

Joslyn Art Museum

The Long Island Museum of American Art, History, and Carriages

Los Angeles County Museum of Art

Mead Art Museum, Amherst College

Metropolitan Museum of Art

Munson-Williams-Proctor Arts Institute Museum of Art

Museum of Fine Arts, Boston

National Academy Museum

National Gallery of Art, Washington, D.C.

The Nelson-Atkins Museum of Art

The Newark Museum

The Parrish Art Museum

Pennsylvania Academy of the Fine Arts

Philadelphia Museum of Art

Phoenix Art Museum

Shelburne Museum

Terra Foundation for American Art

Toledo Museum of Art

University of New Mexico Art Museum

Virginia Museum of Fine Arts

Whitney Museum of American Art

Private Collections

Albritton Collection

Foxley Collection

Collection of David and Laura Grey

The John and Susan Horseman Foundation for American Art

The Thomas H. and Diane DeMell Jacobsen Ph.D. Foundation

The Manoogian Collection

Mr. and Mrs. Joseph Orgill III

Judith and James Pizzagalli Collection

Anonymous lenders

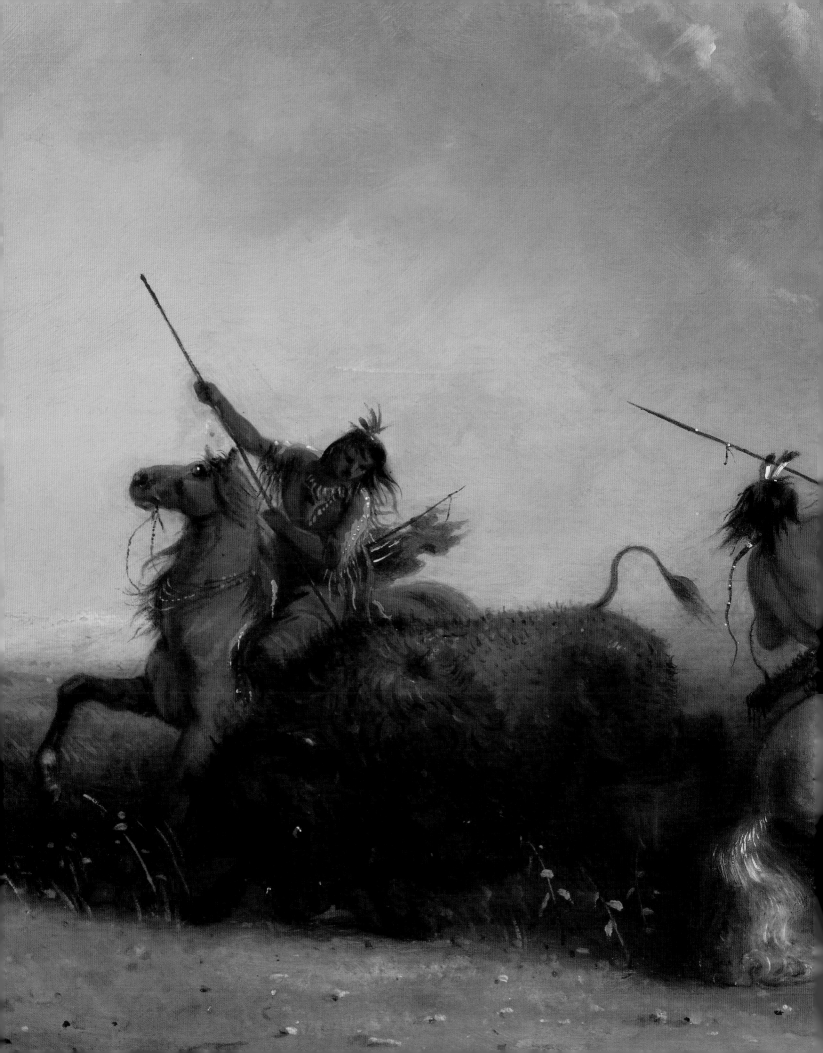

Contents

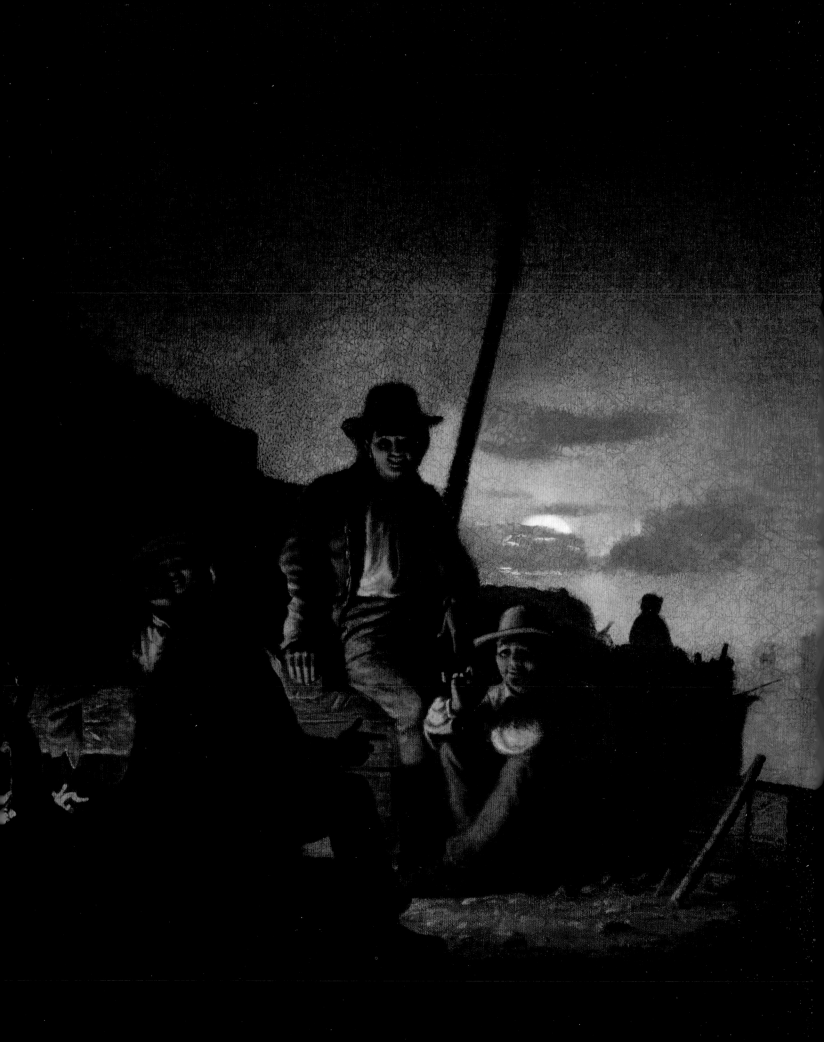

In Plain Sight

In many respects, the history of American painting and sculpture is an area of study still in the exuberance of youth. It darts and veers through the wild and open country of the American imagination, seeking the wisdom that so many pictures and statues might share, and what they meant to the men and women who made them, sold them, saw them, and owned them. There is so much more to know, more to discover, and more, a great deal more, hiding in plain sight.

Throughout the relatively brief history of American painting and sculpture, some of the most brilliant and original artists this country has produced became intrigued at one time or another with subsistence hunters and sportsmen as expressive subject matter. Hunters and fishermen, the hunt and the catch, appear again and again in the work of American painters and sculptors. Sporting images are not unique to the American experience by any means, and artists and nonartists alike from every part of the world have documented, elegized, or reimagined the successful hunt or catch since the beginning of recorded human history. In some cases, those representations *are* the first recorded history. But there seems to be something in the pursuit that speaks specifically to American priorities, and to our embrace of challenge and invention. American painters and sculptors have seen the quest for prey, its perils and rewards, as particularly powerful subjects and as compelling emblems of any number of other pursuits, including their own.

Wild Spaces, Open Seasons: Hunting and Fishing in American Art brings together an impressive group of paintings and sculptures that eloquently convey what the sporting hunter and the provider in the wild have meant to American artists and to the broader American ethos. To arrive at this particular body of work and do justice to a theme so pervasive, we found ourselves at the outset defining boundaries and making difficult decisions. First, we tried not to depend too heavily on the painters and sculptors who specialized in sporting genres. Some artists in the exhibition, notably Arthur Fitzwilliam Tait, Carl Rungius, William R. Leigh, and perhaps others, may fall into this category, and they are crucial to our story. Yet, we were just as interested in the breadth and persistence of the theme across various artistic ages, styles, temperaments, and visions.

We limited the checklist largely to American painters and sculptors who had been on some level academically trained in those artistic disciplines. Clearly, there is another exhibition waiting to be organized that explores representations of hunting and fishing by indigenous Americans, another still that examines these themes in the hands of American decorative artists and artisans, and another project yet that combines all these various explorations (including our own) into one grand endeavor. With some reservations, we elected not to delve into the vast pool of wildlife art or scientific representations of fish and fauna, despite the beautiful and powerful works available in those genres and the temptation to do otherwise. John James Audubon, for example, was a hunter, and a prodigious one at that; but as far as we know, he almost never depicted human hunters or fishermen in his formidable body of

(*detail facing, and above*)
Cat. 7.
George Caleb Bingham
Watching the Cargo by Night,
1854
Oil on canvas, 24 × 29 inches
Joslyn Art Museum, Omaha,
Nebraska. Gift of Foxley and Co.,
1997.33

work. Finally, we remained focused on hunting and fishing to the exclusion of other picturesque sporting activities, such as equestrian or nautical subjects. Some very good exhibitions in recent years have already explored those indelible genres.

We expected our project to do more than simply point out hunters and huntresses, fisher-folk and their catch in American paintings and sculpture. To arrive at a deeper understanding of these thematic touchstones, we have called on a group of four curators and scholars to tease new insights from otherwise well-vetted works of American art. Margaret C. Adler, Kory W. Rogers, Shirley Reece-Hughes, and Adam M. Thomas, through careful investigation, have brought works by such significant artists as Thomas Cole, William Sidney Mount, Martin Johnson Heade, Winslow Homer, Thomas Eakins, Augustus Saint-Gaudens, John

Singer Sargent, Charles M. Russell, Marsden Hartley, George Bellows, Paul Manship, and many others into sharper relief. The results of their research are as nuanced as they are impressive. The only true outdoorsman among us, Stephen J. Bodio, a unique voice and an essential advocate for life in the wild, has contributed a bracing introduction. We are grateful to all these contributors for their insights and excellent work.

Wild Spaces, Open Seasons: Hunting and Fishing in American Art, the catalogue as well as the exhibition it accompanies, should guide even experienced art observers to new ways of seeing long-familiar paintings and sculpture. Those better versed in the outdoors may wonder why it has taken so long to explore such central themes in the history of American art. Hunters and fishermen were there all along; they were just hiding in plain sight.

KEVIN SHARP
Dixon Gallery and Gardens

JACK F. BECKER
Joslyn Art Museum

THOMAS DENENBERG
Shelburne Museum

ANDREW J. WALKER
Amon Carter Museum of American Art

Acknowledgments

Wild Spaces, Open Seasons: Hunting and Fishing in American Art has been a collaborative effort. It would not have been possible without the many individuals who have offered assistance and support to the organizing institutions and contributing authors. We are grateful for the crucial support of the Board of Trustees of the Amon Carter Museum of American Art, in Fort Worth, Texas; the Dixon Gallery and Gardens, in Memphis, Tennessee; Shelburne Museum, in Shelburne, Vermont; and the Board of Governors of Joslyn Art Museum, in Omaha, Nebraska. The curators of the exhibition would like to offer their thanks for the guidance and leadership of the heads of their respective institutions: Andrew Walker, Kevin Sharp, Thomas Denenberg, and Jack Becker.

At the Amon Carter Museum of American Art, we extend our sincerest thanks to interns Taylor Day, Mary Beth Garrido, Erin Grady, and Alexa Ibarguen for their tremendous research efforts. A great debt of thanks goes to library director Sam Duncan, who was instrumental in securing research material and the images necessary for the completion of the essays, and to curatorial colleagues Heather Creamer and Michaela Haffner for their ongoing support.

At the Dixon Gallery and Gardens, we would like to acknowledge the efforts of Kristen Kimberling, who served as photography editor for the project and secured the rights to reproduce all the images in this book. Laura Gray McCann has managed countless details that contributed to the success of the exhibition—everything from creating the first draft of the checklist to formatting final versions of the essays. Julie Pierotti has been a consistent and steadying force throughout the project and instrumental in bringing it to resolution. Naturally, by the time the exhibition lands on the walls of the Dixon, every staff member will have played a role in getting it there.

At Joslyn Art Museum, we would like to thank Toby Jurovics, chief curator and Holland Curator of American Western Art, for his significant participation in this project from start to finish. Kay Johnson, registrar, coordinated loan requests and shipping arrangements for all four venues of the exhibition with great efficiency and aplomb. We would also like to acknowledge the contributions of Joslyn staff in every department.

Several individuals provided support and counsel throughout the project at Shelburne Museum. These include Francie Downing, Peter Martin, Judy and Jim Pizzagalli, Remo Pizzagalli, and Michael Polemis. We also thank Allison Gillette, David Huntington, and Katie Wood Kirchhoff for their help with the catalogue. Exhibitions are the work of many hands, and staff members at Shelburne Museum came together, as they always do, for *Wild Spaces, Open Seasons.* We are especially grateful to curator Kory W. Rogers for his leadership role on the national project team, and Erin Barnaby, Carolyn Bauer, Sara Belisle, Andrea Bergeron, Nick Bonsall, Stephen Boudah, Jim Brumsted, Sandy Fish, Rebecca Hartje, Kim McCray, Denise Morrell, Rick Mount, Kate Owen, Karen Petersen, Liz Phillip-Morris, Barbara Rathburn, Nancie Ravenel, and Suzanne Zaner for the thoughtful and elegant installation.

Additionally, the authors would like to thank Constance Aylward; Theresa Cunningham, of the Palmer Museum of Art; Alice Duncan;

James Collins Moore; Eve Straussman-Pflanzer, of the Davis Museum at Wellesley College; and Yao-Fen You, of the Detroit Institute of Arts, for their assistance and support.

We would also like to express our deep gratitude to the institutions and their directors for generous loans to the exhibition: Anne Pasternak, Shelby White and Leon Levy Director, and Arnold Lehman, former director, Brooklyn Museum; Bruce B. Eldredge, executive director and CEO, Buffalo Bill Center of the West; Louis Zona, director and chief curator, The Butler Institute of American Art; Cameron Kitchin, Louis and Louise Dieterle Nippert Director, Cincinnati Art Museum; Rod Bigelow, director, Crystal Bridges Museum of American Art; Lisa Fischman, Ruth Gordon Shapiro '37 Director, Davis Museum at Wellesley College; Salvador Salort-Pons, director, Detroit Institute of Arts; Paul D'Ambrosio, president and CEO, Fenimore Art Museum; Richard Benefield, interim director, Fine Arts Museums of San Francisco; James Pepper Henry, executive director, Thomas Gilcrease Institute of American History and Art, Gilcrease Museum; Randall Suffolk, Nancy and Holcombe T. Green, Jr., Director, High Museum of Art; Neil Watson, executive director, Long Island Museum of Art; Michael Govan, director, Los Angeles County Museum of Art; Pamela Russell, interim director and head of education, Mead Art Museum, Amherst College; Thomas P. Campbell, director and CEO, Metropolitan Museum of Art; Anna Tobin D'Ambrosio, director and chief curator, Munson-Williams-Proctor Arts Institute Museum of Art; Matthew Teitelbaum, Ann and Graham Gund Director, Museum of Fine Arts, Boston; Carmine Branagan, director, National Academy Museum; Earl A. Powell III, director, National Gallery, Washington, D.C.; Julian Zugazagoitia, director and CEO, Nelson-Atkins Museum of Art; Steven Kern, director and CEO, The Newark Museum; Terrie Sultan, director, The Parrish Art Museum; Harry Philbrick, Edna S. Tuttleman Director of the Museum, Pennsylvania Academy of the Fine Arts; Timothy Rub, George D. Widener Director and CEO, Philadelphia Museum of Art; Amada Cruz, Sybil Harrington Director, Phoenix Art Museum; Elizabeth Glassman, president and CEO, Terra Foundation of American Art; Brian Kennedy, president, director, and CEO, Toledo Museum of Art; Kymberly Pinder, interim director, University of New Mexico Art Museum; Alex Nyerges, director, Virginia Museum of Fine Arts; and Adam D. Weinberg, Alice Pratt Brown Director, Whitney Museum of American Art.

We would also like to extend our sincere thanks to the collectors and individuals from the lending institutions who helped make the exhibition and catalogue possible: Julie Aronson, Paula Binari, Jennifer Belt, Patricia M. Boulos, Naomi Brown, Peter John Brownlee, Timothy Anglin Burgard, Kia Campbell, Sean Campbell, Shelly Buffalo Calf, Teresa A. Carbone, Sarah Cash, Helen A. Connor, Margi Conrads, Ana Cox, Erin Damon, Ulysses Grant Dietz, Sierra Dixon, Peter Dueker, Samuel Duncan, Stephen Fisher, Ilene Susan Fort, Emily Foss, Kathleen A. Foster, Caroline Gallagher, Rhea Garen, Amanda Gaspari, Allison Gillette, Jacob Glenn, Susan Grinols, Joanna Hanna, Adam Duncan Harris, Barbara Haskell, Julia M. Hayes, Paula Haymon, Michelle M. Henning, Danielle Henrici, Stephanie Heydt, Chris Hightower, Erica Hirshler, Peter B. Hirtle, Susan Hudson, Ruth Janson, Jennifer Johns, April Johnston, Laurie H. Kind, Stephanie Fox Knappe, Andrea Ko, Allison LaBelle, Alexandra C. Lane, Nancy Leeman, Karen Y. Lemmey, Susan Lewandowski, Stephen Lockwood, Alicia Longwell, Patricia Lord, Emma Lott, Lisa MacDougall, Vanja Malloy, Donald E. Marcus, Jr., Anna Marley, Jennifer deMartino, Christine M. A. Marzano, Julie Mattsson, Michelle Maxwell, Paul McDermott, Karen McWhorter, Christine (Chris) McNamara, Dana Miller, Laurel Mitchell, Janet Moore, Jeremy Munro, Kenneth Myers, Susan Ishler Newton, Christopher C. Oliver, Emily Olson, Jessica Palmieri, Jessica Pepe, Alicia Perkins, Howell W. Perkins, Allen Phillips, Richard Rand, Catherine L. Ricciardelli, Erin Richardson, Nilda I. Rivera, Cheryl Robledo, Kim Roblin, Joshua Ruff, Barbara Rathburn, Lacy Schutz, Stacey Sherman, Heidi Smith, Jerry Smith, Michelle Smith, Whitney Snyder, Michael Somple, Richard Sorensen, Judy Sourakli,

Barbara Spieler, Estate of Susanne Suba, Mary Sullivan, Joyce Szabo, Rachel Tassone, Diana Thompson, Cynthia Tovar, Giema Tsakuginow, Leni Velasquez, Jane E. Ward, Leslie West, Laura Wenzel, David Whaples, Michele Wright, and Sylvia Yount.

Of course, we are especially grateful to the private lenders, who are sharing works of art from their personal holdings. Their generosity merits special mention. We would like to thank Claude Albritton, the Foxley Collection, David and Laura Grey, John and Susan Horseman, the Thomas H. and Diane DeMell Jacobsen Ph.D. Foundation, Litowitz Family Foundation, the Manoogian Collection, Irene and Joe Orgill, and Judith and James Pizzagalli. Works from private collectors who wish to remain anonymous have been entrusted to us thanks to the support of Elizabeth Beaman and Anne Habecker, at Christie's, New York; John A. Robbins, David Rothschild, and Nina Del Rio, at Sotheby's, New York; and Maxwell Davidson III, New York, among others.

Finally, we offer our sincerest thanks to the kind and patient people at University of Oklahoma Press. Charles E. Rankin, editor-in-chief, has been a generous adviser from the very beginning. We are most grateful also to assistant managing editor Stephanie E. Evans and copyeditor Melanie Mallon, who gracefully edited the book you are now holding.

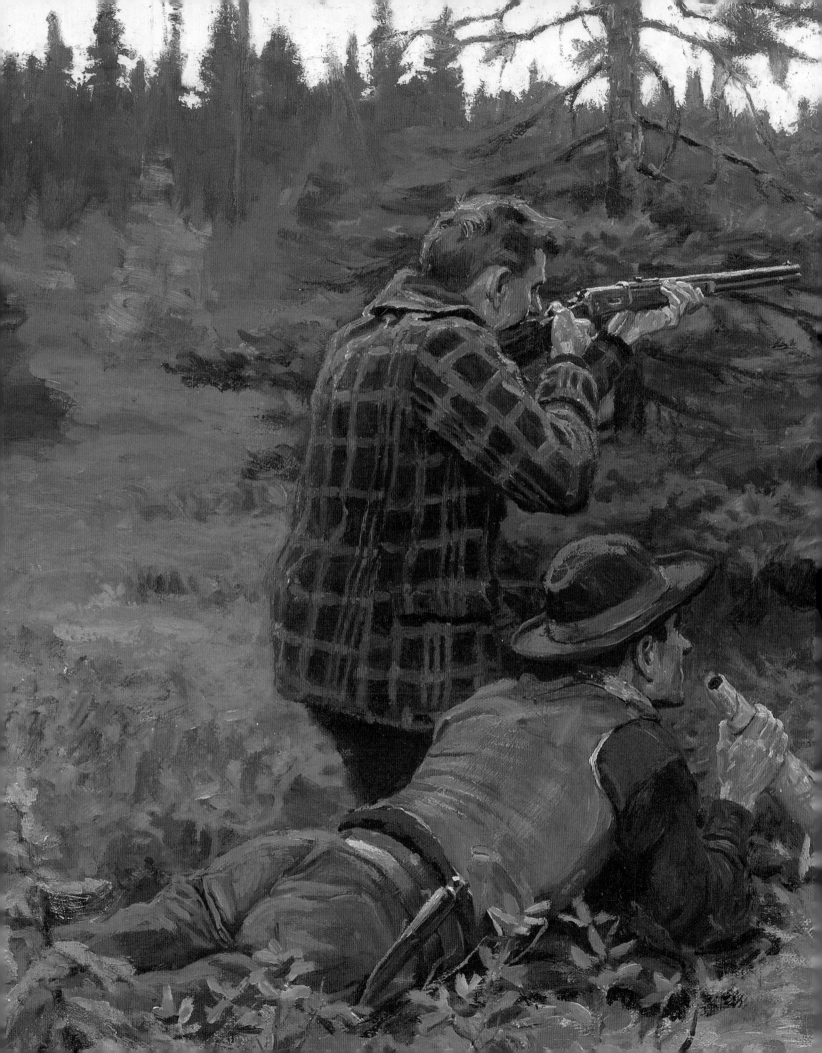

WILD SPACES, OPEN SEASONS

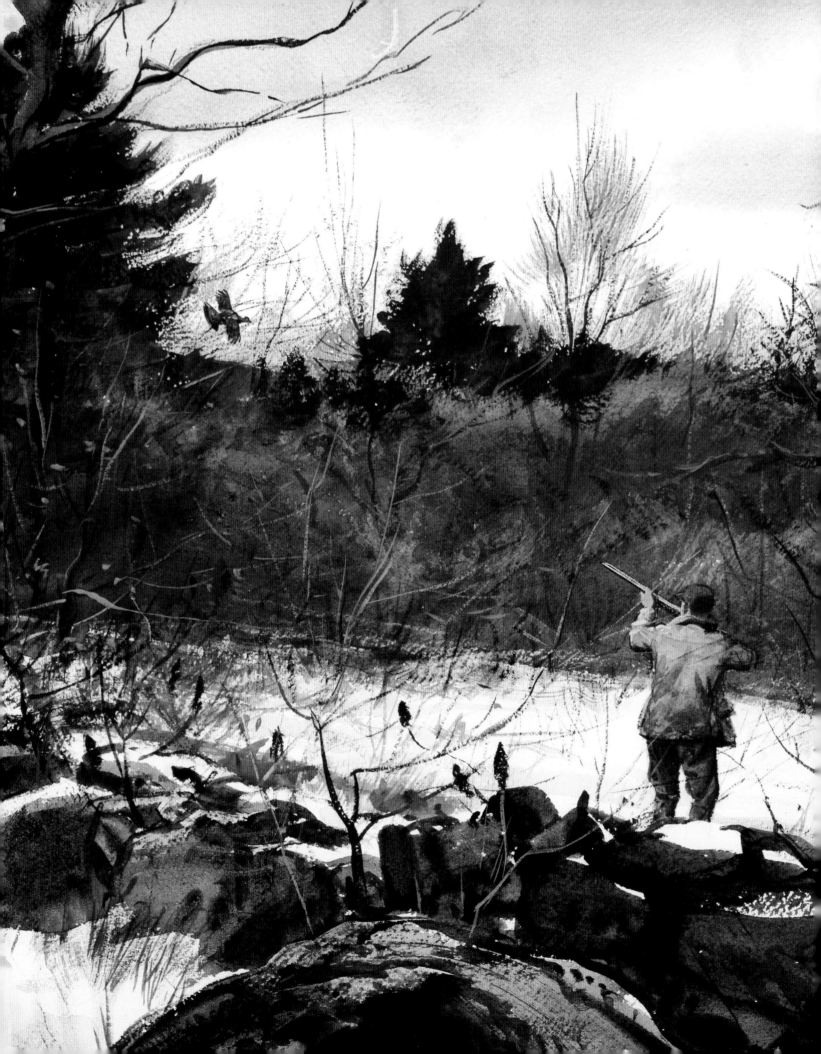

Artists Afield

Stephen J. Bodio

Writing for this remarkable book and introducing an exhibition of seventy-three paintings and sculptures depicting hunting and fishing in America, with a timeline stretching from the early nineteenth century to World War II, is a daunting task. These works share many common themes, but their subjects are not only various; their meanings, both deliberate and unconscious, symbolize and exemplify almost as many changing ideas about sport as there are paintings and sculptures. The artists range from nineteenth-century portraitists to religious thinkers, from genre painters to naturalists. Their motives vary from innocent celebrations of the hunt and serene depictions of high society men and women fishing to political satire and imitations of aristocrats at play, in the style of earlier English or French painting. Throw in Hudson River school painters, sportsmen, Rooseveltians, and modernists, all with different ideas, passions, and, perhaps, agendas; add straightforward depictions of the West by Charles M. Russell as well as superficially similar romanticized narratives by Frederic Remington, and we can see why enjoying each of them is at once an act of celebration and one of criticism. They all contribute something of value, and I hope to show you why.

You might accuse me of overthinking the subject. Surely, we all understand something as elemental as hunting and fishing. But . . . do we? To understand sporting art, one must first understand what "sport" is, and also grasp whether one approves of it and why. None of these decisions is simple. Yale professor Stephen Kellert, in a recent study, found that hunters in the United States usually fall into one of three categories: utilitarian meat hunters, nature hunters, and sport hunters. Most people who say they dislike hunting base this dislike on their image of sport hunters and say that meat hunters are more justifiable. That meat hunters are traditionally people who view the wild as simply a sort of supermarket is not always clear to nonhunters; that sophisticated sport hunters often undergo as many as five stages of evolution to end up, with the "nature" hunters, as the most discriminating and selective of all has not

(detail facing, and above)
Cat. 51.
Ogden Minton Pleissner
Ruffed Grouse Shooting, n.d.
Watercolor on paper,
20⅛ × 27⅞ inches
Collection of Shelburne Museum,
Shelburne, Vermont. Bequest of
Ogden M. Pleissner, 1984-17.18

penetrated the popular consciousness. I know a doctor in Montana who hunts mountain lions with a bow he made himself and hounds he has trained, and he actually eats them, mostly in delicious stir-fry dishes. He also keeps the skull and skin. What kind of hunter is he?[1]

The old utilitarian view is also changing, with the entry of young foodies and sustainable agriculture advocates. Increasingly, thoughtful people question the sources, the morality, and even the aesthetics of food. In this context, a wild game animal or fish apparently leads a better life than one raised on a factory farm.

Most people who say they disapprove of hunting approve of fishing, especially so-called catch-and-release fishing. As I argued in the apologia for my collection of essays about sporting books, *A Sportsman's Library*, fishing *is* hunting. Yet only with fishing do we condone what I call "politically correct fish torture"—catch and release.[2]

Although we refer to the broad category of "sport" in English, I make little distinction in *A Sportsman's Library* between sport and subsistence hunting, reminding readers that if they think the line is clean, they have probably never read the rich literature of English poaching or hunted with those who were until recently condescended to as "primitives." This volume celebrates all the modes of sport, including the more politically incorrect products of a less self-conscious age. We may love wolves and bears now, but when humans could still be prey and contended with predators for food, triumph over great beasts was something to celebrate. The nineteenth century was not always that far from the ancient caves of France.

Within the *Wild Spaces, Open Seasons* exhibition, six major themes overlap, refer to each other, and sometimes even argue among themselves. The first, "Leisurely Pursuits," comprises serene portraits of upper class recreations, one of the earliest themes to appear in sporting art; aristocrats had the wherewithal to commission art. (Paleolithic hunter-gatherers, who also had leisure time, made great hunting art.) "Livelihoods" depicts humbler, realistic pursuits: hunting and gathering of food; hunting as work, however pleasurable (for a full belly is not an ignoble goal), more than as leisure,

including the work of hunter-gatherers. "Communing in Nature" explores hunting and fishing as communal actions. "Perils," an ancient, productive lode of hunting images, shows the dangers (and thrills) inherent in any interaction with the untamed wild, be they dangers from your quarry or dangers from a threatening environment. "Myth and Metaphor" includes examples of field sport's mythological heritage, from the classical to the romantic and even the spiritual. Finally, "Trophies" is composed of works that depict the products of hunting and fishing, realistically (e.g., trompe l'oeil painting and explicit depictions of food) as well as ironically, including slightly satirical depictions of taxidermy and other constructions.

These last three exhibition sections may have the deepest roots, harking back to our oldest art, the cave paintings of the Paleolithic, in their durable ancient themes. R. Dale Guthrie, in his book *The Nature of Paleolithic Art*, suggests that those wonderful paintings had value as instruction, celebration, and warning but were first a form of play. His thoughts about Paleolithic art could perhaps stand for all sporting art and remind us of its continuity: "And though fun was the organic driver for art, it has deeper evolutionary agendas. In that role it is much more than a cluster of symbols for secondary meanings or some epiphenomenon of being human. Rather, Paleolithic art is that first clear spoor of advancing creativity in the human line."[3] This history of the republic in the form of a sporting art show is also a contemporary hunter's grotto; everyone who is interested in nature, from a passionate sportsman or woman to a skeptical professor of art history, should enjoy this unique collection.

In the presence of a moving frontier in the nineteenth century, all these themes overlapped in time. "Leisurely Pursuits" examines hunting and fishing as recreation, usually by the upper classes, but these paintings are not only from the nineteenth century; they go on into the twentieth. Perfect examples include all the portraits of anglers and hunters by John Singer Sargent (fig. 1.1 [cat. 60]; see also figs. 3.25 and 4.21 [cat. 61]). Though they are among the most painterly representations in the show, they can also be considered society portraits, a category

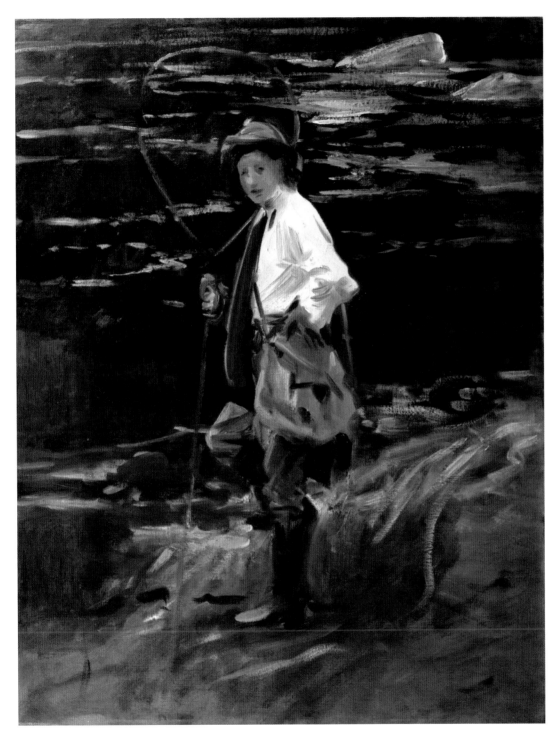

Fig. i.1 (Cat. 60)
John Singer Sargent
A Young Salmon Fisher, ca. 1901
Oil on canvas, 28 × 22 inches
Private collection, New York

Fig. i.2 (Cat. 23)
Alvan Fisher
Under the Bridge, 1828
Oil on canvas, 30 × 25 inches
Collection of Phoenix Art Museum,
Phoenix, Arizona. Museum
purchase with gifted restricted
funds from Mr. Edwin Q. Barbey,
2011.174

that he eventually quit; most show handsome young men and women who seem to be *playing* at fishing. And although Thomas Eakins painted harrowing themes such as operating theaters and, in my favorite painting of his, *Whistling in Plovers*, poor black hunters with muzzle-loaders calling shorebirds, most of his subjects are people of the comfortable classes.

All these images have a lushness and serenity that is pleasing to the eye even in our critical age. David Neal's *After the Hunt* (see figs. 2.13 and 4.6 [cat. 46]) shows a dog, dead game, and an archaic firearm, a wheel lock of a kind not used since the seventeenth century, while a flirtatious couple lurks in the background, almost invisible. Its perfect details almost suggest something preserved under glass. Some of the landscapes, like Alvan Fisher's (fig. i.2 [cat. 23]), are as serene, unlikely, and ethereal as those of Jean-Honoré Fragonard's prerevolutionary concoctions, though in Fisher's case, the figure is a fisherman rather than a decadent aristocrat playing games.

Thomas Hovenden's 1879 *The Favorite Falcon* (see fig. 4.7 [cat. 33]) is another anachronistic portrait—its style resembles that of Thomas Gainsborough, both older and English. It would be interesting to know if the subject were actually a falconer. Historical evidence suggests there was no falconry in the United States until early twentieth-century artist Louis Agassiz Fuertes painted the sport for *National Geographic* in the 1920s, inspiring a generation. Nor does Hovenden's "falcon" resemble any North American species. Could this painting be portraying the subject as more important socially than he was, associating him with aristocratic trappings?

In general, the works in the second section, "Livelihoods," are a more rough-and-ready bunch. They are also more American. While many in the first section could be European, the frontier now becomes a looming, sometimes ominous presence, even when the painters are members of the establishment, like Frederic Remington, Winslow Homer, or Thomas Eakins.

Remington is a good example. A wealthy club-man who spent the majority of his artistic career in New York—save for a brief and unsuccessful stint

as a sheep rancher in Kansas—he painted the frontier, now safely in the past, with enthusiasm if not always with accuracy. Although he is often linked in the popular imagination with the Missouri-born Montanan Charles M. Russell—who came from some means yet still managed to make it as a working cowboy—the similarities end with subject and time. Remington, they said, "knew the horse" and researched paintings in detail, obtaining models of things like native dress. He did not "know" many other denizens of the mountains and plains; his mountain lions for Theodore Roosevelt's book *Ranch Life and the Hunting Trail* resemble starving African lions, and his elk are as bad.[4] His studied images lack the authenticity of Russell's, who painted life as he lived it or how it had been lived in living memory. That said, *An Indian Trapper* (fig. i.3 [cat. 56]) is among Remington's best, with a lively horse and authentic detail. American Indians had been enemies, but they were in the process of being romanticized as their perceived threat diminished and their traditional nomadic life was confined to reservations.

Americans were beginning to grapple with the idea of an authentic *American* art; but who would it portray? William Merritt Chase's *The Pot Hunter* (see figs. 3.11 and 4.10 [cat. 15]) is provocatively titled. Pot hunters were the rednecks of their day, people who killed out of season (for food) and killed more than was considered proper. The stereotype that meat hunters were poor and sportsmen wealthy has survived to some extent to our day, especially among the comfortable. Yet the wealthy nevertheless often hired pot hunters and their like as guides. Despite the snobbery, the first defenders of wildlife came from the upper classes. No one else at the time had the leisure or the money to care. Teddy Roosevelt was the perfect example, but there were countless others, from George Bird Grinnell to Aldo Leopold, not to mention nonhunting conservationists, such as the society women who spearheaded the drive to save the "plume birds" of the Everglades by giving up their fashionable hats. Another polarizing figure, of great importance to American conservation, was the zoologist and innovative taxidermist William T. Hornaday. Unfortunately, he was more like Remington than

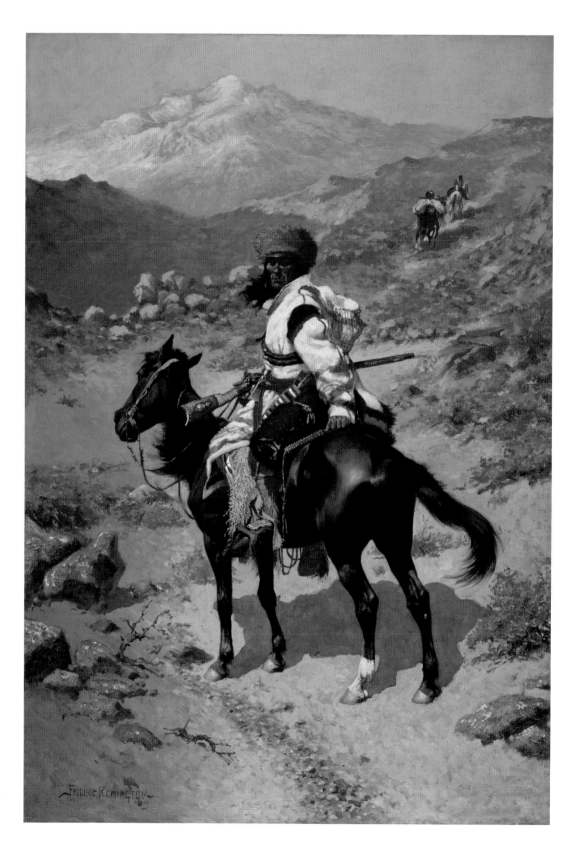

Fig. i.3 (Cat. 56)
Frederic Remington
An Indian Trapper, 1889
Oil on canvas, 49 × 34⅛ inches
Amon Carter Museum of
American Art, Fort Worth, Texas.
Amon G. Carter Collection,
1961.229

Fig. i.4 (Cat. 58)
Charles M. Russell
The Buffalo Hunt [No. 39], 1919
Oil on canvas, 30⅛ × 48⅛ inches
Amon Carter Museum of American
Art, Fort Worth, Texas. Amon G.
Carter Collection, 1961.146

Roosevelt in his views. Imagine my distress at ten, as a precocious reader and naturalist of Italian background, reading in his book that the best way to protect songbirds is to deport Italians and restrict all future immigration!

Meanwhile, artists with less conflicted backgrounds, like Russell, with his *The Buffalo Hunt* (fig. i.4 [cat. 58]), and George Wesley Bellows (see fig. 4.24 [cat. 4]), a painter of the urban Ashcan school, continued with cheerful, realistic depictions of action, be they frightening—buffalo hunts were not safe for man or beast—or almost humorously mundane. Cleaning fish does not lend itself to heroism.

"Communing with Nature" is the most ambitious and most ambiguous category. Everything could be subsumed under it, from eating to adventuring to even fear; consider any nineteenth-century essay on the sublime. The immense uncaring landscape can both terrify and give rise to almost religious feelings of awe. Many of the paintings here

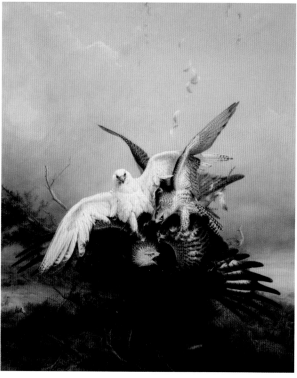

are frankly romantic, deliberately evoking such feelings. Thomas Cole's *The Hunter's Return* (see figs. 1.27, 3.1, and 4.33 [cat. 18]) and virtually *any* Albert Bierstadt have a certain glow previously associated with Renaissance paintings of religious themes.

Others here celebrate community. The hunters in John George Brown's *Claiming the Shot* (see fig. 3.14 [cat. 11]) are sociable, enjoying their discussion of dividing up the spoils. William Tylee Ranney's hunters appear to be discussing matters amicably with their dog (see fig. 3.10 [cat. 55]), as they should; your dog is a legitimate ally and part of your sporting party. Some works are disturbing, Rockwell Kent's *The Trapper* (see fig. 3.20 [cat. 34]) for one. The trapper trudges through an abstract, hard-edged landscape typical of Kent's arctic work, which might evoke feelings of the sublime, but only the coldest comfort. Andrew Wyeth shows an eastern deer hunter so surrounded by his tree that he seems about to disappear into it (see fig. 4.29 [cat. 73]).

"Perils" is a less ambiguous category. As long as art or the human species has existed, we have celebrated the danger of animals and fear in the field, and the necessity of overcoming both. The buffalo hunting paintings of Alfred Jacob Miller or George Catlin could be understood by the cave painters. Arthur Fitzwilliam Tait's *The Hunter's Dilemma* (see fig. 2.2 [cat. 63]), showing a dead deer balanced precariously on a ledge as the hunter tries to retrieve it, is an eternal one, painted in the twentieth century as well by Russell.

Some subjects are less comfortable today. Charles Deas's *The Death Struggle* (see fig. 2.1 [cat. 20]) is a handsomely rendered portrait of two horses, a trapper, and an American Indian, all of whom are plunging to their likely death. It resembles a fighting animal picture, a now-obscure subgenre of older sporting painting, and reminds me of a gleeful quotation from a Renaissance falconer, who tells his readers they will enjoy the mortal "bickerings" between their falcons and their prey, as indeed they did. This painting resembles nothing more than it does Joseph Wolf's nearly contemporary *Gyrfalcons Striking a Kite* (fig. i.5), which shows two gyrfalcons entangled with a dying red kite falling out of the sky.

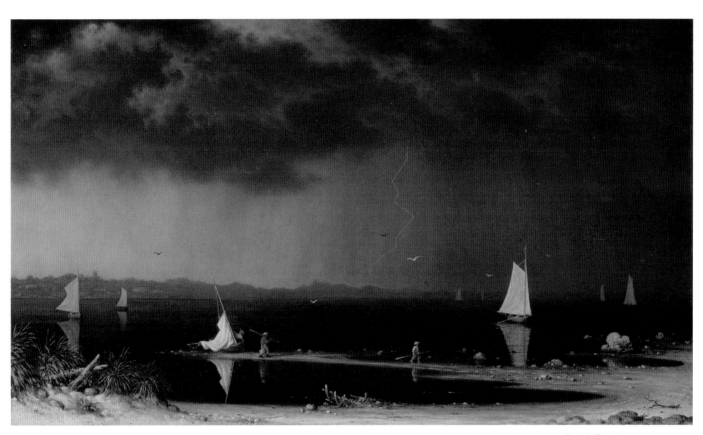

Fig. i.6 (Cat. 29)
Martin Johnson Heade
Thunder Storm on
Narragansett Bay, 1868
Oil on canvas, 32⅛ × 54¾ inches
Amon Carter Museum of American
Art, Fort Worth, Texas, 1977.17

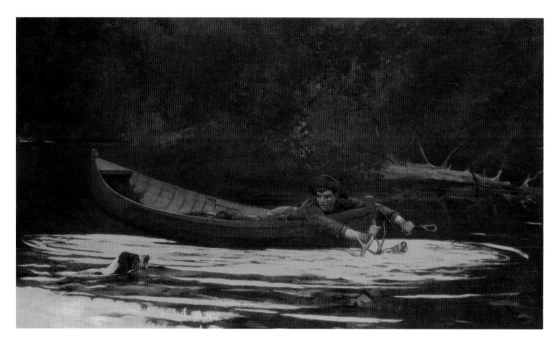

Fig. i.7
Winslow Homer
Hound and Hunter, 1892
Oil on canvas, 28¼ × 48¼ inches
National Gallery of Art,
Washington, D.C. Gift of
Stephen C. Clark, 1947.11.1

In some paintings, fear is palpable, but not the fear of animals or failure. As an outdoorsman, I have had more than one close call with lightning, and I think that Martin Johnson Heade's *Thunder Storm on Narragansett Bay* (fig. i.6 [cat. 29]), showing a looming black cloud behind blowing sails, might be the most terrifying painting in the show, even if it is also an allegory of the Civil War. I would count Winslow Homer's *Hound and Hunter* (fig. i.7), showing a young hunter risking his life to keep from losing his wounded quarry, as another painting in which fear is of the impersonal forces of nature, forces that threaten us and our hunting partners.

In Carl Rungius's *Caribou's Death Struggle* (fig. i.8 [cat. 57]), all humans are off the scene. Two fighting caribou bulls stumble to their knees, their antlers locked together, while carrion birds wheel overhead, and cheerful wolves wait in the distance. The painting is atypical for Rungius, a great painter of "charismatic megafauna," whose late works, I have joked, are big-game cubism, with elaborately constructed granite backgrounds and squared-off muscles, "modern" before their time, or at least outside their genre. But it is a chilling painting, with an unusual backstory. At Shelburne Museum, it is displayed with two locked-together skulls Rungius

found in the Barren Lands, which eventually inspired the painting.

No exhibition of hunting paintings is complete without images of struggles with dangerous animals. In America, despite the presence of relatively minor predators like bobcats and mountain lions, the primary candidates are bears, especially the great grizzly. Bears inhabit a mythical middle ground between animal and human, not least because they can stand up and walk on their hind feet. I was once unnerved by watching a line of bears in the Moscow Circus marching into the ring on their hind feet, like captive humans with large drooping heads or animal masks.

American Indians often portray them as beings that switch back and forth between human and animal identities. In Kipling's poem "The Truce of the Bear," the old guide, who had lost most of his face to a bear mauling, says, "Make ye no truce with Adam-zad, the Bear who walks like a Man!" Although Kipling intended this for political allegory, it works as metaphor. Perhaps for this reason, some of these images, such as Tait's or William R. Leigh's *A Close Call* (see fig. 2.8 [cat. 35]), almost deserve the overused term "iconic," now often misused to mean "typical" or "popular." The pale-faced grizzly in Leigh's painting is as frightening as

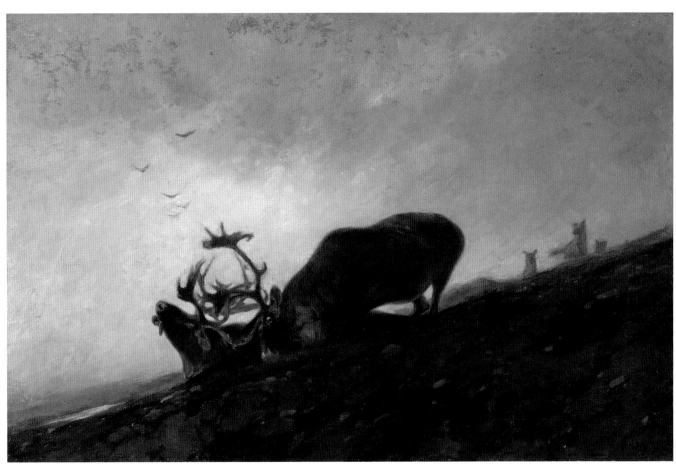

Fig. i.8 (Cat. 57)
Carl Rungius
Caribou's Death Struggle,
1906–1908
Oil on canvas, 30¾ × 46¾ inches
Collection of Shelburne Museum,
Shelburne, Vermont. Gift of the
Sheldon Family in memory of
Mr. and Mrs. Charles Sheldon,
1966-194.1

a goblin. Would these images be as powerful if they depicted a struggle with a cat or a wolf? Considering how unlikely it is that any of us will ever fight a bear, it is a tribute to the mythic power of these images that they can still fill us with unease.

Paul Manship's *Indian Hunter and Pronghorn Antelope* (fig. i.9 [cat. 37]) leads us toward "Myth and Metaphor." As Margaret C. Adler notes in this volume, American Indians were "assuming the mantle of mythological figures." The line between mythical and real seems to move back and forth. Manship also portrays Diana with her bow, and Actaeon being savaged by his own hounds (see fig. 1.8 [cat. 38]). In the nineteenth and early twentieth century, artists were trying to work out distinctly American ways of presenting universal themes.

In changing times, such images could cause controversy. Some reactions to new attempts at mythology are downright funny. When George de Forest Brush painted *A Celtic Huntress* (see fig. 1.9 [cat. 13]), he had studied for six years in Paris with the Orientalist painter Jean-Léon Gérôme and spent time in the West with the Arapahos, Shoshones, and Crows. The powerful painting might well be seen as a Celtic Diana, with her fierce gaze, mournful hound, and brandished arrow.

Some paintings have now lost their original associations. One might think that *Catching Rabbits* (see fig. 1.20 [cat. 43]), by William Sidney Mount, was an image of just that. But apparently it is a convoluted political joke about the aristocratic Whig party's attempts to ensnare down-to-earth voters with "deceptive rhetoric." This interpretation is based on a complicated pun that transforms the word "hare" to 'hair' and "wigs" to "Whigs." Who knew?

Others have more transparent themes. Charles Webster Hawthorne titled his painting of a fisherman *The Calling of St. Peter* (see fig. 1.21 [cat. 28]), emphasizing the human nature of the hard-working saint. The devout Henry Ossawa Tanner, one of only two African Americans in the exhibit and a minister's son, as well as a student of Eakins, believed that devotion was insufficient; only the artist's best work was worthy of being called art. His *The Miraculous Haul of Fishes* (see fig. 1.22 [cat. 67]) is like a gleaming, dramatic impressionist version of N. C. Wyeth's painting of hauling lobster

pots, its overflowing multichrome abundance nearly capsizing the boat (see fig. 3.21 [cat. 72]).

The final section of the exhibition is entitled "Trophies," a word that can refer to many things, from food to stuffed animals. But all trophies are tangible reminders, ones that *didn't* get away. The simplest depict hunters or anglers holding up their prey, or perhaps fish on a bank. Walter M. Brackett's 1867 *Trout* (see fig. 4.15 [cat. 8]) is an example, as is Robert Jenkins Onderdonk's slightly peculiar *Still Life of Fish* (fig. i.10 [cat. 47]), with its painted frame. Hanging dead game is another popular theme, again one transported from the European tradition. Nowadays, these images are often seen as grim. Contemporaries do not realize that game was hung, sometimes for many days, to improve its flavor and make it palatable. Artists have naturally appreciated the beauty of hanging dead game, the spread of feathers, the startling rearrangement of shapes. Richard La Barre Goodwin's *Two Snipes* (see fig. 2.17 [cat. 24]) is a good example, as is Alexander Pope's dramatic, monumental *The Wild Swan* (see fig. 2.15 [cat. 54]), one of the most striking images in the exhibition. I might add that a few painters have continued in this tradition, notably the recently deceased Bruce Kurland and the living Thomas Aquinas Daly. I own a small Daly, *Two Hanging Snipe*, perhaps inspired by Goodwin, which I purchased partly because, as Daly put it, "most people don't like this kind of thing any more."

The Onderdonk painting leads to the strange world of trompe l'oeil, literally "fool the eye"; the best of these are so exacting in their realism that they can momentarily do so, though they do have some peculiar conventions. Most seem to delight in archaic weaponry, perhaps because it is more beautiful than soulless modern weapons. William Michael Harnett's *After the Hunt* (see fig. 2.13 [cat. 26]) shows a wheel-lock rifle, as in David Neal's painting of the same name. My favorite, Alexander Pope's *Trophies of the Hunt* (see fig. 2.12 [cat. 53]), features a muzzle-loading gun (old-fashioned though not quite archaic; muzzle-loaders were still in use during the artist's lifetime), and an extinct bird, the heath hen.

Sometimes the implicit meanings in such paintings can be a little more sinister, such as in

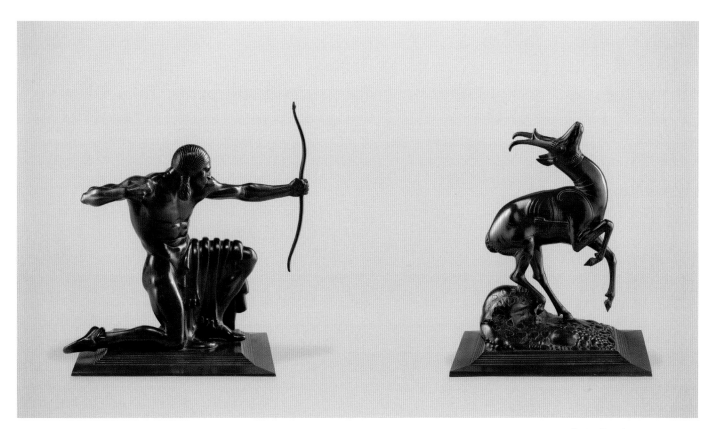

Fig. i.9 (Cat. 37)
Paul Manship
*Indian Hunter and Pronghorn
Antelope*, 1914
Bronze, Indian: 13 × 10⅛ × 8 inches;
Antelope: 12 × 10⅛ × 8 ¼ inches
Amon Carter Museum of American
Art, Fort Worth, Texas. Purchase
with funds from the Ruth
Carter Stevenson Acquisitions
Endowment, 1997.3.a-b

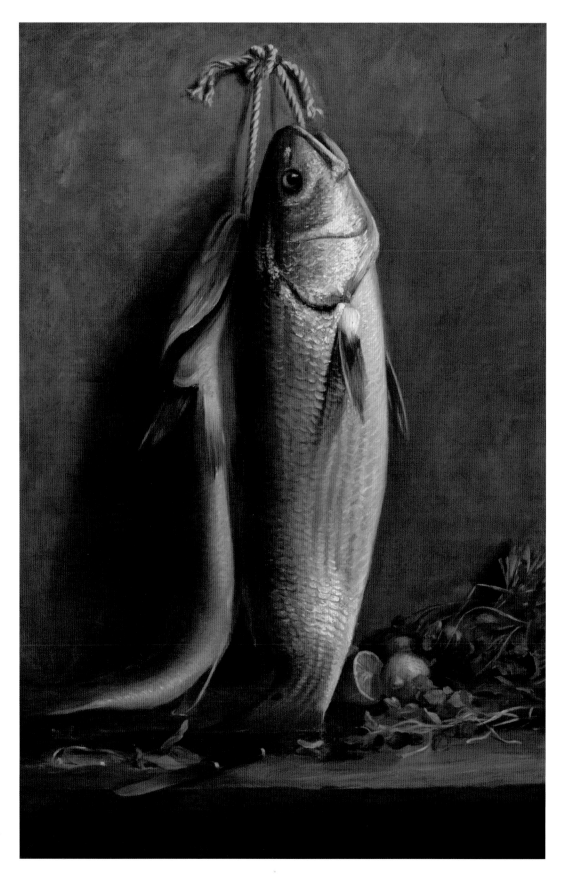

Fig. i.10 (Cat. 47)
Robert Jenkins Onderdonk
Still Life of Fish, 1889
Oil on canvas with painted frame,
30 × 20 inches
Albritton Collection

Astley D. M. Cooper's *The Buffalo Head, Relics of the Past* (see fig. 2.17 [cat. 19]). In addition to its nominal subject, a taxidermic bison head, it features an American Indian pipe, axe, and club, as well as six carte de visite portraits: Red Cloud, Chief Gall, Frank Grouard (formerly a scout for General George Crook), Sitting Bull, and Wild Bill Hickok, all surmounted by Buffalo Bill Cody. Is the artist insinuating that the people themselves were trophies? Odder still is that Cody owned the painting himself, and it hung in his Irma Hotel for many years, as if it were his own head he was mounting on the wall. Other works are not only benign, but imply pleasure. Given the prominence of Italian Americans in the new "foodie" involvement in hunting, especially in the Bay Area, it is tempting to read Luigi Lucioni's 1940 *Fowl and Glass of Red Wine* (see fig. 2.16 [cat. 36]) as a precursor, an "early adapter." Buon appetito!

◆ ◆ ◆ ◆ ◆

Until recently, a fastidious distaste for hunting was the popular view in our largely urban population. But considering how deep the human roots of hunting are, as voiced by Guthrie, it is unlikely that images of such power and resonance will disappear. Recently, a new movement toward sustainable and healthy food has led to a renaissance of hunting in the most unlikely circles, especially in northern California and New York state. The first sign of this was when Michael Pollan, in his critique of industrial agriculture, *The Omnivore's Dilemma*, describes hunting for feral pigs with an Italian American chef and foodie friends in the California hills, with a rifle.[5] The success of this book inspired several other publications, notably Hank Shaw's blog *Hunter Angler Gardener Cook*, twice nominated for a James Beard Foundation Award, and its successor book *Hunt, Gather, Cook*.[6] Books like Steven Rinella's *The Scavenger's Guide to Haute Cuisine* and Georgia Pellegrini's *Girl Hunter* (a good book despite its unfortunate title) bring new perspectives to the table.[7] A recent *Huffington Post* article was even titled "Millennials Must Hunt" and was accompanied by a video of the young writer killing, butchering, and eating a mule deer in Montana's Paradise Valley.[8] A surprise best seller of 2014 was Helen Macdonald's *H is for Hawk*, a first-person account of training a goshawk to hunt, which was excerpted in *Vogue* and profiled in the *New Yorker* and on National Public Radio.[9] I suspect that some serious, nearly tectonic, cultural paradigms have shifted. As long as we have been human, or at least modern *H. sapiens*—more than sixty thousand years—we have made not just art, but hunting art, and we will doubtlessly continue to do so. This magnificent exhibition shows us where we have been; perhaps we can hope next to see one that shows us where we are going.

NOTES

1. David Quammen, *Wild Thoughts from Wild Places* (New York: Scribner, 1998), 187.
2. Stephen Bodio, *A Sportsman's Library: 100 Essential, Engaging, Offbeat, and Occasionally Odd Fishing and Hunting Books for the Adventurous Reader* (Guilford, Conn.: Lyons Press, 2013), xi.
3. R. Dale Guthrie, *The Nature of Paleolithic Art* (Chicago: University of Chicago Press, 2005), 399.
4. Theodore Roosevelt, *Ranch Life and the Hunting Trail*. Illustrated by Frederic Remington (New York: Century, 1888).
5. Michael Pollan, *The Omnivore's Dilemma: A Natural History of Four Meals* (New York: Penguin, 2006).
6. Hank Shaw, *Hunt, Gather, Cook: Finding the Forgotten Feast* (Emmaus, Penn.: Rodale, 2011). Shaw's blog can be found at www.honest-food.net.
7. Steven Rinella, *The Scavenger's Guide to Haute Cuisine* (New York: Miramax/Hyperion, 2005); Georgia Pellegrini, *Girl Hunter: Revolutionizing the Way We Eat, One Hunt at a Time* (Boston: Da Capo Lifelong, 2011).
8. Michael J. Parker, "Millennials Must Hunt," *Huffington Post*, February 5, 2015, www.huffingtonpost.com/michael-j-parker/millennials-must-hunt_b_6623454.html.
9. Helen Macdonald, *H is for Hawk* (London: Jonathan Cape, 2014).

Sacred Rites, Vengeful Goddesses, and Tall Tales

Margaret C. Adler

My library contains a well-thumbed copy of *Zen in the Art of Archery*, the work of a German philosopher who learned to shoot a bow as a means of mystical and spiritual enlightenment.[1] I read the volume only after years devoted to pursuing excellence as a competitive archer, but it struck me that I had been a Zen archery practitioner of my own making all along. The narrative of a shot in the inner workings of the mind sounds something like this:

> Breathe in. Usher all thoughts away—the idea of winning, the machinations of the person next to you, what you ate for breakfast. Lift the bow and begin to push and pull, executing a familiar sequence of movements. Steady. Pause. Feel the breeze circling around, hear the sounds, but let them drift in and out of conscious acknowledgment. Allow the muscles of the body to do what they know. Release. Breathe.

If the archer's brain refrains from interference, there will be no need to examine the target, as the shot will have found its mark.

How can an art historian writing about myth, rites, and metaphor in the artistic expression of the hunt not bring to bear her own experience with the ritual of a shot? Though I am not a hunter of animals, I was a wielder of bows, and when I sleep at night, in the fertile land of the subconscious, the power of the practice resurfaces. I am transported back to competitive playing fields. I can smell the grass; feel the flex of the bow limbs and the sensation of muscles shifting, tightening, and releasing; hear the twang of the bowstring, and listen for the *zip* and *thwock* as the arrow hurtles through space and connects with the target bale. I can taste the thrill of victory. All the senses play a part. The process is as familiar as climbing a staircase or tying my shoes. It has been almost twenty years since I last strung a bow and felt the taxing of well-honed muscles, but that is the power of ritual: it becomes ingrained in our very being and remains integral to who we are.

(facing)
Detail of fig. 1.22 (cat. 67), p. 48
Henry Ossawa Tanner
The Miraculous Haul of Fishes,
ca. 1913–14

The physical and spiritual exercise is seared into my body and mind. I can only imagine that one crux of the lasting power of the hunt, its universal prominence in the major artistic creations of most cultures seeking to commemorate their important moments, is its frequent presence in the soul of its practitioners. The sentiment can be so powerful that we refer to engaging in the practice as an art form; it is no coincidence that serious followers read *Zen in the Art of Archery* or that fly fishermen spend their lives perfecting the *art* of casting.

The human creation of mythic legends and images of the hunt certainly predates the founding of the United States, the locus of the works in this exhibition, and reaches from the deepest recesses of painted caves to the highest vault of the stars. The stories and representations follow us from our earliest days of information sharing to the persistent myth of the "big one"—the ever-elusive catch. The topic plays a role in all of life's major moments, from coming of age, to love, to marriage, to spiritual awakening, to contemplation of frailty and mortality. The earliest people, in an attempt to organize and recognize the world around them at a time when knowledge of the stars and other celestial bodies was critical to survival, drew connections between the objects in the heavens, making imagery to track movement of the seasons and to explain the unexplainable. In this image formation of the most fundamental kind, is it any wonder that the sky pictures they constructed so often disseminated the mythic lore of the hunter and hunted?

The stars tell the tales of perpetually captive prey—whether in the form of an animal or an unwilling recipient of amorous advances. The giant Orion, the Hunter, who is accompanied by his two dogs, Canis Major and Canis Minor, is perhaps the most famous (fig. 1.1). His presence frightens the hare, Lepus, at his feet.[2] According to various myths, Orion was epically sized and purportedly very handsome. He once boasted that he would kill all the animals on earth, inciting the wrath of Gaia, who sent a scorpion after him. Diana, goddess of the hunt, may have been in love with him, rivaled by Aurora, goddess of the dawn. Diana blinded Orion with an arrow rather than see him notice Aurora. Another version of the myth is that Apollo

was displeased with his sister Diana for neglecting her hunting. He goaded her into shooting a hare, knowing full well that Orion, not the hare, was in the underbrush and therefore was caught in the crossfire. Devastated at what she had done, Diana asked Zeus to preserve the great hunter's legacy by placing him among the stars. In the Hindu tradition, the constellation Orion represents Lubdhaka, the Deer Slayer, who saved the beautiful girl Rohini, in the form of an antelope, from the unwanted attentions of her father, Prajápati. For the Maoris, Orion is Tamarereti in a canoe, fishing the night away. After catching a forbidden fish, he choked on his catch and died. His presence in the stars is a warning to respect the gods and their fishing rules.[3]

And the stellar imagery does not stop at Orion. The heavens are full of predator and prey, such as Diana's favorite hunting companion, Callisto, in the form of Ursa Major; hunting dogs; Scandinavian moose antler constellations; and Siberian reindeer stags. Some of the first illustrations of tools of the trade can be found in Hou-chi, the Chinese bow and arrow constellation; the Marshall Islands people's connection of stars to form a fishing rod; and constellations of traps.[4] The greatest mythic hunters have earned the right to eternal pursuit, the instruments and objects of their prowess cemented in imagery organized from the seeming chaos of the firmament.

Back on earth, the myth of the "big one"—the fish catch to end all fish catches—is everywhere in evidence, from the epic struggle portrayed in Ernest Hemingway's *The Old Man and the Sea*, in which pursuer's and pursued's fates are inextricably intertwined, to the recent social media bonanza when a Florida owner of a bait and tackle shop reeled in an 83-inch-long, 552-pound grouper from his one-person kayak.[5] In a statement that is blatantly obvious, but needed to be added to the record, the fisherman advised the general public not to attempt to capture large marine animals while in a kayak. One might fancy the whole thing to be a tall tale or the stuff of myth were it not captured in images, from still photographs to YouTube videos.

Throughout the history of art to present-day Internet memes, the hunt and catch and the mythic tales that accompany the topic have occupied

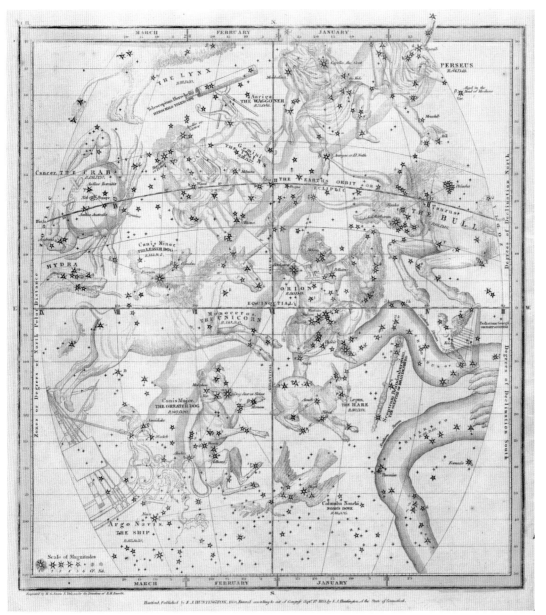

Fig. 1.1
Elijah H. Burritt
*Atlas Designed to Illustrate the
Geography of the Heavens:
The Visible Heavens in January,
February and March*, 1850
University of Michigan Library,
Ann Arbor, Michigan

image makers from a broad range of cultures. Some hunting and fishing metaphors and myths are irresistible to the Western artistic imagination, from a formal or a philosophical standpoint—such as imagery of the goddess Diana, depictions of the successful and unsuccessful pursuit of love, renderings of spiritual and religious lore, and allusions to mortality. Hunting and fishing images in the United States, a nation with a short history and thus the need to form a distinctive identity, build on these fixations and add American concerns to the mix. More can be at stake in renderings by

American artists than mere representations of life's major moments or literal portrayals of the hunt or catch. They took on the subjects of classical myth to assert their understanding of precedent, to connect their society to the great civilizations of the past, and to demonstrate their departure from established norms. They sought a way to understand and represent American Indians through hunting scenes, seeing in their cultures a connection to earlier or simpler times. They celebrated American myth makers and engaged in political commentary through images of the hunt. Religious iconography

related to fishing or the artists' own spiritual sentiments inspired their creations. They contemplated the waning of life. Hunting and fishing images in America abound, whether the artists were seeking to elucidate the ebbs and flows of existence or to evoke the universal through connecting with or diverging from the past.

THE MYTH OF THE UNAPPROACHABLE HUNTRESS

Among the twelve Olympian gods—the most powerful deities, who reign supreme over the daily lives of the human race, according to the Greeks and Romans—the inclusion of the mistress of wild beasts, the chaste goddess of the hunt, Diana (or Artemis), is significant. Diana was the twin sister of Apollo, daughter of Jupiter (or Zeus) and Leto. She was "Huntsman-in-chief to the gods."[6] Pure and maidenly, she could also be fierce, a paradox often examined in artistic representations. Though all animals were sacred to her, foremost among her treasured beasts were deer, particularly hinds.

The famed story of Diana and Actaeon was a favorite among artists (fig. 1.2) because of its iconographic complexity and, undoubtedly, because it provided a pretext for showing nudity. Greek and Roman mythology provided source material for many centuries of Western artistic output.

According to the poet Ovid, the young hunter Actaeon and his companions were completing a day of hunting "on a mountain stained with the blood of many slaughtered beasts." Actaeon, ready to end the day's adventures, addressed his men: "Both nets and spears, my friends, are dripping with our quarry's blood, and the day has given us good luck enough." But bad luck was to ensue. Actaeon came upon a "vale in that region, thick grown with pine and cypress with their sharp needles . . . the sacred haunt of high-girt Diana." He espied the place in which, "when weary with the chase, [Diana] was wont to bathe her maiden limbs in the crystal water."[7] Her nymphs were responsible for dressing and undressing her and accounting for her spear, quiver, and unstrung bow. As Diana's privacy was paramount, the consequences for intruding on this ritual were dire.

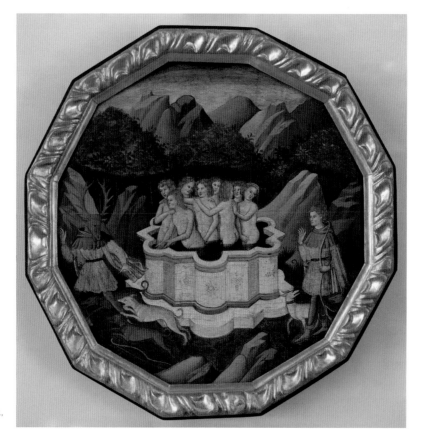

Fig. 1.2
Attributed to **Paolo Schiavo**
Birth Platter: The Story of Diana and Actaeon, ca. 1440
Tempera on panel,
27¹⁵/₁₆ × 27¹⁵/₁₆ inches
Williams College Museum of Art,
Williamstown, Massachusetts.
Bequest of Frank Jewett Mather, Jr.,
Class of 1889, 62.3

Wandering lost in the woods, Actaeon entered Diana's grove. As soon as he was spotted, the nymphs grew distressed. "They thronged around Diana, seeking to hide her body with their own; but the goddess stood head and shoulders over all the rest." The goddess's cheeks flushed red as she was caught in her nakedness. Searching in vain for her arrows, she seized water from the bath and directed it at Actaeon. A transformation ensued: Actaeon turned into a stag with "sharpened ear tips" and "spotted hide" and was rendered mute in the process, so that he could neither tell what he had seen nor warn his loyal pack of hunting hounds that he was their master. His own dogs mauled him, urged on by his hunting companions. According to Ovid, "To some the goddess seemed more cruel than was just; others called her act worthy of her austere virginity." Whether or not her cruelty was justified, there was no doubt that she was vengeful. Not until Actaeon "had been done to death by many wounds, was the wrath of the quiver-bearing goddess appeased."[8]

One of the most famous sculptural representations of Diana is the *Artemis of Versailles*, or *Diana Chasseresse*, in the collection of the Louvre (fig. 1.3). A Roman copy of a Greek bronze original, the classical marble features the chaste goddess modestly clothed in an elaborately articulated chiton, a young deer her faithful companion. Known to Americans through reproductions, the marble is one of two sculptural works that artist Samuel F. B. Morse included in his assemblage of the greatest objects at the Louvre, and artists such as Washington Allston evoked her in their own painted works, such as *Diana in the Chase*, 1805 (Fogg Art Museum).[9] This sculpture emphasizes her innocence; she appears not at all in the guise of a goddess full of vengeful rage, but rather as a forest maiden appropriately attired and gentle enough to be attended by a wild creature.

With bashful or staid precedents in mind, or with an understanding of the full narrative of Diana and Actaeon often depicted in painted versions of the tale, we gain a more complete understanding of the true artistic innovation inherent in the famous American icon *Diana* by Augustus Saint-Gaudens. After the Civil War, increasing industrialization and urbanization in the United

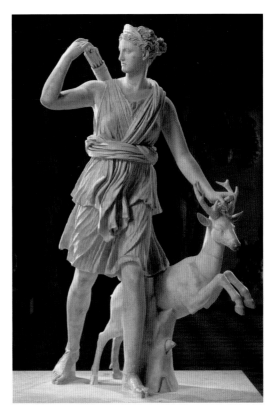

Fig. 1.3
Artist unknown
Artemis of Versailles, "Diana Huntress, accompanied by a hind," C.E. 1st–2nd century
Marble, 78.7 inches
Musée du Louvre, Paris, France, MA 589

States led to civic pride and urban planning. Architects and sculptors were called on to create public monuments. Augustus Saint-Gaudens, friend and collaborator to architect Stanford White, was at the vanguard of public sculptural projects. At the behest of White, Saint-Gaudens conceived of *Diana* for Madison Square Garden in New York City, a new public pleasure palace designed by the firm McKim, Mead, and White. Likely beginning work in 1886, for the first time in his oeuvre, Saint-Gaudens devised a monumental nude sculpture to top the colossal edifice as an impressively scaled, operable weathervane.[10]

The first iteration, an eighteen-foot-tall Diana, adorned with both clinging and flying drapery, was installed in 1891 atop the building's tower, the highest point in Manhattan. She was immensely popular. Describing the public's appreciation for her, critic Mariana Griswold Van Rensselaer wrote, "From the moment of her unveiling, and as long as she was allowed to live with us, the golden Diana which Mr. St. Gaudens set on top of our yellow tower was the most popular personage

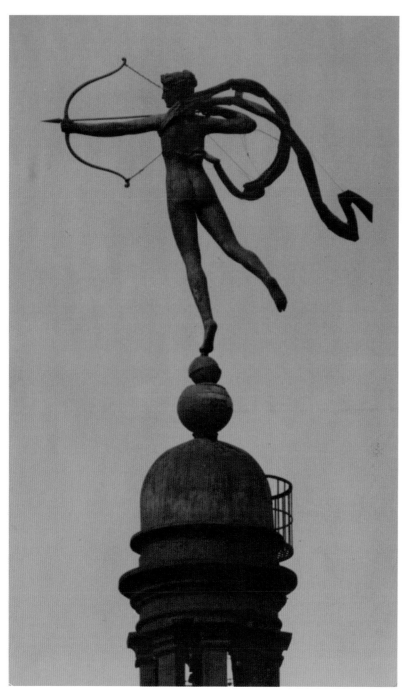

Fig. 1.4
Artist unknown
[Augustus Saint-Gaudens's]
*Statue of Diana Atop the Tower
of the Second Madison Square
Garden*, ca. 1910
Albumen print
Museum of the City of New York,
New York, X2010.11.14116

in all New York."[11] White and Saint-Gaudens, nevertheless, were dismayed to discover she was out of proportion with the building and too unwieldy to move well. Down she came to be replaced with the scantily clad *Diana* now in the collection of the Philadelphia Museum of Art (fig. 1.4).

Delicately balanced on one foot as if caught mid-hunt, drapery trailing behind her in the wind she seems to generate, she appears swift of foot. Like the process of loosing an arrow from a bow, the sculpture is a balance of opposing tensions: of restraint and poise juxtaposed with potential force. It is an exercise in taut muscles countered by a seemingly timeless patience. She can hold this stance forever or release the arrow at any second. In this way, she is a perfect archer—strained and composed, though her tiptoe stance and outstretched leg would prove a challenging position for an effective shot.[12] As critic Royal Cortissoz expressed of the second version, "The lithe goddess now has movement and elasticity as well as dignity; there is more strength in her limbs than there was, and there is more grace. She is what she was not in her earlier phase, an authoritative type of the beauty with which Mr. St. Gaudens has made his public familiar in many works, but never in so buoyant and picturesque a mood."[13]

Perhaps Saint-Gaudens's choice of subject matter was inspired, in part, by the revival of archery in the United States in the late nineteenth century as a leisure sport for ladies and gentlemen of high social order. The resurgence was chronicled and illustrated in the leading periodicals, *Scribner's* and *Harper's* (fig. 1.5).[14] Its pursuit as a genteel sport in America and abroad is confirmed by its frequent association with discussions of lawn tennis and its studied practice by even the likes of Queen Victoria.

The United States' first National Archery Association was founded in 1879, around the time that the seminal instruction manual for bow hunting and target shooting, *The Witchery of Archery*, was published.[15] According to a feature article in *Harper's*, "The spread of the 'toxophilite mania' has been so sudden and wide that dealers have been unable to supply the demand for archery tackle." The author refers to archery's many lady practitioners as "our American Dianas."[16]

The 1890s saw another surge in archery's popularity. The well-known periodical *Field and Stream* featured a column for women in the 1890s called The Modern Diana.[17] The 1904 Olympics in St. Louis included women archers. Though Saint-Gaudens's choice of Diana could have been inspired by the archery craze, the perceived respectability of the sport is in direct contrast to the seeming impropriety of his *Diana* representations.

American painters made the archer Diana a popular subject. In a review of the Twelfth Annual Exhibition of the Society of American Artists from 1890, the critic remarks on the glut of Dianas: "Among the figure painters, Diana seems to be a favorite subject, this year. Ernest L. Major has her, head and bust, in green and red drapery: a good type, but hardly the goddess. Will H. Low has the timid and hesitating huntress in a green forest. . . . And Kenyon Cox has a small, full-length figure."[18] Cox's *Diana* (Chazen Museum of Art) is brazenly nude but intimately scaled. Saint-Gaudens, having studied and worked in Paris, would have also been exposed to many European sculptural Dianas in addition to the works of his American contemporaries: some chaste, and some, such as Jean-Antoine Houdon's own scandal-producing *Diana* (Louvre), nude and in midhunt, absent the pretext of taking a bath. These other Dianas surely influenced Saint-Gaudens's thinking.

With his knowledge of precedent, the artist directed his attention to the innovative conception of the sculpture as a weathervane to be seen from below, in movement, silhouetted by the sky, strong in outline—hence the slim vertical form offset by the grand sweep of her shooting position. At full draw, she is long from elbow to arrow tip, forming an appropriate directional pointer. Saint-Gaudens's variation of an American weathervane combines the classical with attention to the vernacular.

She was a massive, gilded copper apparition, illuminated by electric lights, causing heads to turn and no little amount of imagined envy on the part of her heavily clothed compatriot Lady Liberty. In a July 24, 1904, story for the *New York World Sunday Magazine* entitled "The Lady Higher Up," the famous writer O. Henry drew the contrast between the two public sculptures by having them converse

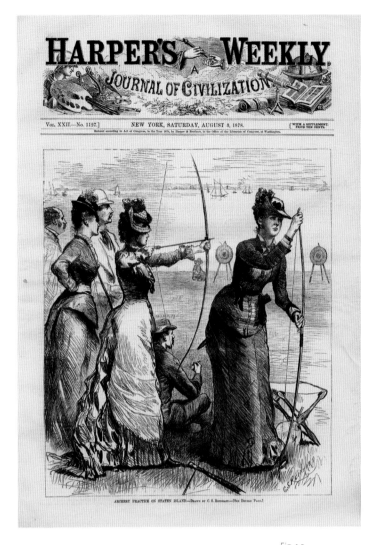

with each other, conforming to what must have been the prevalent opinion of the major divergence in character between Liberty and Diana:

> Three hundred and sixty-five feet above the heated asphalt the tiptoeing symbolic deity on Manhattan pointed her vacillating arrow straight, for the time, in the direction of her exalted sister on Liberty Island. . . .
> The statue of Diana on the tower of the Garden—its constancy shown by its weathercock ways, its innocence by the coating of gold that it has acquired, its devotion to style by its single, graceful flying scarf, its candour and artlessness by its habit of ever drawing the long bow, its metropolitanism by its posture of swift flight to catch a

Fig. 1.5
Cover of *Harper's Weekly*,
August 3, 1878
Amon Carter Museum of
American Art Research Library,
Fort Worth, Texas

Harlem train—remained poised with its arrow pointed across the upper bay. Had that arrow sped truly and horizontally it would have passed fifty feet above the head of the heroic matron whose duty it is to offer a cast-ironical welcome to the oppressed of other lands.[19]

Liberty he characterizes as a "matron" and later on a "schoolma'am." Diana, in contrast, according to the staid Liberty, is "flighty and whirly-whirly" and "light-headed and giddy," characterizations that stem from not only her inherent form but also her context and desired role as a topper of a pleasure palace. Liberty remarks,

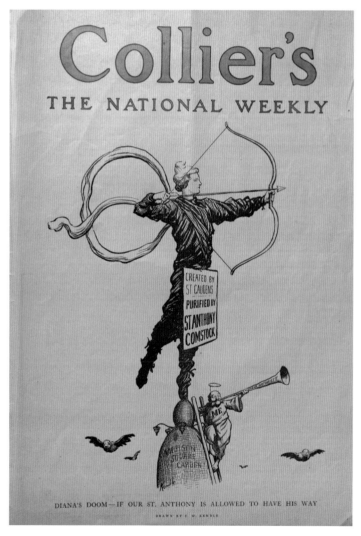

Fig.1.6
Cover of *Collier's* magazine,
August 25, 1906
Baylor University, Waco, Texas

Ye have the cat show and the horse show and the military tournaments where the privates look grand as generals and the generals try to look grand as floor-walkers. And ye have the Sportsmen's Show, where the girl that measures 36 19, 45 cooks breakfast food in a birch-bark wigwam on the banks of the Grand Canal of Venice conducted by one of the Vanderbilts. . . . Ye have the best job for a statue in the whole town, Miss Diana.[20]

A modern goddess, Diana comments on the lack of style of Liberty's garments, saying, "I think those sculptor guys ought to be held for damages for putting iron or marble clothes on a lady. That's where Mr. St. Gaudens was wise. I'm always a little ahead of the styles; but they're coming my way pretty fast."[21]

During the Gilded Age of New York City, when it was scandalous for a lady even to expose her ankles in public, *Diana* was quite shocking. Anthony Comstock, a United States postal inspector, stridently defended his strict interpretation of propriety and morality through a set of laws named after him, seeking to protect Victorians from the slightest lewdness. White and Saint-Gaudens were Comstock's "most visible yet elusive enemies," intent "upon thwarting Comstock's prissy and bullying self-righteous attempts at censorship."[22] Comstock demanded the sculpture be taken down (fig. 1.6).

Much scholarly discussion of the sculpture's impropriety centers on the challenge that a nude presented to Victorian morality. Even more salient or notable, perhaps, is what *this* particular nudity in such a public forum signified to anyone familiar with literature. With this sculpture, Saint-Gaudens turned the myth of the chaste goddess on its head. We see what we absolutely should not see. Newspaper commentary and satire commented on the change of clientele in the park near Madison Square Garden, from innocent children to those seeking a peek at Diana, a veritable fleet of Actaeons, though at least Actaeon came upon the goddess in error. Nevertheless, the reporter for the *Sunday Mercury* misses the point when he remarks that the figure "is nothing more or less than a female person as she

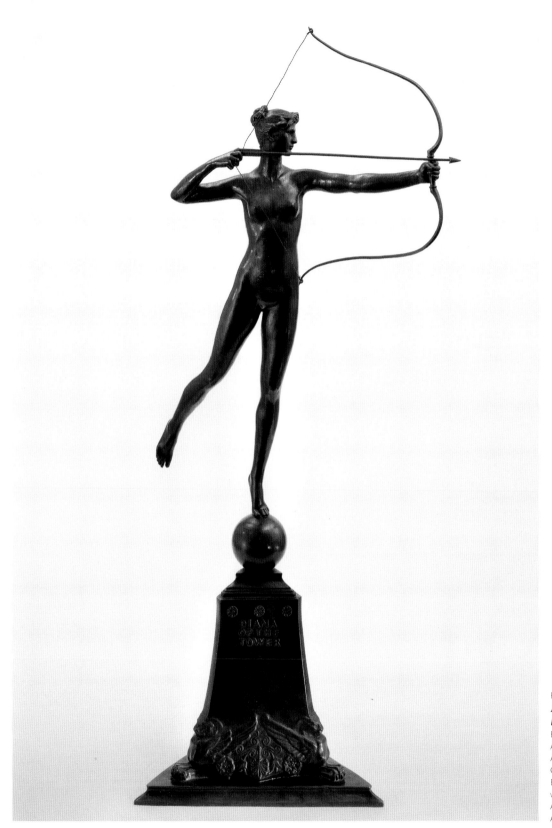

Fig. 1.7 (Cat. 59)
Augustus Saint-Gaudens
Diana of the Tower, 1899
Bronze, 39 × 14¼ × 11 inches
Amon Carter Museum of American
Art, Fort Worth, Texas. Ruth
Carter Stevenson Acquisitions
Endowment, in honor of all who
worked on the expansion of the
Amon Carter Museum of American
Art, 1999–2001, 2001.2

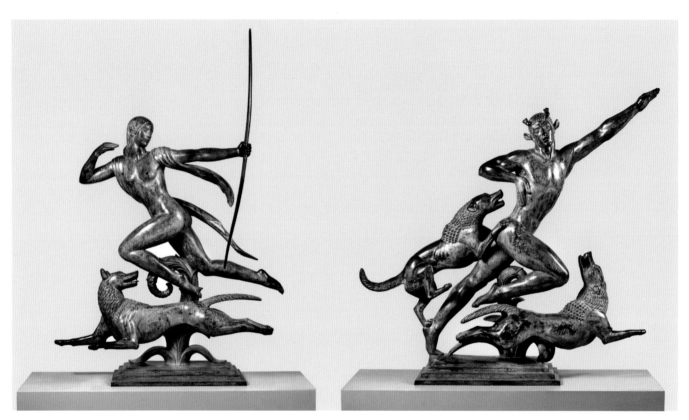

Fig. 1.8 (Cat. 38)
Paul Manship
Diana and Actaeon (#1), 1925
Bronze on onyx base, Diana: 49 × 43
inches; Actaeon: 48 × 52 inches
Smithsonian American Art
Museum, Washington, D.C.
Gift of the artist, 1965.16.32A-B and
1965.16.33

might appear after she has locked her bathroom door and is prepared to make her ablutions safe from prying eyes."[23] She is in fact a modern female nude, but she is also a representation of the goddess who must not be seen that way.

As we know, the consequences are dire for violating Diana's privacy by revealing her nakedness. The modernity of Saint-Gaudens's statement is not just in the form of the goddess, more athletic and slim than a Renaissance ideal of the huntress, but in the brazen flaunting of what makes her most sacred and dangerous. Although a nude Venus would still have irked Comstock's ilk, Saint-Gaudens's publicly nude Diana flew in the face of her classical reputation. The resonance must have been in the sculptor's mind in creating his only female nude sculpture, as well as in the minds of the educated public. All of Manhattan was imperiled if the judgment of Comstock and the myth of Diana and Actaeon are to be taken into account.

In 1895, when Saint-Gaudens secured the copyright for a version of his *Diana*, domestically scaled bronzes were increasingly sought after by collectors. Hoping to capitalize financially on the popularity of his monumental work, he went about creating intricate bronze reductions of the sculpture entitled *Diana of the Tower* (fig. 1.7 [cat. 59]) to be sold through retail vendors such as Tiffany and Company. Each of the smaller versions, his first foray into selling reductions, was created by hand with variations of bow, arrow, string, hair, patina, and base to preserve a sense of a unique creation. They were a commercial success, and their desirability encouraged other sculptors to try their hands at depicting Diana. In reducing his monumental weathervane to a domestic scale, Saint-Gaudens allowed everyone to possess what should not be possessed. When tamed, the wild, fierce goddess becomes a trophy, an object to be gazed on in all her nakedness while she adorns the tabletop of an office or home.

Augustus Saint-Gaudens allowed Diana's threat to be understood only by the learned, but the sculptor Paul Manship, in his *Diana and Actaeon* (fig. 1.8 [cat. 38]), takes another tack. The viewer is placed in the charged space between hunter and prey. Standing between the two sculptures, the viewer is implicated by the path of Diana's arrow;

she is a threat to our safety. In the form of Actaeon, we come to understand the potential ramifications of our intrusion into the vengeful goddess's privacy. No ambiguity here—we know her force, the surety of her arrow, and the vehemence of her revenge. The fleet, spring-loaded, streamlined aspect of the two figures' forms, while referencing sculptures of the past, echoes the speed and urgency of modern life and industry.[24]

One reviewer of painter George de Forest Brush's *A Celtic Huntress*, 1890 (fig. 1.9 [cat. 13]), on exhibition at the National Academy of Design with a pendant painting, *Orpheus*, referred to the main figure as a "Celtic Diana."[25] Inspired by classical precedents, Brush's painted huntress, with her broad shoulders and withering gaze, bears all the threat and power associated with the goddess Diana, and shares some of her archery-related attributes, but claims none of her dainty innocence. Looking askance at the viewer, she fingers her deadly arrow with a powerful hand, daring any who would approach. Her hound elicits more sympathy, its tilted head and mournful eyes causing one critic to remark that a flaw of the painting was "the dog's head being more interesting than the woman's."[26] Perhaps this is because the dog's countenance encourages exchange, while the huntress dares any who seek interaction. In this sense, unlike many depictions of Diana, Brush's huntress wears her threat in the open.

A friend and contemporary of Augustus Saint-Gaudens, George de Forest Brush trained as an artist both at home and abroad. After six years of study in France with the painter of exoticism Jean-Léon Gérôme, Brush undoubtedly sought an American version of the Orientalist subject matter of his teacher. Beginning in the early 1880s, he traveled west to render the Arapaho, Shoshone, and Crow Indians in heroic mode with, as one chronicler remarked, "realism tempered by poetry."[27] Removed from contemporary life's harsh realities, these depictions feature activities that could have taken place in ancient days or in Brush's own moment, providing a sense of mythic timelessness. Their connection to classical or Renaissance predecessors was no accident; Brush taught the antique class at the Art Students League, showing

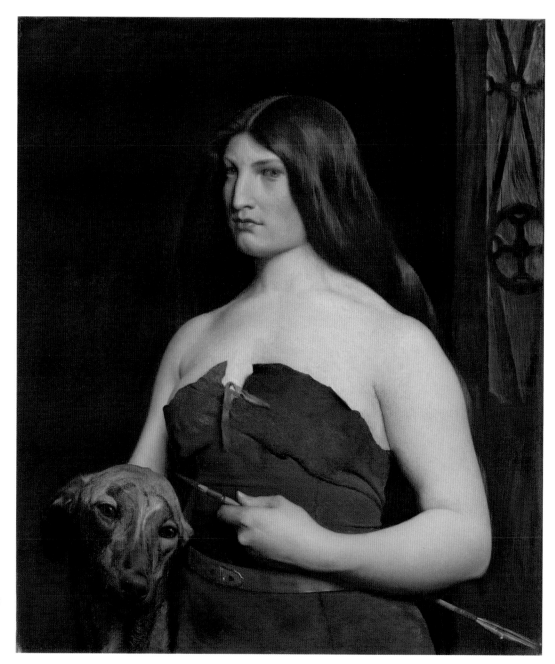

Fig. 1.9 (Cat. 13)
George de Forest Brush
A Celtic Huntress, 1890
Oil on canvas, 20 × 17¼ inches
Fine Arts Museums of San
Francisco, San Francisco,
California. Museum purchase,
partial gift of Roderick McManigal
and funds from The Fine Arts
Museums Foundation, Art Trust
Fund, and the Ethel M. Copelotti
Estate, 1987.28

his students the importance of copying from plaster casts to infuse their modern works with the physical ideals and spirit of centuries-old models.

Because his fame had been secured through his romanticized depictions of American Indians, critics saw a corollary between the protagonist of *A Celtic Huntress*, which followed his noted series, and the subjects of his earlier works: American Indians assuming the mantle of mythological figures. A reviewer for the *New York Times* remarked, "The 'Celtic Huntress' by George de Forest Brush is neither Celtic nor a huntress, but a low-browed woman like an Indian half-breed with red hair."[28] This tendency to read the picture as united with his Indian subjects had much to do with seeing in the work the aspects of Brush's career for which he was most well known. But it was also likely prompted by the perceived connection between Indian hunting subjects and mythology, in keeping with a romanticized view of the western frontier.

Though critics wrote of the work's connection to Brush's Indian paintings, he was clearly inspired by the Pre-Raphaelites' red-headed maidens with ruby lips and by the penchant for Celtic themes among participants in the arts and crafts movement.[29] He painted the work while abroad, where he was likely exposed to the Celtic revival, which may have been particularly appealing because the paternal branch of Brush's family had Celtic roots.[30] Though the figure is described only as a Celtic huntress, not a deity, it is tempting to think of this formidable lady archer in the context of Irish mythological goddesses. Perhaps she alludes to Flidais, known by the epithet Foltcháin (beautiful hair).[31] Like Diana, Flidais ruled over forests, woodlands, and wild beasts. Unlike Diana, she commanded her own deer-drawn chariot, though Diana probably would have relished that conveyance.

Brush was certainly not alone in alluding to earlier artistic precedents, particularly classical and Renaissance traditions, in depictions of American Indians. Decades earlier, the sculptor Henry Kirke Brown created *The Choosing of the Arrow*, 1848 (fig. 1.10 [cat. 12]), a bronze statuette commissioned for distribution via the American Art-Union.[32] He studied and worked in Italy, home of Donatello's graceful young *David*, to which this bronze bears more than a passing resemblance in sensuous contrapposto posture, as he reaches to pull an arrow from his quiver. Upon returning to the United States with artworks from Rome and Florence seared into his memory, Brown established his own foundry in Brooklyn. There he cast sculptures inspired by his Italian forebears, merging American subject matter with European precedent, though he criticized sculptors who "drew too heavily from European models" and feared Europe's influence on his own work.[33]

For *The Choosing of the Arrow*, Brown modeled his figure on members of the Ottawa and Chippewa tribes, whom he had sketched in his travels to the Midwest. Scholars have noted that the figure's complex topknot was characteristic of Upper Michigan Indians, but it is also a striking evocation of Apollo's signature hairstyle, connecting the slim, youthful boy archer to the classical archery god.[34] The Art-Union's annual report characterized the figures in the edition as "beautiful as Apollo, and armed with bow and arrow, like him as he pursued the children of Niobe."[35] Many artists were responsible for creating their own American Apollos, proclaiming their Americanness, seeming to eschew classical mythology while relying on it for precedent.[36]

Brown's own pupil John Quincy Adams Ward was thought by critics ultimately to have succeeded in building on and then transcending classical models in representations of American Indians. Agasias's *Borghese Gladiator* likely inspired the pose of Ward's bronze *The Indian Hunter*, 1857–1859 (fig. 1.11 [cat. 68]), but the visual connection was not readily obvious to the casual observer of the day. Rather than notice its adherence to precedent, critics heralded the sculpture for its attention to real Indian physiognomy and convincing action.[37] According to period reviews, though the figure wields a bow, he is no Apollo but closer to a thoroughly American subject.

THE MYTHIC HUNT FOR LOVE: UNWELCOME OR SACRED

The archery god Apollo, Diana's twin brother, angered the diminutive god of love, Cupid. Apollo derided Cupid for his use of bow and arrow, a weapon of the hunt, customarily used for giving

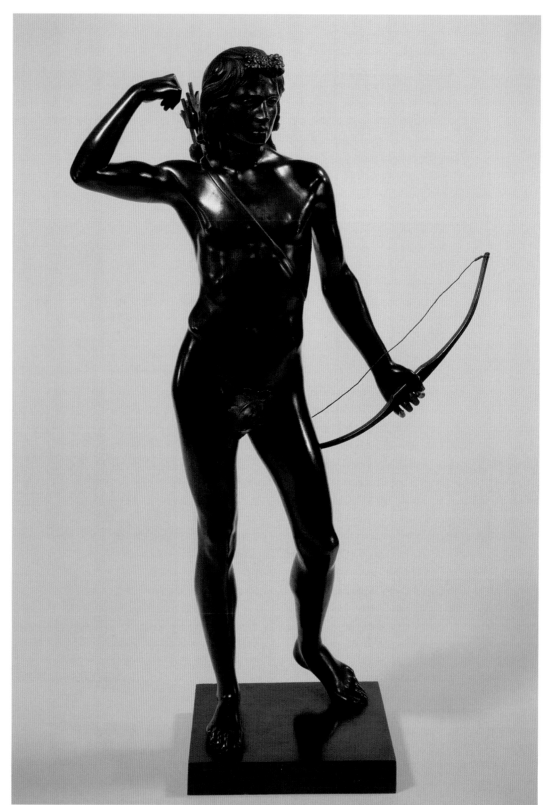

Fig. 1.10 (Cat. 12)
Henry Kirke Brown
The Choosing of the Arrow, 1848
Bronze, 21¼ × 6¼ × 5½ inches
Amon Carter Museum of American
Art, Fort Worth, Texas. Purchase
with funds from the Ruth
Carter Stevenson Acquisitions
Endowment, 1997.143

Fig. 1.11 (Cat. 68)
John Quincy Adams Ward
The Indian Hunter, 1857–1859
Bronze, 16 × 14¹⁵/₁₆ × 8½ inches
Amon Carter Museum of American
Art, Fort Worth, Texas. Purchase
with funds provided by the Council
of the Amon Carter Museum of
American Art, 2000.16

"unerring wounds to the wild beasts," for the mere trifle of love making.[38] His feelings wounded, the ever-vengeful Cupid, in an attempt to prove just how powerful he could be, pierced Apollo with the golden arrow that created instant love. Selecting the lead arrow that produces the opposite effect, Cupid then targeted maiden Daphne, a virginal water nymph corollary of Diana, who lived in the woods rejoicing "in the spoils of beasts which she had snared, vying with the virgin Phoebe."[39] Daphne, now immune to Apollo's ardent love, was passionate to remain pure. Apollo, in an act of desperate futility, pursued her.

Thus begins Ovid's use of language of the hunt to chronicle unwanted amorous advances. Daphne is the prey, running as "the deer from the lion,"

while love is the cause of Apollo's chase. Victim to Cupid's arrow, hunter's and hunted's fates are intertwined. As Ovid writes:

> Just as when a Gallic hound has seen a hare in an open plain, and seeks his prey on fly-ing feet, but the hare, safety; he, just about to fasten on her, now, even now thinks he has her, and grazes her very heels with his outstretched muzzle; but she knows not whether she be not already caught, and barely escapes from those sharp fangs and leaves behind the jaws just closing on her; so ran the god and maid, he sped by hope and she by fear.[40]

Daphne's only protection is to beg transformation. She becomes the laurel tree, which remains forever sacred to the unsuccessful hunter Apollo.

Italian sculptor Gian Lorenzo Bernini's marble masterpiece *Apollo and Daphne*, 1622–1625 (fig. 1.12), much loved and often copied, is just one depiction of a frozen metamorphosis—an unrequited hunt for love that is stopped in time. The figures are caught in that in-betweenness of being forever changed. The stone is becoming flesh, hair, and fabric. The flesh emerging from stone is becoming foliage, roots, and laurel. The stone seizes time as it transforms from white marble to embodied hunting myth. Apollo is paused just at the moment of his potential triumph over his prey. The nymph Daphne is just out of reach, poised on the edge of her botanical escape. Daphne is arrested in a moment between stone, flesh, and laurel tree.

The whole sculpture is a rushing forth of diagonals, a swirling of fabric, flesh, and foliage. It changes depending on vantage point. From one perspective, Daphne seems paralyzed with fear. With a slight movement of our bodies, she seems almost resigned to her arboreal transformation. Sometimes it appears Apollo will never catch her. As we move around the sculptural group, it is clear he has her flesh firmly in his grasp. As we were with Manship's *Diana and Actaeon*, we are complicit in this ever-transforming hunt, because our partic-ipation activates the narrative. As with so many hunting scenes, the fates of pursuer and pursued are interlocking. The drama is a human one, though in

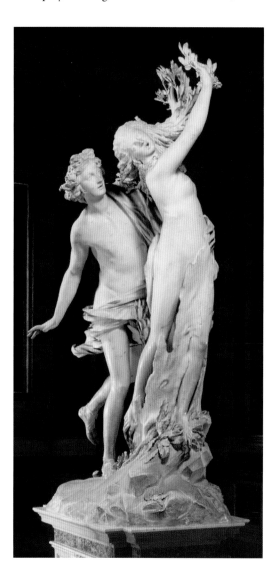

Fig. 1.12
Gian Lorenzo Bernini
Apollo and Daphne, 1622–25
Marble, 95⅝ inches
Galleria Borghese, Rome, Italy

this case, it takes on the magical forms of deities.

If the words and imagery of the hunt are used, as with Ovid and Bernini, to represent amorous advances, so is the ritual of the hunt conjoined with consummation and marriage rites. The sacred union is perhaps most famously articulated by the joining of Dido and Aeneas as told in Virgil's *Aeneid*. A fugitive from the fall of Troy, Aeneas was destined to serve as founder of Italy, ancestor of the Romans—the "race who would someday rule the world."[41] For various reasons, Juno, queen of the gods, was not pleased with this plan, so she devised a trap in the form of Dido, the ruler and founder of the great city of Carthage. If Aeneas were to fall in love with Dido, perhaps he would be swayed off course to settle down as a husband. Aeneas's mother, the goddess of love, Venus, had other plans for her son; she wanted Aeneas to receive whatever Dido would give but to remain undeterred in his quest to found Italy. She enlisted the help of another son, Cupid, who promised to foster the connection with the rather impenetrable Dido, who had, thus far, refused the advances of many suitors. With godly intervention, Dido appeared to Aeneas "lovely as Diana herself" and Aeneas "stood forth beautiful as Apollo."[42] Of course, Dido becomes enamored. Virgil compares her to unwitting prey,

writing, "Unlucky Dido, burning, in her madness / Roamed through all the city, like a doe / Hit by an arrow shot from far away." A hunting scene, the height of ritual, forms the locus for the marriage. Juno's plan was this: "Aeneas and Dido in her misery / Plan hunting in the forest. . . . / My gift will be a black raincloud, and hail, / A downpour, and I'll shake heaven with thunder. / The company will scatter, lost in gloom, / As Dido and the Trojan captain come / To one same cavern. . . . / There I shall marry them and call her his. / A wedding, this will be."[43] Juno will scatter the hunting party, giving the two would-be lovers time alone to conduct their marriage. The hunt, as it has been in so many works of literature and art, is the scene for a sacred union.

One painter of Dido and Aeneas's hunting marriage was English-born landscape painter Joshua Shaw, who came of age as a professional artist at a moment when the ideas presented by Sir Joshua Reynolds, founder and first president of England's Royal Academy, were of great influence on painters. Joseph Mallord William Turner was a particular proponent of Reynolds's notion that much could be gained from rising above mere imitation of the landscape to the expression of the "grandeur of ideas" and attempts at "captivating the imagination."[44] Turner, like Reynolds, believed that

Fig. 1.13
Joseph Mallord William Turner
Dido and Aeneas, exhibited 1814
Oil paint on canvas,
57½ × 93¼ inches
© Tate, London, United Kingdom,
2015

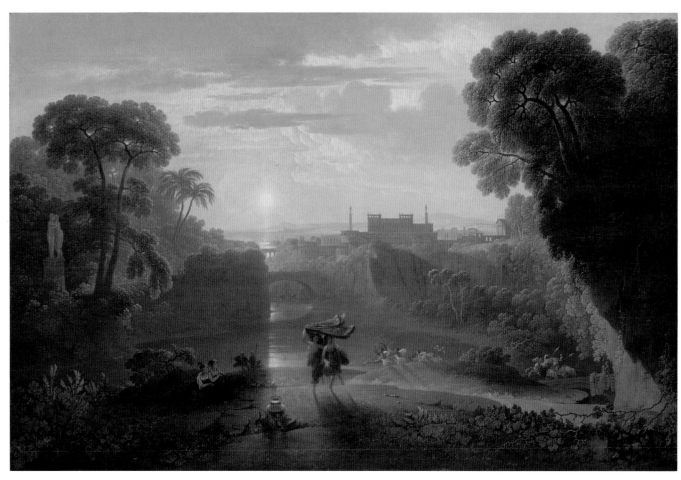

Fig. 1.14 (Cat. 62)
Joshua Shaw
*Dido and Aeneas Going
to the Hunt*, 1831
Oil on canvas, 26⅛ × 38½ inches
Munson-Williams-Proctor Arts
Institute Museum of Art, Utica,
New York. Museum purchase,
60.197

references to poetry and literature, particularly that of Homer and Virgil, would transform an ordinary scene into something more grand.

Turner created a series of paintings based on Aeneas's time in North African Carthage. His *Dido and Aeneas*, exhibited in 1814 (fig. 1.13), transforms a basic pastoral scene into an ennobled depiction of a literary subject, populated with staffage of all sorts of Arcadian figures. American transplant Joshua Shaw's idyllic landscape with glowing sky and imagined city, *Dido and Aeneas Going to the Hunt*, 1831 (fig. 1.14 [cat. 62]), is based on Virgil but shows its debt to Turner.[45] In a setting that appears to be a fantastical amalgam of European countryside, imagined architecture, and an exotic palm tree for good measure, Shaw eschews the identifiable and evokes the imaginary. His landscape bears more resemblance to other artistic renderings of a strip of semicultivated land adjacent to an imagined city than to a faithful depiction of the remote forest setting with "rocky peaks" and "lowland vales" described by Virgil. In the scene as Shaw has set it, we have not yet reached the domain of scores of wild beasts—herds of deer, "foaming boar," or even a "tawny lion."[46] And yet, the rain is about to begin.

Dido and Aeneas, wielding spears, are just setting out on horseback. Their hunting party leads the way, leaving a bit of space between the couple and potential onlookers, creating a sense of privacy. The gathering clouds and the cloth held over the heads of the central dancing figures foreshadow Juno's rainstorm, the cause of the retreat to a cave and the consummation of the marriage. The sculpture tucked among the trees of Cupid and Psyche locked in an embrace speaks to surmounting love's obstacles, engaging in sensual acts, and uniting in marriage, if the viewer has knowledge of literary precedent. As the occasion for marriage and its physical expression, scenes of hunting are often scenes of ritual. We know that Aeneas will eventually leave Dido to a miserable fate and break his vows, so the sacred rite enacted on this hunt represents the calm before the proverbial storm.

Although Shaw widely exhibited this paradisiacal scene, with glowing sun and resplendent city, as well as other pastoral works infused with myth and poetical precedent, his American audience preferred his picturesque depictions of the untouched scenery that surrounded them to the invented scenes meant to elevate the mere depiction of nature. It is worth noting that in addition to his career as a painter, Shaw was apparently "a good sportsman," whose youthful sporting experience inspired multiple patents, including some used in hunting.[47] Though he claimed to be the original inventor of the copper percussion cap, that fact was disputed, ultimately causing Shaw to fight for U.S. patent reform. For a man clearly invested in the technology of firearms, it is fitting that he would include a significant hunting scene from an important work of literature as one of his elevated landscape subjects.

AMERICAN MYTH MAKERS

In the colonial period, the hunter was often considered the antithesis of the productive farmer. Farmers cultivated the lands of indigenous peoples who were known for their hunting prowess. The practice of farming, therefore, was used as justification for the displacement of American Indians. To draw a distinction, hunters were cast as wild, uncivilized, and threatening to the domestication of the colonies.[48] Agrarian pursuits were the ideal. In Washington Irving's 1819 satirical tale *Rip Van Winkle*, set in the colonial past, the title character, a British American villager of Dutch ancestry living in the Catskill Mountains, plays at hunting and fishing, but he shirks his responsibilities as head of household.[49] In the voice of an imagined narrator, Diedrich Knickerbocker, Irving writes,

> The great error in Rip's composition was an insuperable aversion to all kinds of profitable labor. It could not be from the want of assiduity or perseverance; for he would sit on a wet rock, with a rod as long and heavy as a Tartar's lance, and fish all day without a murmur, even though he should not be encouraged by a single nibble. He would carry a fowling piece on his shoulder, for hours together, trudging through woods and swamps, and up hill and down dale, to shoot a few squirrels or wild pigeons. . . . Rip was ready to attend to anybody's

Fig. 1.15 (Cat. 9)
Albertus Del Orient Browere
*Rip Van Winkle in the
Mountains*, 1880
Oil on canvas, 30 × 44 ¼ inches
Collection of Shelburne Museum,
Shelburne, Vermont. Museum
purchase, acquired from Maxim
Karolik, 1959-265.9

business but his own; but as to doing family duty, and keeping his farm in order, it was impossible.

Though farming labor was well regarded in Van Winkle's time, his hunting and fishing pursuits were considered evidence of his lack of devotion to proper work. It was said that he would "rather starve for a penny than work for a pound."[50]

Irving's story inspired several illustrative paintings. Albertus Del Orient Browere's *Rip Van Winkle in the Mountains*, 1880 (fig. 1.15 [cat. 9]), features a mocking portrayal of a bug-eyed Van Winkle wearing a jaunty hat, in a rich, uncultivated landscape, his scraggly dog, Wolf, looking more lupine than canine. The story and the painting are jocular musings on the colonial past, created for the amusement of Irving's nineteenth-century readers. By the time these works were created, celebrating farming over the popular pursuit of hunting was outmoded, hence the good-natured tone of the criticism of Van Winkle.

Irving, James Fenimore Cooper, and other nineteenth-century authors and artists codified the myth of the hunter-hero. Rather than denigrating hunters' exploits in the wild or urging their cultivation of the land, these authors celebrated the American spirit of woodsmen. Hunters Daniel Boone and Davy Crockett emerged as the epitome of frontier gumption and American individualism "precisely when the tentacles of modernization reached into most aspects of American life."[51] Their stories would reemerge whenever American society needed reminding of these wild, manly attributes, particularly in moments of domestication. Think of the 1950s, when suburbia flourished, and Crockett's portrayal by Disney fomented a craze for raccoon skin caps. At stake in characterizations of American icons, from Boone to Teddy Roosevelt, was an affirmation of prowess and American exceptionalism, with hunting heroes serving as reminders of mythic greatness, which Americans would assert was native to the landscape. It was, in effect, our own creation of mythology apart from the borrowed legacy of the ancients.

One perpetuator of the rugged American adventurer myth in the vein of Daniel Boone was the naturalist-artist John James Audubon,

Fig. 1.16
John Syme
John James Audubon, 1826
Oil on canvas, 35½ × 27½ inches
The White House Historical Association (White House Collection), Washington, D.C., 963.385.1

chronicler of all the birds of North America and many of its quadrupeds. Audubon shed his gentlemanly guise and encouraged his own mythology when soliciting attention for his publications from audiences abroad, donning a buckskin or fur-lined coat and playing the part of a frontiersman to cultivate a reputation for being a quintessential American (fig. 1.16). What America had to offer that was distinctive was its wildness. Audubon knew his market and capitalized on a perpetuation of foreign perceptions of American character. Though in his travels to the western frontier, Audubon mostly stayed in his tent, he often emphasized his American adventurer status, calling himself "The American Woodsman."[52] He was an inveterate hunter and a trained taxidermist, killing and reanimating his specimens himself so that he could show them in action.[53] With a few exceptions, artists attempting his likeness featured his mythic outdoorsman persona rather than his cerebral indoor aspect or the business acumen that had ensured his success.

At the very dawn of the Hudson River school of painting, Thomas Cole considered the majesty of the untouched landscape to be uniquely American. Together with the poetry of William Cullen Bryant and the literary imaginings of Cooper, which employed descriptions of legendary

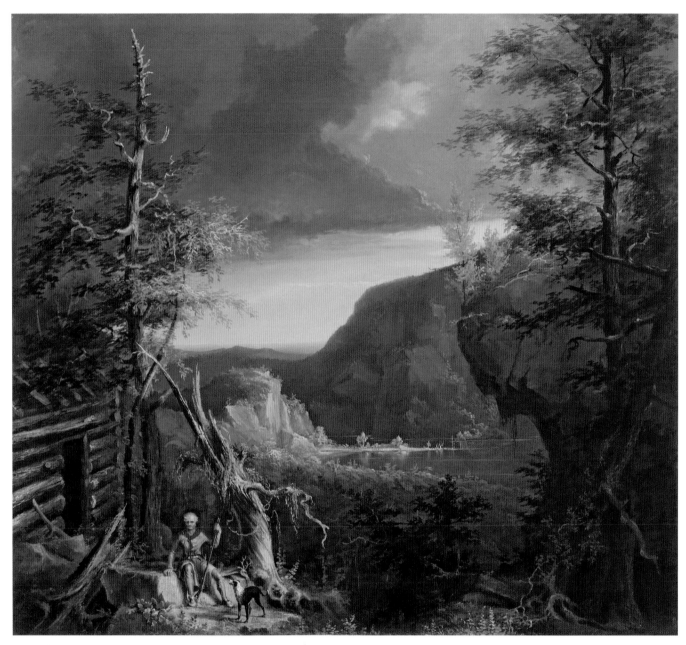

Fig. 1.17 (Cat. 17)
Thomas Cole
*Daniel Boone at His Cabin in
Great Osage Lake*, ca. 1826
Oil on canvas, 38½ × 42⅝ inches
Mead Art Museum, Amherst
College, Amherst, Massachusetts.
Museum purchase

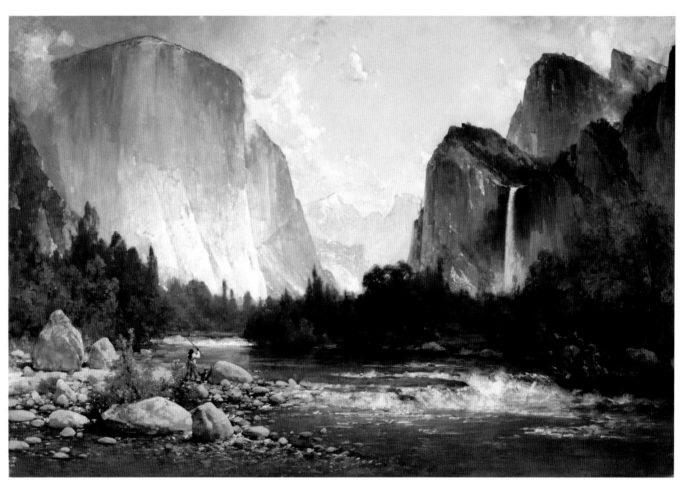

Fig. 1.18 (Cat. 30)
Thomas Hill
Fishing on the Merced River, 1891
Oil on canvas, 36 × 54 inches
The Thomas H. and Diane DeMell
Jacobsen Ph.D. Foundation

heroes and depictions of the wild, Cole's paintings attempted to create self-conscious representations of American merits.[54] Though many artists would make Daniel Boone's exploits the subject of their artistic enterprises, with Boone occupying the starring role, Cole's *Daniel Boone at His Cabin in Great Osage Lake*, ca. 1826 (fig. 1.17 [cat. 17]), features two protagonists: the vast American landscape's wildness and an American myth maker and denizen of the wild.[55] Boone, who appears a bit larger than life in this painting, resides in a tiny enclave of cultivation. Whereas Cole was ultimately not known for a major figural presence in his work, in this early painting, Boone is present for more than just the purposes of showing the scale of the sublime landscape. We see him as one who has tamed a corner of the wilderness, even if the reality was that he was largely unsuccessful at cultivating his own land.[56] Though in the time of Boone's initial occupation of the region, he was venturing into untamed territory, Cole likely chose to make this rendition shortly after Missouri had become a state and settlement had proceeded at a rapid pace. The frontiersman sits proudly in front of his log cabin, juxtaposed with felled trees, a foreshadowing of Cole's environmental concerns to come. Eschewing dramatic action, the prodigious hunter is shown sedate at home, juxtaposed with a faithful canine companion, another aspect of taming portrayed in this painting. Boone died in 1820, so this is perhaps a tribute to disappearance—the loss of Boone and the settling of the unspoiled land that Cole so greatly treasured.

Much as Cole's rendition of Boone privileges the vast landscape over human presence and foretells its transition out of its untouched state, so Thomas Hill's painting *Fishing on the Merced River*, 1891 (fig. 1.18 [cat. 30]), while ostensibly a view of fishing, is more than a scene of human incursion into the land. Its true subject is the expansiveness of the western landscape, in particular Yosemite Valley, and the promise it held of wild grandeur. As critic S. G. W. Benjamin wrote of Hill's early paintings of California, "to those who had not yet seen the Yosemite these paintings were like a revelation. Little had we dreamed what astonishing spectacles were stored away for us in the recesses of those mighty barriers which divide the continent—the vast sierras of the Pacific slope."[57]

As urbanization and cultivation moved ever westward, California was one of the last frontiers. Of course, by 1891, Hill, who frequently resided in San Francisco, had seen California through several cycles of boom and bust, from the gold rush to the success of the railroad and Comstock Lode to periods of economic depression.[58] He made the sublimity of Yosemite Valley's jagged rocks and thundering waterfalls the subject of his brush for the very patrons who had tamed California's wildness.

The people who had used the land for economic speculation were this painting's likeliest audience, but the lone fisherman, in harmony with his surroundings, is the one who experiences the quiet wonder of the land—undisturbed by and undisturbing to his environment. Though the 1870s saw Hill, an avid hunter and angler, portraying genteel communal fishing parties in woodland glens, his late-in-life depiction of the solitary person dwarfed by nature's majesty carries with it nostalgia for the scenery of the western imagination.[59]

British-born artist Arthur Fitzwilliam Tait's country upbringing fostered a passion for nature, animals, and hunting and fishing. Having befriended George Catlin, whose traveling American Indian exhibition included live performances, paintings, and artifacts, Tait became enamored with the legends of the American frontier as expressed by Catlin's art and showmanship.[60] He decided to experience America for himself, moving to the United States in 1850. He had frontier aspirations, but he did not travel out to the Wild West. Once he was in the United States, he came under the influence of artist William Tylee Ranney, who was an avid sportsman. Ranney's studio was decorated with western buckskins and American Indian accoutrements, which Tait could use as source material.[61] Much as Audubon had styled himself a woodsman, Tait donned a fringed buckskin tunic for his favorite portrait photograph, presenting himself as one of the heroic woodsmen he portrayed in his paintings.[62]

Rather than live on the frontier, Tait settled in New York City and made the wildlife of the

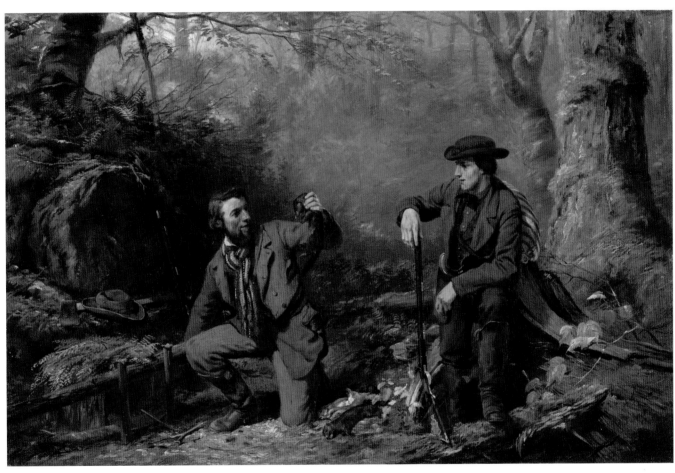

Fig. 1.19 (Cat. 65)
Arthur Fitzwilliam Tait
Mink Trapping Prime, 1862
Oil on canvas, 20⅛ × 30 inches
Collection of Shelburne Museum,
Shelburne, Vermont. Gift of
Richard H. Carleton, 1969-1

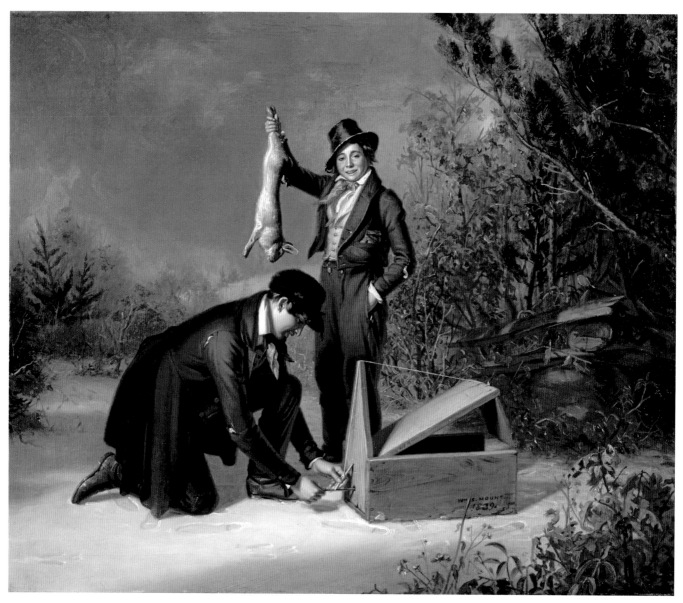

Fig. 1.20 (Cat. 43)
William Sidney Mount
Catching Rabbits, 1839
Oil on panel, 18⅛ × 21¼ inches
The Long Island Museum of
American Art, History, and Carriages,
Stony Brook, New York. Gift of
Mr. and Mrs. Ward Melville, 1954,
0000.001.0026

Adirondacks his most frequent subject matter, earning a reputation for living a "real hunter's life," unavailable to him in England but possible in the egalitarian environment of America.[63] Tait's Adirondack scenes of hunting and trapping, such as *Mink Trapping Prime*, 1862 (fig. 1.19 [cat. 65]), became enormously popular through their wide distribution as prints, with a middle-class audience increasingly invested in the sporting life.

Rather than a straightforward hunting and trapping subject, genre painter William Sidney Mount's *Catching Rabbits*, 1839 (fig. 1.20 [cat. 43]), can be viewed as a metaphor for American social and political issues. It is also his rumination on the somewhat innocent schemes of rural boyhood in a society preoccupied with urban adulthood's anxieties of manipulation and speculation. Known for his compositions showing scenes of daily life, Mount's work did more than simply reflect the trappings of everyday existence.[64]

His representations promoted newly forming national and regional ideals and mores to clientele eager to assert their social status and identity, rather than merely reproducing scenes put before the eye—in other words, he was disseminating a kind of contemporary mythology and ideology. His paintings often reflected a national nervousness about "being bested" or falling victim to others' political or business schemes, a prevalent concern of the time. *Catching Rabbits*, one of his ostensible hunting scenes, can be seen as an inside joke about the aristocratic Whig party's attempts to ensnare down-to-earth voters with "deceptive rhetoric" and tall tales.[65] The painting's patron was an impassioned Whig, Charles Augustus Davis. Common parlance connected rabbits to the Whig party through the transformation of the words "hare" to "hair" and "wigs" to "Whigs."[66]

Much as Audubon saw a benefit in perpetuating the story of his woodsman status, and as ever-shifting stories of Boone emphasized taming the wild and cultivating the land, so too did high-level politicians form their own narrative of innocence and rural upbringing, which emphasized their accessibility. Mount's paintings brought the use of this idiom to light. His images of hunting and trapping, commonly reproduced and disseminated, formed an effective delivery vehicle for addressing social and political themes through metaphor, as nineteenth-century Americans tried to formulate what made them special.

SPIRITUAL MATTERS

For some avid fishermen I know, there is no American text more sacred than Norman Maclean's *A River Runs through It*. A few have referred to it as their bible. Interestingly, if *A River Runs through It* is a sort of scripture, Maclean's protagonists consider the practice of fishing akin to religious worship. He writes in the semiautobiographical novella, "In our family, there was no clear line between religion and fly fishing. . . . Our father was a . . . minister and a fly fisherman. . . . He told us about Christ's disciples being fishermen, and we were left to assume . . . that all first-class fishermen on the Sea of Galilee were fly fishermen." On Sundays, the day of the week "given over wholly to religion," they tied lures and traversed the hills between services, and the practices were connected in their minds. The sons of the family "probably received as many hours of instruction in fly fishing as . . . in all other spiritual matters."[67]

Of course, while Maclean and his family considered fishing a religion, in the Judeo-Christian tradition, stories and symbolism including fishermen and fishes abound—beginning with Genesis 1:26, in which humankind would "have dominion over the fish of the sea" as well as the birds of the air and the wild animals of the earth. Fish were believed to save the world by drinking the waters of the flood. The Greek word for fish is ΙΧΘΥΣ, a shorthand representation of Jesus, using the first letter of each word in the sentence "Jesus Christ son of God, the Redeemer." The men who would become Jesus's disciples, Simon (later called Peter), Andrew, James, and John, were fishermen he came upon while they were fishing the Seven Springs and mending their nets. Using their occupational language, Jesus encouraged them, "Follow Me, and I will make you fishers of men."[68]

At one point, Peter's faith began to waver. He was uncertain whether following Jesus would accommodate his daily needs. He decided to rely on himself to provide, returning to his fishing, but

his expedition was unsuccessful. After preaching from Peter's boat, Jesus encouraged him to set back out to do the impossible, attempt to fish again in the daytime after having caught nothing with the nets he normally used at night, the time when they were least visible to the fish. What resulted was a miraculous haul. The boats were so full with fish that they began to sink. Having learned his lesson, Peter believed that he could trust Jesus to provide.[69] What more salient proof did the fisherman need than the catch of a lifetime?

Charles Webster Hawthorne's painting *The Calling of St. Peter*, ca. 1900 (fig. 1.21 [cat. 28]), is a poignant combination of the real-life grit of the fishing profession with the power of metaphor. Son of a sea captain, Hawthorne was exposed to the fishing trade as a young man, cutting ice used in packing fish from the Kennebec River in Maine and working the docks of New York City. When he attended the Shinnecock Summer School of Art on Long Island, run by William Merritt Chase, he purportedly lived in a shack intended to store fishing gear.[70] He was inspired by the work of Franz Hals and spent time on the shores of the North Sea of the Netherlands, where he could witness the daily operations of the village fishermen.

Seeking to establish his own summer art school, Hawthorne settled in Provincetown on Cape Cod in 1899, where the traces of the fishing trade were everywhere in abundance. The rugged fishing denizens of the Cape would be his inspirational models. Fishing paintings from his residency there proliferate. Reviewer Royal Cortissoz praised "the toil-worn gravity" of Hawthorne's fisherfolk, regarding in them an "authentically religious" sentiment, despite what he perceived as their wholly American subjects.[71] Whether or not actual fishermen posed for his paintings, the figures in his work are transformed into the real thing.

Hawthorne believed that the ordinary object or person could become divinely beautiful in the right hands. He advised aspiring artists, "There is as much beauty and religion in the painting of this black iron stove as in any of your so-called religious paintings. . . . One of the greatest things in the world is to train ourselves to see beauty in the

commonplace."[72] Without the title, *The Calling of St. Peter*, we might not fully appreciate the religious allusion, though the fisherman's hands are evocative of gesturing Christ figures and saints, and the fish are a time-honored religious symbol. The title's allusion to Peter allows us to see in the humility of the person—with his weathered skin and uneven tan as signs of his toil—a modern version of a commonplace fisherman becoming a disciple. Hawthorne's painting encourages its viewer to contemplate the great leaps of faith taken by the original disciple fishermen.

The scion of an exceptional family, artist Henry Ossawa Tanner was raised by a bishop of the African Methodist Episcopal Church and a social activist mother. As such, Tanner devoted considerable energy to the daily study of scripture. As his career began to gain momentum, he left America for the grand European tour and for training in Paris ateliers. His great renown in Paris came from his paintings of religious subjects.

In the years leading up to those in which Tanner rose to prominence, the Salon was replete with religious paintings.[73] Part of their popularity can be attributed to the work of French biblical historian Ernest Renan. Renan's best-selling *Vie de Jésus* asserted that the life of Jesus should be written as though it were about a common man. Issued in the 1860s after Renan first saw the Holy Land, the book garnered reviews admiring his concept of Jesus's life as a "story that took a form, a solidity. . . . In place of an abstract being, who, one might say, never had an existence," Renan writes of Jesus as "an admirable human figure."[74] Renan undoubtedly inspired a resurgence of humble depictions of the august figures of biblical stories in settings that evoked their original context, much as Hawthorne casts an everyday modern fisherman in the role of Peter. According to a critic familiar with Tanner, the artist had read Renan.[75]

On his calling to create paintings of religious subjects, Tanner wrote,

> Painters of religious subjects (in our time) seem to forget that their pictures should be as much works of art (regardless of the subject) as are other paintings with

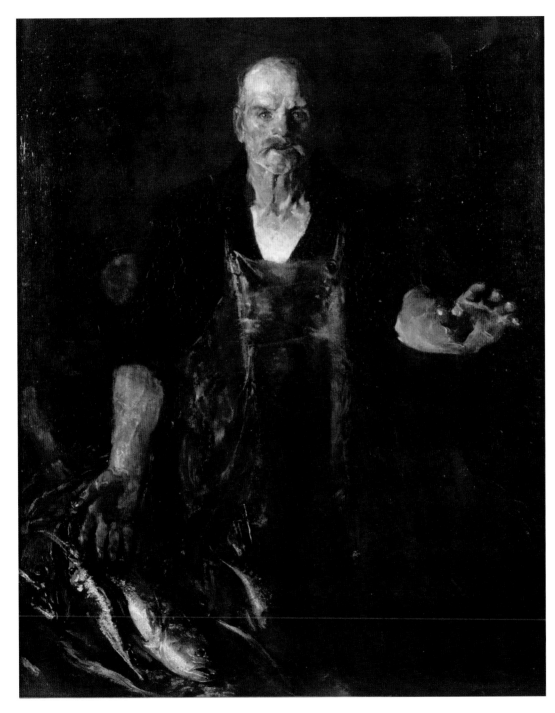

Fig. 1.21 (Cat. 28)
Charles Webster Hawthorne
The Calling of St. Peter, ca. 1900
Oil on canvas, 60 × 48 inches
Collection of The Newark
Museum, Newark, New Jersey. Gift
of Bernard Rabin in memory of
Nathan Krueger, 1962, 62.170

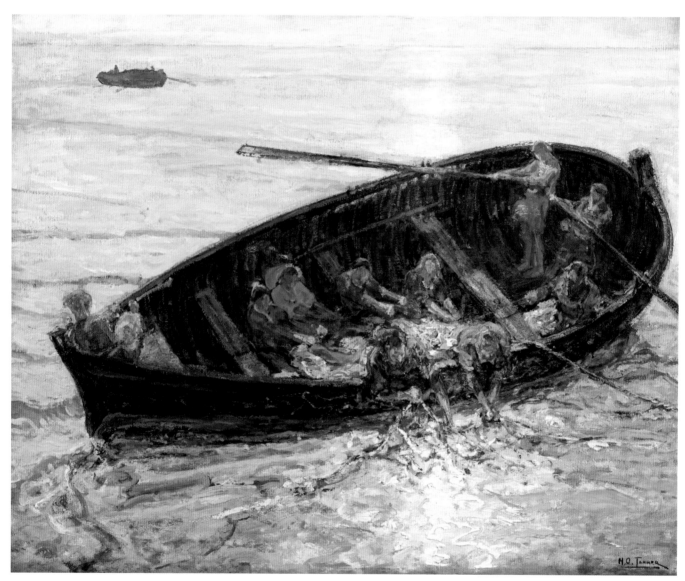

Fig. 1.22 (Cat. 67)
Henry Ossawa Tanner
The Miraculous Haul of Fishes,
ca. 1913–14
Oil on canvas, 38 × 47½ inches
National Academy Museum,
New York, New York, 1236-P

less holy subjects. To suppose that the fact of the religious painter having a more elevated subject . . . makes it unnecessary for him to consider his picture as an artistic production . . . simply proves that he is less of an artist than he who gives the subject his best attention. . . . The want of high ideals in religious art will, as in other things, be fatal.[76]

In many paintings, most notably in his *Annunciation*, 1898 (Philadelphia Museum of Art), Tanner attempted to make the Bible come to life, as Hawthorne attempted with Peter. Tanner preached through painting. As he wrote, "My efforts have been to not only put the Biblical incident in the original setting . . . but at the same time give the human touch 'which makes the whole world kin.'"[77]

Nevertheless, in contrast to the dark, gritty rendition of a common fisherman taking on the mantle of Peter, as in Hawthorne's work and in other paintings in Tanner's oeuvre, his *The Miraculous Haul of Fishes*, ca. 1913–14 (fig. 1.22 [cat. 67]), is resplendent in its otherworldly glow, jewel tones, epically sized fishing boat, joint labor, and abundant catch.[78] Though the figures appear to be common fisherfolk, the light and the energy of the paint make the scene anything but ordinary.

THE END OF LIFE

Perhaps the most appropriate way to end a discussion of the mythological, ritual, metaphorical, and spiritual nature of depictions of the hunt and the catch is to close with the end of life. As we have seen, hunting and fishing metaphors abound in humankind's major events, from love to identity formation to spiritual feeling. Perhaps most poignantly, hunting myth and metaphors often surface in visual and literary imagery when artists and writers are contemplating or discussing their own demises or those of their loved ones. Often, the symbolic meaning lingers beneath the surface in a less than literal fashion, such as in the association of the fisherman and the demise of his fish in Hemingway's *The Old Man and the Sea*.[79] In visual art, Winslow Homer's *Right and Left*, 1909 (fig. 1.23), executed shortly before his death in 1910, can be considered a contemplation of the artist's mortality. The red flash of a gun points at the viewer, who is face to face with the intended targets: two ducks in opposing states, one diving and one ascending, seen possibly just before the shot hits. Known for his "poignant identification with the hunted," Homer was likely linking his fate to the fates of these birds.[80]

Horace Pippin's *The Buffalo Hunt*, 1933 (fig. 1.24 [cat. 48]), shares a sense of foreboding with

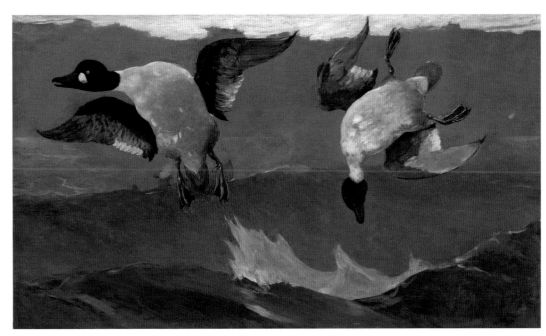

Fig. 1.23
Winslow Homer
Right and Left, 1909
Oil on canvas, 28¼ × 48⅜ inches
National Gallery of Art,
Washington, D.C. Gift of the
Avalon Foundation, 1951.8.1

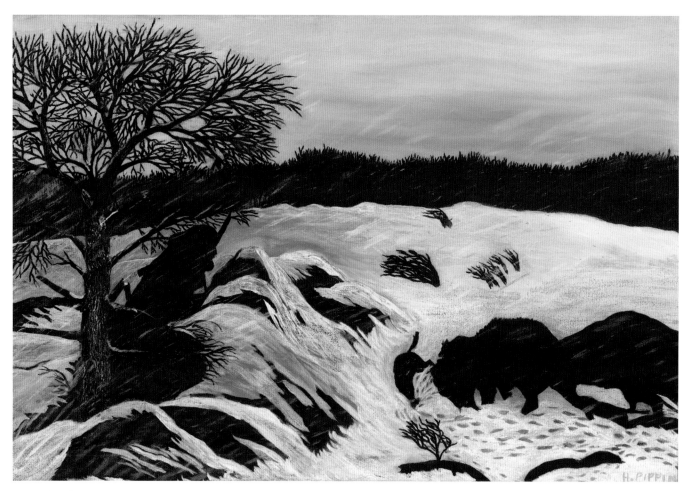

Fig. 1.24 (Cat. 48)
Horace Pippin
The Buffalo Hunt, 1933
Oil on canvas, 21⁵⁄₁₆ × 31⁵⁄₁₆ inches
Whitney Museum of American Art,
New York, New York. Purchase,
41.27

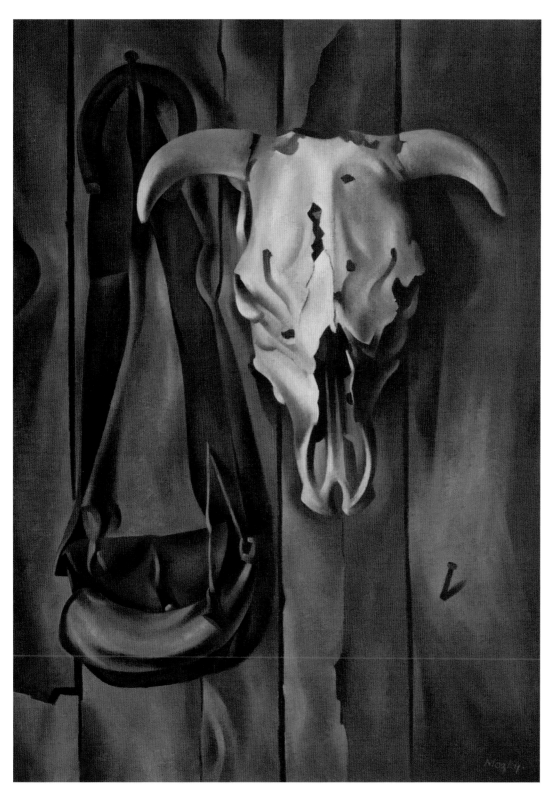

Fig. 1.25 (Cat. 45)
Loren Mozely
Skull and Powder Horn, 1941
Oil on canvas, 40 × 30 inches
Albritton Collection

Right and Left. The abstracted blackened forms, the dark mass of the hunter, and the traces of struggle in the deep snow allude to the shadowy specter of death. This imagined depiction of a legendary western buffalo hunt, displaced to the snowy East, normally a scene of triumphant human prowess over an abundant animal population, here is a somber reflection on the isolation and violence of the hunt. Pippin had enlisted as an infantryman in World War I and had served in France. Many of his paintings, even if not literal depictions of the war, manifest his lifelong preoccupation with the horrors he witnessed. He wrote of his war experience

as "the catalyst that 'brought out all of all [*sic*] the art in me.'"[81] This imagined scene of aggression is perhaps reflective of the lasting visions of war in Pippin's consciousness.[82]

Loren Mozely came of age artistically in Taos, New Mexico, serving as the secretary for Mabel Dodge Luhan, the host to artists such as Marsden Hartley, Georgia O'Keeffe, and John Marin, some of whom became Mozely's lifelong friends. Their influence is everywhere in evidence in Mozely's work, as is his firsthand experience of French cubism and the New York art scene.[83] Despite his modernist artistic milieu, his *Skull and Powder Horn*, 1941 (fig. 1.25 [cat. 45]), has as much in common with the trompe l'oeil paintings of hunting regalia by traditional American artists such as William Michael Harnett as it does with Mozely's modernist colleagues. Mozely's choice of objects— skull, powder horn and hunting bag, horseshoe, and rusted nails—and the painting's seductive nod to tactility are evocative of earlier masters of the genre. The boards splinter, the nails protrude into the viewer's space, and the bag and horn feel easily at hand, ready to be removed and implemented. The cow skull broadcasts death by decay while the powder horn and bag allude to human participation in the hunt. Given its creation at the dawn of the United States' involvement in World War II, a period during which Mozely's paintings turned ever darker in palette and subject matter, the painting both celebrates artistic illusionism and broadcasts its mortal theme. Skulls have long been symbols of mortality, and in the context of wartime, the bag takes on the guise of a soldier's munitions bag.

George Ault's *Hunter's Return*, 1943 (fig. 1.26), in contrast to Thomas Cole's painting with the same name from nearly a century earlier (fig. 1.27 [cat. 18]), is not the celebration of a bounteous hunt, of a hunter returning to his family displaying his prowess, with livelihood achieved and subsistence obtained. Instead, it is a scene of quiet contemplation and loneliness. A solitary figure trudges through the crisp snow of winter in rural Woodstock, New York, perhaps a doppelganger for the long-suffering Ault.[84] If so, there may be some resonance to the absence of game, given the Aults' seemingly constant struggle to sustain

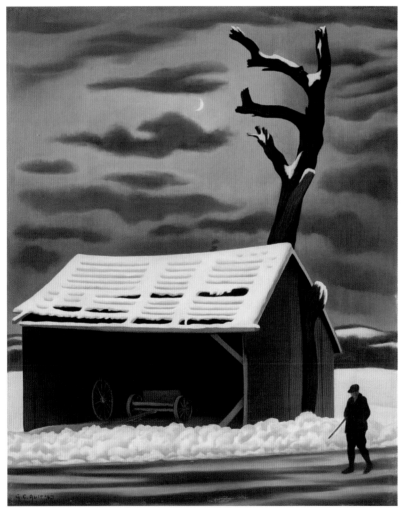

Fig. 1.26
George Ault
The Hunter's Return, 1943
Oil on canvas, 20¼ × 16¼ inches
Private collection

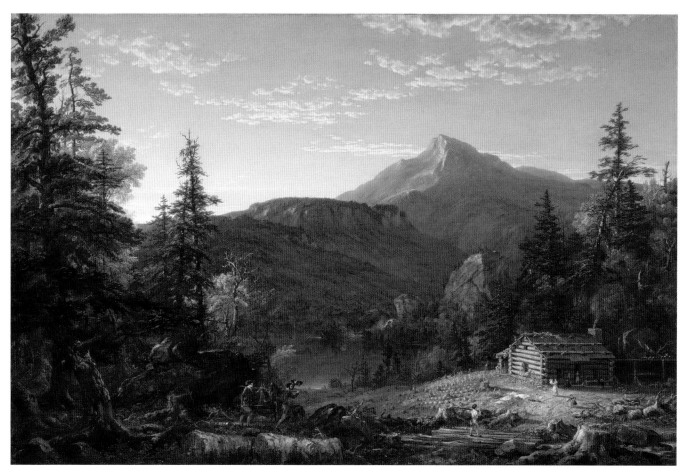

Fig. 1.27 (Cat. 18)
Thomas Cole
The Hunter's Return, 1845
Oil on canvas, 40⅛ × 60½ inches
Amon Carter Museum of American
Art, Fort Worth, Texas, 1983.156

themselves financially, particularly around the time of this painting. The lowered rifle, the lack of spoils, the dead tree, the stormy clouds, and the roof in disrepair lend an air of the melancholic, especially knowing that Ault eventually drowned on a walk in nature, perhaps not by accident. Whether or not it is an intentional harbinger of things to come, the painting takes on a somber significance.

From the caves and stars to cast bronze and canvas, imagery of life's moments—love, marriage, spirituality, definition of national identity, and contemplation of mortality—are reflected in the mythic, spiritual, and metaphorical images of the hunt. American artists took up the gauntlet of their artistic predecessors to fit their context and moment. They learned from stories passed through the generations while challenging the status quo and making their own statements in reaction to and in celebration of the hunting and fishing tales and images of the past. It remains to be seen how America today responds to or diverges from that myth-laden, ritualistic legacy in grappling with the role of hunting and fishing in contemporary society. The works of living artists, such as modern-day artist/taxonomist Mark Dion, whose installations of hunters' lodges and blinds, taxidermic specimens, and symbolic hunting emblems combine empathy and critique, address the conflict and issues inherent in the topics connected to hunting and fishing, while acknowledging their rich traditions and passionate pursuit.[85] Dion and others take as their subject the respect for the knowledgeable hunter-naturalist, the fraught relationship between humankind and animals, the dichotomy of the back-to-nature aspect of the hunt with the detached technology sometimes employed, and the often gentlemanly opulence of today's practice. Embedded in how we understand these artists' productions should be some recognition of the historical power and cultural ramifications of representing the hunting and fishing genre, as well as an understanding of the artistic complexity of imagery alluding to major philosophical aspects of life—from love to politics to human frailty.

NOTES

1. Eugen Herrigel, *Zen in the Art of Archery* (New York: Vintage Books, 1989).

2. Julius D. Staal, *The New Patterns in the Sky: Myths and Legends of the Stars* (Blacksburg, Va.: McDonald and Woodward, 1996), 59.

3. Ibid., 61, 64, 67, 70.

4. Ibid., 123, 17, 53.

5. Joel Landau, "Florida Fisherman Catches 552-Pound Grouper on Kayak," *New York Daily News*, May 27, 2015. See also the pictures in Esteban On, "9 Largest Fish Ever Caught," *Total Pro Sports*, May 31, 2014, www.totalprosports.com/2011/07/28/9-largest-fish-ever-caught.

6. For an overview of Diana and the myths associated with her, see Edith Hamilton, *Mythology* (New York: New American Library, 1969), 31.

7. Ovid, *Metamorphoses*, books 1–8, ed. G. P. Goold, trans. Frank Justus Miller (Cambridge, Mass.: Harvard University Press, 1977), 3.143, 3.148–49, 3.155–56, 3.163–64.

8. Ibid., 3.180–82, 3.195–97, 3.253–55, 3.251–52.

9. Wendy Bellion, "The Sculpture Club," in *Samuel F. B. Morse's "Gallery of the Louvre" and the Art of Invention*, ed. Peter John Brownlee (New Haven, Conn.: Yale University Press, 2014), 89–99.

10. For an in-depth look at the multiple Diana versions, see John H. Dryfhout, *The Work of Augustus Saint-Gaudens* (Hanover, N.H.: University Press of New England, 1982); John Dryfhout, "Diana," in *Metamorphoses in Nineteenth-Century Sculpture*, ed. Jeanne L. Wasserman (Cambridge, Mass.: Fogg Art Museum, 1975; distributed by Harvard University Press), 181–217; Thayer Tolles, ed., *American Sculpture in the Metropolitan Museum of Art* (New York: Metropolitan Museum of Art, 1999), 305–309; and Alain Daguerre Hureaux, ed., *Augustus Saint-Gaudens, 1848–1907: A Master of American Sculpture* (Paris: Somogy Editions D'Art, 1999).

11. Mariana Griswold Van Rensselaer, "The Madison Square Garden," *Century*, March 1894, 746.

12. Of course, artistic considerations take precedence, but archery technique indicates the need for a

proper anchor point—the hand and string should meet the face in a consistent spot. Pulling back the string so far behind the head deprives the archer of the ability to use the string as a sight and to ensure proper bodily alignment every single shot, not to mention that such a position precludes the archer from knowing that the exact same amount of force will be applied to the arrow each time, as the farther the bow is pulled back, the more force is exerted. She might also be in danger of losing an ear! One would certainly never use the entire hand to draw the string, either. Images of the champions of the day, for instance, a depiction of the aptly named Mrs. C. Bowly conform to these notions of proper archery form; see *Mrs. C. Bowly, Championess, 1893*, figure 190 in C. J. Longman and Col. H. Walrond, *The Badminton Library: Archery*, 1894, www.archerylibrary.com/books/badminton/docs/chapter23/190_large.html. We must remember, however, that Diana is a goddess, and she probably does not suffer from human frailty and error or the vicissitudes of inconsistency.

13. Royal Cortissoz, "The Metamorphosis of Diana.," *Harper's Weekly*, November 25, 1893, 1124.

14. See, for instance, "An Archery Meeting," *Harper's Weekly*, October 18, 1879, 830–31; "Archery," *Harper's Weekly*, August 3, 1878, 613–14; "Archery in America," *Harper's Weekly*, August 2, 1879, 610–11; and "The Archery Tournament," *Harper's Weekly*, July 23, 1881, 510.

15. Maurice Thompson, *The Witchery of Archery* (New York: Scribner, 1878). Interestingly, one of the archery illustrations in the book is by Will Low, friend to Saint-Gaudens.

16. "Archery," *Harper's Weekly*, 614.

17. Andrea L. Smalley, "'Our Lady Sportsmen': Gender, Class, and Conservation in Sport Hunting Magazines, 1873–1920," *Journal of the Gilded Age and Progressive Era* 4, no. 4 (October 1, 2005): 356.

18. "The Fine Arts—The Society of American Artists," *Critic*, May 3, 1890, 224–25.

19. Reprinted in O. Henry, *The Complete Works of O. Henry* (Garden City, N.Y.: Doubleday, 1911), 706.

20. Ibid., 707.

21. Ibid., 708.

22. Paula Uruburu, *American Eve* (New York: Penguin, 2008), 66–67.

23. The 1891 *Sunday Mercury* article is quoted in Charles C. Baldwin, "The Festive Diana," in *Stanford White* (Boston, Mass.: Springer US, 1931), 209.

24. For more about Manship, see Susan Rather, *Archaism, Modernism, and the Art of Paul Manship* (Austin: University of Texas Press, 2014); Harry Rand, *Paul Manship* (Washington, D.C.: Smithsonian Institution Press, 1989).

25. "The Academy of Design," *New York Tribune*, April 4, 1890.

26. "Pictures at the National Academy of Design," *New York Sun*, April 24, 1890.

27. Lula Merrick, "Brush's Indian Pictures," *International Studio* 76, no. 307 (December 1922): 187–93.

28. "The Spring Academy," *New York Times*, April 7, 1890.

29. Scott A. Shields, *The Exoticized Woman and Her Allure in American Art, 1865–1917: M. H. de Young Memorial Museum, Fine Arts Museums of San Francisco, February 14–June 16, 1996* (San Francisco: Fine Arts Museums of San Francisco, 1996), exhibition catalogue.

30. Nancy Douglas Bowditch, *George de Forest Brush: Recollections of a Joyous Painter* (Peterborough, N.H.: Noone House, 1970), 2.

31. For more on Flidais, see James MacKillop, *Myths and Legends of the Celts* (London: Penguin UK, 2006), or Patricia Monaghan, *The Encyclopedia of Celtic Mythology and Folklore* (New York: Infobase, 2004), 197.

32. *Bulletin of the American Art-Union* 2, no. 4 (July 1849): 5.

33. Karen Lemmey, "Henry Kirke Brown and the Development of American Public Sculpture in New York City, 1846–1876" (Ph.D. diss., City University of New York, 2005), 64. See also Karen Lemmey, "'I Would Just as Soon Be in Albany as Florence': Henry Kirke Brown and the American Expatriate Colonies in Italy, 1842–1846," in *Sculptors, Painters, and Italy: Italian Influence on Nineteenth-Century American Art*, ed. Sirpa Salenius (Saonara, Padova: Il prato, 2009), 67–83. For more about the foundry, see Michael Edward Shapiro, *Bronze Casting and American Sculpture, 1850–1900* (Newark: University of Delaware Press, 1985). See also, Carol Lea Clark, "Indians on the Mantel and in the Park," in *The American West in Bronze, 1850–1925*, ed. Thayer Tolles and Thomas Brent Smith (New York: Metropolitan Museum of Art, 2014), 26–29.

34. Will Gillham, ed., *An American Collection: Works from the Amon Carter Museum* (New York: Hudson Hills Press in association with the Amon Carter Museum, 2001), 48.

35. Annual report quoted in Wayne Craven, "Henry Kirke Brown: His Search for an American Art in the 1840's," *American Art Journal* 4, no. 2 (November 1, 1972): 49. Interestingly, alongside Hiram Powers's *Greek Slave*, *The Choosing of the Arrow* was cited by the author of the *Home Journal*, January 5, 1850, for the impropriety of its nudity. The coppery bronze patina was considered so near the natural skin color as to be more egregious than marble. Both the

classicized form and the American Indian subject matter were used as a pretext for nudity. The metal fig leaf was added by the Art-Union as a measure of propriety.

36. Lemmey, "I Would Just as Soon Be in Albany," 72.

37. "Mr. Ward's 'Indian Hunter,'" *Round Table: A Saturday Review of Politics, Finance, Literature, Society and Art*, October 28, 1865, 124; David Cateforis, Janice Driesbach, and Norman A. Geske, *Sculpture from the Sheldon Memorial Art Gallery*, ed. Karen O. Janovy (Lincoln, Neb.: Bison Books, 2006), 7–9; Lewis I. Sharp, "John Quincy Adams Ward: Historical and Contemporary Influences," *American Art Journal* 4, no. 2 (November 1, 1972): 71–83.

38. Ovid, *Metamorphoses*, 1.452–62.

39. Ibid., 1.475–76.

40. Ibid., 1.505, 1.533–39.

41. Hamilton, *Mythology*, 223.

42. Ibid., 224.

43. Virgil, *The Aeneid*, trans. Robert Fitzgerald (New York: Vintage, 1990), 4.95–97. 4.166–77.

44. Sir Joshua Reynolds, *The Discourses of Sir Joshua Reynolds* (London: J. Carpenter, 1842), 37.

45. Paul D. Schweizer, ed., *Masterworks of American Art from the Munson-Williams-Proctor Arts Institute* (New York: Abrams, 1989), 35.

46. Virgil, *The Aeneid*, 4.210–20.

47. "Joshua Shaw, Artist and Inventor—The Early History of the Copper Percussion Cap," *Scientific American*, August 7, 1869, 8.

48. For a discussion of American hunting and its relationship to manliness, respectability, identity, and nation, see Daniel Justin Herman, *Hunting and the American Imagination* (Washington, D.C.: Smithsonian Institution Press, 2001).

49. Washington Irving, *Rip Van Winkle and the Legend of Sleepy Hollow* (New York: Macmillan, 1893). Van Winkle's reluctance to be industrious, in part, has to do with his nagging wife, who is a disincentive for him to function as head of household when the household involved is irksome. This is one of the main themes of the story, more so than Van Winkle's failure at farming. Nonetheless, a running theme of the story is that farming was considered the proper form of labor, while hunting and fishing were forms of idleness.

50. Ibid., 27–31, 35.

51. Herman, *Hunting and the American Imagination*, 2.

52. Sarah E. Boehme, *John James Audubon in the West* (New York: Abrams in association with the Buffalo Bill Historical Center of the West, 2000).

53. Jennifer L. Roberts, *Transporting Visions: The Movement of Images in Early America* (Berkeley: University of California Press, 2014), 71.

54. See, among others, Earl A. Powell, *Thomas Cole* (New York: Abrams, 1990); Howard S. Merritt, *Thomas Cole* (Rochester, N.Y.: Memorial Art Gallery of the University of Rochester, 1969).

55. Daniel J. Herman, "The Other Daniel Boone: The Nascence of a Middle-Class Hunter Hero, 1784–1860," *Journal of the Early Republic* 18, no. 3 (October 1, 1998): 429–57.

56. Ibid., 435.

57. S. G. W. Benjamin, *Our American Artists* (Boston: Lothrop, 1881), 26.

58. Birgitta Hjalmarson, "Thomas Hill," *Magazine Antiques*, November 1984, 1200–1207.

59. See, for example, communal fishing scenes in ibid., 1204–1205.

60. Warder H. Cadbury and Patricia C. F. Mandel, *A. F. Tait: Artist in the Adirondacks* (Blue Mountain Lake, N.Y.: Adirondack Museum, 1974), 15.

61. Caroline M. Welsh, *The Adirondack World of A. F. Tait* (Blue Mountain Lake, N.Y.: North Country Books, 2011), 10.

62. Herman, *Hunting and the American Imagination*, 191.

63. Ibid., 193.

64. Elizabeth Johns, "Boys Will Be Boys," in *William Sidney Mount: Painter of American Life* (New York: American Federation of Arts, 1998); and Elizabeth Johns, *American Genre Painting: The Politics of Everyday Life* (New Haven, Conn.: Yale University Press, 1993).

65. Johns, "Boys Will Be Boys," 12, 13.

66. Johns, *American Genre Painting*, 49.

67. Norman Maclean, *A River Runs through It and Other Stories*, 25th anniversary ed. (Chicago: University of Chicago Press, 2001), 1, 2.

68. See Matthew 4:18–22; Mark 1:16–20.

69. See Luke 5:1–11 and John 20:29–21:13, for example.

70. Richard Mühlberger, *Charles Webster Hawthorne* (Chesterfield, Mass.: Chameleon Books, 1999).

71. From "Charles W. Hawthorne—An Appreciation," in the 1938 edition of *Hawthorne on Painting*, reprinted in ibid., 90.

72. Charles Webster Hawthorne, *Hawthorne on Painting* (New York: Dover Publications, 1960), 49.

73. For an understanding of the relationship between the Salon painters and religious thinking in nineteenth-century France, see Michael Paul Driskel, *Representing Belief: Religion, Art, and Society in Nineteenth-Century France* (University Park: Pennsylvania State University Press, 1991).

74. William Henry Furness, *The Power of Spirit Manifest in Jesus of Nazareth* (Philadelphia: Lippincott, 1877), 156.

75. Vance Thompson, "American Artists in Paris," *Cosmopolitan*, May 1900, 17, quoted in Alan C.

Braddock, "Painting the World's Christ: Tanner, Hybridity, and the Blood of the Holy Land," *Nineteenth-Century Art Worldwide* 3, no. 2 (Autumn 2004): 10.

76. H. O. Tanner, "The Story of an Artist's Life II," *World's Work* 18, no. 3 (July 1909): 11775.

77. Tanner in a 1924 exhibition brochure quoted in Braddock, "Painting the World's Christ," 10.

78. Knowing that biblical fishermen relied on nets, and having seen artistic precedent of loaded nets of sparkling fish, I can't help but see Winslow Homer's *The Herring Net*, 1885, as also alluding to the haul of fishes—like Hawthorne, it's a balance between true life and allegory.

79. For one philosopher's take on the hunt and the connectedness of species, see Jose Ortega Gasset, *Meditations on Hunting* (Bozeman, Mont.: Wilderness Adventures Press, 1996).

80. Marc Simpson, *Winslow Homer: Paintings of the Civil War* (San Francisco: Fine Arts Museum of San Francisco, 1988), 181. See also John Wilmerding, "Winslow Homer's Right and Left," *Studies in the History of Art* 9 (1980): 59–85; Henry Adams,

"Mortal Themes: Winslow Homer," *Art in America* 71 (February 1983): 112–26; and Bruce Robertson, *Reckoning with Winslow Homer: His Late Paintings and Their Influence* (Cleveland, Ohio: Cleveland Museum of Art in association with Indiana University Press, 1990).

81. Pippin quoted in Anne Monahan, "I Rember the Day Varry Well: Horace Pippin's War," *Archives of American Art Journal* 47, nos. 3/4 (2008): 19.

82. See Judith E. Stein, *I Tell My Heart: The Art of Horace Pippin* (New York: Universe, 1993).

83. Grace Museum and Dallas Museum of Art, *Loren Mozely: Structural Integrity* (Dallas, Tex.: McKinney Avenue Contemporary, 2012).

84. For more on Ault and his battles with mental illness, see Susan Lubowsky, *George Ault* (New York: Whitney Museum of Art, 1988). See also Alexander Nemerov, *To Make a World: George Ault and 1940s America* (New Haven, Conn.: Yale University Press, 2011).

85. Dieter Buchhart and Mark Dion, *Mark Dion: Concerning Hunting* (Ostfildern, Germany: Hatje Cantz, 2008).

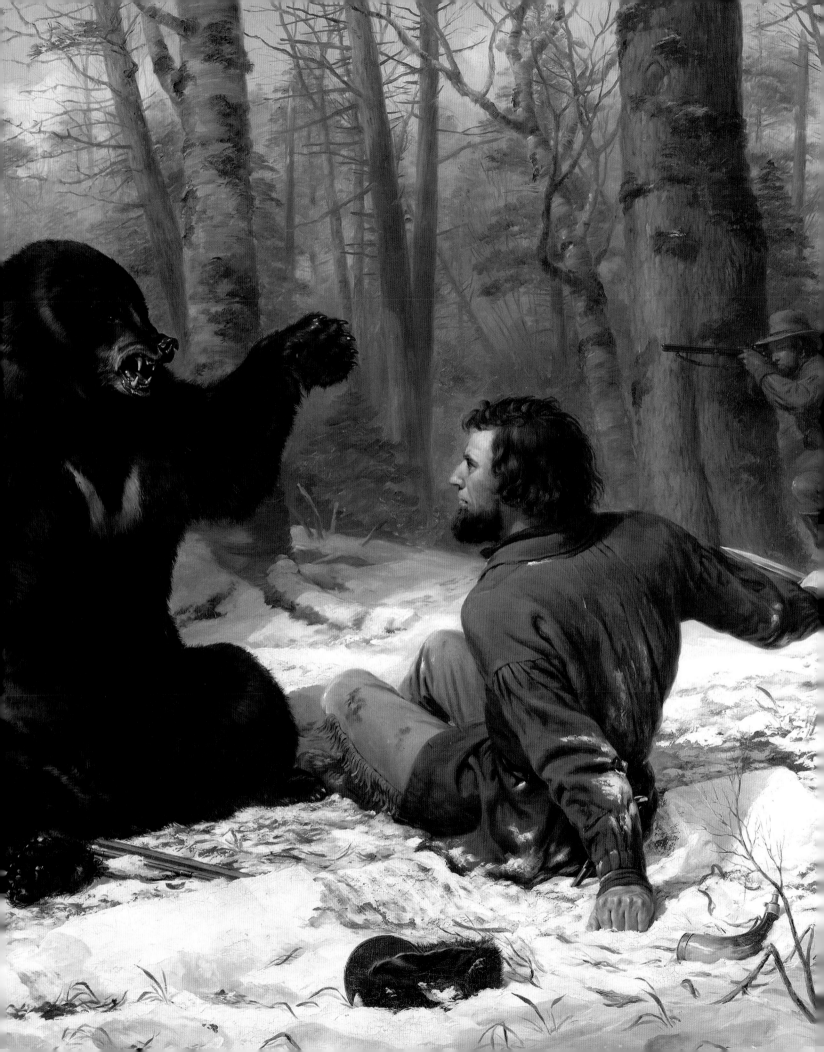

Risky Business
THE PERILS OF HUNTING IN AMERICAN ART

Kory W. Rogers

Paintings depicting the perils of the hunt enjoyed great currency in the second half of the nineteenth century. As the United States evolved from a social economy of small rural communities to a modern urban nation, new conditions of life gave birth to a constellation of mythologies that valorized preindustrial rituals and pastimes—including the rugged and often risky endeavor of securing sustenance from nature.[1] The dangers associated with hunting proved to be a persistent and persuasive trope within the visual culture of the era, beginning in the 1840s as an organizing myth for the young nation, and continuing well into the twentieth century as a nostalgic collective memory. With industrial life challenging traditional notions of masculine labor and leading to deep-seated fears of neurasthenia, idealized images of wilderness peril performed important cultural work as examples of energizing behavior for the modern era.

PERIL AS ORGANIZING MYTH

Charles Deas painted *The Death Struggle* (fig. 2.1 [cat. 20]) between 1840 and 1845. It is a paradigm of the dangers, real and imagined, that stalked the popular imagination in mid-nineteenth-century America. Frozen in terror, a fur trapper and an Indian warrior cling to one another as their two horses plummet off a precipice. Eyes bulging, the trapper reaches back with his right hand, still holding a bloody knife, in a futile attempt to grasp a small branch. In his left hand he clutches the *casus belli*, a beaver still in the trap. The animal in turn bites the arm of the warrior, creating a cycle of violence that animates the canvas. On the surface, *The Death Struggle* trades in simple narrative, European settler versus aboriginal inhabitant. The settler, however, is clearly a trapper, which lends a subtext to the painting— competition for resources brought about by international commerce. Trade, compounded by decades of ethnic hatred, heralds the modern era, as the man in the red shirt directly

(facing)
Detail of fig. 2.6 (cat. 64), p. 66
Arthur Fitzwilliam Tait
A Tight Fix—Bear Hunting, Early Winter [The Life of a Hunter: A Tight Fix], 1856

59

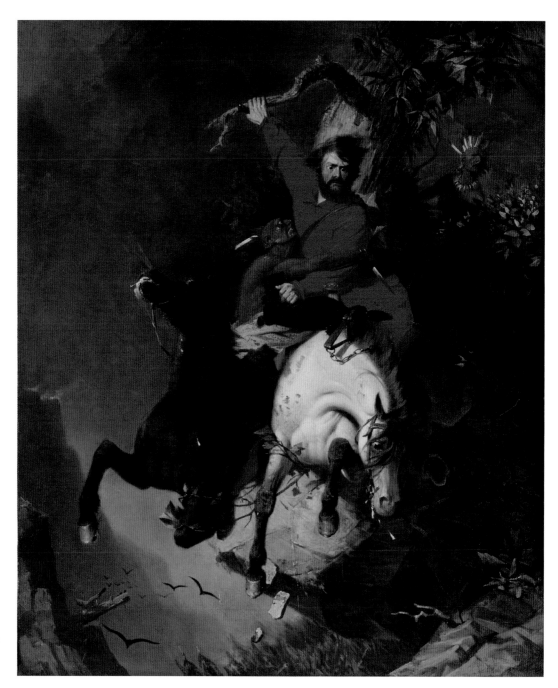

Fig. 2.1 (Cat. 20)
Charles Deas
The Death Struggle, 1840–45
Oil on canvas, 30 × 25 inches
Collection of Shelburne Museum,
Shelburne, Vermont. Museum
purchase, acquired from Maxim
Karolik, 1959-265.16

threatens the American Indian's ways of life in the interests of larger economic systems.

The Death Struggle personalizes Manifest Destiny—a phrase coincidentally coined in 1845—and presages decades of grand-scale conflict, sparked by a nation that viewed westward expansion in quasi-religious terms. Deas himself would not see this era of escalation, as *The Death Struggle* proved to be the magnum opus in a career cut short by mental illness and a premature death. As early as 1844, the artist suffered from "religious anxieties," caused by "inflammation of the brain," which resulted in his eventual commitment to the Bloomingdale Asylum in New York in 1848.[2] On an intimate level, the perils of the hunt clearly represent a kind of transference for Deas, a story that resonated with the artist as he struggled with mania. The larger narratives encoded in the painting, however, set the stage for a half century of imagery fraught with a romantic view of the hunt against a background of rapid national growth.

DOMESTICATING DANGER

Artists like Deas and, slightly later, Arthur Fitzwilliam Tait perpetuated the archetype of the brave hunter who, through courageous acts, conquered and tamed America's wilderness. Wildly popular in his day, Tait made a career painting wildlife and hunting scenes set in the Adirondack Mountains of Upstate New York. Born in England in 1819, he immigrated to the United States in 1850 in search of opportunity, settling with his wife in New York City. Family responsibilities brought him to the Adirondacks a year later to assist a sister-in-law who had been abandoned by his brother.[3] Tait found inspiration (and patronage) in the region, capturing the beauty of its rugged terrain and valorizing the sturdy and daring character of the men who hunted in its forests for sustenance and commerce. Tait's vision helped to popularize the Adirondacks as a domestic wilderness, a romantic landscape of tall peaks and sheltered valleys, which drew intrepid visitors from nearby urban centers by mid-century, inspired a genre of outdoor adventure literature in the 1860s and 1870s, and became a middle-class tourist haunt in the decades after

the Civil War. One such example is Boston pastor William Henry Harrison Murray, who published a compendium of articles based on his experiences camping in the Adirondack Mountains, which, according to William K. Verner, "exerted a lasting influence upon outdoor recreation in America, and it left an indelible mark upon the history of the Adirondacks."[4]

The Hunter's Dilemma, 1851 (fig. 2.2 [cat. 63]), represents Tait's stock in trade, the ways of the Adirondack woodsman. It also reflects a larger theme in American paintings of the second half of the nineteenth century—the mortal quandary. The work is engaging and moralizing, satisfying the need for sentiment so popular in the decades that bracketed the Civil War. Tait's protagonist, a young commercial gunner or pot hunter, finds himself in a precarious situation. Risking life and limb, the hunter has climbed down onto a ledge set halfway up the face of a sheer cliff to retrieve his kill. Dressed in buckskin, a traditional garb that resonated throughout popular culture as the costume of such heroic figures as Daniel Boone, the young man courageously confronts the seemingly insurmountable obstacle of hoisting his dead quarry to higher ground. Grasping the deer's antlers in his right hand, he stakes his claim to the hide and meat of the prize, which he intends to sell, as he tests the strength of the twisted vines in his left hand. Looking up, the hunter calculates the odds of success with a look of determination.

The persistence of predicament paintings testifies to their depth of meaning in American culture. Charles M. Russell's 1915 *Meat's Not Meat Till It's in the Pan* (fig. 2.3), perhaps the apogee of the genre, offers a hunter in a similar situation to Tait's courageous backwoodsman. Standing on the edge of a precipice, Russell's hunter scratches his head as he considers his prospects. Having successfully tracked and dispatched a bighorn sheep, the hunter experiences an unlucky turn when his quarry falls over the edge of a cliff. Pensively the hunter considers his situation from a rocky outcrop. As Russell's title suggests, there are sure shots but no certainties in the great outdoors, and skill does not guarantee success. Unlike Tait's

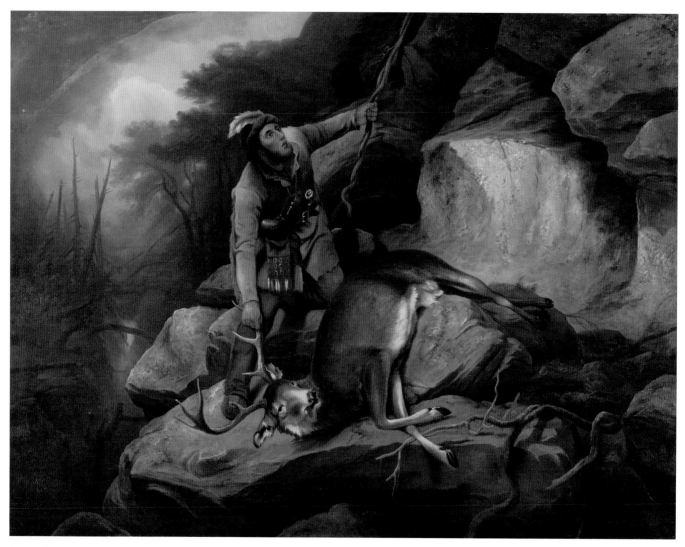

Fig. 2.2 (Cat. 63)
Arthur Fitzwilliam Tait
The Hunter's Dilemma, 1851
Oil on canvas, 33¾ × 44¼ inches
Collection of Shelburne Museum,
Shelburne, Vermont. Gift of
William H. Scoble, 1961-2

heroic figure, Russell's hunter appears to have been beaten by nature and fate.

COMMERCE VERSUS SPORT

Public attitudes toward hunting evolved dramatically over the course of the nineteenth century. Hunters, according to the historian Daniel Justin Herman, were initially regarded as uncouth rubes who hunted for subsistence. Over time they came to be seen as conquerors of nature and, ultimately, refined sportsmen.[5] Herman credits this sea change in perspective to the development of sporting literature, a rubric typified by the Englishman Henry William Herbert, under the pseudonym Frank Forester, and painters like Tait, who "alternated between painting courageous backwoodsmen and equally courageous gentlemen hunters, as if to underscore the kinship between the two."[6] Few painters understood the relationship between sport and commerce better than Winslow Homer, a master of painting moral concerns of the hunt.

Winslow Homer's credentials as a hunter were established in the 1870s through a series of visits to the Adirondacks. A Boston native, he grew to maturity in a family that prized the sporting life, and he came to national attention as a sketch artist during the Civil War. After taking some time to explore other regions, Homer returned to the Adirondacks in 1889, staying at Baker's Clearing—later renamed the North Woods Club—twice that year for a total of sixteen weeks.[7] This trip set a pattern for the next several years. Homer and his brothers traveled to the area each spring to fish, returning in the fall to hunt. In doing so, Homer developed a close relationship with local guides as well as a nuanced understanding of Adirondack culture.

The brave young man in Winslow Homer's *A Huntsman and Dogs* (fig. 2.4 [cat. 31]), similar to Tait's backwoodsman, fits the popular archetype of conquering hunter as he confidently strides over the root of a dead tree, carrying the skinned hide on the barrel of his firearm. Yet the method of the young backwoodsman's success casts a pall over the subject's valor, moving from courage to illegal and risky behavior. Homer's hunter is flanked on

either side by two barking hounds, indicating that the deer was taken by hounding, a divisive practice that was viewed as unsporting by most hunters outside the Adirondack region. So controversial was this means of hunting that it led one reviewer of the painting to complain: "He is just the sort of scoundrel this fellow who hounds deer to death in the Adirondacks for the couple of dollars the hide and horns bring in, and leaves the carcass to feed the carrion birds." The critique ended with one last final damning remark about the contentious hunting practice stating, "One doesn't expect hounds to have any instinct above slaughter, throughout, however, the picture—albeit well composed and firmly drawn—is a cold and unsympathetic work, entirely unworthy of the artist."[8]

Visually and morally ambiguous, Homer's painting *Hound and Hunter*, 1892 (fig. 2.5), enters the debate. Set on a lake in the Adirondacks, the scene portrays a young backwoods hunter lying flat on his stomach as he leans over the edge of his boat. He reaches out to grab hold of the rack of a deer that is submerged up to its head in water, as he calls out to the swimming hound off to his right. As with

Fig. 2.3
Charles M. Russell
Meat's Not Meat Till It's in the Pan, 1915
Oil on canvas mounted on Masonite, 23 × 35 inches
Gilcrease Museum, Tulsa, Oklahoma, GM 0137.2244

Fig. 2.4 (Cat. 31)
Winslow Homer
A Huntsman and Dogs, 1891
Oil on canvas, 28⅛ × 48 inches
Philadelphia Museum of Art,
Philadelphia, Pennsylvania. The
William L. Elkins Collection, 1924,
#E1924-3-8

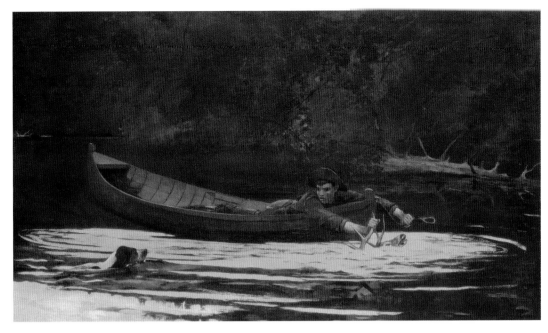

Fig. 2.5
Winslow Homer
Hound and Hunter, 1892
Oil on canvas, 28¼ × 48⅛ inches
National Gallery of Art,
Washington, D.C. Gift of
Stephen C. Clark, 1947.11.1

the earlier painting, changing demographics in the increasingly urban United States invited misinterpretation. A critic writing for the *Art Amateur* in 1893 mistakenly described the subject as "A hunter lying flat in his boat, has caught a deer that has taken to the lake by one antler, and is being rapidly towed along through the disturbed water, while he calls up his dog, that is striving hard to overtake him."[9] The crux of this description lay in the writer's assumption that the deer was alive. In fact, the previous year, Homer had rebutted another critic's incorrect assumptions: "The critics may think that the deer is alive but he is not, otherwise the boat & man would be knocked high & dry."[10] Homer included telltale signs of death in the animal's expression, characterized by its lifeless half-closed eyes, gaping maw, and extended tongue. Homer continued his acerbic response by offering to "shut the deer's eyes & put pennies on them if that will make it better understood." He conclusively finished his chiding response by declaring, "It is a simple thing to make a man out an Ass & fool by starting from a mistaken idea. So anyone thinks this deer is alive is wrong."[11]

Homer's paintings of hounding document the shift in popular attitude toward hunting. Once the time-honored practice of harvesting a

natural resource, hunting now required a sporting code or ethos of conservation. Hound hunting in particular was restricted and outlawed several times throughout the nineteenth century, by both local and state legislations. As early as 1833, the towns of Blenheim and Fulton, in Schoharie County, New York, sought to outlaw the practice, stating, "No person shall at any time hunt, pursue, or destroy any wild buck, doe, or fawn, with any blood-hound or beagle." To do so would have been punishable by a $12.50 fine.[12] Decried by opponents as unsporting, hound hunting was severely restricted by the controversial Adirondack Deer Law of 1888, albeit without the financial means and manpower to enforce it. By the following year, supporters of the practice, who believed "hounding left no wounded animals to die slowly in agony in the forest," convinced authorities to grant them a limited hunting season in early fall.[13] By 1896, New York State finally banned hunting deer with hounds for good.[14] Bear baiting, a far more dangerous pastime, proved to be another matter.

URSUS UBIQUITOUS

The earliest European narratives of the New World painted a picture of North America as a forested land teeming with wild animals. Large

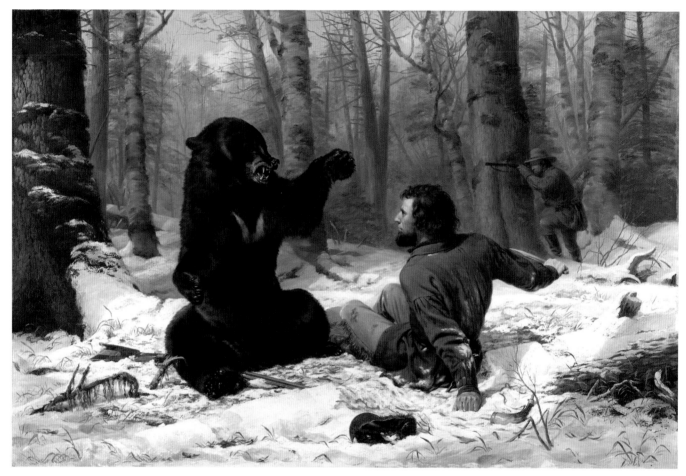

Fig. 2.6 (Cat. 64)
Arthur Fitzwilliam Tait
*A Tight Fix—Bear Hunting,
Early Winter [The Life of a
Hunter: A Tight Fix]*, 1856
Oil on canvas, 40 × 60 inches
Crystal Bridges Museum of
American Art, Bentonville,
Arkansas

predators—catamounts, wolves, and bears—captured the imagination and featured prominently in narratives of settlement and frontier life. With the advent of the rotary press in the 1830s, leading to mass market publishing and yellow journalism, gory tales of encounters with bears filled newspaper reports and journal articles. While ostensibly based on true events, such stories were embellished by journalists and writers looking to sensationalize the narrative in the interests of increased circulation. Tales of men who came face to face with one of the most powerful predators in nature took on a larger meaning for American readers living in urban areas. Factory workers would have recognized and identified with the dangers bears posed. They too faced similar risks. Instead of the jagged canines, incisors, and molars in a bear's maw, laborers now confronted the regularly spaced teeth of sprockets and cogs that devoured human limbs with the same ferocity. Industrial workers of the nineteenth century found escape from the dangers in their own lives in harrowing frontier stories. One such tale of Scottish-born frontiersman Hugh Glass, whose incredible story of survival, revenge, and forgiveness has captivated audiences for almost two centuries.[15]

In 1823, Hugh Glass embarked on a fur-trapping expedition in the upper Missouri River region, in what is now South Dakota. One August day, while scouting around a stream, he inadvertently crossed paths with a female grizzly bear. Though the details of the mauling vary between accounts, the severity of the life-threatening injuries he sustained from the altercation is consistently gruesome. As Jon T. Coleman describes in *Here Lies Hugh Glass*, the bear "caught him as he scrambled up a tree, slicing a gash with a foreclaw from scalp to hamstring. She bit his head, punctured his throat, and ripped a hunk from his rear." After being torn "nearly to pieces," Glass was abandoned and left for dead by two companions, who absconded with his firearm.[16] Remarkably, Glass survived the attack, crawled and walked over two hundred miles of wilderness, living on a diet of insects, snakes, and puddle water, in pursuit of revenge against those who had left him behind. After months of searching, Glass successfully

hunted down the scoundrels who had abandoned him, but instead of killing them, he ultimately forgave them.

Tait's *A Tight Fix—Bear Hunting, Early Winter*, 1856 (fig. 2.6 [cat. 64]), as the title suggests, depicts an unlucky hunter caught in a life-threatening situation with an angry black bear. Somehow, the two adversaries have managed to knock each other back, the bear sitting on the hunter's rifle, and the hunter leaning back on his left hand. The bear extends its arms in self-defense, while the hunter brandishes a knife in his right hand, both ready to strike. The tense moment is made even more so by the presence of the hunter's companion in the background. His diminutive scale and misaligned aim add ambiguity to the outcome. *A Tight Fix* is arguably Tait's most recognizable and controversial painting.[17]

Tait returned to the subject in 1861, when he was commissioned by Currier and Ives to reexamine the battle between man and bear. *The Life of a Hunter: A Tight Fix* (fig. 2.7), the popular print and the now-lost painting on which it was based,

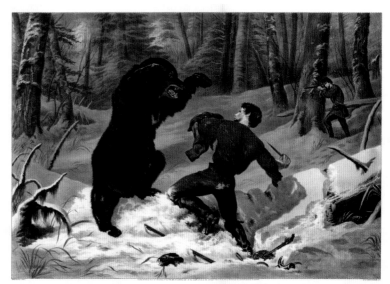

THE LIFE OF A HUNTER.

Fig. 2.7
Arthur Fitzwilliam Tait
The Life of a Hunter:
A Tight Fix, 1861
Lithograph published by
Currier and Ives
Old Print Shop, Inc., New York,
New York

depict an even more dramatic and dynamic scene. Both the bear and the hunter, now standing, strike aggressive postures. On higher ground, the bear rears up on its hind legs as the hunter heroically lunges forward, knife perfectly aimed at the bear's exposed midsection. The hunter's companion, now wearing a Union soldier's cap, has perfectly lined up his shot. The print, as one of Tait's associates described it, was a more accurate depiction of the perilous true events that had inspired both versions of the scene: "The bear actually clawed the man's shoulder. Then for some reason the bear pushed the hunter away with his snout, thus giving the hunter's companion the chance to 'draw a bead' on the bear"[18]

The unconscious hunter in William R. Leigh's *A Close Call*, 1914 (fig. 2.8 [cat. 35]) has suffered injury from an encounter with a grizzly bear. Leigh's hunter has yet to be mauled by the animal; instead, he lies prostrate on the ground, knocked out by a swipe of the bruin's paw. Surrounded by a pack of eight snarling dogs, the bear looms over the hunter, standing tall on its two hind legs. Protecting their master from being mauled to death, the canines bait the bear by barking and biting, distracting the bruin until help can arrive. Hurtling over a fallen tree, two hunters with rifles in hand rush to the aid of their fallen comrade.

The bear in *A Close Call* appears to be the aggressor, and the hunter its unfortunate victim. The story behind the painting's inspiration, however, reveals a reversal of the roles. In 1912, Leigh was invited by J. D. Figgens, director of the Colorado Museum of Natural History in Denver, to join a grizzly bear hunting expedition in the northern Rocky Mountains. Figgens was looking to add a new specimen to augment the museum's collection, and Leigh went along to study the anatomy of live bears. When the guides tracked down a male bear, Leigh requested that the party allow him to make sketches of the creature before it was killed.[19] The hunters consented because the bear, surrounded by a pack of well-trained hounding dogs, "could not get away, because we [Figgens and the rest of the party] were within a few yards of him and both the guide and myself [Figgens] were better than ordinary marksmen." As Leigh scrutinized and sketched

the bear's movement and defensive behavior, a guide "came too close to the fighting dogs and was knocked down."[20] This careless accident gave Leigh the inspiration for *A Close Call*. Although the details were fictional, the animal's posture and the background were based on careful observation. Leigh even went so far as to visit the site several times after the animal was taken to measure the landscape and its features.

George Catlin's nostalgic reflection on a dangerous episode from his youth, *The Rattle Snakes Den (Fountain of Poison)* (fig. 2.9 [cat. 14]), pits heroic hunters against a deadly and unpredictable foe.[21] Inspired by a childhood memory, the painting portrays a time when Catlin accompanied his father and local farmers on a rattlesnake hunt near his hometown of Wilkes Barre, Pennsylvania. Set on the slopes of the Ocquago Mountain near the banks of the Susquehanna River, the scene depicts the hunting party surrounding the mouth of a rattlesnake den in early spring. The reptiles have just woken from their winter hibernation and are sunning themselves in clusters of hundreds on the warm rocks and tree branches near the small opening of the cave. Equipped with clubs and muskets loaded with buckshot, the men set about the rattlers as they lie in their torpid state. Young Catlin is positioned above the den, crouching on the brink of a precipice with gun in hand, drawing a bead on the large tangle of writhing snakes in the center of the clearing. Reflecting on the situation, Catlin was fully aware of the dangerous position he was in, speculating, "Oh! What a beautiful sight, and what a perdition, if, by slip of the foot, one were to have launched into the midst of it." He goes on to describe the aftermath of "grand *onslaught of the devils*" stating, "My double charge of shot had cut the knotted mass (perhaps from fifty to one hundred) to pieces, and the party rushing on with their clubs, had thrashed some hundreds more to death." Those snakes that survived the attack were quick to retreat to the safety of the den. An ingenious child, Catlin was quick to devise a plan to eradicate the remaining rattlers by tying a powder horn and slow match to the tail of one of the survivors, which went back into the

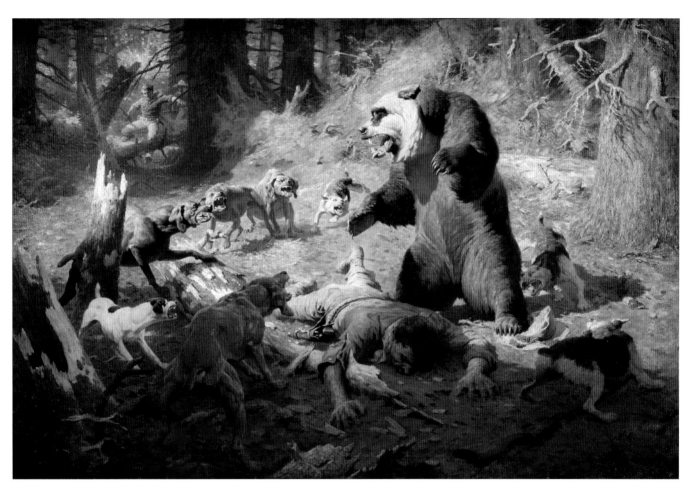

Fig. 2.8 (Cat. 35)
William R. Leigh
A Close Call, 1914
Oil on canvas, 40½ × 60½ inches
Gilcrease Museum, Tulsa,
Oklahoma, GM 0127.2232

Fig. 2.9 (Cat. 14)
George Catlin
The Rattle Snakes Den
(Fountain of Poison), 1852
Oil on canvas, 18 × 26¾ inches
Gilcrease Museum, Tulsa,
Oklahoma, GM 0176.2167

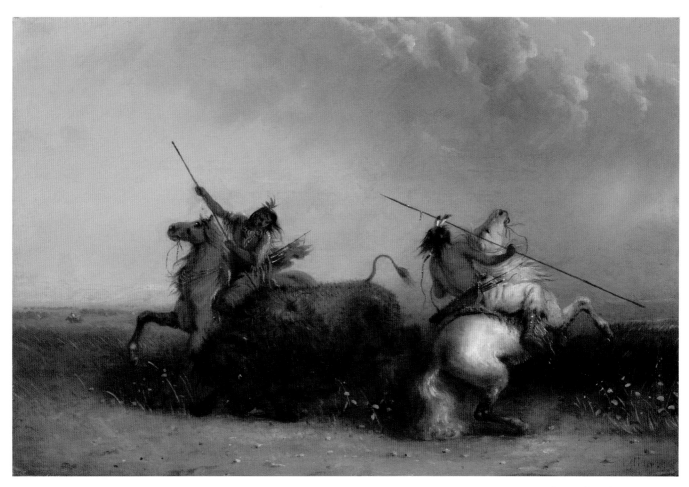

Fig. 2.10 (Cat. 39)
Alfred Jacob Miller
Buffalo Hunt, ca. 1838–42
Oil on wood panel,
9³/₁₆ × 13¹¹/₁₆ inches
Amon Carter Museum of American
Art, Fort Worth, Texas, 2003.10

Fig. 2.11 (Cat. 40)
Alfred Jacob Miller
The Surround, ca. 1840
Oil on canvas, 66 × 94½ inches
Joslyn Art Museum, Omaha,
Nebraska. Museum purchase,
1963.611

cave. According to Catlin, the explosion, which sounded "like an instant clap of thunder," was successful in disposing of the rattler population in the region for many years.[22]

Alfred Jacob Miller offers another window on the perils of the hunt through his dramatic depictions of Plains Indians and their pursuit of buffalo, including his *Buffalo Hunt* (fig. 2.10 [cat. 39]) and *The Surround* (fig. 2.11 [cat. 40]). The latter does so through the guise of a swashbuckling escapade designed to appeal to his patron's sense of adventure. Miller accompanied Scottish sportsman Sir William Drummond Stewart on an 1837 trip through the Nebraska Territory, following the Platte River, and into the Wind River Mountains. The two attended one of the last of the annual fur trappers' rendezvous along the Green River, in present-day Wyoming, witnessing the end of a chapter in the exploration of the western frontier. *The Surround* originally hung in Stewart's home at Murthy Castle, Scotland, an energetic reminder of his time in the American West. In the painting, a mounted band of Plains Indians are captured in flight, swiftly enclosing a herd of buffalo into an ever-tightening vortex. In the foreground, two warriors drive their spears into a bull who has been herded from a cliff, their white mounts glowing. Miller's scene is quite different in mood from Catlin's narrative. Though heroic and fraught with excitement, the hunt seems to have a certain outcome, and we understand our hunters will emerge victorious. Miller was careful to avoid the larger peril faced by the Plains Indians, which Catlin well understood. Miller's monumental canvas nevertheless memorialized a traditional way of life that was as imperiled as the fate of the buffalo.

REWARDS OF THE HUNT

The risky business of hunting, for commerce or sport, offered great reward. For the commercial hunter, the outdoor life offered a livelihood. For the sportsman, taking a trophy provided a potent symbol of masculinity, mortality, and sentimentality. To the artist, the desires for a trophy painting lent new meaning to a traditional genre, the trompe l'oeil, or "fool the eye." Long prized for their artifice and ability to test the limits of

perception, trompe l'oeil still lifes were placed in the service of memorializing the hunt for a growing class of sportsmen. These optical illusions fed Victorian America's hunger for novelty and whetted its appetite for death. Realistically rendered portrayals of dead animals taken from land, sea, and air visually transformed elegantly appointed Victorian parlors into trophy rooms and ornately decorated dining rooms into well-stocked larders. Death was most conspicuous in Victorian families' dining rooms, where the well-to-do supped amid a smorgasbord of nature's bounty, including dead fish, wildfowl, rabbits, and deer, in paintings or intricately carved into large ornate sideboards. Though dining in the presence of carved carcasses and painted corpses might seem distasteful to modern sensibilities, Victorian families viewed these trophies as affirmations of man's biblically sanctioned dominion over animals.[23] Instead of being repulsed by such images, they marveled at their visual veracity and were amused by the skill of the artist.

Alexander Pope's 1899 *Trophies of the Hunt* (fig. 2.12 [cat. 53]) provides a master class in trompe l'oeil. According to contemporaneous newspaper reports, the painting fooled gullible viewers to "abandon the etiquette of passive spectatorship."[24] Some were so convinced by the illusion that they reached out to "make off with" the dead game. Pope's trophy painting follows a simple formula established in the 1880s by the Irish American painter William Michael Harnett, whose realistic works (fig. 2.13 [cat. 26]) were in turn inspired by the sumptuous interior setting of artist David Neal's 1870 masterpiece *After the Hunt* (fig. 2.14 [cat. 46]). Whereas Neal's hunting tableau is part of a larger narrative scene, Harnett's and Pope's trophy paintings are more exercises of technical skill, focusing on the verisimilitude of their renderings of hunting accoutrement and dead animals. Like Harnett, Pope's primary concern was to create an illusion that would captivate and entertain spectators, as evidenced by his inclusion of a visual pun, using the deer's antlers as a gun rack. Amused onlookers would have understood the implied masculine subtext conveyed by Pope's artfully composed assemblage of hunting paraphernalia

Fig. 2.12 (Cat. 53)
Alexander Pope
Trophies of the Hunt, 1899
Oil on canvas, 37¼ × 43 inches
The Manoogian Collection

Fig. 2.13 (Cat. 26)
William Michael Harnett
After the Hunt, 1884
Oil on canvas, 55 × 40 inches
The Butler Institute of American
Art, Youngtown, Ohio. Museum
purchase, 1954

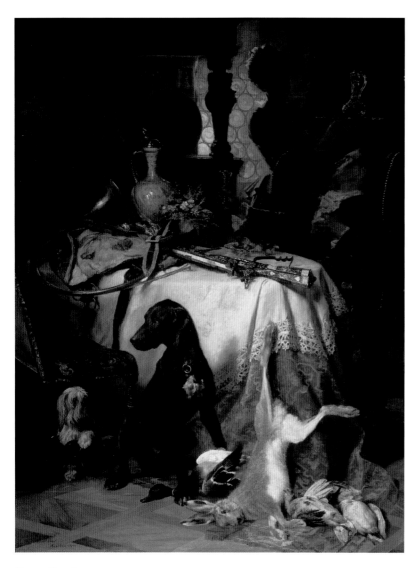

Fig. 2.14 (Cat. 46)
(See also fig. 4.6, p. 128)
David Neal
After the Hunt, 1870
Oil on canvas, 62⁵⁄₁₆ × 46¾ inches
Los Angeles County Museum of
Art, Los Angeles, California. Gift
of Mr. and Mrs. Will Richeson, Jr.,
M.72.103.1

juxtaposed with the animals they killed, the tools and spoils of a virile provider.

Pope's *The Wild Swan*, 1900 (fig. 2.15 [cat. 54]), presented audiences with images of death front and center. In this painting Pope suspended his swan in front of an ambiguous paneled wall; he intended the stark contrast between the bird's pristine white plumage and the dark green backdrop to focus the eye on the bird's lifeless body as it is being contorted by gravity. The artist referred to his illusionistic portrayal of the dead swan as an example of his "characteristic" paintings, so called because of their exacting attention to the anatomical detail characteristic to a specific animal.[25] An avid hunter and fisherman, Pope acquired his knowledge of wildlife anatomy from his experience in the field, as a writer for the *Boston Globe* describes: "Primarily [Pope] is a sportsman, although at heart he is a naturalist, as well as a painter. He likes to paint the things he loves and the things with which he is most familiar. So did Audubon in his day."[26]

Although adult swans were not hunted for sustenance on a large scale, the bird species found in other trophy paintings reflected turn-of-the-century America's insatiable appetite for wildfowl. Italian American painter Luigi Lucioni stocked his 1940 painting *Fowl and Glass of Red Wine* (fig. 2.16 [cat. 36]) with a full menu of game bird species commonly found in mid-twentieth-century American diets, including Canada goose, mallard ducks, pheasants, and quail. Shorebirds, like those featured in Richard La Barre Goodwin's *Two Snipes*, painted between 1880 and 1902 (fig. 2.17 [cat. 24]), were once a popular source of protein for nineteenth- and early twentieth-century diners, but were conspicuously left out of Lucioni's composition. By the time Lucioni painted *Fowl and Glass of Red Wine*, hunting shorebirds had been outlawed. Commercial gunners who supplied game birds to restaurants and butchers in burgeoning urban markets had hunted many species to the brink of extinction. The massive slaughter of shorebirds inspired the U.S. federal government to enact groundbreaking legislation in the Migratory Bird Act of 1918, which protected the most vulnerable species from complete annihilation.

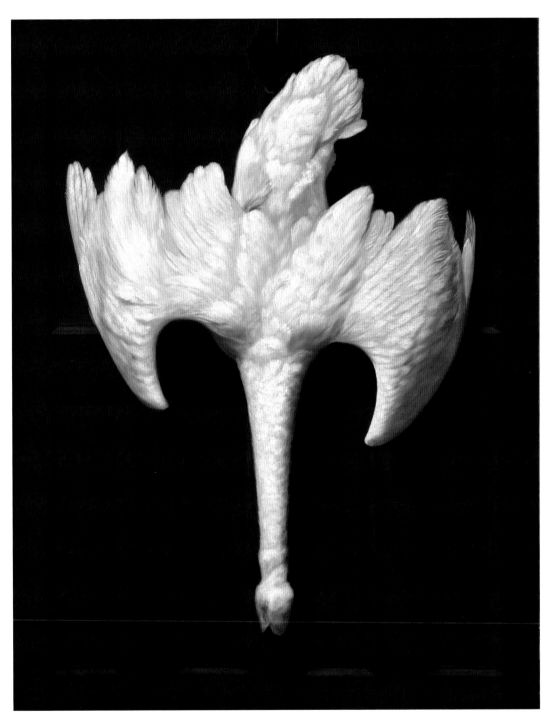

Fig. 2.15 (Cat. 54)
Alexander Pope
The Wild Swan, 1900
Oil on canvas, 57 × 44½ inches
Fine Arts Museums of San
Francisco, San Francisco,
California. Museum purchase,
gifts from members of the Boards
of Trustees, the M. H. de Young
Museum Society, the Patrons
of Art and Music, Friends of the
Museums, and by exchange,
Sir Joseph Duveen, 72.28

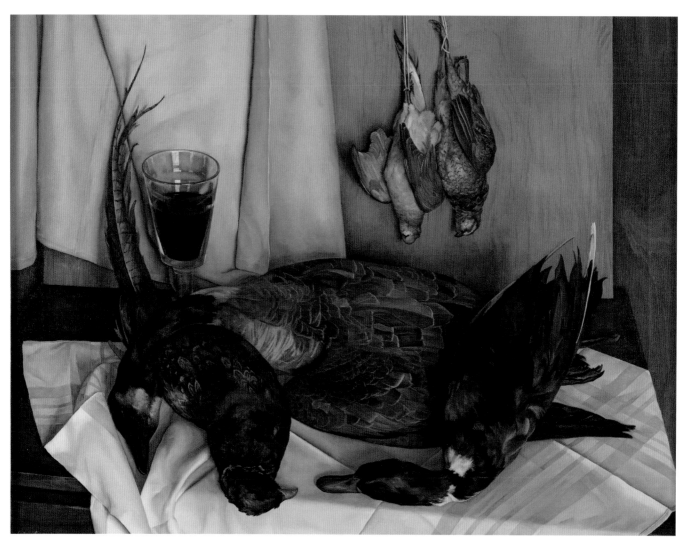

Fig. 2.16 (Cat. 36)
Luigi Lucioni
Fowl and Glass of Red Wine, 1940
Oil on canvas, 23 × 30 inches
Collection of Shelburne Museum,
Shelburne, Vermont. Bequest of
Electra Havemeyer Webb, 1961-1.35

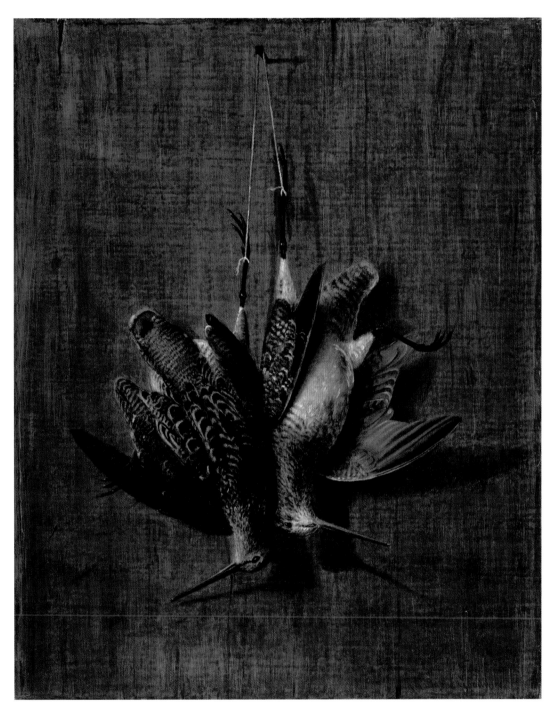

Fig. 2.17 (Cat. 24)
Richard La Barre Goodwin
Two Snipes, between 1880
and 1902
Oil on canvas, 20⅛ × 17⅛ inches
Terra Foundation for American Art,
Chicago, Illinois. Gift of Mr. and
Mrs. John Estabrook, C1982.2

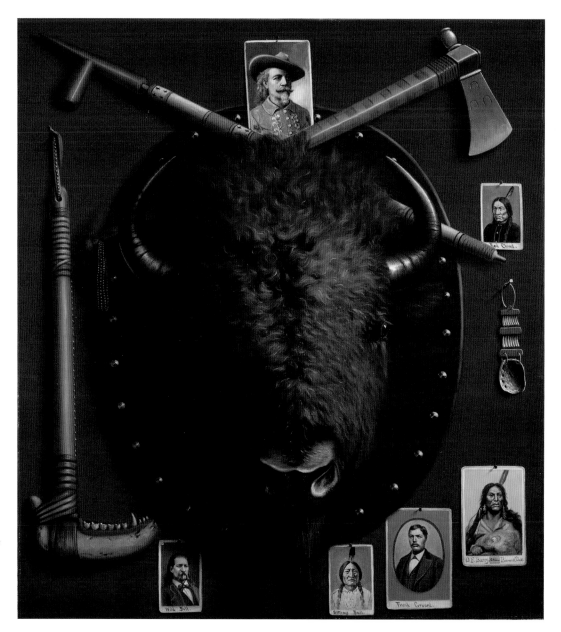

Fig. 2.18 (Cat. 19)
Astley D. M. Cooper
The Buffalo Head, Relics of the
Past, before 1910
Oil on canvas, 40 × 36 inches
Buffalo Bill Center of the West,
Cody, Wyoming. Bequest in
memory of the Houx and Newell
families, 4.64

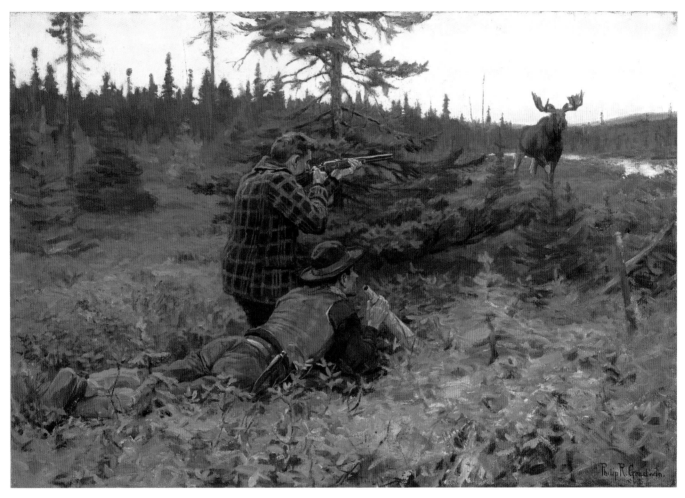

Fig. 2.19 (Cat. 25)
Philip R. Goodwin
*The Northwood King—Calling
the Moose*, n.d.
Oil on canvas, 25 × 36 inches
Foxley Collection

Once owned by William F. "Buffalo Bill" Cody, Astley D. M. Cooper's trompe l'oeil painting *The Buffalo Head, Relics of the Past* (fig. 2.18 [cat. 19]), before 1910 from around 1890, pays tribute to America's Old West, which was passing into legend at the time the picture was made. Similar to Alexander Pope's *Trophies of the Hunt*, Cooper's assemblage of artifacts is carefully arranged and depicted in hyperrealistic detail. Unlike Pope's work, Cooper's painting was intended to be more than an amusing optical illusion; it was designed to pay homage to a bygone era in American history, when vast herds of buffalo roamed the plains, homesteaders and American Indians battled, and larger-than-life characters like Buffalo Bill made names for themselves through daring exploits. Infused with nostalgia, the painting includes a large stuffed buffalo head mounted in the center of the composition, surrounded by Indian weaponry, ceremonial artifacts, and souvenir cabinet cards of legendary western celebrities, including Cody himself at the top. Cody must have looked fondly on those old reminders of the days when he had killed 4,280 head of buffalo, earning him his nickname and fame.

A PARTING SHOT

At any point in American history, hunting—whether for sustenance, commerce, or sport—has involved a high level of risk for both hunter and prey alike. Dangers abound when human interests intersect with animal instinct, as in Philip R. Goodwin's *The Northwood King—Calling the Moose* (fig. 2.19 [cat. 25]).

Nineteenth-century paintings of hunters in peril continue to provoke and thrill audiences much as they did when first unveiled. Encoded with new notions of masculinity, these paintings trace nineteenth-century America's changing attitudes toward the activity of hunting from lower-class means of survival to a sporting culture that appealed to middle- and upper-class men against the backdrop of modernity.

NOTES

1. See Jackson Lears, *Rebirth of a Nation: The Making of Modern America, 1877–1920* (New York: Harper Perennial, 2009).
2. Carol Clark, *Charles Deas and 1840s America* (Norman: University of Oklahoma Press, 2009), 35–38.
3. F. Turner Reuter, Jr., *Animal and Sporting Artists in America* (Middleburg, Va.: National Sporting Library, 2008), 696.
4. William K. Verner, ed., *Adventures in the Wilderness*, by William H. H. Murray (Syracuse, N.Y.: Adirondack Museum and Syracuse University Press, 1989), 11.
5. Daniel Justin Herman, "From Farmers to Hunters: Cultural Evolution in the Nineteenth-Century United States," in *A Cultural History of Animals in the Age of Empire*, ed. Kathleen Kete (New York: Berg, 2007), 5:47–72.
6. Ibid., 58.
7. Patricia Junker, ed., *Winslow Homer: Artist and Angler* (New York: Thames and Hudson, 2003), 96.
8. Alfred Trumble, "Notes for the New Year," *Collector*, January 1, 1892, 71.
9. "Minor Exhibitions," *Art Amateur*, January 1893, 45.
10. Homer's response to critic Thomas B. Clarke is quoted in Lloyd Goodrich, *Record of Works by Winslow Homer*, vol. 5, ed. Abigail Booth Gerdts (New York: Goodrich-Homer Art Education Project, 2012), 132.
11. Ibid., 135.
12. Ibid.
13. David Tatham, *Winslow Homer in the Adirondacks* (Syracuse, N.Y.: Syracuse University Press, 1996), 116.
14. Ibid.
15. Glass has been a popular subject of several literary and scholarly publications in recent years, including Jon T. Coleman, *Here Lies Hugh Glass: A Mountain Man, a Bear, and the Rise of the American Nation* (New York: Hill and Wang, 2014); and Michael Punke, *The Revenant* (New York: Basic Books, 2003).

16. Coleman, *Here Lies Hugh Glass*, 1.

17. The controversy revolved around authorship of the painting. Some claimed that the painting was a joint effort between Tait and his fellow artist James M. Hart. Evidence proves that it was in fact the sole product of Tait's hand. For more information, see Warder H. Cadbury, *Arthur Fitzwilliam Tait: Artist in the Adirondacks* (Newark: University Delaware Press, 1986), 52–56.

18. Ibid., 57.

19. Dean Krakel, "Mr. Leigh and His Studio," *Montana: The Magazine of Western History*, Summer 1967, 40–59. Krakel references an interview Figgens gave to the *Rocky Mountain News* on April, 7, 1917.

20. Ibid., 45.

21. George Catlin, *The Last Rambles Amongst the Indians of the Rocky Mountains and the Andes* (London: Sampson Low, Son, and Marston, 1868), 1–45.

22. Ibid., 27, 28, 30.

23. Kenneth L. Ames, *Death in the Dining Room and Other Tales of Victorian Culture* (Philadelphia: Temple University Press, 1992), 71.

24. Michael Leja, *Looking Askance: Skepticism and American Art from Eakins to Duchamp* (Berkley: University of California Press, 2004), 130.

25. Howard J. Cave, "Alexander Pope, Painter of Animals," *Brush and Pencil* 8 (May 1901): 106.

26. "Alexander Pope's Realistic Paintings," *Boston Sunday Globe*, December 26, 1909, 30.

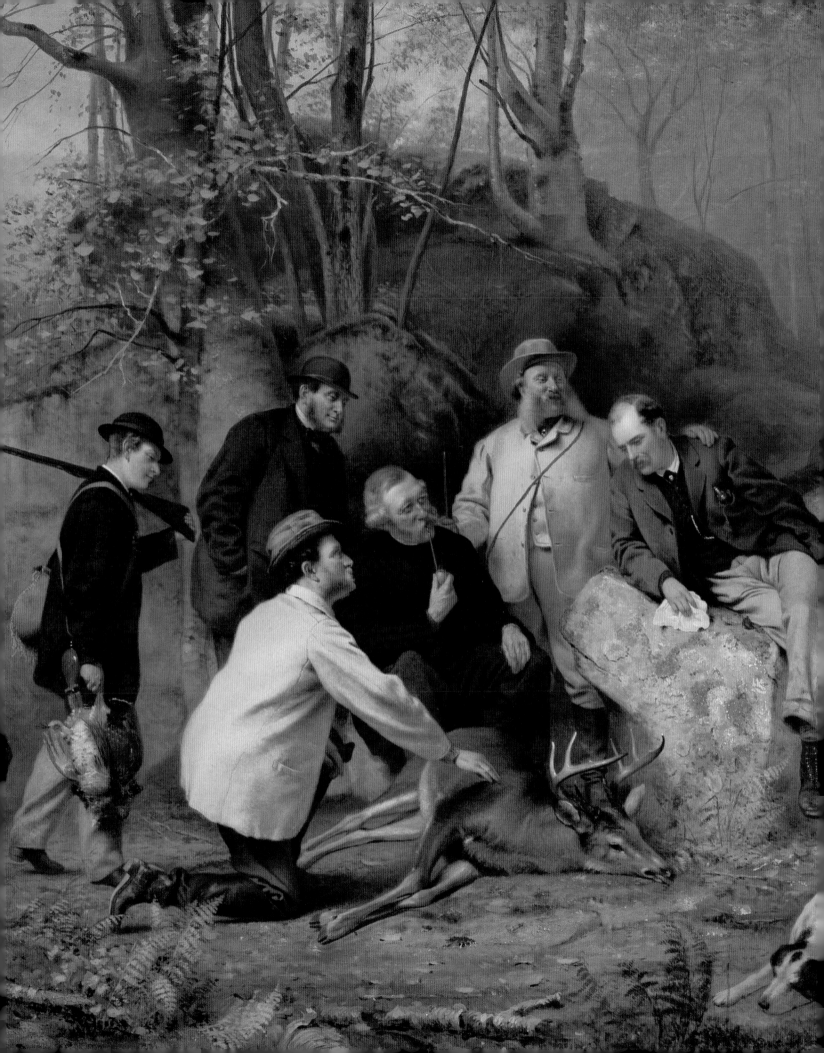

Community Renewed
SCENES OF HUNTERS AND ANGLERS IN AMERICAN ART

Shirley Reece-Hughes

During his two-year excursion through the United States, beginning in 1822, Englishman William Newnham Blane was stranded for three days at the White River in central Indiana because heavy ice blocked the ferry passage across the waterway. This short stay in his extensive journey enabled Blane to experience the rudiments of American hunting with frontier families in what he described as the "thinly settled countries":

> If a traveller [sic] be detained, or if he wish to stop a day or two to rest his horse, he can, if either a sportsman or a naturalist, find abundant amusement. Go to what house I might, the people were always ready to lend me a rifle, and were in general glad to accompany me when I went out hunting. Hence, in addition to the pleasure of the chase, I had, at the same time, an opportunity of becoming better acquainted with the manners of the Backwoodsmen.[1]

Although Blane distinguishes himself as a sportsman-naturalist, as opposed to the backwoodsmen he stayed with, his account reveals how hunting in early nineteenth-century America was a venture that fostered instant camaraderie even among acquaintances from different backgrounds. Blane probably learned to pursue game with his father as a means of sport in England, whereas the backwoodsmen acquired their experience for the purpose of sustenance in the American wilderness. Although they may have learned their skills for different ends, Blane and his settler-hosts forged a bond that suggests hunting's inherent ability to create a sense of community among its practitioners.

A similar theme of social bonding among strangers unfolds in one of the first treatises on fishing, *The Compleat Angler*, by seventeenth-century Englishman Sir Izaac Walton. The author provides a manual of instruction through the guise of a narrative between two characters, Piscator (a fisherman, and Walton's alter ego in the text) and Venator (a hunter). When

(facing)
Detail of fig. 3.14 (cat. 11), p. 101
John George Brown
Claiming the Shot: After the Hunt in the Adirondacks, 1865

these men meet on foot traveling on their way to Ware, in Hertfordshire, Venator is so moved by Piscator's eulogistic description of angling that he asks him to share his knowledge. Piscator's philosophical descriptions on the techniques needed to catch a variety of fish fills the pages of *The Compleat Angler*, making it a definitive user's guide. Yet Walton's tome is also a testimony to fishing as a vehicle for forming relationships in the natural environment.

As Blane and Walton revealed, hunting and fishing provided natural extensions for intimacy among pairs and circles of people. Still today, as Dennis Cutchins and Eric Eliason recently noted, the sports "play the important role for many of creating and maintaining familial bonds." Handed down as a skill from parent to child, generation after generation, these outdoor endeavors are steeped in ancestral associations, lending them sanctified meaning for some practitioners. Piscator (Walton) referenced the Old Testament to impart fishing's venerable family history to Venator: "Seth, one of the sons of Adam, taught it to his sons, and that by them it was derived to posterity."[2]

In America, angling prompted the establishment of the first known social club in 1732, the Schuylkill Fishing Company.[3] Organized for the purpose of exercise and fellowship, the group's membership has extended through generations of families. One of the company's original founders and financial supporters, William Warner (d. 1766), allowed the club to build its clubhouse, or castle, on his property in western Philadelphia, along the Schuylkill River—property he had inherited from his grandfather, who was one of the first colonists in the area. William's son, Isaac Warner (d. 1794), continued his father's legacy by becoming chief warden of the castle after the company was renamed the State in Schuylkill following the Revolution. A toast by a member at an 1824 club event—"Her sportive citizens, may be proud of her ancestry, and should prove themselves worthy descendants"— suggests the organization's objective to maintain a distinguished lineage, which it achieved—the State in Schuylkill still exists today.[4]

In the nineteenth century, hunting, too, became associated with family tradition, particularly by elite sportsmen who wanted to promote it as a respectable sport. It "was identified with something one's father had done, and one's grandfather before him, and one's forefathers before him," as Daniel J. Herman recently explained; it was considered a "sacred knowledge," and having this knowledge identified men as men and as Americans. In 1825, for instance, a commentator advised a younger generation that they must hunt "if they wish to emulate the bodily vigor, or fine manly character of their forefathers."[5]

By the 1840s, hunting was a catalyst for forming associations, such as the New York Sportsman's Club (est. 1844) and the Massachusetts Shooting Club (est. 1848), which were organized by elite sportsmen to create private fraternities, elevate hunting as a proper endeavor, and establish seasonal and game limits to control the animal population.[6] Hunting and fishing were promoted in journals like *American Turf Register and Sporting Magazine* (1829–1844), the *Cabinet of Natural History and American Rural Sports* (1830–1833), and *Spirit of the Times* (1831–1861) for their health benefits and ability to reconnect Americans to their rural identity. "Hunting is the soul of a country life: it gives health to the body, and content to the mind," noted one author in *American Turf Register and Sporting Magazine*. Fishing was also able to dispose "the soul to that quiet and serenity which gives him the fullest possession of himself and his enjoyments."[7] These journals also revealed an audience eager to read true and fictional accounts of exciting hunting and fishing excursions—tales that almost always involved courage, camaraderie, and social bonding in the wilderness.[8]

Aware of the growing interest in outdoor sports, artists used the adventurous pursuit of game or the fine art of angling as stories in works that bridged genre and landscape painting traditions. Most of the artists who addressed these subjects, such as Thomas Cole, William Sidney Mount, John George Brown, William Tylee Ranney, and Thomas Eakins, among others, were sportsmen themselves. Their paintings reflected their own outdoor experiences with family members or friends, and their works are often imbued with the theme of fellowship in the field. Though they primarily portrayed men, who largely defined the

culture of these sports, later in the century, artists such as John Singer Sargent and Julian Alden Weir depicted female anglers.

At the heart of many of these hunting and fishing pictures is the theme of kinship, betraying ideas about the desire for interpersonal relationships in communion with nature in the rapidly changing nation. These paintings grew in popularity at a time when maintaining the country's traditional notion of community became a concern among Americans as never before. In the first half of the nineteenth century, commentators expressed changes to American life—whether social, political, or economic—in terms of how these factors affected the community. In an 1828 article "Lecture on the Social System," for instance, the author stated that the welfare of the community rested on women maintaining their domestic responsibilities. When New York senator Silas Wright lost his campaign for reelection to the senate in 1846, a writer stated that it boded "no good, but much evil, to the community." Another midcentury author advocated that commerce increased the "mental vigor" of men, which "is so much gain to the community."[9]

The opinions expressed by these commentators reflected the fact that the colonial concept of community still lingered in their minds and in the minds of their readers. America was founded on the construct of small communities, where residents worked together for the social, educational, and religious welfare of their town, which consisted of one principal farm village surrounded by clusters of satellites.[10] These villages and neighborhoods were based on kinship systems that functioned through face-to-face relations. By 1820, westward expansion, urbanization, industrialization, and the dawn of a national political and economic system were altering the experiences of local life within villages and towns. Massachusetts historian Charles Francis Adams, Jr., for instance, noted how the enlarging economic and political structures affected local life in Quincy in palpable ways. Adams viewed the new quarry in the city, established in 1825, which prompted the construction of a railway to supply granite to Boston, as one of the greatest instigators of change in thought and modes of life. Change "was felt not only everywhere," remarked Adams, "but in all sorts of ways."[11]

With a desire to retain community integrity, nineteenth-century artists used the theme of hunting and fishing to visualize social networking in the natural world. Community is "marked by mutuality," notes cultural historian Thomas Bender, and can be a family, a neighborhood, or a group of friends. As such, community is better understood as an experience, rather than a place.[12] Hunting and fishing were outdoor rituals that could bond even strangers together, as many artists knew from their own experiences. Their paintings expressed the idea that hunters and anglers were bound together by their emotional ties and desire to relate to the land, rather than by self-interest. These hunting and fishing scenes met the needs of a populace concerned about the country's changing community structures and its shifting identity from an agrarian to an industrial nation. In 1844, Ralph Waldo Emerson advocated for any means that inspired Americans to relate to their land: "The habit of tiling it, mining it, or even hunting on it, generates a feeling of patriotism."[13]

More than any other nineteenth-century artist, Thomas Cole expressed his anxieties about modernization, particularly in relation to the wilderness surrounding his home in Catskill, New York.[14] Here, the artist witnessed a sequence of events similar to what Adams had observed in Quincy, where industry had sparked railroad building and expansion. The first tannery established in 1818 in the hills above Catskill, and the others that followed, was the primary reason for the building of the Canajoharie and Catskill Railroad in 1836, to transport the tannery's freight.[15] Cole recorded his vitriol toward the expanding railway because it meant the desecration of trees and groves that were his former sketching haunts. The artist, while understanding the need for technological progress, hated the greed embedded in society's new economic outlook. He wrote in his journal, "Society is uncongenial, it is material, unspiritual—among my acquaintances there are few very few whose minds assimilate to my own."[16] Yet, as much as he blamed citizens for destroying the varied splendors of their natural arcadia, Cole also acknowledged community as a needed component in valuing nature: "The community increasing in intelligence, will know

better how to appreciate the treasures of their own country."[17]

As an antidote to society's growing materialism, Cole treated the theme of pioneer settlers, whose abilities to live by means of farming, hunting, and fishing were in direct opposition to the citizenry's pursuit of money through industry. In *The Hunter's Return* (fig. 3.1 [cat. 18]), he portrayed the homecoming of a father to his pioneer homestead, where the settlers have successfully carved out a portion of this remote world for their rustic log cabin and blossoming farm of corn, cabbage, and pumpkins. This was the artist's first true genre scene focusing on the theme of family. Elwood C. Parry has suggested that the artist used himself and his own children as models for the settlers.[18] Whether it is the artist's immediate circle represented or not, the painting revels in the idea of a family surviving in the remote wilderness. To the artist and his audience, these settlers were bettering the community because they lived off the earth rather than stripping its natural resources to make a profit.

Since the era of Thomas Jefferson, America's farmers had come to be understood as virtuous and industrious citizens of nature. Backwoods hunters, on the other hand, had been considered more like savages than inhabitants of the land in the eighteenth century. This perception changed, notes Herman, in the early nineteenth century, when backwoods hunters became exemplars of virtue and nobility flushed out against the backdrop of modern urbanization and corruption. According to E. Anthony Rotundo, Daniel Boone and James Fenimore Cooper's fictional character Natty Bumppo embodied these noble backwoodsmen, whose bravery in the wild provided new physical ideals of manhood, since they relied on instinct more than reason. Backwoods huntsmen were also celebrated by commentators such as Episcopal minister Joseph Doddridge, for presenting the colonial and post-Revolutionary idea of placing the community above their own self-interest.[19]

The Hunter's Return intimates all these contemporary ideas. Cole's virtuous family not only lives in relation to the land but partners with a buckskin-clad figure who assists the father-huntsman in the picture. Cole knew that this figure, reminiscent of Boone, whose portrait the artist had painted in 1826 and whose autobiography was

first published in 1844, would resonate with his audience. The backwoodsman holds the pole with the white-hooved deer on it, indicating that he has assisted in the pair's successful hunt. Herman notes that an important custom among backwoodsmen was sharing their kill.[20] Providing sustenance, their hunt has been a joint effort on behalf of an intimate circle, and hunting will continue this communal system, since the young boy walking in front carries his father's rifle and bag over his shoulder. He symbolizes the passing down of a hunting tradition and the knowledge of how to stalk and kill game. These settlers are models for an ideal community— determined individualists whose perseverance and mutual support enabled them to survive happily, even in the roughs of the wild.

The theme of a huntsman-father returning to his family had broad appeal to a mid-nineteenth-century audience. Currier and Ives printmaker Frances (Fannie) Flora Bond Palmer used the subject for two different prints: *The Pioneer's Home on the Western Frontier*, 1867 (fig. 3.2), and *American Country Life: October Afternoon*, 1855 (fig. 3.3). The former seems almost a direct thematic transcription of Cole's painting, although with a different compositional arrangement and more idyllic touches. Palmer does not allude to the threat of encroaching civilization with tree stumps peppering the foreground as Cole did in *The Hunter's Return*. Instead, the scene is portrayed as a virtual paradise in the woods. A father and another man, both dressed in buckskin clothing, return from their hunt with plentiful game. The family warmly greets them from a trim log cabin, behind which a lofty haystack, a covered wagon, and a field of wheat are all neatly arranged. These elements and the print's warm coloring combine to indicate that these pioneers are proof of the blessings of western migration and Manifest Destiny.

Like Cole, Palmer was born and raised in England in a close-knit family, and after immigrating to America around 1844, she probably became aware of the country's interest in backwoodsmen. She completed *The Pioneer's Home on the Western Frontier* in 1867, more than twenty years after Cole's version of the theme, indicating the audience's nostalgia for the passing of the frontier following the

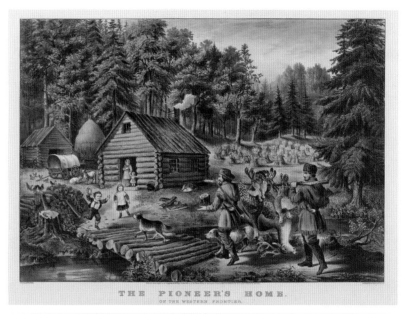

THE PIONEER'S HOME.
ON THE WESTERN FRONTIER.

AMERICAN COUNTRY LIFE.

(above)
Fig. 3.2
Frances Flora Bond Palmer
The Pioneer's Home. On the Western Frontier, 1867
Lithograph with applied watercolor, 18¾ × 26¾ inches
Published by Currier and Ives
Amon Carter Museum of American Art, Fort Worth, Texas, 1970.224

(below)
Fig. 3.3
Frances Flora Bond Palmer
American Country Life: October Afternoon, 1855
Toned lithograph with applied watercolor, 18¾ × 26¾ inches
Printed and published by Nathaniel Currier
Amon Carter Museum of American Art, Fort Worth, Texas, 1970.175

Civil War. As Currier and Ives scholar Bryan F. Le Beau notes, from 1850 to 1880, the printing firm created a series of frontier farming scenes to meet the demand for images espousing the country's belief that American farmers were the most dignified, ideal citizens, fulfilling democratic principles.[21]

Palmer's other print devoted to a hunter's return, *American Country Life: October Afternoon*, 1855, was part of a series based on the idea of the leisure class enjoying the pursuits of nature during the four seasons. As Le Beau notes, these prints celebrated the prosperity of those able to afford a second home and appealed to city dwellers nostalgic for their former country life.[22] In the print, two gentlemen sportsmen returning with rabbits and small game are greeted by a mother holding a small child, similar to the iconography of Cole's *The Hunter's Return*. Like the son in Cole's painting, the young boy has appropriated his huntsman-father's rifle and carries it on his shoulder, but in Palmer's version, the youth wears a paper hat with a feather to indicate that he will become a future soldier for the nation. For this family, hunting is a leisurely pursuit, an avocation that the artist knew well, since her husband, who probably posed for one or both

of the men in the picture, was a sportsman-hunter.[23] This idyllic image reified the idea that national progress was in full bloom—the woods are full of game, two men are conducting a trade in the background, a productive gristmill stands beyond them, and sailboats in the distance indicate increasing leisure time. Still, hunting is the act that bonds the families in Palmer's prints and in Cole's painting.

These images reflected the mid-nineteenth century belief that the integrity of family was central to American community life. According to sociologist Robert Nisbet, family is the "archetype, both historically and symbolically" for a community. In 1857, *Harper's Weekly* founder Fletcher Harper said that the journal prioritized family in discussions involving the interactions between the family, the church, and the state. "Only where the Family is sacred," noted the author, will there be "a high degree of civilization." Communities were understood as subsets of American civilization, whose success depended on "the differences in the action of the Family and the Church upon community," according to Harper.[24]

For families to be beneficial to the community, however, parents had to be adept at their

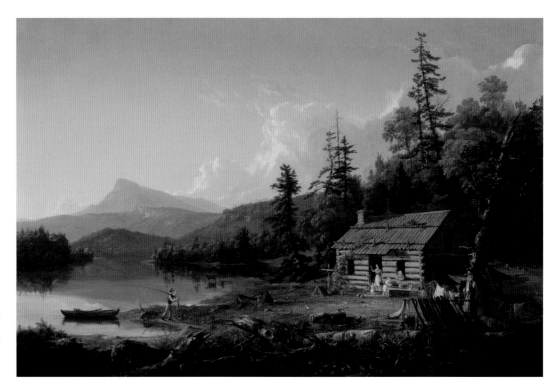

Fig. 3.4
Thomas Cole
Home in the Woods, 1847
Oil on canvas, 44⅜ × 66⅛ inches
Reynolda House Museum of
American Art, Affiliated with Wake
Forest University, Winston-Salem,
North Carolina. Gift of Barbara B.
Millhouse, 1978.2.2

responsibilities. The increasing number of parenting advisers and guides beginning in the early nineteenth century reflected the desire to bolster filial unity. In 1831, for instance, Heman Humphrey (1779–1861) devoted his sermon, "The Way to Bless and Save Our Country," to the theme of proper moral guidance for children, emphasizing that it was every parent's responsibility to "train up" their offspring to better the larger society.[25]

The interest in family unity at midcentury perhaps inspired Cole to readdress the theme of a father's homecoming, this time with a fisherman-father in *Home in the Woods* (fig. 3.4) Viewed as a complementary pair of paintings, this work and *The Hunter's Return* both have prominent mountainous backgrounds, a log cabin positioned on the right side of the canvas, tree stumps pervading the foreground, and a father waving a greeting as he returns home to mother and children. The most striking difference between the works is in the palettes. The verdant scenery and clear skies indicate springtime in *Home in the Woods*, whereas the ochre, green, and red foliage suggests autumn in *The Hunter's Return*. Some scholars interpret Cole's later work as a more civilized family than the one in *The Hunter's Return*, since the father is a fisherman rather than a hunter.[26] Ever since Walton's tome, fishing had been considered a more meditative and refined outdoor practice than hunting.

That fishing symbolized a more civilized community to a mid-nineteenth-century audience was evidenced by prints of industries, where the trope of men fishing alongside factories indicated that society had been relatively untouched by technology. As John F. Kasson noted, Americans were trying to reconcile their former yeoman identity with expanding industrial development. Town planners tried to address this problem by situating domestic manufacturing in the countryside under strict moral supervision.[27] A hand-colored lithograph of Davis and Furber Wool Machine Works, for instance, shows the factory as peacefully coexisting alongside the river in North Andover, Massachusetts (fig. 3.5). With the mill's complex in the center of the image, and a group of well-dressed gentlemen, one holding fishing rods over his shoulder, in the left foreground, the message of the print suggests that the wilderness

Fig. 3.5
Artist unknown
Wool Machine Works, Davis & Furber, North Andover, Mass: Near Lawrence, 1866
Hand-colored lithograph
Printed and published by J. H. Buford and Sons
American Textile History Museum, Lowell, Massachusetts

and society are virtually unscathed as men are still able to go angling in the river.

At midcentury, fishing provided a theme, as it did for Cole, for William Sidney Mount to explore the idea of interpersonal relationships in the midst of changes to community life. Mount had visited Cole in July 1843, hoping to glean some of the older artist's flair for capturing scenery.[28] Shortly thereafter, he turned to depicting different facets of the populace in pictures rife with political and societal commentary. Mount grew up in Setauket, New York, but settled in New York City during his adult years. There, the artist experienced the changes wrought by Andrew Jackson's political era, the growing number of manufacturing plants, and the rise of mercantilism and immigration. Mount was among those artists who questioned how these dramatic changes affected the character of American society.[29]

In his masterwork *Eel Spearing at Setauket*, 1845 (fig. 3.6 [cat. 44]), he transformed the art of catching eels into a dramatic outdoor exploit that paid homage to life in Suffolk County on Long Island. Commissioned by New York City attorney George Washington Strong, as a reminder of his childhood, the painting is a nostalgic nod to both the patron and the artist's upbringing in Setauket.

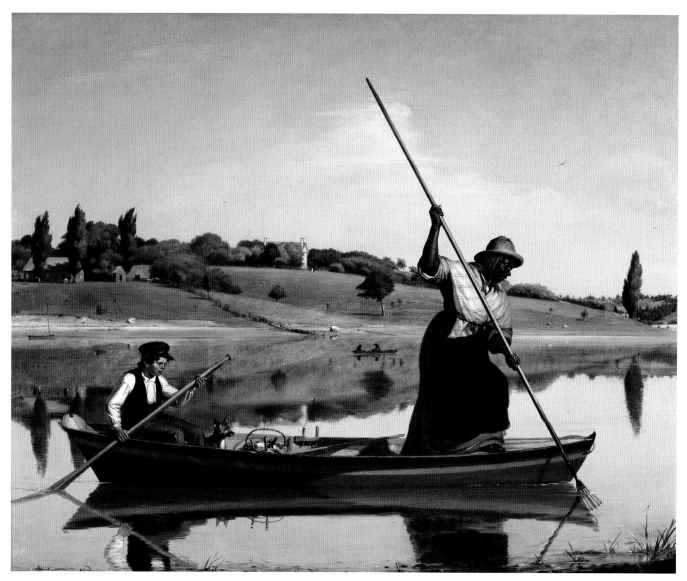

Fig. 3.6 (Cat. 44)
William Sidney Mount
Eel Spearing at Setauket, 1845
Oil on canvas, 28½ × 36 inches
Fenimore Art Museum,
Cooperstown, New York. Gift of
Stephen C. Clark, N0395.1955

Although the tenor of the hamlet remained relatively untouched by material progress until the 1870s, when railroad and shipbuilding expanded, New York City's burgeoning proletariat was affecting leisure time in the area by midcentury. Spending their summer Sundays and holidays on Long Island in affordable boarding houses and hotels, this vacationing populace was threatening to residents like Strong and his son, George Templeton Strong, who chronicled such social changes in his expansive forty-year diary. The influx of these masses, according to George Templeton Strong, prompted his friends to carry revolvers when they went out at night.[30]

Mount was surely a witness to Long Island's changing social dynamics, which perhaps inspired the solitude that pervades *Eel Spearing at Setauket*. As a reflection of an earlier, more tranquil era, the painting is also filled with the boyhood and manhood ideals from the artist's generation. As Rotundo describes, "usefulness" was the most prolific phrase found in relation to a man's responsibilities in the North from about the 1770s to the 1820s. In colonial America, men were supposed to sacrifice their self-will on behalf of their communities. By the nineteenth century, however, Rotundo notes the term "self-made" was predominantly used in relation to masculine identity.[31] The path to self-awareness and improvement started in childhood, when boys were expected to master skills through physical activities that in turn nurtured social abilities.[32]

Eel fishing was evidently a boyhood pursuit that fostered dexterity and sociability in Mount and his contemporaries. Thaddeus Norris, the "American Walton," recalled bobbing for them with friends: "Imagine three of four urchins, barefooted . . . and occasionally a cold, slimy Eel . . . gliding over their feet. . . . There was some screaming and laughing on such occasions."[33] Similarly, Walt Whitman fondly remembered venturing forth "with a chum or two, on those frozen fields with hand-sled, axe, and eel-spear, after messes of eels" in the Great South Bay of Long Island, not far from where Mount fished. As Whitman recalled, "The scenes, the ice, drawing the hand-sled, cutting holes, spearing the eels . . . were of course just such fun as is dearest to boyhood."[34]

Antebellum boys also formed their bodily expertise by learning from their fathers, whose roles had evolved from moral leaders and family educators in the eighteenth century to playmates and companions in the nineteenth century. Mothers were expected to be a family's moral guidepost, while fathers were expected to play with their offspring outdoors to cultivate emotional ties and replenish their spirits from the drudgery of their working lives.[35] The Currier and Ives hand-colored lithograph *Bass Fishing* (fig. 3.7) reflects the popularity of this nineteenth-century parenting notion. Here, a father is both a cohort and a mentor to his child. Through the act of angling, he not only enjoys recreation with his son, he teaches him the virtues of "patience and observation," qualities most often attributed to fishing.[36] Dressed in a middle-class coat and tie, he is the embodiment of success as both a working man and a father, since he has happily taught his son how to catch a bass.

Fig. 3.7
Artist unknown
Bass Fishing, undated
Hand-colored lithograph
Printed and published by
Currier and Ives
Michele and Donald D'Amour
Museum of Fine Arts, Springfield,
Massachusetts. Gift of Lenore B.
and Sidney A. Alpert, supplemented
with Museum Acquisition Funds,
2004.D03.697

Fig. 3.8
Artist unknown
*Eel Spearing on the
Mill Pond, Boston*, 1852
from *Gleason's Pictorial Drawing-
Room Companion*, January 24, 1852
Boston Athenæum, Boston,
Massachusetts

In *Eel Spearing at Setauket*, Mount, too, suggests he learned to act with fortitude and scrutiny from his guide through their shared experience in nature. To compose the painting, he used his boyhood memories of a family male servant: "An old Negro by the name of Hector gave me the first lesson in spearing flat-fish and eels."[37] As scholars have suggested, a heroic black male aiming a spear would have been too threatening for Mount's antebellum audience, so the artist transformed his teacher into an African American woman in the painting, suggesting positive relations between blacks and whites before the Civil War.[38] The woman is reportedly Rachel Holland Hart, who was a slave for his patron's family. To reference the Strongs, the artist included their manor in the background, the white house with two chimneys.[39]

Given that Mount's father passed away when he was only seven years old, Hector may have assumed the role of a mentor for the boy, at least to teach dexterities outdoors. His tutelage left an indelible impression on the artist. Mount was able to transcribe in detail an outing with his guide in a letter to his friend Charles H. Lanman, who had asked Mount to share his fishing knowledge for a book he was writing on the topic in 1847. The artist even recalled Hector's dialogue: "'Steady there at the stern,' said Hector, as he stood on the bow (with his spear held ready) . . . while I would watch his motions, and move the boat according to the direction of his spear. . . . 'Look out for the eyes,' observes Hector. . . . He kept hauling in the flat-fish, and eels, right and left, with his quick and unnerving

hand."[40] Mount brings these memories to life in the painting through the placement, actions, and positioning of the figures, as well as their concentrated facial expressions. His meticulous detail in depicting the figures and their clothing gives them a crispness and clarity against the reflective water and still sky.

Mount crreated an image of spearfishing that he thought would appeal to his audience. "Paint scenes that come home to everybody," the artist noted in his diary in 1846.[41] Eel catchers at the Mill Pond in Boston (fig. 3.8) were "a sight worth a long walk to see," remarked an author in *Gleason's Pictorial Drawing-Room Companion*.[42] Here, the engraving accompanying the author's passage captured a scene of Massachusetts eel fishermen and their respective onlookers in the foreground of the picture, with ice skaters at play on the left, and a chugging locomotive in the background. The train, as an emblem of the progress of civilization, is contrasted with the historical art of catching eels, which dates back to Aristotle's Greece. Even though the railroad is the symbol of modernity, the eel catchers are the novelty worth watching.

As commercial fishing diminished the eel population, there were fewer opportunities for eel spearing, as Mount had captured it on canvas. In 1845, George H. Palmer published a report, *The Exhaustion of Food Fishes on the Seacoast of Massachusetts*, which addressed the proliferation of fishing companies' pounds, traps, and weirs, which had reduced the sea-life population for the everyday fisherman. Palmer complained that "the right to catch fish belongs to all the people alike," and that the nets and other "stationary apparatus" had captured at least five to six million fish in two seasons. [43] Although Palmer specifically addressed the Massachusetts coastline, his report echoed the effects of professional fishermen all along the East Coast, where weirs were entrapping countless numbers of eels. By the time Mount painted *Eel Spearing at Setauket*, he was memorializing one of his generation's favorite boyhood pastimes.

Artists, like Mount, who painted from their experiences seemed best suited to capturing dramatic outdoor moments in their paintings. Mount's

Fig. 3.9 (Cat. 55)
William Tylee Ranney
The Retrieve, 1850
Oil on canvas, 30⅛ × 40⅜ inches
National Gallery of Art,
Washington, D.C. Corcoran
Collection. Gift of William Wilson
Corcoran, 2014.79.29

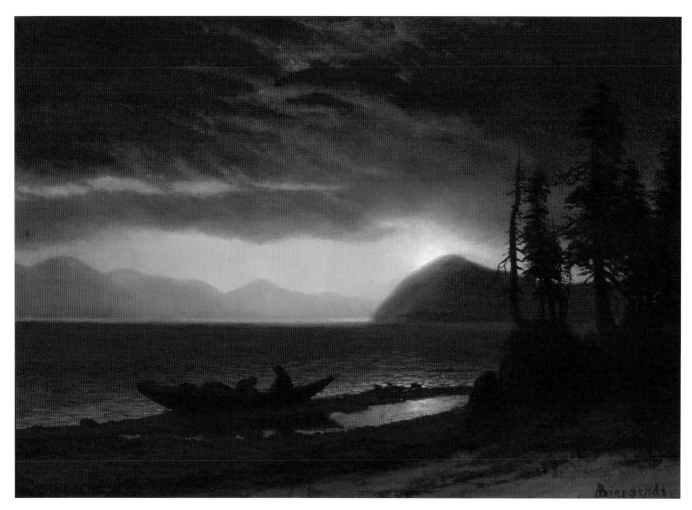

Fig. 3.10 (Cat. 6)
Albert Bierstadt
The Trappers, Lake Tahoe,
ca. 1890
Oil on canvas, 19½ × 27¾ inches
Joslyn Art Museum, Omaha,
Nebraska. Gift of Mrs. Harold
Gifford, 1961.430

friend William Tylee Ranney was one of the most avid huntsmen of his generation. His paintings encapsulate tense instances for hunters in the field, as well as endorse strict codes of sportsmanship.[44] He used his passion for duck hunting as a theme in *The Retrieve*, 1850 (fig. 3.9 [cat. 55]), to capture a defining moment for a springer spaniel when he is supposed to deliver a felled duck directly into his master's hand. Ranney undoubtedly used his own hunting experiences as a source for the picture, but guidance on training dogs was prolific in sporting literature of the period. "Almost every sort of dog may be taught to retrieve," noted one journalist, advising that after a dog has recovered a decoy or real game, "gently coax him to let you have it."[45] Ranney's hunter follows this direction, extending his hand to persuade the spaniel to hand over the game.

The theme of training a sporting dog in the field enabled Ranney to portray characteristics necessary for a gentleman hunter. "To break a dog properly," noted an author for the *Cabinet of Natural History and American Rural Sports*, "it is necessary to possess skill, patience, and perseverance; and without these two latter qualities, it will be useless for any one to undertake."[46] Ranney's hunter exemplifies this resilience and embodies the overall attributes that defined a "true sportsman."[47] This phrase was popularized in journals like the *Spirit of the Times*, whose publisher, John Richards, and editor, William T. Porter, were close friends with Ranney. A "true sportsman" was a virtuous hunter and fisherman who has "taken great pains to have legal protection afforded to the fish and game during the breeding season," and "is particularly careful about his gun and rod." Yet those who kill "game out of season" are essentially committing acts of "high treason."[48]

Ranney's contemporaries viewed pot hunters (who hunted to fill the pot) and trappers as those committing such acts of sedition. Terms like "murderous" and "villainous" were used by contributors to *Spirit of the Times* to describe those who hunted for sustenance or for sale and trade.[49] The elite sportsmen who authored such texts wanted to control the game population for their own pursuits and encourage legislation for wildlife protection.

Artists such as Albert Bierstadt and William Merritt Chase depicted trappers and pot hunters as lone figures, suggesting their marginalized status in hunting society.

Bierstadt was a sportsman, and although a charter member of the Boone and Crockett Club, founded by Theodore Roosevelt, he was in reality not the big-game hunter members of the club were supposed to be.[50] Yet his familiarity with guides and backwoodsmen as he traveled westward was evident in his paintings. When he depicted trappers, he portrayed them in nighttime settings that seemed to underscore their subordinated standing in the world of upper-class sportsmen. *The Trappers, Lake Tahoe* (fig. 3.10 [cat. 6]) shows two figures on the edge of the lake, possibly about to venture into night hunting, a practice typically frowned on as an unsportsmanlike technique because it used fire to attract the birds that were killed. Yet this picturesque scene, with the warm glow of dusk, also romanticizes the idea of trappers, whose lifestyles were quickly fading away.

William Merritt Chase's pot hunter is an ambiguous figure, donning a traditional hunting jacket like Ranney's huntsman, but he has his back turned to the viewer. The artist has blurred the lines between backwoodsman and contemporary sportsman (fig. 3.11 [cat. 15]). In fact, if Chase had not titled the work *The Pot Hunter*, viewers would be unable to identify what type of rifle-wielding figure was featured in the painting. Depicting the environment of his beloved Shinnecock Hills, Chase was more concerned with capturing the beauty of the New York hamlet than suggesting a figure who threatens elite sportsmen, especially since little if any game is discernible in the scene.

Whereas Chase portrayed hunting as an isolating endeavor, Ranney expressed it as an act that forged fellowships and loyalty. He was among a fraternity of artists, like Arthur Fitzwilliam Tait, and writers, like Lanman, who were sport-hunters and fishermen. Richards, Porter, and Ranney were also members of the New York Cricket Club, located in West Hoboken, New Jersey, where Ranney also hunted and captured most of his scenes. Set in the Hackensack meadows near his home in West Hoboken, *The Retrieve* is a literal

Fig. 3.11 (Cat. 15)
William Merritt Chase
The Pot Hunter
(The Road through the Fields;
The Hunter), ca. 1894
Oil on canvas, 16¼ × 24⅛ inches
Parrish Art Museum, Water Mill,
New York. Purchase fund and gift
of Mr. Frank Sherer, 1974.5

Fig. 3.12 (Cat. 66)
Arthur Fitzwilliam Tait
Hard Hit, 1883
Oil on canvas, 20⅛ × 30⅛ inches
Collection of Mr. and Mrs. Joseph
Orgill III

and figural celebration of brotherhood. It depicts the place where Ranney enjoyed his fraternal associations, and the huntsman figure is reportedly the artist's younger brother, Richard Ranney.[51] The artist positions him, his guide, and dog in a tight triangular format that suggests their support for one another in the field. Demonstrating not only sportsmanlike behavior, which was code for other elite hunters, these men are dignified exemplars for the larger community. Richards and Porter believed that their dedication to describing appropriate etiquette for hunters and fishermen in *Spirit of the Times* could improve not only the lives of sportsmen, but society at large. In 1859, the journal touted, "No greater compliment could be paid the 'Spirit,' for the healthful influence it possesses in the community."[52]

Ranney stylistically and thematically composed *The Retrieve* with a broad audience in mind. The reception of the painting as a "truly . . . American picture," suggests the appeal of the artist's increasingly romantic style, in which his figures are illuminated against the foreboding gray sky with long dashes of pinks and blues along the horizon line.[53] But the painting was well received also because of

its subject matter, centering on a sporting dog's specialized skills. British painter Sir Edwin Landseer had created a market for paintings of highbred hunting dogs, as well as anthropomorphized and sentimentalized canines at midcentury. His paintings of spaniels, pointers, and retrievers were described as "especially attractive to the sporting world," and "very appropriate and pleasing subjects for engraving."[54]

Aware of Landseer's success, Ranney faithfully depicted a Welsh springer, known for its red and white coat and round hazel eyes, in *The Retrieve*. Because of this springer's obstinate nature, it is often more difficult to train than other retrievers and requires a calm, strong trainer to ensure its success. Ranney's hunter is thus the embodiment of a true sportsman, whose patient yet firm guidance with his canine companion is clearly portrayed in the painting. Dogs were often critical characters in Ranney's sporting scenes, but the artist was not known to paint portraits of the animals as did his friend and colleague Arthur Fitzwilliam Tait, who adeptly captured sporting dogs in the field in works like *Hard Hit* (fig. 3.12 [cat. 66]), 1883. Tait focused on a highbred pointer demonstrating his tracking abilities with a wounded grouse, who, though hard hit, is scurrying for cover. Were it not for the keen dog, the bird might have eluded the hunters.

As Tait knew, the specific skills and pedigree of sporting dogs were fascinating not only to hunters, but to a wider public in general. Trials for hunting breeds had become a popular form of spectator sport by the 1870s. In 1878, *Harper's Weekly* described a series of field trials for pointers, flushers, and retrievers near Westport Lake, Minnesota (fig. 3.13), where competitors from more than fifteen states had gathered. Artist-illustrator W. A. Rogers documented the events in his drawings, with the center scene featuring a pointer who has spotted game, indicated by the judge raising the flag for the spectators gathered in the background. "The crowd was supposed to keep about seventy-five yards in the rear," noted Rogers, "but such was the eager interest of the spectators to witness the exciting sport that it was difficult to restrain their ardor."[55]

Whether dog trials, horse racing, baseball, or shooting matches, spectator sports were increasing

Fig. 3.13
W. A. Rogers
Field Trial of Dogs Near Westport Lake, Minnesota
from *Harper's Weekly*, October 5, 1878
Amon Carter Museum of American Art
Research Library, Fort Worth, Texas

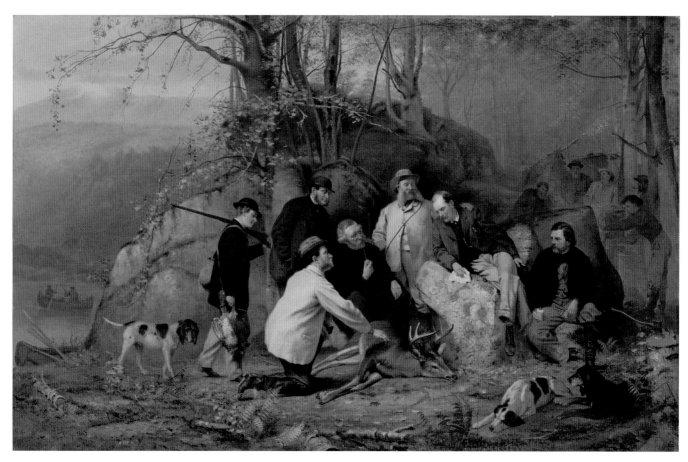

Fig. 3.14 (Cat. 11)
John George Brown
Claiming the Shot: After the Hunt in the Adirondacks, 1865
Oil on canvas, 32 × 50 inches
Detroit Institute of Arts, Detroit, Michigan. Founders Society purchase, R. H. Tannahill Foundation Fund, 73.226

Fig. 3.15 (Cat. 10)
John George Brown
Portrait of William Brand, 1864
Oil on canvas, 16 × 12 inches
Judith and James Pizzagalli
Collection

in numbers and linking diverse communities together, given the advances in transportation. Steamboats, in the 1830s, provided the first means of joining equestrian enthusiasts from different parts of the South. By 1853, railroad transportation and telegraphy's ability to disseminate sporting news facilitated the intermingling of audiences for sports like baseball and rowing in the East.[56] Shooting matches, in particular, were some of the most popular spectator sports and linked audiences from different states. As early as 1794, notes Jennie Holliman, such matches provided social interaction among folks from neighboring towns. A pigeon-shooting match between Pennsylvania and South Carolina sportsmen in 1852, for instance, drew "a vast concourse of spectators" from the respective states.[57]

Understanding Americans' newfound enjoyment of competitive sports, and the acclaim that anointed an expert marksman, John George Brown depicted his patron William Brand as the centerpiece in a subtle rivalry among hunters in *Claiming the Shot: After the Hunt in the Adirondacks*, 1865 (fig. 3.14 [cat. 11]). Although best known for the genre scenes of children he produced beginning in the 1860s, Brown had completed his most complex group portrait to date, *Curling—A Scottish Game, at Central Park*, 1862 (Museum of Fine Arts, Houston), commissioned by Robert Gordon, a few years before he painted *Claiming the Shot*. Brown probably met Brand, one of the founders of the St. Andrew's Curling Club, while working on the painting of the players on ice.

Brand was known as an exceptional shot, and the painting addresses the theme of hunters debating who provided the fatal blast to a lifeless buck. Brown placed his patron, the heavy, bewhiskered gentleman in the beige suit, in the middle of the picture. The artist had completed a study of Brand (fig. 3.15 [cat. 10]) in the same position, dress, and composed demeanor as in *Claiming the Shot*. Reportedly an affable fellow beloved by both friends and acquaintances, Brand is depicted as the mediator of the group, with one hand holding a rifle and the other on the shoulder of the hunter likely responsible for killing the deer.[58] Brown suggestively links all the figures in the scene through a left to right motion. A dog and young hunter's assistant (who is perhaps one of Brand's two sons) enter on the left of the composition, as the postures, gestures, and expressions of the men in the foreground form an arc that culminates at the top in the figure of Brand and then tapers downward to the man holding the flask. Their compositional placement, as opposed to the guides, who appear faded out in the right side of the backdrop, reflects a social hierarchy of hunters.

Brown may have borrowed the painting's class structure ideology and compositional strategies from Louis Maurer's print for Currier and Ives, *Camping Out: "Some of the Right Sort,"* 1856 (fig. 3.16). Maurer was a frequent visitor to Tait's residence at New York's Tenth Street Studio Building, where Brown had moved in the summer of 1860.[59] Whether or not Brown knew Maurer, he may have seen *Camping Out*, since it was a popular print created ten years before his painting.

Brown used Maurer's devices of arranging the sportsmen in a triangular arc in the foreground

Fig. 3.16
Louis Maurer
Camping Out: "Some of the Right Sort," 1856
Toned lithograph with applied watercolor
Printed and published by Nathaniel Currier
Amon Carter Museum of American Art, Fort Worth, Texas, 1970.209

with a fallen buck, a hunter and dog entering the scene from one side and guides in the background looking at the gentleman hunters. Maurer was a noted marksman and perhaps hunted with Tait in the Adirondacks, the setting for this print. The subtitle, *"Some of the Right Sort,"* suggests Maurer's status as a sportsman, and that he wanted to maintain that culture. The main protagonists in this image are portrayed as good for hunting, while the figure at the left breaking a stick with his knee and dressed like a backwoodsman is not.

Although Brown depicted this elite group of huntsmen as their own intimate society, they are represented as men able to negotiate and work through their differences. Since Brown painted the scene at the close of the Civil War, he was perhaps suggesting the need for the solidarity of community, albeit among a certain class of men. They are shown in strong relief against a backdrop of boulders and trees losing their leaves. The delicacy of Brown's autumnal foliage owes a debt to Worthington Whittredge, who, like Brown, occupied a space in New York's Tenth Street Studio building.[60]

As a second-generation Hudson River school painter, Whittredge was known for his pure landscapes focusing on the sublimity of nature. When he incorporated hunters and fishermen, they were generally diminutive in relation to their landscape settings, evident in the frontiersmen he depicted as hunters in his works beginning in the 1840s. He was particularly adept at capturing dense groves where sunlight filters through the leaves. Sport fishermen begin to appear in these thicketed scenes in the 1870s, as in *Trout Stream* (fig. 3.17 [cat. 71]), in which two men are barely discernible through the tangled web of lush vegetation and golden light. A cast of sun illuminates the angler closest to the stream with his line in the water, while his companion behind him becomes lost in the earthen palette of the woods. These fishermen seem to be urbanites out for a much needed respite from the city. As scholar Anthony F. Janson suggests, this work and others from the 1870s represented a distinct shift in the artist's outlook. Rather than a worshiper of nature, Whittredge now perceived the woods as an urban man, viewing it as an outlet and escape from civilization.[61]

Whittredge's newfound desire to retreat from urban life reflected the dramatic changes occurring in American cities in the 1870s. This was a pivotal decade in the transformations of community life, as towns became absorbed into nearby metropolises. According to Bender, the former ways of local life "were being eroded by new attitudes toward centralized authority and by innovations in transportation, communications, and organizational structure." By 1870, farmers, too, were for the first time adapting their production for the larger marketplace.[62] Nineteenth-century historian Brooks Adams observed that from 1789 to 1860, the country moved "toward a triumph of the central power." All these centralizing forces, notes Bender, altered the nature of social relationships that had once been bounded by ideas and customs relevant to a community locale.[63]

When Thomas Eakins returned to Philadelphia in 1870, after four years of travel and study in Europe, he found his hometown increasingly depersonalized because of its dramatic population and industrial growth. Street railways lined nearly every major road in heavily populated areas, intermingling urban citizens as never before.[64] As an escape from this consolidated city, Eakins produced a series of genre scenes depicting sculling, yachting, and hunting between 1871 and 1874. Within these pictures, the artist created isolated communities or social contexts for intimate relationships that seemed no longer possible within Philadelphia proper. These works appeared to derive from or allude to memories and experiences with his father, Benjamin Eakins, who had been central to his son's intellectual and emotional growth. As a boy sailing in his father's boat, notes Lloyd Goodrich, the artist grew to feel at home on the Schuylkill and Delaware Rivers, which were often the settings for his genre scenes.[65]

Of all the sports he depicted, hunting revealed Eakins's most cherished experiences with his father. He captured a particularly telling moment with him in *The Artist and His Father Hunting Reed-Birds on the Cohansey Marshes*, ca. 1874 (fig. 3.18 [cat. 22]), showing his filial debt to his father's influence by inscribing "Benjamin Eakins's son painted this" (Benjamin Eakins filius pinxit) at the bottom of the

Fig. 3.17 (Cat. 71)
Worthington Whittredge
Trout Stream, ca. 1870s
Oil on canvas, 12 × 15 inches
David and Laura Grey Collection

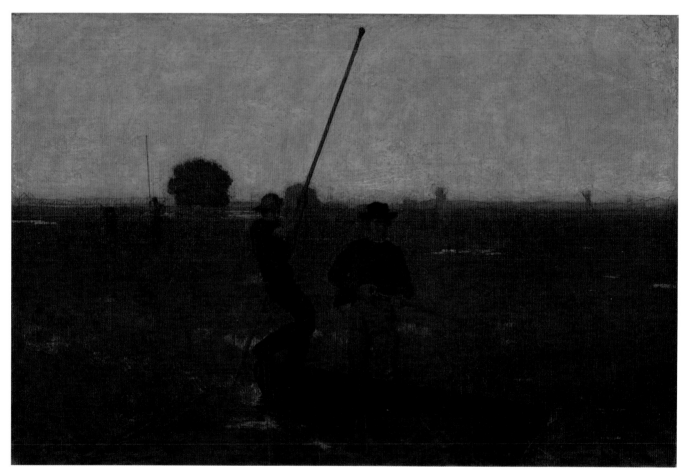

Fig. 3.18 (Cat. 22)
Thomas Eakins
The Artist and His Father
Hunting Reed-Birds on the
Cohansey Marshes, ca. 1874
Oil on canvas laid on composition
board, 17⅛ × 26½ inches
Virginia Museum of Fine Arts,
Richmond, Virginia. Paul Mellon
Collection, 85.638

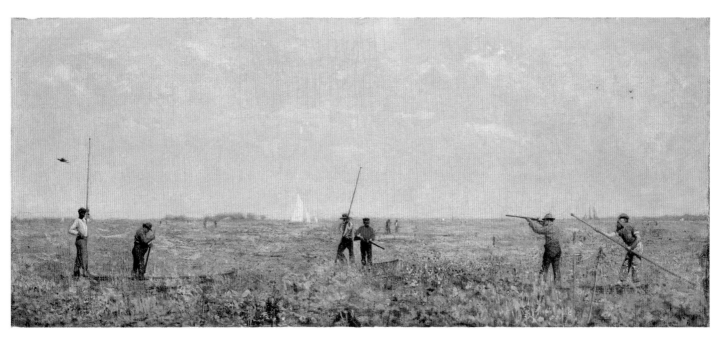

Fig. 3.19 (Cat. 21)
Thomas Eakins
Pushing for Rail, 1874
Oil on canvas, 30 × 30¹⁄₁₆ inches
Metropolitan Museum of Art, New
York, New York. Arthur Hoppock
Hearn Fund, 1916, 16.65

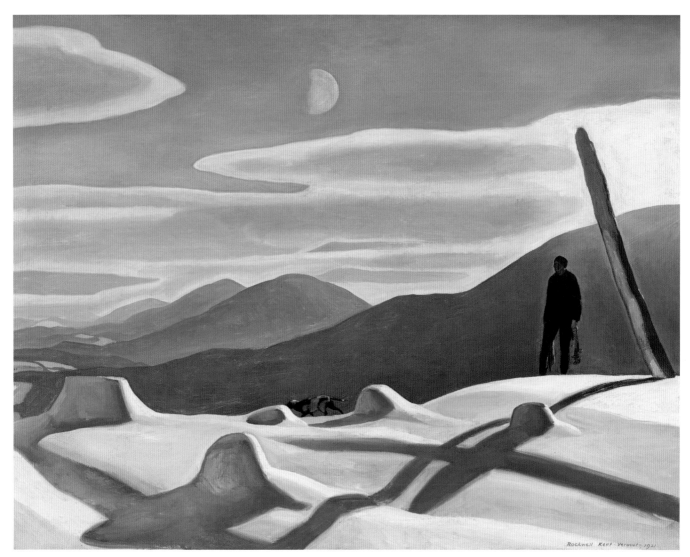

Fig. 3.20 (Cat. 34)
Rockwell Kent
The Trapper, 1921
Oil on canvas, 34⅛ × 44⅛ inches
Whitney Museum of American Art,
New York, New York. Purchase,
31.258

painting. The setting for this and another hunting scene, *Pushing for Rail*, 1874 (fig. 3.19 [cat. 21]), was in the wide marshes along the Delaware, close to Fairton, New Jersey, on the Cohansey River, where Benjamin Eakins owned a two-story boathouse with friends George Morris and William R. Hallowell.[66] In the painting of father and son, Eakins casts himself as pusher while his father scouts for plovers, or Virginia rails—small, henlike birds that nested in the reeds of the Cohansey and were easier to hear than see. "Much of the railer's success depends on the pusher," noted an author for *Harper's Weekly*.[67] As pusher, or guide, the artist is largely responsible for his father's ability to shoot the small prey. Eakins must not only steer the boat through the red-brown marshes to find the rail, he is responsible for spotting the birds, calling "Mark!" to let his father know when to fire, and then finding the fowl after it is shot. The artist's evocative mix of painterly qualities and compositional structure, especially in the placement of the figures and the angle of the pole that the pusher (Thomas Eakins) holds, draws attention to the two men and their relationship. The theme of mutuality pervades the scene as the golden glow of the atmosphere underscores the warmth of their father and son relationship.

Eakins expounded on the idea of hunters and guides operating together in *Pushing for Rail*. Three pairs of men fill the foreground, each one realistically captured for their physiognomy and dress. Unlike the gentleman sportsmen that Ranney and Brown portrayed at midcentury, Eakins's hunters and guides are casually dressed in brightly colored shirts, scarves, and pants that do not imply class distinctions. The artist was celebrating the notion of hunting as a sacrosanct and ancestral rite of passage for all American men, handed down from father to son and friend to friend. With its egalitarian spirit, the painting is intended as a work that could evoke American qualities. As Alan C. Braddock noted, when Eakins sent *Pushing for Rail* to the Paris Salon of 1875, it was entitled *A Hunt in the United States*, suggesting that hunting was one of the country's peculiar traits.[68] "A delightful hunt in my country," Eakins reportedly wrote about the painting to his former teacher Jean-Léon Gérôme,

adding, "I have chosen to show my old codgers in the season when the nights are fresh with autumn."[69]

As *Pushing for Rail* portrayed father and son, as well as close friends, who are evenly disseminated across the marshes, Eakins created an idyllic vision of a preindustrial community, where men function through face-to-face relations in connection with the land. By depicting the men in successive phases of the hunt, with one man loading his gun, another waiting for the boat to steady, and another taking aim, the artist suggested a successful network of progress and productivity, harkening back to the colonial idea of kinship networks. Their emotional and physical support for one another is unmistakable, and Eakins's work seemed to presage the belief in hunting as a common man's right—a philosophy that Theodore Roosevelt would promote at the turn of the twentieth century to invoke government support for the protection of wildlife.[70]

In 1887, when Roosevelt established the Boone and Crockett Club, he ideologically reclaimed hunting from its aristocratic associations and returned it to the common man, even though he and his cofounders represented the upper echelon of society. To him, the nation's first hunters were the generative force behind the supremacy of his race. He promoted hunting as a means of fulfilling his belief in the "strenuous life" that would reinvigorate the enervated leisure class.[71] By naming the club for his two most admired hero hunters, he advanced a philosophy of the sport as one that honored individualism and egalitarianism. Paintings of lone huntsmen set against sparse vistas, seen in works like William Merritt Chase's *The Pot Hunter* or Rockwell Kent's *The Trapper*, 1921 (fig. 3.20 [cat. 34]), seem inspired by Roosevelt's vision of hunting as an individualistic, democratic venture.

Among a generation influenced by the Rough Rider's philosophy, Kent was reportedly a proponent of "the strenuous life." According to fellow student Edward Hopper at Robert Henri's art school, the class divided into two camps, "The Simple Life Party," and "The Strenuous Life Party." Hopper said he aligned himself with the former group, while Kent and painter George Bellows belonged to the latter one.[72] Indeed, Kent became

an adventurous voyager who independently traveled to untrammeled locales, including Newfoundland, Alaska, Tierra del Fuego, and Greenland, in search of artistic inspiration.

The Trapper is a meditative reflection of Kent's experiences in Alaska from 1918 to 1919. There, the artist witnessed firsthand the imposing power of nature, which he believed was a manifestation of the divine. He captured the monumental forces of this natural world with a modernist sensibility, through simplified horizontal forms that evocatively suggest the features of an arctic landscape, dramatically enhanced by the white and cerulean palette and deep, shadowy forms. While this painting is appreciated for its transcendental poetic associations, *The Trapper* also suggests Kent's ode to ancestral frontiersmen like Boone and Crockett, who braved unchartered territory to build the nation. The hunter's canine companion, perhaps reminiscent of Buck, the main character of Jack London's novel *The Call of the Wild* (1903), underscores this theme of relying on primeval character for survival. In London's novel, Buck is stolen from his home in California and sold into service as a sled dog in Alaska, where he progressively reverts to primordial instincts and learned experience to subsist in the wild. Kent's generation was deeply influenced by *The Call of the Wild*, notes Rotundo, and its popularity reflected men's perceptions of themselves as brave animals whose primitive instincts should not be suppressed.[73]

Kent was not the only artist to portray the early twentieth-century ethos of physical and ideological manhood. Fishing scenes by those of his contemporaries, like N. C. Wyeth and Gifford Beal, also idealized the theme of rugged, solitary men harnessing nature. An ardent admirer of Kent's work, and perhaps inspired by *The Trapper*, the famed artist-illustrator Wyeth similarly cast a sole figure within a foreboding landscape in *Deep Cove Lobster Man*, ca. 1938 (fig. 3.21 [cat. 72]). The billowing sea of saturated blues with notes of beryl and the variegated, sepia-hued rocks represented the coast of Port Clyde, Maine, where the artist owned a summer home named Eight Bells, in honor of Winslow Homer's 1886 tour-de-force painting chronicling man's fraught relationship to the ocean (Addison Gallery of American Art). Wyeth's beloved area of the St. George peninsula provided a menacing backdrop against which he could dramatize the valor and industriousness of the lobsterman. This painting and others of Maine's fisherfolk were exhibited at the Macbeth Galleries in New York in 1939. Commenting on this group of works, Wyeth's son-in-law Peter Hurd alluded to the fact that fishing themes enabled the artist to enact a "revolt" against illustration and create a world "at once grave and lyric."[74]

Beal, too, conveyed the solemnity of extracting sustenance from the sea in *The Fisherman*, 1922 (fig. 3.22 [cat. 2]). Silhouetted against the coast of Rockport, Massachusetts, where the artist spent his summers, a fisherman tightly grasps his bending rod to counter the swelling forces of the ocean. Like the lobsterman in Wyeth's painting, Beal's figure is turned so that his facial features are concealed from the viewer. Both artists presented anonymous figures to suggest the self-effacing personalities of their subjects. Beal used loose impressionist brushstrokes of cool hues to capture the waves, and broader passages of neutral to dark colors to create the rocky coast and imposing fisherman; Wyeth created a more descriptive scene through a structured composition, with tight, linear forms and brushwork. Yet *Deep Cove Lobster Man* also represented Wyeth's increasing move toward abstraction. "Without for a moment ceasing to be representational," remarked Edward Alden Jewell, "this work fascinatingly departs from strict naturalism."[75]

That angling subjects were conducive to abstract interpretations is evidenced by Max Weber's cubist painting *The Fisherman*, 1919 (fig. 3.23 [cat. 69]). Born in Russia and arriving in the United States at the age of ten, Weber had a unique perspective as an artist-immigrant when selecting his themes. He traveled to Paris in 1905, where he assimilated the tenets of European modernist styles, and after returning to America, he translated distinctive native subjects, such as this fisherman, into cubist narratives. Fragmenting the figure and his surroundings into multifaceted gray and earthen-colored planes, Weber composed the fisherman casting his rod from a cacophony of

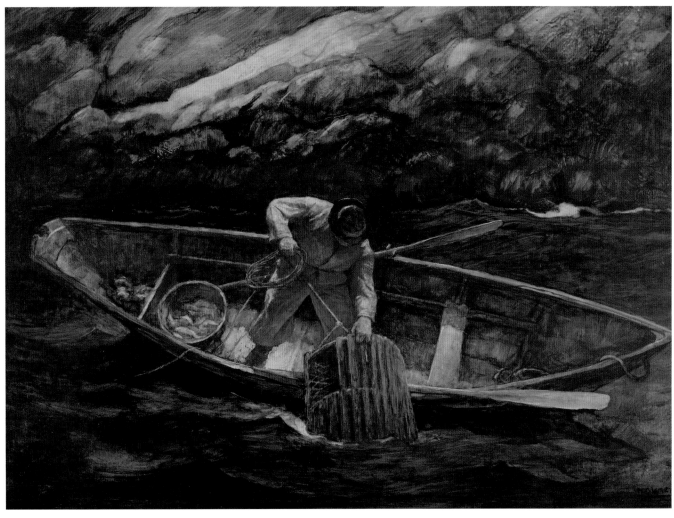

Fig. 3.21 (Cat. 72)
N. C. Wyeth
Deep Cove Lobster Man, ca. 1938
Oil on gessoed board
(Renaissance panel),
16¼ × 22¾ inches
Pennsylvania Academy of the Fine
Arts, Philadelphia, Pennsylvania.
Joseph E. Temple Fund, 1939.16

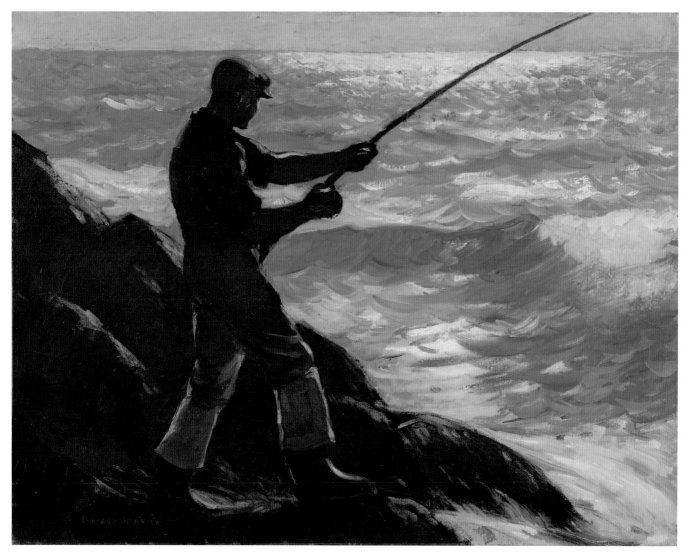

Fig. 3.22 (Cat. 2)
Gifford Reynolds Beal
The Fisherman, 1922
Oil on canvas, 37 × 46 inches
Brooklyn Museum, Brooklyn, New
York. Samuel E. Haslett Fund, 23.72

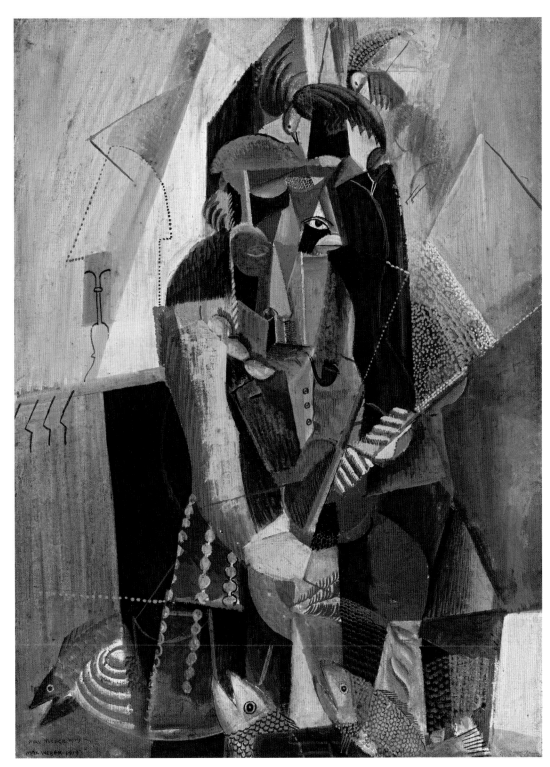

Fig. 3.23 (Cat. 69)
Max Weber
The Fisherman (Fisherman,
Fish and Sea Gulls), 1919
Gouache on canvas,
23⅛ × 17 inches
Private collection

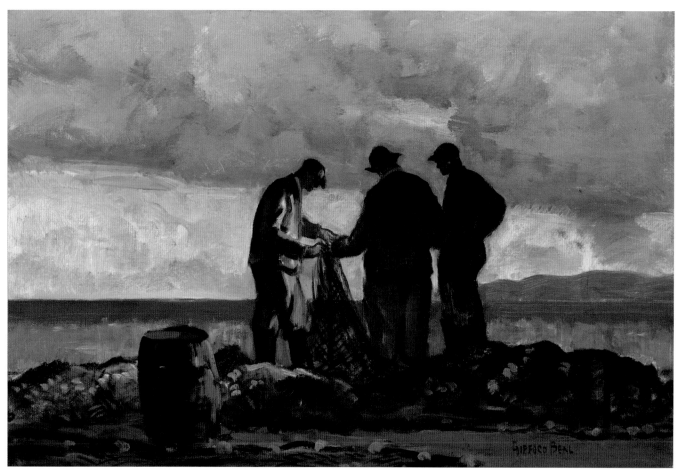

Fig. 3.24 (Cat. 3)
Gifford Reynolds Beal
Fishermen with Nets, 1920s
Oil on canvas, 20¼ × 30 inches
Joslyn Art Museum, Omaha,
Nebraska. Mr. and Mrs. Edwin S.
Miller Bequest Fund, 1951.660

moving forms, anchored in the center by a single eye and dangling pipe. The fish at the man's feet and the gulls surrounding his head suggest his location on a dock.

Although hunting and fishing excursions still provided opportunities for familial and social bonding, Beal, Wyeth, and Weber's paintings of solitary fishermen, and Kent's portrayal of the lone huntsman, reflected the emphasis on individualism in early twentieth-century societal thought. English novelist and historian Herbert George Wells, in his 1906 travel essay, "The Future of America: The Search for Realities," lamented the focus on self-interest he observed in American newspapers: "It is all individuality, all a matter of personal doings. Of what so and so said and how so and so felt. And all these individualities are unfused."[76] Wells disparaged Americans for not working toward the collective well-being of their communities.

Eighteenth- and nineteenth-century models of workers, families, and townspeople being linked together within an intimate sphere of interaction and reinforcement was replaced by the cult of competitive desire for independent success. Paintings of individual huntsmen and fishermen echoed the primacy of individual achievement. Other outdoors scenes, however, particularly of commercial seamen, like Beal's *Fishermen with Nets* (fig. 3.24 [cat. 3]) and Wyeth's *Dark Harbor Fishermen*, 1943 (Portland Museum of Art, Maine), reflected the time-honored practices of remote seaside communities, where livelihoods depended on supportive networks.

With the labor and civil unrest, strikes, and radical activism of the progressive era, hunting and fishing provided outlets from the turbulence of city life and compensated for the diminishment of engaging interpersonal experiences in everyday community life. Upper- and middle-class white women left their domestic domains to establish clubs and organizations for social, health, and environmental reform. They also entered the woods as hunters, revealing their desire to enjoy the vigor of a sport previously considered off-limits.[77] As Andrea L. Smalley explains, sporting magazines advocated for women to engage in hunting in order to make the sport more respectable and thereby worthy of legislation to preserve lands and wildlife.

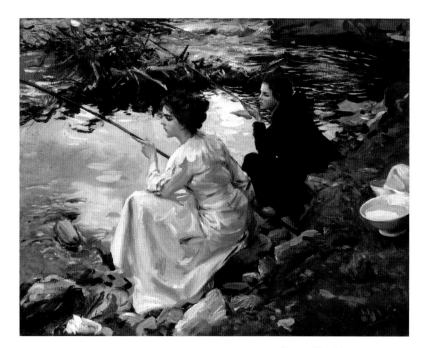

Fig. 3.25 (Cat. 61)
(See also fig. 4.22, p. 143)
John Singer Sargent
Two Girls Fishing, 1912
Oil on canvas, 22 × 28¼ inches
Cincinnati Art Museum, Cincinnati, Ohio. John J. Emery Fund, 1918.39

These periodicals also revealed that by the 1890s, as one author noted, "now it is no unusual thing to see a woman fishing a stream, following the dogs, or sailing a yacht."[78]

Paintings such as John Singer Sargent's *Two Girls Fishing*, 1912 (fig. 3.25 [cat. 61]), and Julian Alden Weir's *The Return of the Fishing Party*, 1906 (fig. 3.26 [cat. 70]) depicted women at ease in outdoor settings. These lush depictions of young ladies as anglers—Sargent's nieces and most likely some of Weir's daughters—perhaps reflected the intimate associations that women had with the sport of fishing. Historians Ronald J. Zboray and Mary Saracino Zboray have noted that since the mid-nineteenth century, fictional literature in New England had employed the theme of angling as a metaphor for empowering women to "hook and lure" a man. Rotundo, too, noted that men's letters and diaries from the nineteenth and early twentieth century figuratively expressed their anxieties about women as the "fisher and the bait, the trapper and the lure."[79]

A hand-colored print by Kellogg and Comstock from 1850 entitled *The Angler* (fig. 3.27]), with the subtitle *Fishing for a Prize Worth Having*, illustrates fishing as a courting ritual. A genteel young woman reads to her adoring suitor, who literally

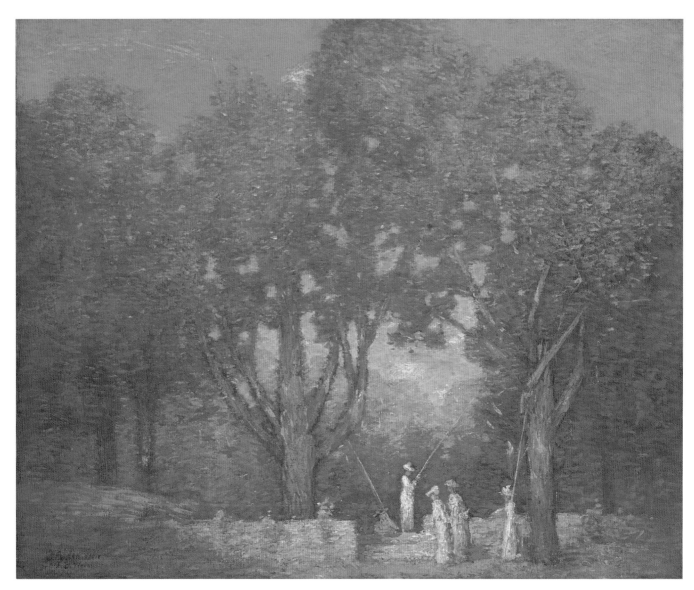

Fig. 3.26 (Cat. 70)
Julian Alden Weir
The Return of the Fishing Party,
1906
Oil on canvas, 22⅞ × 27¹⁵⁄₁₆ inches
High Museum of Art, Atlanta,
Georgia. Gift of Miss Mary E.
Haverty for the J. J. Haverty
Collection, 61.65

THE ANGLER.
Fishing for a prize worth having.

Fig. 3.27
Kellogg and Comstock
The Angler: Fishing for a Prize Worth Having, 1850
Hand-colored lithograph
Connecticut Historical Society,
Hartford, Connecticut, 1955.15.2

and figuratively waits for a bite on his line with a creel at his feet ready for his catch. Intended for a mass audience as a sentimental genre scene of Victorian social virtue, this print relayed angling as an intimate pastime. The Zborays' found that men and women of all classes sometimes centered their courtships and honeymoons on fishing excursions, and *The Angler* depicts such a romantic interlude.

From romantic to practical, by the twentieth century, the presence of female anglers submerged in a natural arcadia, as in Weir's *The Return of the Fishing Party*, visually embodied the written descriptions in sporting periodicals that hailed fishing, as well as hunting, as respectable feminine exercises. "The ideal sportswoman," according to a commentator for *Forest and Stream*, "is a refined, cultivated, womanly woman who pursues sports

for health and pleasure and rears her children to be manly men and refined women."[80] This change in gender roles and acceptance of women in the field parlayed into hunting and fishing as family-centered recreations.

With the rise of the impersonal modern city, Americans searched for community-like experiences beyond their urban circles. Artists of the nineteenth and early twentieth centuries visualized how hunting and fishing in the natural world created opportunities for cooperation, achievement, and social bonding—the dimensions of traditional community life. By using such outdoor sports as themes, these artists revealed the idea that rather than being defined by place, community was an experience of social engagement best practiced and renewed in the outdoors.

NOTES

1. William Newnham Blane, *An Excursion through the United States and Canada during the Years 1822–1823*, vol. 41 (Carlisle, Mass.: Applewood, 1824), 145.

2. Dennis Cutchins and Eric Eliason, ed., *Wild Games: Hunting and Fishing Traditions in North America* (Knoxville: University of Tennessee Press, 2009), xix; Izaac Walton and Charles Cotton, *The Compleat Angler: Or the Contemplative Man's Recreation* (New York: Modern Library, 2004), 25. Cotton's supplement on fly fishing was added during the printing of the fifth edition.

3. Jennie Holliman, *American Sports, 1785–1835* (Durham, N.C.: Seeman Press, 1931; repr., Mansfield Center, Conn.: Martino, 2003), 62. Citations refer to the Martino edition.

4. John W. Jordan, ed., *Colonial and Revolutionary Families of Pennsylvania* (New York: Lewis Historical, 1911), 245–46, http://archive.org/stream/colonialrevolutio1jord#page/244/mode/2up; Nineteenth-century Schuylkill member William Milnor (1769–1848) recorded this toast at an 1824 member's event. William Milnor, *An Authentic Historical Memoir of the Schuylkill Fishing Company of the State in Schuylkill* (Philadelphia: Judah Dobson, 1830), 98–99, available at https://archive.org/details/authentichistorioomiln.

5. Daniel Justin Herman, *Hunting and the American Imagination* (Washington, D.C.: Smithsonian Institution Press, 2001), 2; "The Baltimore Hunt: [From the Annals of Sporting] Pleasures and Advantages of Hunting," *American Farmer, Containing Original Essays and Selections on Rural Economy and Internal Improvements*, November 11, 1825, 271.

6. For a thorough examination of how hunting art revealed the issues critical to American conservation thought and agendas in the mid to late nineteenth century, see Doyle Leo Buhler, "Capturing the Game: The Artist-Sportsman and Early Animal Conservation in American Hunting Imagery, 1830s–1890s" (Ph.D. diss., University of Iowa, Iowa City, 2011), available at http://ir.uiowa.edu/cgi/viewcontent.cgi?article=4575&context=etd.

7. "Thoughts on Hunting," *American Turf Register and Sporting Magazine*, October 1834, 78; J. R. P., "Trout Fishing," *American Turf Register and Sporting Magazine*, May 1831, 451.

8. These adventure stories are ubiquitous in sporting journals. See for instance, John S. Sleeper, "Adventure in the Cumberland Mountains," *American Turf Register and Sporting Magazine*, July 1840, 349–52; Frank Forester, "A Week in the Woodlands; or Scenes on the Road, In the Field, and Round the Fire: Day the First," *American Turf Register and Sporting Magazine*, May/June 1839, 487–96.

9. "Original Communications: Lecture on the Social System," *Mechanics' Free Press*, May 31, 1828, 2; "New York Election," *Brooklyn Daily Eagle*, November 4, 1846, 2; Hunt, "Influence of Commerce," *Gleason's Pictorial Drawing Room—Companion*, October 1, 1853, 212.

10. Glen T. Trewartha, "Types of Rural Settlement in Colonial New England," *Geographical Review* 36, no. 4 (October 1946): 568.

11. Charles Francis Adams, Jr., *Three Episodes of Massachusetts History*, 2 vols. (Boston: Houghton Mifflin, 1892), 2:927–28, quoted in Thomas Bender, *Community and Social Change in America* (Baltimore, Md.: Johns Hopkins University Press, 1978), 87.

12. Bender, *Community and Social Change*, 6–7.

13. Ralph Waldo Emerson, "The Young American," *New York Tribune*, April 14, 1844, available at http://chroniclingamerica.loc.gov/lccn/sn83030213/1844-04-20/ed-1/seq-4.

14. His often quoted passage from "Essay on American Scenery," originally published in 1835, articulates his remorse about the defiling of the American wilderness: "I cannot but express my sorrow that the beauty of such landscapes are quickly passing away—the ravages of the axe are daily increasing"; Thomas Cole, "Essay on American Scenery," in *American Art, 1700–1960, Sources and Documents*, ed. John W. McCoubrey (Englewood Cliffs, N.J.: Prentice Hall, 1965), 109.

15. For a description of the burgeoning industries in Catskill, and the rise and fall of the Canajoharie and Catskill railroad, see Allan Wallach, "Thomas Cole's 'River in the Catskills' as Antipastoral," *Art Bulletin* 84, no. 2 (June 2002): 339.

16. "Thoughts and Occurrences," May 22, 1836, journal entry, 49, quoted in Kenneth W. Maddox, "Thomas Cole and the Railroad: Gentle Maledictions," *Archives of American Art Journal* 26, no. 1 (1986): 7.

17. Cole, "Essay on American Scenery," 101.

18. Elwood C. Parry and Angela Miller read the painting as a nostalgic view of the frontier lifestyle rapidly fading away by the mid-nineteenth century, suggesting Cole's longing for a more primitive state of human existence in the pristine wilderness. Miller, *The Empire of the Eye: Landscape Representation and American Cultural Politics, 1825–1875* (Ithaca, N.Y.: Cornell University Press, 1992), 52–53; and Elwood C. Parry, "Thomas Cole's 'The Hunter's Return,'" *American Art Journal* 17 (Summer 1985): 3. Parry notes that the little boy who is walking ahead of the two hunters is possibly the

artist's son, Theddy Cole, while the young girl who embraces the hunting dog is his daughter Mary. Cole's wife, Maria, could be the matriarch of the family, who in the picture holds a baby close in age to the Coles' new daughter, Emily; Parry, "Thomas Cole's," 15.

19. Herman, *Hunting and the American Imagination*, 61; E. Anthony Rotundo, "Body and Soul: Changing Ideals of American Middle-Class Manhood, 1770–1920," *Journal of Social History* 16, no. 4 (Summer 1983): 26–27; Herman discusses Doddridge in *Hunting and the American Imagination*, 62.

20. Herman, *Hunting and the American Imagination*, 53.

21. For more on Palmer see, Charlotte Streifer Rubinstein, "The Early Career of Frances Flora Bond Palmer (1812–1876)," *American Art Journal* 17, no. 4 (Autumn 1985): 71–88; Bryan F. Le Beau, *Currier and Ives: America Imagined* (Washington, D.C.: Smithsonian Institution Press, 2001), 131.

22. Le Beau, *Currier and Ives*, 177–78.

23. Rubinstein, "Early Career," 79.

24. Robert Nisbet, *The Sociological Tradition* (New York: Basic Books, 1966), 47–48, quoted in Bender, *Community and Social Change*, 9; Fletcher Harper, "The Family, the Church, and the State," *Harper's Weekly*, January 3, 1857, 2.

25. Heman Humphrey, "The Way to Bless and Save Our Country," a sermon, preached in Philadelphia, at the request of the American Sunday School Union, *Hume Tracts*, 1831, available at www.jstor.org/stable/60213275.

26. Dawn Glanz views *Home in the Woods* as a more civilized scene than *The Hunter's Return* because the homestead in the former appears more peaceful, and in a written description of the latter work, the artist purposefully conceived it as a "wild scene." Dawn Glanz, *How the West Was Drawn: American Art and the Settling of the Frontier* (Ann Arbor, Mich.: UMI Research Press, 1982), 75.

27. John F. Kasson, *Civilizing the Machine: Technology and Republican Values in America, 1776–1900* (New York: Hill and Wang, 1999), 62.

28. Mount's description of his visit to Cole's home is provided in Deborah J. Johnson, *William Sidney Mount: Painter of American Life* (New York: American Federation of the Arts, 1998), 56–58.

29. For more information on Mount's genre paintings in relation to the changes in his era's social and political landscape, see Elizabeth Johns, "An Image of Pure Yankeeism," in *American Genre Painting: The Politics of Everyday Life* (New Haven, Conn.: Yale University Press, 1991), 24–59; and William T. Oedel and Todd S. Gernes, "The Painter's Triumph: William Sidney Mount and the Formation of a Middle Class Art," in *Reading American Art*, ed. Marianne Doezema and Elizabeth Milroy (New Haven, Conn.: Yale University Press, 1998), 128–49. Oedel and Gernes view Mount as among a generation of reformists, and his art intent on disseminating a middle-class ideology that endorsed both social and cultural homogeneity.

30. Edwin G. Burrows and Mike Wallace, *Gotham: A History of New York City to 1898* (New York: Oxford University Press, 1999), 774.

31. Rotundo, "Body and Soul," 24–25.

32. E. Anthony Rotundo, *American Manhood: Transformations in Masculinity from the Revolution to the Modern Era* (New York: Basic Books, 1993), 43–44.

33. Thaddeus Norris, *The American Angler's Book: Embracing the Natural History of Sporting Fish and the Art of Taking Them* (Philadelphia: Porter and Coates, 1865), 187, https://archive.org/stream/americananglersb01norr#page/186/mode/2up.

34. Walt Whitman, *The Complete Writings of Walt Whitman* (New York: Putnam and Knickerbocker Press, 1902), 14.

35. Stephen M. Frank, *Life with Father: Parenthood and Masculinity in the Nineteenth-Century American North* (Baltimore, Md.: Johns Hopkins University Press, 1998), 114–15.

36. May-Fly [Hamilton Smith], "On Fishing in General, and Trout Fishing in Particular," *American Turf Register and Sporting Magazine*, July 1843, 403.

37. William Sidney Mount to Charles H. Lanman, November 17, 1847, reprinted in Alfred Frankenstein, *William Sidney Mount* (New York: Abrams, 1975), 120.

38. See Johns, *American Genre Painting*, 118–19; and Karen M. Adams, "The Black Image in the Paintings of William Sidney Mount," *American Art Journal* 7, no. 2 (November 1975): 56–57. Albert Boime suggests that Mount did not want to portray himself as being dominated by a powerful black male in "Henry Ossawa Tanner's Subversion of Genre," *Art Bulletin* 75, no. 3 (September 1993): 423.

39. Johnson, *William Sidney Mount*, 65.

40. Frankenstein, *William Sidney Mount*, 122.

41. August 29, 1846, diary entry, reprinted in ibid., 143, and quoted in Oedel and Gernes, "The Painter's Triumph," 129; Bruce Robertson, "Stories for the Public: 1830–1860," in *American Stories: Paintings of Everyday Life, 1765–1915*, ed. H. Barbara Weinberg and Carrie Rebora Barratt (New Haven, Conn.: Yale University Press, 2009), 29.

42. "Eel Catching" *Gleason's Pictorial Drawing-Room Companion*, January 24, 1852, 57.

43. George H. Palmer, *The Exhaustion of Food Fishes on the Seacoast of Massachusetts* (Boston: Addison C. Getchell, 1887), 8, 20.

44. In a letter to Charles Lanman, August 13, 1847, Mount mentions Ranney as having a "Sunny countenance"; reprinted in Frankenstein, *William Sidney Mount*, 117.

45. Ramrod, "Dogs and Dog Breaking," *Spirit of the Times*, December 1, 1849, 485. Authors for hunting and fishing journals often used tongue-in-cheek pseudonyms.

46. "Treatise on Breaking Dogs," *Cabinet of Natural History and American Rural Sports* 1 (1830): 160.

47. Buhler notes that artist Thomas Doughty was probably the first to coin the phrase and description of a "true sportsman," in the journal the *Cabinet of Natural History and American Rural Sports*, in Buhler, "Capturing the Game," 1.

48. "American Sketch of a True Sportsman," *Spirit of the Times*, April 23, 1836, 79.

49. Scolopax, "Game and the Game Laws," *Spirit of the Times*, August 18, 1860, 337.

50. Eric W. Nye and Sheri I. Hoem, "Big Game on the Editor's Desk: Roosevelt and Bierstadt's Tale of the Hunt," *New England Quarterly* 60, no. 3 (September 1987): 454–65.

51. Linda Bantel and Peter H. Hassrick, *Forging an American Identity: The Art of William Ranney, With a Catalogue of his Works* (Cody, Wyo.: Buffalo Bill Historical Center, 2006), 84.

52. "The 'Spirit' and its High Character," *Spirit of the Times*, September 10, 1859, 361.

53. Bantel and Hassrick, *Forging an American Identity*, 84.

54. "Edwin Landseer's 'Three Sporting Dogs,'" *Spirit of the Times*, July 7, 1849, 233.

55. "Field Trial of Dogs," *Harper's Weekly* (October 5, 1878), 788–89.

56. For more information on the general growth of sports in nineteenth-century America see John Rickards Betts, "The Technological Revolution and the Rise of Sport, 1850–1900," *Mississippi Valley Historical Review* 40, no. 2 (September 1953): 231–56.

57. Holliman, *American Sports*, 21–22; "Pigeon-Shooting Match Extraordinary: South Carolina vs. Pennsylvania," *Spirit of the Times*, October 9, 1852, 404.

58. Brand was a Scottish immigrant who started his own successful linen business in New York. "William Brand," *Biographical Register of Saint Andrews Society of the State of New York*, www.mocavo.com/Biographical-Register-of-Saint-Andrews-Society-of-the-State-of-New-York-Volume-Ii/581862/219.

59. Le Beau, *Currier and Ives*, 316.

60. Martha Hoppin believes that Whittredge may have inspired Brown to pursue landscape painting for a short time after Brown completed *Claiming the Shot*, since he explored painting forest interiors in the manner of his Tenth Street companion; Hoppin, *The World of J. G. Brown* (Chesterfield, Mass.: Chameleon Books, 2010), 39.

61. Anthony F. Janson, *Worthington Whittredge* (Cambridge: Press Syndicate of the University of Cambridge, 1989), 105.

62. Bender, *Community and Social Change*, 109–10.

63. Brooks Adams, "The Platform of the New Party," *North American Review* 119, no. 244 (July 1874): 34; Bender, *Community and Social Change*, 110.

64. The population of Philadelphia and its surrounding area had increased 58 percent in the 1840s and another 38.3 percent in the 1850s. At this time, Philadelphia had become an industrial city with large-scale industries, including the manufacture of locomotives, textiles, gas fixtures, umbrellas, bricks, and iron machinery. By 1860, eighteen street railways held charters. In 1870, the city's population was 674,022. Russell F. Weigley, ed., *Philadelphia: A 300-Year History* (New York: Norton, 1982), 309, 374–79, 419.

65. Lloyd Goodrich, *Thomas Eakins* (Cambridge, Mass.: Harvard University Press for the National Gallery of Art, 1982), 1:87.

66. For more on Morris and Hallowell, see ibid., 89.

67. "Rail Shooting on the Delaware," *Harper's Weekly*, November 1, 1890, 847. Eakins explained the role of the pusher in a letter to his former instructor, Jean-Léon Gérôme, in 1874. Cited in Alan C. Braddock, "Eakins, Race, and Ethnographic Ambivalence," *Winterthur Portfolio* 33, nos. 2/3 (Summer–Autumn 1998): 152.

68. Braddock, "Eakins, Race, and Ethnographic Ambivalence," 148. Braddock also suggests that the specific locale of Eakins's hunting pictures carried connotations of "Otherness" to his audience.

69. Eakins to Gérôme, undated, 1874, reprinted in Goodrich, *Thomas Eakins*, 93.

70. For more on the complexity of Roosevelt's role in promoting hunting, see Herman, *Hunting and the American Imagination*, 12, 218–25.

71. Richard Slotkin discusses Roosevelt's frontier thesis and books on hunting in "Nostalgia and Progress: Theodore Roosevelt's Myth of the Frontier," in "American Culture and the American Frontier," special issue, *American Quarterly* 33, no. 5 (Winter 1981): 608–37.

72. "The Silent Witness," *Time*, December 24, 1956, http://content.time.com/time/subscriber/article/0,33009,808832-3,00.html.

73. Rotundo, *American Manhood*, 229.

74. Peter Hurd quoted in "The Clan Wyeth Presents the Famed Patriarch," *Art Digest*, December 15, 1939, 8.

75. Edward Alden Jewell, "Other Shows: Among the Current Exhibitions," *New York Times*, December 10, 1939, 11.

76. H. G. Wells, "The Future in America: A Search after Realities," *Harper's Weekly*, September 1, 1906, 1239.

77. Herman, *Hunting and the American Imagination*, 228.

78. Andrea L. Smalley, "'Our Lady Sportsmen': Gender, Class, and Conservation in Sport Hunting Magazines, 1873–1920," *Journal of the Gilded Age and Progressive Era* 4, no. 4 (October 2005): 355–80; "Woman Out of Doors," *Forest and Stream*, October 13, 1894, 109.

79. Ronald J. Zboray and Mary Saracino Zboray, "The Romance of Fisherwomen in Antebellum New England," *American Studies* 39, no. 1 (Spring 1998): 5–6; Rotundo, *American Manhood*, 105.

80. A. N. Cheney, "Angling Notes: Women at the Sportsmen's Show," *Forest and Stream*, March 27, 1897, 250.

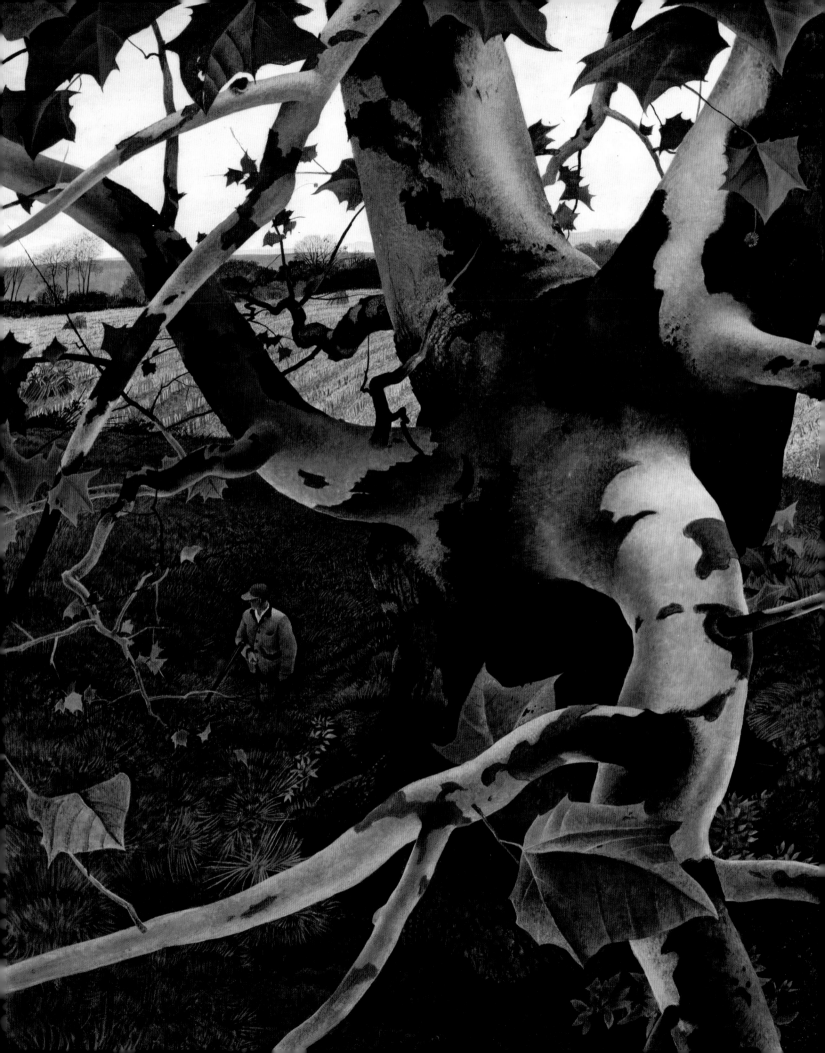

Trailblazer, Trespasser, Soldier, Squire

THE MULTIPLICITY OF THE HUNTER IN AMERICAN PAINTING

Adam M. Thomas

Hunting was integral to the pioneer brand of individualism that became a staple of westward expansion across antebellum America. Exploration and hunting were often paired preoccupations in the lives of frontiersmen. Surveyors, traders, and backwoodsmen of various stripes relied on hunting for sustenance (as well as reward). If Europe's forests were the private domain of the landowner or crown, and hunting was, in general, reserved for the select few who had status, resources, time, and access, America's abundant wildlife was, by contrast, more readily available to the Everyman. In the early republic, the term "long hunter" referred to a hunter who went away for long periods, sometimes a year or more. The term also applies to the extension of geographic distance—that is, long as an allusion to space and not just time. As game became scarcer, long hunters would range farther afield from settlement, pushing into— from their perspective—the uncharted regions of the continent. There was no more renowned long hunter than Daniel Boone, a paragon of self-determination for Jacksonian America.[1]

When Thomas Cole painted *Daniel Boone at His Cabin in Great Osage Lake* (fig. 4.1 [cat. 17]), Boone had been dead for some six years. Nestled next to a self-built abode in the wilds of Missouri, his relatively small figure adds human scale to vast nature. Cole's Boone is a hardened older man clad in buckskin, the color of which corresponds to the turning foliage and hence identifies him as part of the late autumn landscape. Similarly, the red of the blood from the vanquished deer—so intimate in its proximity—is repeated in his kerchief, a quasi-amulet. The agitated atmosphere—gray-violet waves of lowering vapor—treads into the aesthetic territory of the sublime, where tumultuous weather was associated with traditional masculine qualities of vigor and aggression.[2] Boone sits impassively on the natural rock formation as though he were a sculptural fixture of the woods springing from massive stone steps. His steadfast frontal position contrasts with the diagonals of the twisted tree stumps flanking him. He is a character of timeless resolve, an Orion-like force in his command of

(*facing*)
Detail of fig. 4.29 (cat. 73), p. 151
Andrew Wyeth
The Hunter, 1943

the backcountry. The forest is uncultivated yet in flux; Boone establishes a foothold for development that will imminently follow—railroads, cities, industries.[3]

Boone, in his outward mode of address, is mobilized in Cole's depiction into something more than a mere figure in a landscape. The painting functions as a kind of posthumous mythmaking portrait of the man. It does not simply perpetuate the legend of Boone—already famed in his lifetime—it enhances it. By the early nineteenth century, he was an important cultural lodestar and embodied a new model of masculinity derived from hunting. The inflation of his legacy in subsequent decades further exalted geographic mobility and self-sufficiency as national traits.[4] The "figure of Boone was," as historian Richard Slotkin elucidates, "the most significant, most emotionally compelling myth-hero of the early republic." Notably, "it was as a hunter that Boone achieved his

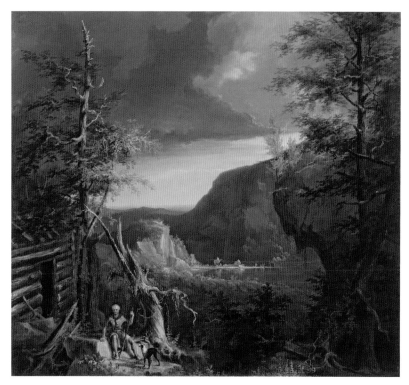

Fig. 4.1 (Cat. 17)
(See also fig. 1.17, p. 40)
Thomas Cole
Daniel Boone at His Cabin in Great Osage Lake, ca. 1826
Oil on canvas, 38½ × 42⅝ inches
Mead Art Museum, Amherst College, Amherst, Massachusetts. Museum purchase

heroic stature," but "acceptance of the hunter as the archetypal American hero . . . meant adopting the hunter's . . . love of exploit and violence."[5] Boone's wayfaring self-reliance proved double edged.

For European Americans, hunting fauna often went hand in hand with a proprietary attitude toward the continent. In Alfred Jacob Miller's bust-length portrait of Joseph Reddeford Walker (fig. 4.2 [cat. 41]), probably from the late 1840s, the bristly trapper-cum-scout fills the pictorial space and gingerly fingers the muzzle of his gun. Walker could apparently be quite brutal toward American Indians as a fighter, and though his sympathetic mien in Miller's portrayal belies this fact, the prominence of his weapon—so near at hand—indicates a readiness to violence.[6] The illusionistic frame around Walker recalls the dozens of ennobling porthole portraits of George Washington that artist Rembrandt Peale produced in these decades.[7] If this honorific formal device plays up the dignity of the country's symbolic father in Peale's portraits, it also goes some way toward asserting the authority and standing of Captain Walker. The oval frame, we might say, props up the guise of what was called civilization and progress. The three-quarter profile against an atmospheric glow likewise follows Peale's example. Thus the portrait asked viewers, if not exactly to see the character of Walker on the level of Washington, then to rate the carnage-filled escapades of the western pathfinder as necessary to the expansion of the nation.

Cole's *Daniel Boone* thematically relates to another work in the early career of this leading light of American landscape painting. In the foreground of his *Lake with Dead Trees* (fig. 4.3), one stag looks up warily while another flees. The action implies that a human presence, conceivably a hunter, has invaded the Catskill Mountain scenery. Moreover, the beholder's point of view simulates how a hunter, set apart by the fallen foreground trunks, furtively advances on his prey against the wind. The deer's antlers mimic the animated shapes of the withered and decaying tree branches, suggesting that the animals too were under threat from human encroachment and hunting in particular.[8] Europeans in America killed deer—white-tailed deer above all—in enormous numbers. By the early

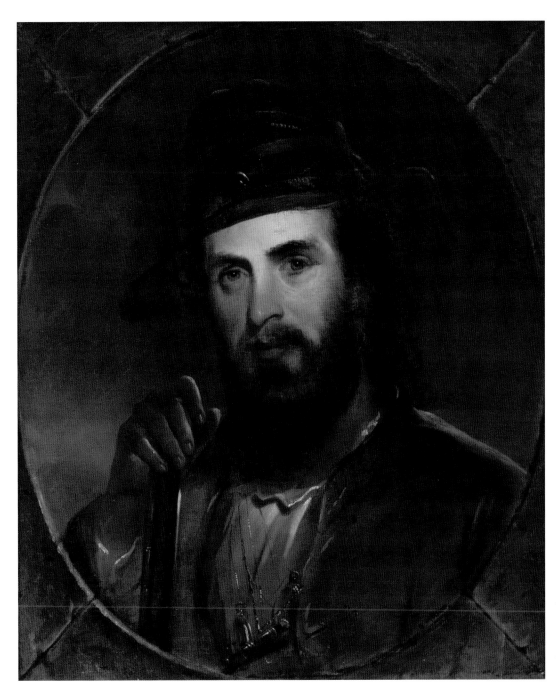

Fig. 4.2 (Cat. 41)
Alfred Jacob Miller
*Portrait of Captain Joseph
Reddeford Walker*, ca. 1845–50
Oil on canvas, 24 × 20 inches
Joslyn Art Museum, Omaha,
Nebraska. Museum purchase,
1963.610

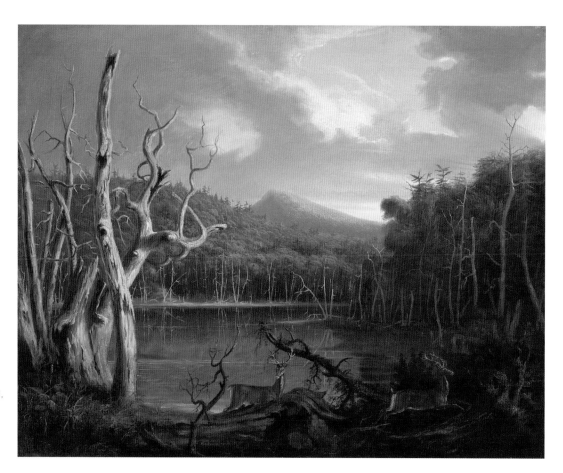

1800s, its population had declined by as much as 50 percent from precontact levels.[9]

Thomas Doughty, whose landscape paintings Cole had studied in Philadelphia in the preceding years, contributed most of the illustrations of animals for the multivolume *The Cabinet of Natural History and American Rural Sports*.[10] Edited jointly with his brother and issued monthly in the early 1830s, its first installment opens with Doughty's hand-colored plate *Common Deer* (fig. 4.4) and a treatise that contains several paragraphs on the "many stratagems" for hunting deer. "From the number annually destroyed, and the rapid settlement of the country," the piece concludes, "they are becoming much less common than they were a few years since."[11] The publication's hybrid content spanned topics in natural history, travel narratives, and sporting accounts, including other hunting chronicles.[12] An important transitional figure in the history of landscape painting in America, Doughty specialized in incorporating hunters in the 1820s

and 1830s. The dual appeal of the text and its imagery to both the hunter and the naturalist is also borne out in a painting Doughty executed in 1835, *In Nature's Wonderland* (fig. 4.5). Here, a solitary hunter rests his flintlock rifle at his side and stands awestruck before the splendor of the summit. The romantic trope of the turned-away body enables the spectator to more imaginatively partake in the experience of discovery. Doughty's concocted landscape overwhelms his small figure with the old canard of the near-virgin forest—albeit absent any visible deer—and offers an exemplary conjunction of hunting and wanderlust in the antebellum era.[13]

◆ ◆ ◆ ◆ ◆

In the postbellum United States, hunting as a nonessential leisure activity became more frequently a subject for artists. Set apart from utilitarian concerns, various depictions of hunting treat it as a pastime undertaken largely for its inherent pleasures. This had distinct class implications. Witnessed in the lavish ceremonies of monarchs

with byzantine codes of etiquette, the trappings of wealth and privilege had attended hunting for centuries. The landed sportsman's keenness for hunting as recreation instantiated his power and capacity to provide. Hunting, under these conditions, was identified with the highest socioeconomic stratum. Two paintings from the 1870s suggest how class divisions were reinforced through the portrayal of hunting as a quintessentially elite hobby.

David Neal's *After the Hunt* (fig. 4.6 [cat. 46]) displays a European interior arrayed with sumptuous fabrics and varied textures from floor to furniture. Neal, an American who studied in Munich and traveled widely abroad, paid close attention to the minute details of every still-life element, including the inlaid horn and mother-of-pearl stock of the seventeenth-century central European wheel-lock (or Tschinke) rifle. Amid the accoutrements of the hunt, the lord of the manor leans back in his chair and raises his glass to the female servant, who brings him a fresh decanter of wine. He toasts her but also radiates some measure of licentious energy. Absent a companion in the seat opposite him, they amorously lock eyes. Her bosom aligns with his gaze, and he reciprocates by clutching his own chest as though professing his affection. The painting's strong contrasts of light and dark afford a shadowy corner for them to flirt. As day fades to night, other areas of the composition play into this central innuendo: the firearm oriented across the table like a phallic extension over his lap; the splayed hind legs of the hare in the foreground; and the sheepish hound turned away from his master's consorting yet analogously engaged with what one reviewer called "the friendly advances of a lap-dog."[14] Overindulgence is relayed not just in the potentially caddish figure seeming to imbibe too many drinks but also in the orchestration of his opulent surroundings.

Links between erotic seduction and hunting have a long history.[15] These two forms of predation find expression in Thomas Hovenden's *The Favorite Falcon* (fig. 4.7 [cat. 33]), another historical genre scene. The relationship between falcon and falconer was founded on an intimate connection, even love. Sixteenth- and seventeenth-century falconry manuals, for example, drew on the language of

COMMON DEER.

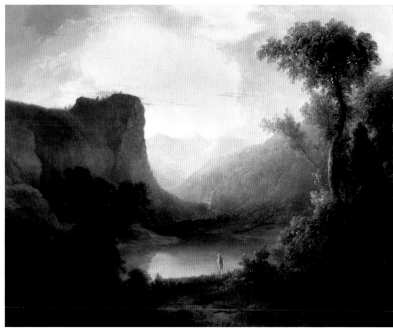

(*above*)
Fig. 4.4
Thomas Doughty
Common Deer, n.d.
Engraving on paper,
7 × 8¹³⁄₁₆ inches
Bowdoin College Museum of
Art, Brunswick, Maine. Museum
purchase, James Phinney Baxter
Fund, in memory of Professor
Henry Johnson

(*below*)
Fig. 4.5
Thomas Doughty
In Nature's Wonderland, 1835
Oil on canvas, 24½ × 30 inches
Detroit Institute of Arts, Detroit,
Michigan. Founders Society
purchase, Gibbs-Williams Fund,
35.119

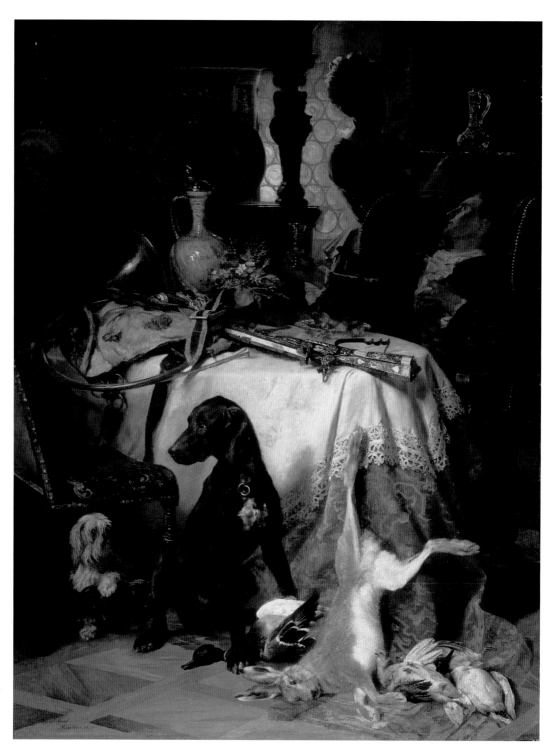

Fig. 4.6 (Cat. 46)
David Neal
After the Hunt, 1870
Oil on canvas, 62 5/16 × 46¾ inches
Los Angeles County Museum of
Art, Los Angeles, California. Gift
of Mr. and Mrs. Will Richeson, Jr.,
M.72.103.1

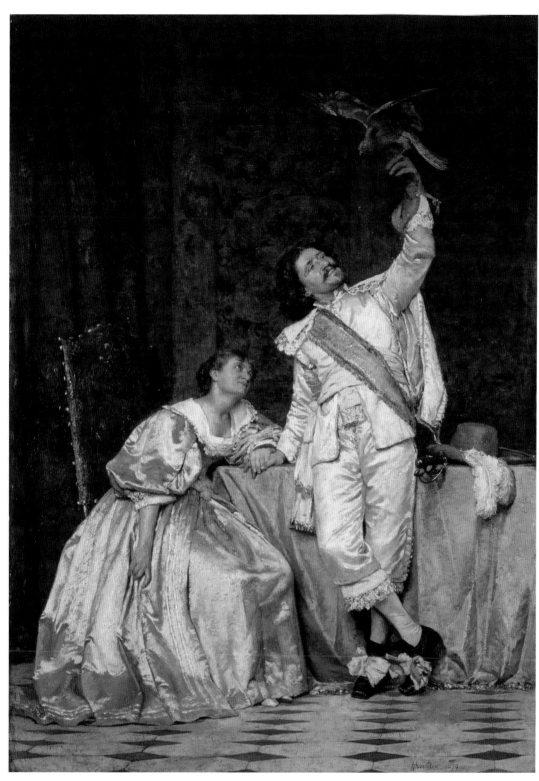

Fig. 4.7 (Cat. 33)
Thomas Hovenden
The Favorite Falcon, 1879
Oil on canvas, 53⅝ × 38¾ inches
Pennsylvania Academy of the Fine
Arts, Philadelphia, Pennsylvania.
Gift of Mrs. Edward H. Coates
(The Edward H. Coates Memorial
Collection), 1923.9.1

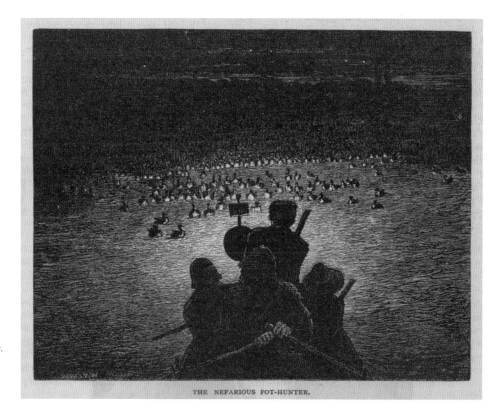

Fig. 4.8
The Nefarious Pot Hunter
From the article "Canvas-Back and Terrapin," *Scribner's Monthly*, November 1877, 2–3. Cornell University Library, Ithaca, New York. Making of America Digital Collection

THE NEFARIOUS POT-HUNTER.

matrimony to describe the process of fostering a strong bond with the birds. Falconry metaphors often implied that a falconer tames his falcon as a man would his wife.[16] Hovenden's painting highlights the rituals of courtship within this framework. The man's admiration for the feathered creature seems to spark romantic attraction: the bird attaches to one hand, and the lady clutches the other. We are left to wonder which one receives more affection.

Hovenden skillfully renders the pair's ruffled finery and reinvigorates the idea that falconry "in old paintings was the criterion of nobility."[17] Period commentators regarded falconry, the preferred diversion of feudal sovereigns, as "the most aristocratic of sports—a gilt relic of the chivalric days."[18] It had "almost fallen into oblivion" in these years, but a "few falconers . . . remain, and steadfastly hold to the old sport."[19] In the United States, remarked one publication, "the art of hunting birds and small game with trained hawks is practically unknown."[20] Yet a renewed fascination with the sport paralleled the rise of an affluent trans-Atlantic mercantile

class—including art patrons—in the United States as well as a Gilded Age cosmopolitanism that sought to emulate European models of aristocratic taste. As part of this trend, the second edition of the 1855 treatise *Falconry in the British Isles* was reissued in 1873, for example.[21] And New York City had, in 1875, erected a larger-than-life bronze sculpture in Central Park, George Simonds's *The Falconer*, a quaintly absurd figure in Elizabethan costume raising a bird aloft.

Hovenden's and Neal's ostensibly decorous paintings emphasize grandeur and the link between hunting and courtship at the expense of violence and class frictions. "The ideal sportsman is, first, a thorough-going business man," proclaimed an 1881 article, bringing their patrician bias up to date for the American capitalist in the age of the robber baron. This supposedly genuine sportsman touted his closeness with, and mastery over, nature. He was "not a sneaking pot-hunter, slaughtering convoys of cowering victims upon the ground." For him, as for his aristocratic predecessors, hunting amounted to "a noble pastime, and not a money-getting trade."[22]

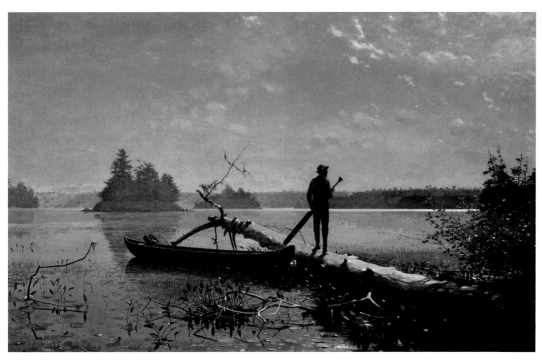

Fig. 4.9
Winslow Homer
An Adirondack Lake, 1870
Oil on canvas, 24½ × 38¼ inches
Henry Art Gallery, University of
Washington, Seattle, Washington.
Horace C. Henry Collection,
FA 26.71

The pot hunter occupied the other end of the socioeconomic spectrum from the highborn associations of the aforementioned paintings. The term originally designated a woodsman who filled the pot on his stove and lived off the land.[23] But gradually these men killed for the salable parts of animals exclusively, and the pot hunter was looked down on as a poacher, a pest, a pariah. Also known as a skin hunter because of the hides he coveted, the pot hunter was deemed to lack the skill, virtues, and refinement of the self-appointed "ideal sportsman." Judged a man of low morals and motivated by greed, he "mercilessly slays everything possible."[24] He killed illicitly and indiscriminately, using the most brutish means—any way that would bring the most meat to market.[25] Underlying the multiplying denunciations of the violation of propriety and of the inordinate elimination of wildlife, however, was, as historian Philip G. Terrie acknowledges, the "implication that the wilderness and field sports were the exclusive province of white, Anglo-Saxon, well-to-do men." Their status-conscious sensibilities were threatened by neophytes in the woods, by new crowds of what they considered "the wrong kind of people."[26]

In an 1877 illustration captioned *The Nefarious Pot-Hunter* (fig. 4.8), a boat stealthily approaches a raft of ducks under cover of darkness. The article that accompanied it explained how "market gunners" employ the "night reflector," a tactic tantamount to "wholesale murdering." First, "a large reflector behind a common naphtha lamp" is "mounted upon the bow of a boat." Then, locating the ducks at night, the bright light dazes them, and they "swim to it from every side and bob against the boat in helpless confusion." Massed together, "twenty to thirty ducks to each shot" can easily be dispatched. Yet the pot hunter has to be cautious, for he is liable to receive "a charge of shot in his body from some indignant sportsman on the shore. If a rifle is handy and any one chances to be up and about at the hour, no hesitation is felt at having a crack at the 'pot-hunter's' nefarious light."[27] Giving us a waterside view, Winslow Homer's *An Adirondack Lake* (fig. 4.9) refers to a similar and controversial practice known as "jack shooting" with the lantern laid in the stern of the canoe.[28] Except here, its use in deer hunting is dormant; all is placid; the mountain sun is what dazzles. And still, the partly

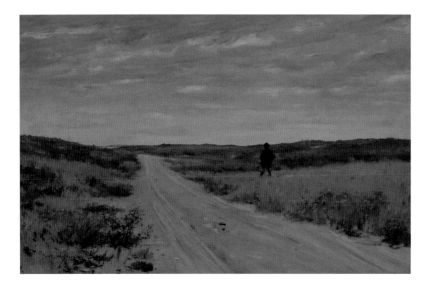

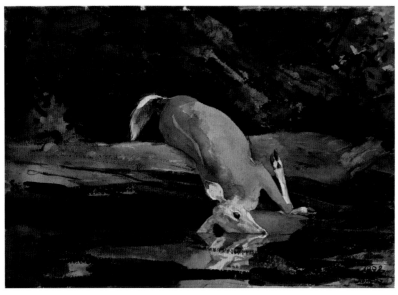

(above)
Fig. 4.10 (Cat. 15)
(See also fig. 3.11, p. 98)
William Merritt Chase
The Pot Hunter (The Road through the Fields; The Hunter), ca. 1894
Oil on canvas, 16¼ × 24⅛ inches
Parrish Art Museum, Water Mill, New York. Purchase fund and gift of Mr. Frank Sherer, 1974.5

(below)
Fig. 4.11
Winslow Homer
The Fallen Deer, 1892
Watercolor over graphite pencil on paper, 13⅞ × 19¹³⁄₁₆ inches
Museum of Fine Arts, Boston, Massachusetts. The Hayden Collection—Charles Henry Hayden Fund, 23.443

submerged antler-like boughs seem to foretell of the downed stags that, mesmerized by the beam of light, will die in the same shallow waters of the littoral. The aid of a jacklight, avers Terrie, "testifies to the incompetence" of most Adirondack hunters, who would exert any "leverage they could dream up in order to exercise their 'gentleman's right' to exploit the wilderness."[29]

William Merritt Chase's *The Pot Hunter* (fig. 4.10 [cat. 15]) complicates this despised type. Chase presents a single figure tracking his elusive prey in a desolate corridor of Long Island, probably not far from where the artist resided in Shinnecock Hills. Unlike the 1877 illustration and its textual elaboration, there is little in the painting to differentiate the pot hunter from his more socially acceptable counterparts. The road cuts through scrub grasses and dunes, and its well-traveled appearance suggests boundaries and private property, which the intruder may transgress in full daylight. It is a dividing line that, by virtue of its very inclusion, seems designed to give rise to a desire to defy it. Chase leaves open the possibility, however, that the hunter is on the artist's own land, calling into question where and how class and pot hunting intersect.

Though apparently not a hunter, Chase was something of an aficionado of firearms. He once "astonished everybody" at a foreign dinner party when expertly demonstrating, as he put it, "a faint idea of the way my countrymen can handle a pistol." As a result of Chase's flair for marksmanship, one onlooker "stood in awe of the powers of the Yankee with a gun."[30] During his stint as a teacher at the Pennsylvania Academy of the Fine Arts in the 1890s, he regularly visited Thomas Eakins in his Philadelphia studio, where the two artists improvised an indoor shooting gallery for target practice. Chase, it was said, "could hit a fifty-cent piece at fifty paces."[31]

Illegal hunting was a particularly serious problem on Long Island in the early 1890s. The opening day of the 1894 deer-hunting season was "marked by such scenes of disorder, bloodshed, and general rioting" that the county sheriff had to be called to "disperse the gangs of pothunters."[32] In 1895, the legislature passed a law prohibiting the killing of deer for two years in the county because

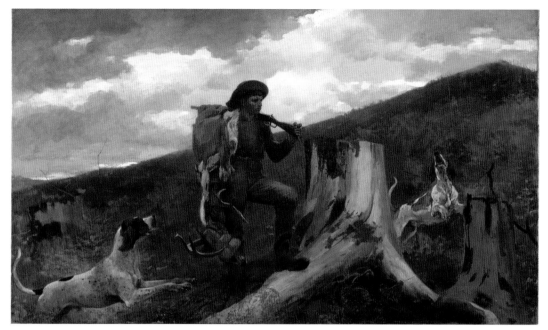

Fig. 4.12 (Cat. 31)
(See also fig. 2.4, p. 64)
Winslow Homer
A Huntsman and Dogs, 1891
Oil on canvas, 28⅛ × 48 inches
Philadelphia Museum of Art,
Philadelphia, Pennsylvania. The
William L. Elkins Collection, 1924,
#E1924-3-8

pot hunters—"hoodlums" refusing to comply with existing restrictions—had "inaugurated a reign of terror."[33] Despite such measures, complained one source, Long Island remained "far and away the most backward in the protection of its woodlands and wild animal life of any section in the United States." Overrun, it was effectively a "haven" and "retreat" for pot hunters.[34]

Two years before Chase created his painting, Homer had observed related unsportsmanlike behavior firsthand in the Adirondack Mountains. On the verso of the watercolor *The Fallen Deer* (fig. 4.11), he scribbled in graphite "just shot" by "A miserable . . . Pot hunter." As if to show the freshly slain doe in the process of expiring, Homer focuses attention on its open obsidian eye. The doe physically sinking into the murky water amplifies its state of hovering between life and death. The empathetic directness of its appeal is in keeping with Homer's caustic notation. Whereas Chase situates the pot hunter stalking at a benign distance, Homer's deer stares him in the face. The resultant cruelty is unnerving. The animal, seemingly untouched,

contorts awkwardly over the tree trunk. The splotch of red pigment on the left functions as a surrogate for the unseen bloody bullet wound.[35]

The young man at the center of Homer's *A Huntsman and Dogs* (fig. 4.12 [cat. 31]) can also be read as a pot hunter. He carries the parts of the stag—pelt and horns—intended for the marketplace but "leaves the carcass to feed the carrion birds." Critic Alfred Trumble found that his crude physiognomy marked him as a "sort of scoundrel" prone to barbarism—"low and brutal in the extreme."[36] Trumble's reaction is perhaps inflected with class and ethnic prejudices, but Homer certainly casts his young man in atavistic and visceral terms that provoke ethical interrogation of his actions. With a final blood-splatter-esque flourish, Homer signed his name in red along the lower tree stump, a gesture underscoring the apparent callousness of the figure's bearing.[37] In 1890, pot hunters had reportedly proposed lengthening the season for deer hunting in the Adirondacks. If the "true sportsman" recognizes "the necessity of protecting the game," the *New York Times* editorialized on

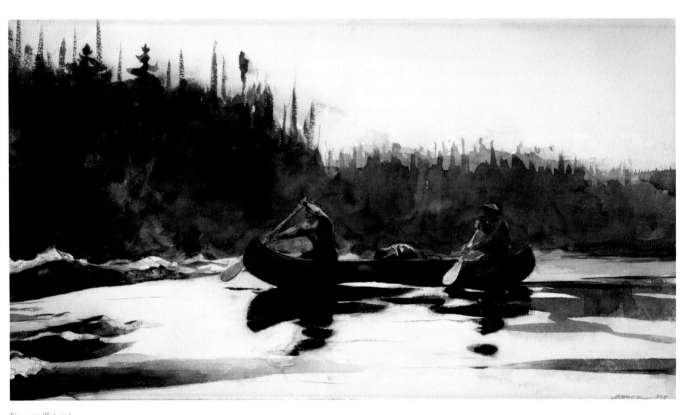

Fig. 4.13 (Cat. 32)
Winslow Homer
Guides Shooting Rapids, 1895
Watercolor and charcoal,
11³⁄₁₆ × 20¹⁄₁₆ inches
Davis Museum at Wellesley
College, Wellesley, Massachusetts.
Bequest of Samuel G. Houghton
(husband of Edda Kriender
Houghton, Class of 1934), 1976.14

the occasion, "professional hunters" are only in it for "making as much money as they can."[38] This ideal was easily undermined. One problem with any rigid social stratification between these groups was the fact that those who hunted for profit often served as guides for well-to-do sportsmen on tourist expeditions—the guide in Homer's *An Adirondack Lake* being just one representation.

The two figures in the later "spirited" water-color *Guides Shooting Rapids* (fig. 4.13 [cat. 32]), from Homer's peregrinations in Quebec, Canada—his second visit—maneuver a canoe toward the fast and hazardous stretches of the Saguenay River.[39] The dependable repetition of paddles slicing through the surface of the water also characterizes the formal rhythm of the pared-down, nearly mono-chromatic scene, with its oscillations between dark and light. The verticals of the silhouetted spruce trees counterpose the horizontal momentum of the boat, alive with "muscular tension."[40] The tree line rises and becomes more opaque and more energized in handling with the direction of their movement, building to a roiling crescendo that anticipates the turbulence awaiting the guides. Here, amid the "black waves" and "inky depths" of the so-called River of Death, man and nature clash.[41]

No matter who was doing the hunting, the outcome was routinely the same, as an early conservationist lamented about the once-plentiful pronghorn antelope in 1883: "Civilized man has proved himself the antelope's worst enemy, and in those districts where hunters are numerous, the species soon disappears. The traveler kills it for food, the skin-hunter for the few cents its hide will bring, the sportsman for its head, the cow-boy to try his six-shooter, and everybody for 'fun.'"[42] Nevertheless, the perceived differences between those hunting for sport and those hunting for profit diverged further as the era progressed.

✦ ✦ ✦ ✦ ✦

In 1893, *Forest and Stream* lumped together the "trout hog" with the "pot hunter" as out-of-door siblings who "find enjoyment only in wholesale destruction carried even to the limit of extermination." Members of this "mercenary class" merely "masquerade in the garb of sportsmen."[43] As editor from 1880 to 1911, George Bird Grinnell steered

AMERICAN BROOK TROUT.

Fig. 4.14
Artist unknown
American Brook Trout, 1872
Hand-colored lithograph
Published by Currier and Ives
Winterthur Museum, Garden and
Library, Wilmington, Delaware.
Bequest of C. Porter Schutt,
2000.0019.061 A

the weekly magazine, founded in 1873, to criticize the exploitation of wildlife and crusade for habitat conservation. Grinnell advocated for a growing number of game laws that sought to redress the wanton damage inflicted on dwindling species. He was alert to the tension between the drive to consume and the desire to conserve—a tension that would eventually lead to palliative techniques such as the catch-and-release of fish.[44]

When it came to fishing, trout were always intensely prized. The spots and metallic sheen of the trout—its pinks and oranges and yellows—made it an enchanting fish of great physical beauty. In the postbellum years, trout became even more of an object of obsession for American anglers. In an 1872 print from the New York City lithographic firm Currier and Ives (fig. 4.14), five speckled brook trout, native to the eastern United States, lie stacked on the bank, suggesting the abundance of American waterways—one natural resource that helped spawn the unfolding material prosperity of the Gilded Age. A *New York Times* article from 1874 ventured, "Perhaps no description of outdoor sports is more generally followed or admired than that of trout fishing," an avocation on which "Men of wealth expend their money freely."[45] Fly-fishing for trout acquired especially high value as an aspirational leisure activity during this time; it developed

Fig. 4.15 (Cat. 8)
Walter M. Brackett
Trout, 1867
Oil on canvas, 14 × 20¹⁄₁₆ inches
Brooklyn Museum, Brooklyn,
New York. Bequest of Caroline H.
Polhemus, 06.321

Fig. 4.16 (Cat. 16)
James Goodwyn Clonney
The Happy Moment, 1847
Oil on canvas, 27 × 22 inches
Museum of Fine Arts, Boston,
Massachusetts. Gift of Martha C.
Karolik for the M. and M. Karolik
Collection of American Paintings,
1815–1865, 47.1222

a patina of prestige and privilege.[46] Sportsmanship in fishing "includes the first principles of gentility," as one writer put it.[47] Another asserted that "game-fish," such as trout, only "inhabit the fairest regions, . . . drink only from the purest fountains"—"clear and sparkling waters"—and are not found in "foul or sluggish waters."[48] Much like the upper-class anglers themselves, trout had the right pedigree. Paintings such as Walter M. Brackett's *Trout* (fig. 4.15 [cat. 8]) became popular with these urban gentlemen, enabling them to more readily recollect their aquatic adventures when regaling guests in their dining rooms—particularly handy during the fish course.[49] The pleased country rustic in James Goodwyn Clonney's earlier *The Happy Moment* (fig. 4.16 [cat. 16])—with threadbare hat and patched knees—conveys a rather humbler appreciation of angling; the float fisherman avails himself of float or bobber. Float fishing "requir[ed] a less degree of skill, and a less expense in tackle" than fly-fishing but was loved as a "tranquil pursuit" and "suited to a peaceful and contemplative turn of mind."[50]

Trout Stream (fig. 4.17 [cat. 71]) from the 1870s testifies to Worthington Whittredge's approach to

depicting inland forests: densely packed trees surround a brook presumably rich with fish. Nature's bounty seems to have endless reserves, to be ever replenishing. Beginning in 1860, "I hid myself for months in the recesses of the Catskills," remembered Whittredge years later.[51] An avid fisherman, he sometimes trekked through the woods with friend and fellow artist Sanford Robinson Gifford: "On rainy days in the Catskills . . . we went for trout. The fish we caught were small."[52] In this painting, sun filters through the canopy to highlight the fisherman in the distance.[53] Whittredge repeated the presence of the faraway fisherman at water's edge—almost blending into the trees—in other works (fig. 4.18). The water in the immediate foreground spills into the viewer's space. The gentle susurration of the opaque gold stream communicates a dedication to rumination. The faint fisherman has a meditative quality of Thoreauvian dimensions. Of one old fisherman "always to be seen in serene afternoons haunting the river," writes Henry David Thoreau in *A Week on the Concord and Merrimack Rivers* (1849), "His fishing was not a sport, nor solely a means of subsistence, but a sort of solemn sacrament and

Fig. 4.17 (Cat. 71)
(See also fig. 3.17, p. 105)
Worthington Whittredge
Trout Stream, ca. 1870s
Oil on canvas, 12 × 15 inches
David and Laura Grey Collection

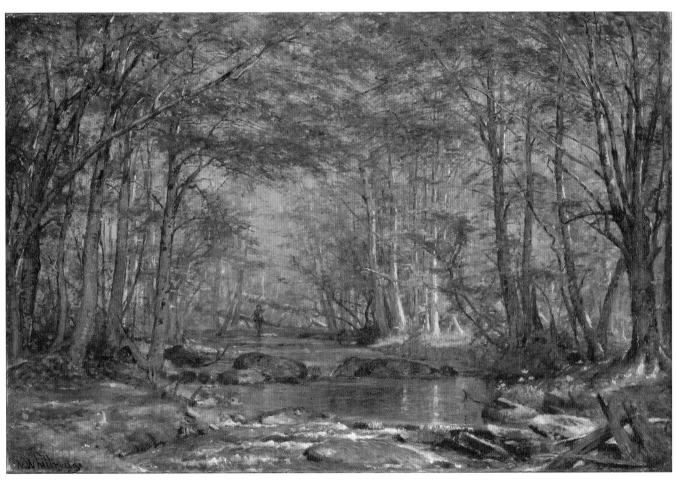

Fig. 4.18
Worthington Whittredge
Trout Stream, ca. 1875
Oil on canvas, 20 × 27 inches
Davis Museum at Wellesley
College, Wellesley, Massachusetts.
Gift of Marion Eddy Wheeler
(Class of 1924), 1994.51

withdrawal from the world, just as the aged read their Bibles."[54] A fellow nemophilist, Whittredge constructs a purified image of the Catskill streams, a quiet, sanctified zone for communion between fisherman and forest, in which "trees, grow in pretty clumps, like the Gothic columns of a cathedral, the branches arching overhead."[55]

Although on the face of it, Whittredge painted, in his own words, "the primitive woods with their solemn silence reigning everywhere,"[56] there was actually quite a lot of activity in the Catskill Mountains during these decades—activity that bore directly on the brooks and pools that captivated Whittredge. In 1854, for example, another landscape painter, T. Addison Richards, found that "tanneries are numerous in the Catskills," and he protested that the industry "destroys the beauty of many a fair landscape—discolors the once pure waters—and, what is worse than all, drives the fish from the streams! Think of the sacrilege!" In expressing his "indignation at the shameful innovation" that tarnishes the local waters, Richards singled out the plight of the "bright-tinted trout."[57] The "famous" trout from "the wilderness of northern New York," which Richards also extolled in his 1857 guidebook, can weigh "up to two and a-half or three pounds, and sometimes up to six."[58]

Richards saw the severe costs of the Catskills' tanning industry firsthand, notably the polluted waterways and the damage to brook trout habitat. Tanneries required convenient access to forests and tended to be established near hemlock growth, rapidly stripping those trees along the Hudson River in the early nineteenth century to such an extent that, by the 1830s, the tanning industry had relocated to the Catskill Mountains.[59] Clear-running streams were necessary for the tanning process, but many did not stay that way for long. In the estimation of historian Alf Evers, "waste and destruction" followed.[60] Evers summarizes the watery wreckage from the tanneries: "Trout were vanishing from many streams because the temperature of the water was raised too high for their comfort as the shading forests were ripped away. The water became polluted with tannery wastes and ashes."[61]

The tanning business in the Catskills may have peaked by the time Whittredge painted his first trout stream, but its deleterious environmental effects persisted. *Forest and Stream* observed, in 1884, "tanneries are among the principal offenders" for "spreading . . . death to fishes and their deposits of eggs."[62] In the 1870s, the state attempted to reverse the harm from tannery pollution by supplying trout for the restocking of streams, hoping that second-growth forest would offer a sufficiently cool environment for trout to flourish.[63] Amid this crisis the so-called Trout War of the late 1870s pitted owners of game preserves against poachers in a fight over fishing rights, particularly near the Beaverkill, a prized Catskill Mountain trout stream. In 1881, the speaker at the annual meeting of the New York State Association for the Protection of Fish and Game, a sportsmen's club, vented concomitant worries about "the increasing scarcity of our fish," since "demand" has "sadly diminished the products of our streams."[64] Water contamination problems also arose from the end-of-the-century surge in tourists to the Catskills, a desirable vacation destination because of its proximity to and enhanced accessibility by rail from New York City. In 1899, neighbors of Sandberg Creek wondered what to do about the summer hotels and resorts that increasingly defiled the creek and effectively banished the trout, turning it and other watercourses into "mere sewage channels," as the local press reported.[65]

In addition to tannery production, the lumber and charcoal industries contributed to the devastation of old growth forests in the Catskills by the 1880s.[66] An estimated 80 to 90 percent of the original first growth Catskill forest no longer existed by 1885, the year the forest preserve was created to enable the state to begin buying land in the Catskills and Adirondacks for protection from development.[67] In Gifford's 1866 Catskill landscape *Hunter Mountain, Twilight* (fig. 4.19), wide swaths of trees have already been cleared away, and stumps dominate the foreground, signifying a hillside stripped and despoiled by the logging and tanning industries. The fact that Gifford's grandfather was a tanner likely made the depletion of trees for this purpose particularly resonant for the artist.[68] New York City businessman James Pinchot may have purchased Gifford's painting because it aligned with his budding interest in

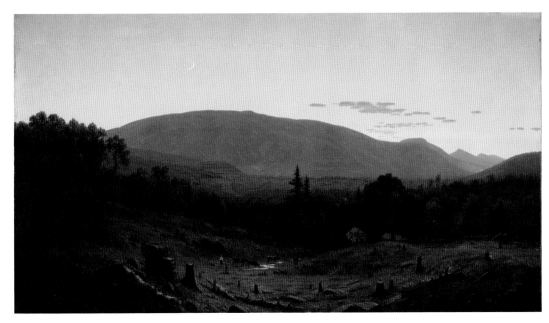

Fig. 4.19
Sanford Robinson Gifford
Hunter Mountain,
Twilight, 1866
Oil on canvas, 30⅝ × 54⅛ inches
Terra Foundation for American Art,
Chicago, Illinois. Daniel J. Terra
Collection, 1999.57

conservation management. Pinchot, who also befriended and collected works by Whittredge, became an active leader in the American Forestry Association (founded in 1875) and, through various philanthropic initiatives, an outspoken proponent of stopping the reckless loss of natural resources.[69]

In contrast to Gifford's painting, Whittredge's serene woodland interiors deny the reality that trout struggled to survive in rivers and creeks besieged by tannery wastes. Both versions of *Trout Stream* feature heavy vegetation—"the trunks of ancient trees," to quote one respondent.[70] The native trout, meanwhile, was fast becoming extirpated from many watercourses. For instance, in 1883, brown trout, introduced from Europe and more comfortable in warmer waters, began to push out the indigenous and smaller brook trout.[71] Whittredge, who advocated going "beyond a literal transcript[ion]" of nature, seems to have willfully turned away from the far-reaching industrial incursions into, even mistreatment of, woodland for commercial purposes.[72] In these pictures, the figures journey into the wilderness to slough off the constraints of civilization.[73] Yet, by the 1870s, the line between what could be understood as civilization and as wilderness was becoming ever more blurred. Whittredge may have had to "penetrate further and further into the recesses of the wood," in the words of one beholder

of another Catskill scene by the artist, to discover such heavily forested and seemingly untouched environs.[74] Dense and untrammeled woods were becoming a thing of the past.

While Whittredge focused on the cherished sporting tributaries of the upper Delaware River in the Catskills, Eakins pictured its lower reaches in and around Philadelphia. In two versions of *Shad Fishing at Gloucester on the Delaware River* from 1881 (fig. 4.20), Eakins turned his attention to commercial fishermen just across the river in New Jersey. It would be decades before shad drew much notice from anglers.[75] In the spring, the shad sought fresh water, embarking from the Atlantic on a reproductive journey to return, like salmon, to their natal rivers. The most bountiful yields occurred during a short span of about four weeks between April and May—the peak time known as "the great run."[76] The shad fishing industry was of major economic significance in these decades, but catches would dwindle around the turn of the twentieth century, at least partially from overfishing and pollution.[77] Eakins depicted the pulling in of the seine during the limited season with a fidelity that was regarded as "accurate transcripts of the commonplaces of fishermen's lives."[78] The insistent ordinariness of this scene hearkens back to the revolutionary realism of Gustave Courbet—showing conditions

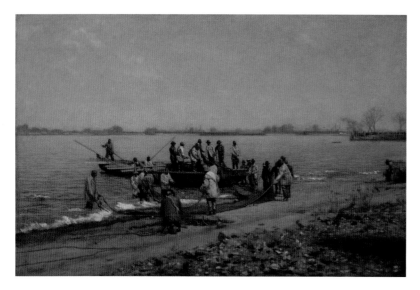

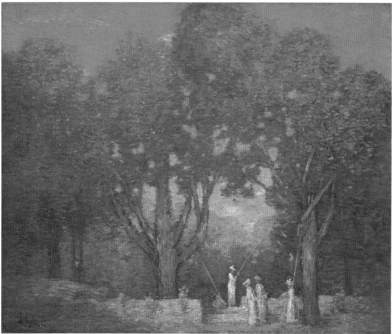

(*above*)
Fig. 4.20
Thomas Eakins
*Shad Fishing at Gloucester on
the Delaware River*, 1881
Oil on canvas, 12 × 18 inches
Ball State University, David Owsley
Museum of Art, Muncie, Indiana.
Elisabeth Ball Collection. Gift
of the George and Frances Ball
Foundation, 1995.036.010

(*below*)
Fig. 4.21 (Cat. 70)
(See also fig. 3.26, p. 116)
Julian Alden Weir
The Return of the Fishing Party,
1906
Oil on canvas, 22⅞ × 27¹⁵⁄₁₆ inches
High Museum of Art, Atlanta,
Georgia. Gift of Miss Mary E.
Haverty for the J. J. Haverty
Collection, 61.65

of work so ubiquitous that they are not even noticed anymore. Eakins's unsensationalized account embraces a formal flattening of affect akin to the deadening routine of labor itself.[79]

The manmade setting of Julian Alden Weir's 1906 *The Return of the Fishing Party* (fig. 4.21 [cat. 70]) is his frequently painted Branchville, Connecticut, farm, which he acquired in 1882 and expanded over the years.[80] In 1896, he constructed a fishpond by damming a stream on the property—a fitting endeavor given that the artist's surname means "a fence, as of twigs or stakes, set in a stream for catching fish."[81] In 1907, Charles H. Townsend, formerly of the U.S. Fish Commission and then director of the New York City Aquarium, remarked on the relatively new phenomenon of "experimenting with . . . artificial ponds on private estates in the vicinity of New York."[82] The cultivation of private fishponds was considered an increasingly viable alternative to fishing on public lands, where, according to Townsend, "the natural supply is being depleted by over-fishing and the pollution of waters."[83] Townsend detailed the challenges faced in engineering and maintaining fishponds; a flourishing one "require[s] intelligent care and considerable work" but is similar to raising livestock or growing produce.[84]

Weir's pond became a hub for both fishing and painting, often with friends. He had developed a passion for fishing from a young age.[85] Anticipating the arrival of spring in 1912, Weir wrote enthusiastically about the sport: "This is about my time to get loose on the streams and I assure you fishing is not all in catching fish. A day in the open on a dancing stream is most exhilarating and if I do say it, it is ideal."[86] Discussing a trip to England later that fall, he reveals his knowledge of the esteemed literature of the sport: "I visited and fished in the Dove, Isaak [*sic*] Walton's favorite stream. It was as clear as crystal and the fish were very scarce but the delight of those we got, very gamey and beautiful in color."[87] For someone who loved fishing so much, however, it rarely shows up in his paintings. Fishing was more of an outlet, a way to get away from art.[88] Indeed, the pursuit greatly vied for his attention, as he admitted: "I know not what I am best at. I believe I am a fisherman, dreamer and lover of nature and . . . if I lived to 120 I might become an artist."[89]

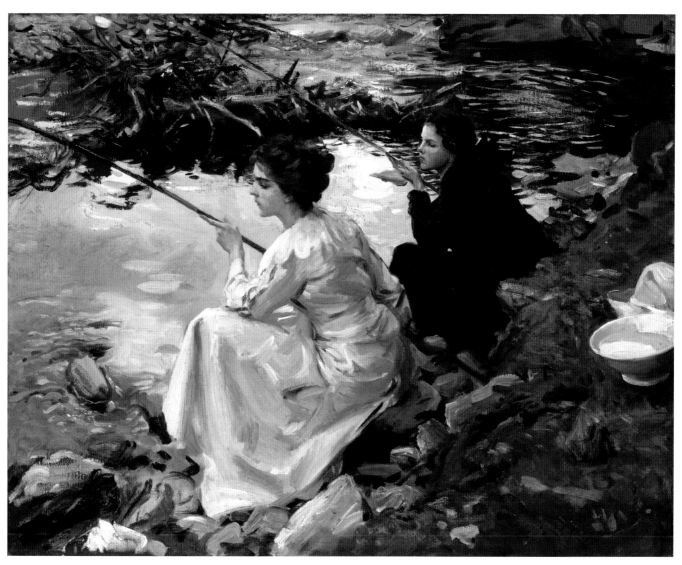

Fig. 4.22 (Cat. 61)
John Singer Sargent
Two Girls Fishing, 1912
Oil on canvas, 22 × 28¼ inches
Cincinnati Art Museum, Cincinnati,
Ohio. John J. Emery Fund, 1918.39

The Return of the Fishing Party shows a communal outing, possibly comprising Weir's daughters or other members of his family. Four women in white dresses assemble at the top of the path leading to the pond, while a fifth figure appears to ascend the hill. Weir withholds visual details about fishing except for the inclusion of poles. The activity of fishing, kept mostly unseen, belongs to the space beyond the foreground. The focus is more on an elegant summertime idyll—"the atmosphere is of a smoky enchantment," to quote one response.[90]

Weir's treatment of fishing lacks drama, and instead the painting indulges in the enjoyment of the rural sanctuary and the domestication of nature. Although figures seldom grace his landscapes, here they highlight a languid pause under the shady locale, even if incidental to it. They are "pretty women who . . . make decorative spots among the green masses," as another had it.[91] Weir's delicate brushstrokes—mostly short, horizontal dashes—befit the genteel overtones of his fishing subject. He reprised this theme around 1915. *The Fishing Party* (The Phillips Collection) depicts a view of the pond, over which stand several similarly

attired women with fishing poles on a bridge.[92] Both pictures, as friend and art collector Duncan Phillips recognized, "are for connoisseurs of rare beauty—not for sportsmen."[93]

Fishing was generally not considered an acceptable pastime for middle-class women for much of the nineteenth century.[94] But with the rise of fashionable resort culture and rural retreats, especially after the Civil War, fishing became one of several ostensibly innocent amusements available to women vacationers, along with swimming, tennis, and cycling.[95] Whether undertaken by the seaside or in the mountains, these vigorous pursuits could be controversial, however, raising some eyebrows over dress, decorum, and close physical contact with the opposite sex.[96] For young women of "the class possessing wealth, leisure and opportunities," noted an 1895 article, "out-of-door sports are finding greater favor each year."[97] Another, in 1904, recorded that "of late fishing has found more feminine followers and this summer it has become a sort of cult to go into the country and pursue the gamy trout."[98]

Among the many artists hosted at Weir's Connecticut estate was the expatriate John Singer

Fig. 4.23
John Singer Sargent
Girl Fishing at San Vigilio, 1913
Oil on canvas, 19½ × 28 inches
Private collection

Fig. 4.24 (Cat. 4)
George Wesley Bellows
Cleaning Fish, 1913
Oil on panel, 13¼ × 19½ inches
The Nelson-Atkins Museum of Art,
Kansas City, Missouri. Gift of
Mrs. Logan Clendening through
the Friends of Art, 47-31

Fig. 4.25
Nicolas Dorigny [after Raphael]
*The Miraculous Draught
of Fishes*, 1719
Etching and engraving on paper
© Victoria and Albert Museum,
London, United Kingdom.
Bequeathed by Rev. Alexander
Dyce

the decorous, the refined—that promulgated the importance of athletics and outdoor activities in salvaging toughness and masculinity. Bellows's art, commented a critic approvingly in 1914, possessed "strength—a great, broad, bulging muscular strength, a strength with all its imperfections and crudities, its advantages and disadvantages thrown at you in the raw." Like the brawny figures he depicts in *Cleaning Fish* (fig. 4.24 [cat. 4]), Bellows styled himself, to quote the critic, a "hard worker."[101]

The basic configuration of the painting's structure owes a debt to Raphael's famous tapestry cartoon, *The Miraculous Draught of Fishes*, from 1515–16 (fig. 4.25), the design of which is often reversed in subsequent prints after Raphael. Bellows's painting is also a mirror image of Raphael's, albeit revised, from the edge of coastline in the immediate foreground to the landmasses in the background. In both compositions, a frieze-like band of leaning, active bodies culminates in a calm, presiding figure. Though the total number of men has been reduced, and the hefty catch has moved ashore, it is as if the halos of Christ and his disciples have been reconstituted as the circular brims of the fishermen's hats in *Cleaning Fish*. In this borrowing, Bellows's arrangement does not necessarily retain the religious aspect of Raphael's scene, but it channels some of it into the idea of salvation through hard work. There is reverence for toil. The miracle of the Everyman's labor replaces Christ's miracle.

The anonymous fishermen are endowed with monumental dignity, even a sort of sanctity, in their occupation, yet they are not impervious to fatigue. Dory trawling, the system of fishing indicated here by the heavy boat and in Bellows's related 1913 painting *The Big Dory* (New Britain Museum of American Art), was extremely physically demanding as well as dangerous.[102] The position of the faceless men conjures the repetition and monotony of the assembly line, the manufacturing process that achieved its most influential application in the mass production of the Ford Model T automobile beginning in December that same year. The figures are all the more challenged by the squabble of seagulls that swarms around them like bursts of white spray from crashing ocean waves. The bulbous clouds—would-be boulders to shoulder—also

Sargent, whose *Two Girls Fishing* (fig. 4.22 [cat. 61]) and *Girl Fishing at San Vigilio* (fig. 4.23), from 1912 and 1913, respectively, were part of the expanding universe of fishing. In the earlier picture, Sargent's two nieces sit on the bank, extend fishing rods, and concentrate intently. The mountain stream flows into rippling pools, where Sargent deftly captures reflections of sky and clouds. This restful interlude in formal dress caused one reviewer to wonder, "Is it English or is it American?"[99] Female beauty in the natural world is again on display in Sargent's painting of the following year, but in this case the site is near a small picturesque village on Lake Garda, Italy. The wispy daubs that make up the pebbled shore and the surface of the sapphire water, into which the figure steps, produce a brilliant backlit effect.

George Bellows distinguished his own work from that of impressionists such as Weir or Sargent—the merely "pretty" paintings, as he saw it, cluttering New York exhibition gallery walls in 1910—and he advocated for an art that was instead alive with "manliness, [and] frankness."[100] His views were in keeping with the early twentieth-century rhetoric of "the strenuous life"—Theodore Roosevelt's prescription against the overly civilized,

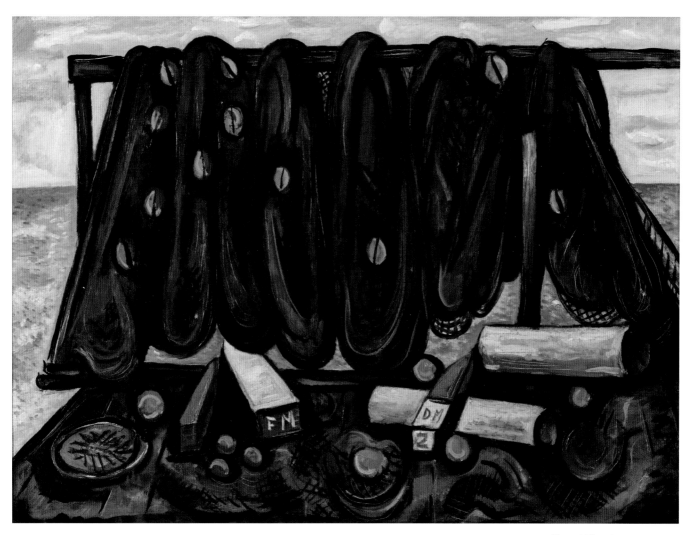

Fig. 4.26 (Cat. 27)
Marsden Hartley
Lobster Buoys and Nets, 1936
Oil on canvas, 18½ × 24 inches
Albritton Collection

Fig. 4.27
Marsden Hartley
*Young Hunter Hearing
Call to Arms*, ca. 1939
Oil on Masonite, 41 × 30¼ inches
Carnegie Museum of Art,
Pittsburgh, Pennsylvania.
Patrons Art Fund, 44.1.2

lend the scene a Sisyphean quality. Bellows's picture takes up the note of burdensomeness or disconsolation that art historian Hermann Grimm found in Raphael's cartoon a few decades prior: "He lets the lake expand under clouds that lose themselves in the distance and awakes a feeling of loneliness and being abandoned in us."[103] Bellows reworked that sense of being spiritually adrift toward a more general expression of respect for the existential quandary of daily struggle. Industrialization would threaten—indeed soon ruin—the livelihood of many fishermen.

Maine sea fisheries, which principally pursued deepwater cod and mackerel, had been declining since the 1860s.[104] On Monhegan Island in particular, fishing was as much a way of life as a monetary venture. About twenty miles from the mainland, it began as a station for English cod fishing in the seventeenth century before the founding of Plymouth Colony.[105] When Bellows first arrived on Monhegan in the summer of 1911, the island was "only inhabited by about a hundred people, fishermen and their families, who live there the year around."[106] Two small hotels catered to the few summer visitors, but Bellows stayed in a studio close to the beach—the better to see the fishermen at work. His Monhegan paintings from 1913, such as *Cleaning Fish*, suggest, in the ritualism of their sweat and strain, that the heroic feats they perform are part of the natural order. The rightmost man, leaning on the boat, continues the contour of the distant rock face. *Cleaning Fish* thus both reifies their actions and elevates the mighty Maine fishermen.

✦ ✦ ✦ ✦

Coastal and inland Maine became key fodder for Marsden Hartley from 1937 until his death in 1943. Intent on fashioning himself "the painter of Maine," Hartley returned to his home state with renewed interest in its rocky shoreline and mountain peaks, its lobstermen and lumberjacks.[107] *Lobster Buoys and Nets*, from 1936 (fig. 4.26 [cat. 27]), showcases his sensitivity toward the formal possibilities of New England dock pilings and coiled netting in a manner that almost veers from still life to abstract study of shapes and colors. When Hartley painted *Young Hunter Hearing Call to Arms* (fig. 4.27) around 1939, he had already been experimenting

with a blocky, simplified approach to human anatomy in his portraits. The chiseled figure, a Maine mountain man type, kneels among the spoils of the hunt. The raw physicality of Hartley's paint application—what the art critic Edward Alden Jewell characterized in the late paintings as "rugged and generally harsh, marked by stylizing of a rough-hewn sort"—reinforces this sense of strength and solidity.[108] The suggestively placed deer antlers intensify the flaunting of male virility.

With Europe engulfed by war in September 1939, Hartley's hunter would soon be a soldier. The memory of Hartley's friend (and possible lover), a German officer killed in battle in 1914, may have inspired the figure.[109] If so, the painting summons up the hero worship of Hartley's abstract War Motif series from that period and his fervent, if perhaps naive, infatuation with Germany in the thrall of World War I.[110] Particularly problematic is the conflation of New England backwoodsman and Aryan folk idol of the 1930s, as art historian Donna Cassidy has argued.[111] The blond hair, square jaw, and granite physique owe much to Hartley's complicated admiration for German culture and eroticization of Germans. The image also mixes Maine hunting garb and German folk attire.[112] The onset of World War II, however, made Hartley unable to "speak the word German with grace."[113]

Possibly because of the mitigating patriotism for its title, *Young Hunter Hearing Call to Arms* does not seem to have been understood as sympathetically German at Hartley's retrospective exhibition in 1944, when the United States was at war with the Axis power. Even though there is no military regalia here, its title smacks of a battle cry. The timely painting seems imbued with the intimation of war—and with what, in 1940, the poet William Carlos Williams called Hartley's "broader and deeper prescience."[114] Framed by luminous trees that meet like a Gothic arch, the hunter—his hair aglow in a radiant crown—takes on quasi-religious significance.[115] He is a sacrificial son. The barren trees and his hollow eye sockets emphasize this foreboding; the shape of his eyes rhymes with the fallen leaves, suggesting his own future demise. His face becomes a death mask. Hartley treads

on the universal theme of premature martyrdom. The painting elegizes not only a lost friend but other soon-to-disappear young men, whatever their nationality.

Young Hunter Hearing Call to Arms opens onto a broader examination of the way hunter and soldier were intertwined in the mid-twentieth century. Although a kinship between hunting and warfare has persisted throughout history, the image of the hunter became an exceptionally powerful and malleable metaphor around World War II. Leading up to and during the war years, the hunter was a figure charged with multilayered meanings on the home front. Soldier and sportsman were often understood as complementary representatives of the nation and hunting as the defining test of manliness in preparation for combat. An editorial, entitled "Sportsmen in the War," from early 1942, spoke, in rather grandiose terms, to the recurrent symbiosis between the two activities: "Never before has the sportsman been able to do so much for his country as he is doing today. Everyone can help, but none so much as the man who has kept himself fit through outdoor living, who owns guns and knows how to use them, and who doesn't get panicked when things go wrong. No other single group can offer as much as that." British entreaty for assistance amounted to a "call to American sportsmen for guns and ammunition," recently answered when the United States entered the war two months prior. The article further contends that hunting at home—"the big part we are playing in the war"—helps boost morale overseas.[116]

The martial underpinnings of Hartley's painting are close in spirit to Clifford K. Berryman's political cartoon from May 1941, *The Open Season for Eagles* (fig. 4.28), which appeared on the front page of the *Washington Star* in the wake of President Franklin D. Roosevelt's heated war of words with isolationist supporter Charles Lindbergh, the famed aviator. Berryman depicts the president as a hunter taking up arms against the appeasement stance of his long-time adversary, nicknamed "The Lone Eagle." (In the center flies "The Blue Eagle" emblem for the discarded National Recovery Administration, a New Deal program ruled unconstitutional in 1935.) In January, Lindbergh

had urged Congress to negotiate a neutrality pact with Hitler and then, at the end of April, had resigned from the Army Air Corps Reserve because of comments from Roosevelt.[117] The pressing question debated in these months was, how should America respond to the European crisis? As Roosevelt, recently reelected to his third successive term, prepared to make the leap to war, Lindbergh advocated keeping America from "meddling with affairs abroad."[118] In Berryman's drawing, the president looks across the water, toward distant shores, his gun muzzle smoking. The image implies that Roosevelt has his sights not just on Lindbergh but on leading the armed forces into strategic readiness to fight the Nazis as well. One irony of the image, however, is that Franklin Roosevelt eschewed the game hunter bravado of his cousin and predecessor president Theodore Roosevelt. In fact, FDR's administration prioritized wildlife preservation and

habitat development as never before.[119]

In June 1941, the month after Berryman's cartoon was published, the film *Man Hunt* premiered in New York City as part of the interventionist push. Directed by émigré Fritz Lang, recently naturalized after fleeing Nazi Germany, it tells the story of a professional big-game hunter who comes close to assassinating Hitler—he has the Führer in the crosshairs of his high-powered rifle in the opening sequence. Lang adapted the film from Geoffrey Household's *Rogue Male*, a novel serialized in the *Atlantic Monthly* over the summer of 1939 and published in full shortly thereafter, as Europe slid toward war. The British protagonist is, writes Household, "a sportsman who couldn't resist the temptation to stalk the impossible" and takes "a perverse pleasure in hunting the biggest game on earth," an unnamed, but thinly disguised, dictator.[120] Lang's film is a fever dream of political intrigue and paranoia mingled with hunter mythologizing; a reversal of fortunes finds the hero in the role of prey for much of the thriller. Months before Japan attacked Pearl Harbor, *Man Hunt* invited American audiences to identify with the civilian hunter vis-à-vis the war in Europe and to ponder the ramifications of their possible entrance.[121]

The hunter becomes the hunted in a 1943 painting by Andrew Wyeth (fig. 4.29 [cat. 73]). Across autumnal fields a single figure strides, wielding his double-barreled shotgun confidently and capably. The starkness of the season appealed to Wyeth for layering grim reverberations: "I prefer winter and fall, when you feel the bone structure in the landscape—the loneliness of it—the dead feeling of winter. Something waits beneath it—the whole story doesn't show."[122] The hunter stares at some spot outside the picture plane, away from the vertiginous, predatory vantage point in the upper tree branches. Wyeth's bleak approach—"the dead feeling"—moves into even darker territory in this painting. Here is a level of coolness "so ominous, [and] tragic," to borrow terms from one critic.[123] War whirs "beneath it" like a low hum. Growing up "reading old newspapers in my father's studio," recalled Wyeth, "I would spend hours poring over lists of [World War I] casualties, photographs of officers and enlisted men in uniform, and pictures

Fig. 4.28
Clifford Kennedy Berryman
The Open Season for Eagles, 1941
Drawing from *Washington Evening Star*, May 2, 1941.
Library of Congress Prints and Photographs Division, Washington, D.C., LC-DIG-ds-07745

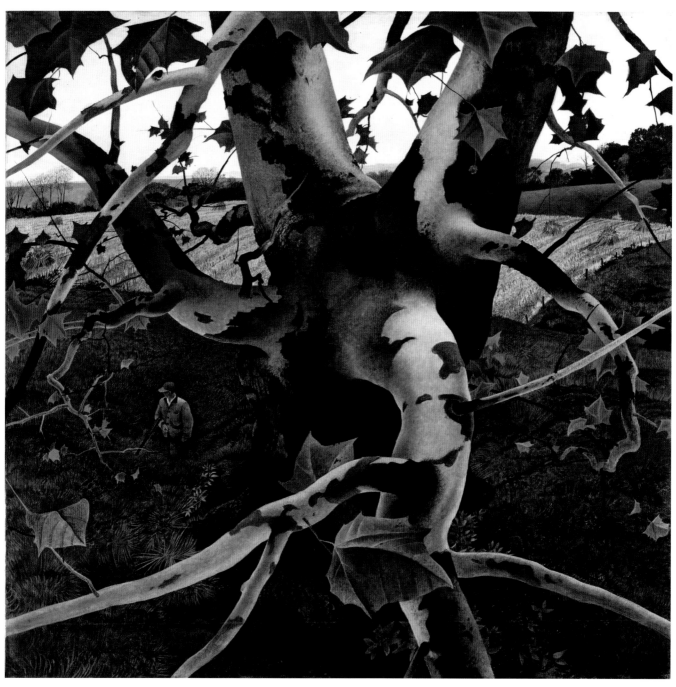

Fig. 4.29 (Cat. 73)
Andrew Wyeth
The Hunter, 1943
Tempera on Masonite,
33 × 33⅞ inches
Toledo Museum of Art,
Toledo, Ohio. Elizabeth C. Mau
Bequest Fund, 1946.25
© 2016 Andrew Wyeth/Artists
Rights Society (ARS), New York

of the front lines."[124] He knew its pivotal battles, decorated soldiers, and strategy of attrition. Military terminology consistently absorbed language from the animal world, and the expression "sniper's nest" seems apposite to *The Hunter*.[125]

The conditions of war inform the painting, demonstrated by the fact that it appeared on the October 16 cover of the *Saturday Evening Post*, an issue laden with articles related to the fighting.[126] Italy's declaration of war on its former partner Germany, only days prior, loomed large in the public consciousness that week. As fragments of this major reversal, consider two additional news items that weekend. On Friday, a headline in the *Boston Globe* baldly decreed that it is your "Patriotic Duty to Go Duck and Goose Hunting this Year."[127] On Sunday, an article in the *New York Times* discussed the danger of soldiers in combat unable to locate the enemy until "an unseen sniper's bullet knocks a man to the ground."[128] Wyeth's painting exists at the intersection of these discourses, in conversation with both kinds of articles. It sets that vulnerability to a "quick burst of fire" out of nowhere, as the latter article described, within the bounds of a stateside

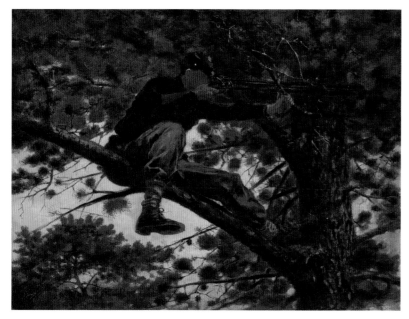

landscape.[129] Wyeth crystallizes the sense of being caught unaware when an enemy sniper's bullet can maim and kill with lightning swiftness.

The essentially square canvas makes it conducive to thinking about in terms of the circular telescopic sight of a rifle. More specifically, Wyeth's painting is reminiscent of one by a fellow Maine artist: Winslow Homer's *Sharpshooter* from 1863 (fig. 4.30). Aside from Wyeth's father, Homer stands as his decisive artistic forebearer.[130] He knew well, even deeply loved, Homer's work, and in *The Hunter* he offers a glimpse of sorts across the trunk of the other's tree. Both paintings feature brown tones set against pale skies and are punctuated by caps with red fixed atop obscured faces. In Wyeth's, the four heavy tree limbs, coalescing at the indentation of the trunk, appear almost as undulating crosshairs of a reticle. It is as if Wyeth has transplanted the viewer aloft into the position of the lone shooter in Homer's painting, giving us the view to the kill. "Some horrible thing—violence—always hits you in nature," Wyeth once remarked, and that unpredictable ferocity accords with *The Hunter*.[131] Cultural theorist Paul Virilio observes how in warfare, "Hand-to-hand fighting and physical confrontation were superseded by long-range butchery, in which the enemy was more or less invisible save for the flash and glow of his own guns."[132] Wyeth stages this invisibility in *The Hunter* by making the viewer the free-floating agent and witness. Later comments from his wife, Betsy, on Wyeth's art explicitly unite his interest in disembodiment with war: "He's talking about intangible speech, the sound of a voice that's not there anymore. The sense of history that's gone before. Wars that have been waged."[133] The complexity of *The Hunter* deepens by leaving something out so that "the whole story doesn't show"—the sudden horror and incorporeal reach of the sniper's deadly shot become more acute.[134]

Killing and concealment resonate in other ways in the painting. For comparison, Frank Weston Benson's *Pintails Decoyed* (fig. 4.31 [cat. 5]) evinces the subterfuge favored in bagging waterfowl: the hunter crouches at the dramatic center of the composition yet is easily missed because he is at one with the reeds. In World War II, military camouflage, derived from hunting traditions, was

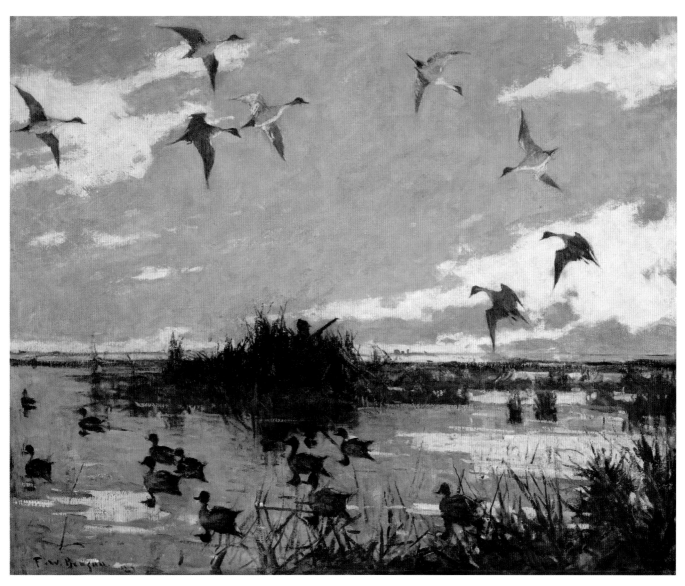

Fig. 4.31 (Cat. 5)
Frank Weston Benson
Pintails Decoyed, 1921
Oil on canvas, 36⅛ × 44⅛ inches
Museum of Fine Arts, Boston,
Massachusetts. Gift of Frederick L.
Jack, 35.1230

used in all phases of war on an unprecedented scale.[135] Methods of masking tanks and industrial facilities with netting or disruptive coloration, for example, certainly predate the conflict, but the 1940s gave rise to a new focus on the individual soldier's disguise on the field of battle. The United States first produced camouflage uniforms in 1942 and issued the so-called frog-skin, or duck-hunter, design extensively to troops in 1943. Snipers delivered a special tactical advantage and were among the earliest forces to wear the reversible garment.[136] Its three-color brown beach pattern closely resembles the distinctive bark of the American sycamore tree in *The Hunter*. The tree's tan and gray patches against a lighter trunk subsequently became identified with the splotchy shapes of military camouflage.[137] The genus of Wyeth's tree thus adds to the residual menace of the hidden sniper wearing fatigues as though a part of the terrain.

As U.S. government and civilian operations transformed for total war in these years, metal used in the manufacture of rounds was a precious commodity. From the beginning of the war, supplies of zinc and copper, for example, were in a precarious state due to escalating demand. The historian Maury Klein summarizes: "Brass, a vital component of cartridges, was a mixture of 70 percent copper and 30 percent zinc; military demands had already forced it out of the civilian economy. No one cared to contemplate what would happen if the country got into a shooting war."[138] These were anxious times.

Precisely how the conservation message exhorted on billboards and in magazines—"Do with less—so they'll have enough!"—altered the habits of hunters stateside is difficult to gauge. On the one hand, hunting for food was in keeping with the wartime trend of home-planted gardens, and thus hunters could potentially shoot game "to replace domestic beef and mutton needed for the armed forces."[139] On the other hand, the conditions imposed by the war were such that travel restrictions and gas rationing discouraged sportsmen from roaming too far and, as congressional findings put it in 1943, "the supply of ammunition for civilian use is approaching a low level."[140] The apparent curtailment of domestic hunting also had less predictable repercussions, disrupting the comparative equilibrium of the prewar years. "Unless the harvest of some species is continued, the natural increase will create serious overpopulations and cause conflicts with other land uses in certain areas," warned the congressional committee on conservation, noting in particular excesses of elk and deer. "The question becomes one of methods for continuing hunting and fishing during wartime, without endangering the American system of sport hunting and fishing."[141]

If soldiers had to contend with shortages of ammunition, hunters certainly had to make do.[142] Despite hopes "to obtain the release of adequate amounts of shotgun shells and cartridges for deer rifles, the situation is confusing and appears none too bright," said the New York State Conservation Department commissioner in fall 1943. Hunters were encouraged "to share their ammunition," for it was surmised that many had anticipated the "uncertain" outlook and amassed "sufficiently large private stocks." Alluding to the war, the commissioner estimated that at least one-third of the usual deer hunters in the state that season were "now hunting bigger game elsewhere."[143] In fall 1944, the War Production Board, by one count, allocated to "release approximately 500,000 shells—about 75 percent of a normal supply."[144]

The industrial materials shortage awakened a new conscientiousness about recycling and the search for scarce metals to bring back into war production. Drives to recover scrap metal were held everywhere, from baseball games to theaters.[145] To alleviate the shortage, the War Production Board also spread the word through a concentrated nationwide campaign to collect scrap metal in the lost corners of rural America, insisting to farmers, "There's a Bomb in Your Barnyard!" Notices in publications such as *Farm Business News* and *Agricultural Leaders' Digest* declared, "It's a dud, now. Just a pile of junk. It's your scrap metal! Rusting away and no earthly good to you or to the courageous men fighting this war. They need it. Their lives depend on it. Your lives depend on it. Let Uncle Sam load this bomb for you!" The announcements added, "By far the biggest pile of scrap metal left in America is on farms." An average farm could generate seven hundred pounds of scrap.[146]

With this context in mind, consider George Ault's *The Hunter's Return* (fig. 4.32). The approaching figure seems to pause before the pieces of disused farm equipment in the dilapidated outbuilding. The general air of neglect—sagging eaves and pierced roof—contributes to the sense of the contents likewise "rusting away." The farm is not merely out-of-season but a more worrisome and inscrutable symbol. We might go so far as to say it has a bombed-out appearance. In the silence and remoteness of the setting, the war feels worlds away. And yet the scene also evokes the farms laid waste on the European continent and under siege in Britain.[147] *The Hunter's Return* thus relays "the disintegration of our times that he felt," to quote Ault's wife, Louise, on a work of his from 1944.[148] The portents of the war years cast a shadow over the painting, which lends itself to the phrase "scorched earth."

The swirly, ashen road is a continuation of the clouds in both color and pattern, reminding that forces from the sky—be they weather or bombs—affect the land below. The aerial and the earthbound, the upward reaching and the downward looking, the global and the local, interplay here. The incisions on the roof pick up the repeated bands of clouds to the right of the tree—more crisp and regular, to be sure, but echoes of the other no less. This formal rhyme further implies a causal relationship between the two realms. The thick, moody cloud cover—so like plumes of smoke—carries the wartime gloom of this moonlit walk home. The amputated tree, as if the charred remainder of a telegraph or power line pole decimated in a blast, also hints at overhead clashes. The tree is very similar in shape and size to the one at the center of Ault's *Black Night: Russell's Corners* (Pennsylvania Academy of the Fine Arts), another 1943 painting whose emotional power, as art historian Alexander Nemerov has shown, carefully registers wartime disquietude.[149]

The derelict edifice of *The Hunter's Return*, however, lacks the wholeness and fitness of those found in *Black Night* and elsewhere, and the hunter seems strangely arrested by it. The dark cavity serves as the visible counterpart to the interior melancholy of the man's mind. Similar red and black color schemes link figure and building; the barrel of his gun also parallels the lower board at its threshold and leads the viewer's eye back into the shadows. The painting asks us to contemplate the two together, to read their histories, their characters, their fates, as mutually entwined—just as those aspects of the building are entwined with the tree itself. Ault's conception of return here is a far cry from the triumphal reintegration into family life that Thomas Cole depicted nearly one hundred years earlier (fig. 4.33 [cat. 18]). Instead, the downcast hunter arrives empty handed, his gun neutered to almost a walking stick. The painting's difference—its emphasis on solitariness and introspection—helps convey the weight of the catastrophe. As one WWII major general would later reflect: "Every soldier learns in time that war is a lonely business."[150] Ault's painting thereby

Fig. 4.32
George Ault
The Hunter's Return, 1943
Oil on canvas, 20¼ × 16¼ inches
Private collection

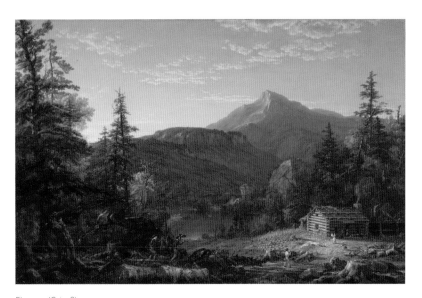

Fig. 4.33 (Cat. 18)
(See also fig. 1.27, p. 53)
Thomas Cole
The Hunter's Return, 1845
Oil on canvas, 40⅛ × 60½ inches
Amon Carter Museum of American
Art, Fort Worth, Texas, 1983.156

reframes the notion of return: returning soldiers will face unexpected challenges in adjusting to the new realities of a changed American society.

John Atherton, like Wyeth, produced covers for the *Saturday Evening Post*, among other periodicals.[151] In addition to his commercial projects for publishers, Atherton was integrally involved with the war effort from the beginning as a poster artist. In April 1941, the Museum of Modern Art in New York sponsored a competition to bring new poster artists to the attention of government agencies in need of commissioning their services. A pool of notable contestants submitted to the competition, publicized as an exhibition of contemporary poster design. Atherton won for his "Buy a Share in America" poster, promoting the purchase of defense savings bonds and stamps from the U.S. Treasury.[152] As was often the case, this image calls on all Americans to share in the responsibility of national defense—every citizen a soldier, so goes the Jeffersonian motto.

Against the backdrop of the rapidly escalating war, Atherton also painted *Fisherman's Paradise* (fig. 4.34 [cat. 1]) that year. The paradise of the title signals an extraordinary location, but instead of a lush open-air environment—a bountiful stream, say—Atherton offers a still life on a shallow shelflike space. The arrangement of upright fishing rod case and detached fishing reel, its line dangling among fishing lures and the silhouette of a fish, presents an

odd compromise. Not only is there no creel overflowing with fish, but there is not even an actual fish in the scene—no tangible reward from the waters, just the tease of the slightly wrinkled cutout. Nor does this assemblage of equipment motion toward future action; the case is shut, the rod stowed, the line tangled. This is paradise deferred. The war seems to enter obliquely—Atherton served during World War I—as a soldier might leave behind such treasured objects, and the promise of the glorious catch, when deployed.

It is as though the dry misdirection of the title also presages the imminent consequences of war on the activities of sport fishermen. Soon the government introduced a wide-ranging limitation order that "restrict[ed] the use of any critical material or iron and steel in the processing, fabrication, assembly or repair of any fishing tackle product or part therefor."[153] This stipulation applied to all metal fishing gear—hooks, lines, sinkers, and so forth—and would not have escaped the notice of Atherton, a dedicated angler. An illustrator for *Sports Afield*, along with other outdoor magazines, and author of *The Fish and the Fly* (1951), a seminal book on the sport, Atherton eventually drowned while fishing.[154] It was not until the final stages of the war, with the return to "recreational normalcy" in view, that the War Production Board "authorized increased production of rods, reels and other fishing tackle." This was regarded "as a definitive break for America's sports-loving millions," who, together with the nation at large, began to collectively exhale as the war approached its end. The paradisiacal bliss of life off duty—of R&R, the military jargon for rest and recuperation—seems to be postponed in Atherton's 1941 painting as well.[155] "Even the Army and Navy agree that there is nothing quite so good for the nerves as a day in a boat or on the bank trying to tempt bass or trout," noted the *New York Times* late in 1944, mere weeks before the bloody Battle of the Bulge. "They encourage convalescing war veterans to go fishing as often as possible."[156]

Recreation and hostilities come together in Miklos Suba's *20 Shots, 5 Cents* (fig. 4.35). In this carnival shooting gallery, the bands of primary colors frame the central objects after the fashion of

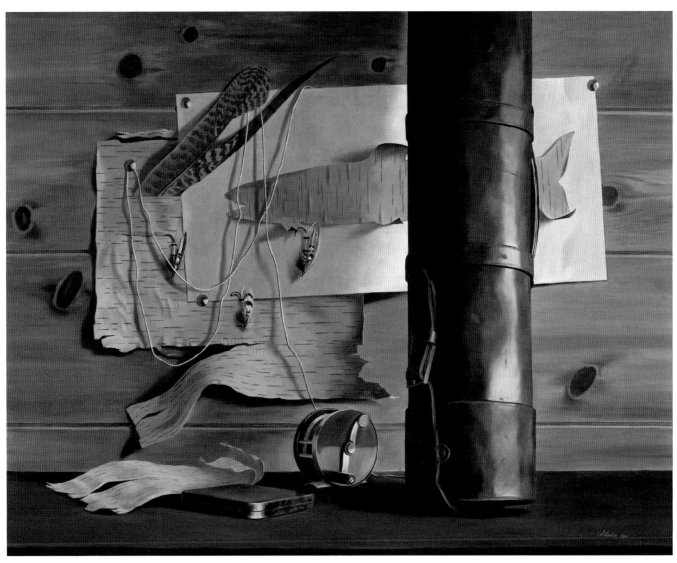

Fig. 4.34 (Cat. 1)
John Atherton
Fisherman's Paradise, 1941
Oil on canvas, 24 × 30 inches
The John and Susan Horseman
Collection of American Art

concentric circles on a target. Military and animal figurines compete for the shooter's attention: warships (on the top level) and ducks (on the fourth level). The shooting gallery is both a distraction from war and a training ground for it. Down at Coney Island, in the off hours, young and old alike could play war, performing in the guise of servicemen, as the point of view here provokes us to pull the trigger.[157] To stress the high stakes of amusement, Suba has emblazoned "We Have Japs to Shoot" across the lower edge of the watercolor, printing the offensive, jingoistic shorthand for Japanese fighters. Game hunting in these years was rarely just a game.

During the last months of the war, cartoonist Edwin Marcus portrayed the Allied Forces as a hunter (fig. 4.36). The carcass of a wolf—inscribed Nazi—lies at his feet; another—Japan—snarls aggressively on the horizon. Published a few days after Germany surrendered and Victory in Europe Day celebrations ensued, Marcus's image reminded

that, though the European theater may be over, the hunter's mission was incomplete: Japan still threatened. Tightly gripping his weapon, the Lincolnesque figure tenses to discharge it again. Other conflations between hunter and soldier relied on similar animalistic denigrations of the enemy. For example, in discussing the finer points of stalking quarry—it requires "experience, care, shrewdness and patience, to get within range"—a 1943 *Boys' Life* article counsels, "You can practice the same thing on any wild animal (or a Jap)."[158] The hunt was an arena where masculine authority could be negotiated and codified in anticipation of warfare. The instinct for destruction could be forged, character built, violence orchestrated—hunting as a socially acceptable way of breaking down the inner resistance to taking a human life.

In the postwar aftermath, Adolph Gottlieb's pictographic paintings *Omen for a Hunter* (1947; New Britain Museum of American Art) and *Hunter and Hunted* (1948; private collection)

Fig. 4.35
Miklos Suba
20 Shots, 5 Cents, 1943
Pen, ink, and watercolor on paper,
13⅞ × 16⅞ inches
Estate of Susanne Suba on loan
to the Brooklyn Historical Society,
Brooklyn, New York

incorporated motifs associated with the hunt to plumb the irreparable trauma wrought by the worldwide devastation. Each surface teems with a semiabstract maze of weapons, targets, disembodied eyes, and schematic faces in rectangular compartments. These vaguely hieroglyphic, Jungian-inspired forms approximate a degree of disorientation and inner turmoil, struggling to emerge from unconscious depths.[159] The trope of the hunter-cum-combatant continued in subsequent reflections on overseas military conflicts, as evident from the titles of James Salter's novel *The Hunters* (1956), based on his own experience in the Korean War, and of director Michael Cimino's film *The Deer Hunter* (1978), centered on three friends sent to Vietnam. The film in particular takes the slippage from hunting animals to hunting humans into the evocative territory of parable. Hunting is a rite of passage that leads not only to manhood but also to military service, and inexorably to a more profound loss of innocence—to the utmost physical damage and psychic anguish. In 1936, on the cusp of the Spanish Civil War—that monstrous prelude to World War II—Ernest Hemingway, no stranger to both blood sports and battle, may have best encapsulated the darker psychological implications of hunting and war, disclosing that forsaken zone when the veneer of civilization wears thin:

"Certainly there is no hunting like the hunting of man and those who have hunted armed men long enough and liked it, never really care for anything else thereafter."[160]

Fig. 4.36
Edwin Marcus
One Killer Still at Large, 1945
Drawing for the *New York Times*, May 13, 1945
Library of Congress, Prints and Photographs Division, Washington, D.C., LC-DIG-ds-07965

NOTES

1. For a recent discussion of Boone and the long hunt, see Meredith Mason Brown, *Frontiersman: Daniel Boone and the Making of America* (Baton Rouge: Louisiana State University Press, 2008), 28–38. Boone was essentially a hero of the Jacksonian era: at least seven biographies of him were published between 1833 and 1860, according to Daniel Justin Herman, "The Other Daniel Boone: The Nascence of a Middle-Class Hunter Hero, 1784–1860," *Journal of the Early Republic* 18 (Fall 1998): 429–57. The recasting of Boone in the nineteenth century in some ways tracks the categorical shift from political individualism to economic individualism, a framework put forth in Stephanie M. Walls, *Individualism in the United States:*

A Transformation in American Political Thought (New York: Bloomsbury Academic, 2015).
2. Alan Wallach, "Thomas Cole: Landscape and the Course of American Empire," in *Thomas Cole: Landscape into History*, ed. William H. Truettner and Alan Wallach (New Haven, Conn.: Yale University Press in association with the National Museum of American Art, 1994), 29.
3. "Nature in transition" is the phrase used to describe this and related paintings by Cole in "Catalogue of the Exhibition," in ibid., 172.
4. For Boone in this context, see Michael Kimmel, *Manhood in America: A Cultural History*, 3rd ed. (New York: Oxford University Press, 2012), 46–47.

5. Richard Slotkin, *Regeneration through Violence: The Mythology of the American Frontier, 1600–1860* (Norman: University of Oklahoma Press, 2000), 21, 267, 307.

6. For Walker's reputation, see Lisa Strong, *Sentimental Journey: The Art of Alfred Jacob Miller* (Fort Worth, Tex.: Amon Carter Museum, 2008), 209n19. For discussion of the portrait, see 168–72. Walker's record of violence is contentious; see especially Cheryll Glotfelty, "Embedded in the 'Battle of the Lakes': A Report from the Textual Frontlines of the 1833 Humboldt Sink Massacre," *ATQ* 18 (December 2004): 277–97.

7. For Peale's production of these works—modeled on his *Patriae Pater* (1824; United States Senate Collection)—in the 1840s in particular, see Lillian B. Miller, *In Pursuit of Fame: Rembrandt Peale, 1778–1860* (Washington, D.C.: National Portrait Gallery, Smithsonian Institution in association with the University of Washington Press, 1992), 231; and Carol Eaton Hevner, "The Paintings of Rembrandt Peale: Character and Conventions," in Miller, 280.

8. Relatedly, a deer occupies the foreground of Cole's *From the Top of Kaaterskill Falls* (1826; Detroit Institute of Arts). Cole also listed "Deer hunt" as a possible subject in his sketchbook (dated 1827 but running throughout his life). See Earl A. Powell, *Thomas Cole* (New York: Abrams, 1990), 131.

9. John Fletcher, *Deer* (London: Reaktion Books, 2014), 155.

10. Wallach, "Thomas Cole," 33.

11. "Common Deer," in *The Cabinet of Natural History and American Rural Sports*, vol. 1 (Philadelphia: J. and T. Doughty, 1830), 6, 7.

12. See Robert F. Looney, "Thomas Doughty, Printmaker," *Imprint: Journal of the American Historical Print Collectors Society* 4 (1979): 2–10; and Kenneth Haltman, *Looking Close and Seeing Far: Samuel Seymour, Titian Ramsay Peale, and the Art of the Long Expedition, 1818–1823* (University Park: Pennsylvania State University Press, 2008), 188–90.

13. For Doughty's painting, see Gerald Carr, "Thomas Doughty," in *American Paintings in the Detroit Institute of Arts*, vol. 1 (New York: Hudson Hills Press in association with the Founders Society, Detroit Institute of Arts, 1991), 72–74.

14. "After the Chase," *Aldine*, November 1872, 227.

15. See, for example, Anne Rooney, *Hunting in Middle English Literature* (Cambridge: D. S. Brewer, 1993). For a contemporary account of the sexuality of hunting, see Brian Luke, *Brutal: Manhood and the Exploitation of Animals* (Urbana: University of Illinois Press, 2007), 81–108.

16. Sean Benson, "'If I do prove her haggard': Shakespeare's Application of Hawking Tropes to Marriage," *Studies in Philology* 103 (Spring 2006): 186–207. For an example of a much earlier image connecting falconry and courtship, see Israhel van Meckenem's engraving *The Falconer and the Lady* (ca. 1495; Metropolitan Museum of Art); and Nadine M. Orenstein's discussion in "Renaissance and Baroque Europe," *Metropolitan Museum of Art Bulletin* 61 (Autumn 2003): 16.

17. "Falconry," *Dollar Monthly Magazine*, January 1863, 78. For Hovenden's painting, see Anne Gregory Terhune with Patricia Smith Scanlan, *Thomas Hovenden: His Life and Art* (Philadelphia: University of Pennsylvania Press, 2006), 59–62. For the broader fad for historical revival scenes, see also Eric M. Zafran, *Cavaliers and Cardinals: Nineteenth-Century French Anecdotal Paintings* (Cincinnati, Ohio: Taft Museum, 1992).

18. Vance Thompson, "Falconry in France," *Outing*, December 1901, 296.

19. "About Hawks and Hawking," *Frank Leslie's Popular Monthly*, March 1887, 335.

20. "A Use for Falconry," *Forest and Stream*, October 21, 1886, 241. See also "Falconry in America," *Overland Monthly*, April 1875, 356–60; and Charles Q. Turner, "The Revival of Falconry," *Outing*, February 1898, 472–80.

21. See Francis Henry Salvin and William Brodrick, *Falconry in the British Isles*, 2nd ed. (London: John Van Voorst, 1873).

22. H. P. U., "The Ideal Sportsman," *Forest and Stream*, December 29, 1881, 429. See also "Deer in the Adirondacks," *New York Times*, February 14, 1886, 6.

23. David Tatham, *Winslow Homer in the Adirondacks* (Syracuse, N.Y.: Syracuse University Press, 1996), 111.

24. Lynn Tew Sprague, "Ethics and the Sportsman," *Forest and Stream*, June 21, 1902, 484.

25. A useful period definition: "One who hunts or fishes for profit, regardless of close seasons, the waste of game, or the pleasure to be derived from the pursuit." *The Century Dictionary: An Encyclopedic Lexicon of the English Language*, vol. 6 (New York: Century, 1897), 4652.

26. Philip G. Terrie, *Forever Wild: A Cultural History of Wilderness in the Adirondacks* (Syracuse, N.Y.: Syracuse University Press, 1994), 72–73.

27. "Canvas-Back and Terrapin," *Scribner's Monthly*, November 1877, 2–3.

28. For Homer's painting, see Nicolai Cikovsky, Jr., "Reconstruction," in *Winslow Homer*, by Nicolai Cikovsky, Jr., and Franklin Kelly (Washington, D.C.: National Gallery of Art, 1995), 127. For objections to jack shooting and other hunting practices, see, for example, "Adirondack Deer," *Forest and Stream*, January 25, 1896, 67. In Homer's

The Trapper (1870; Colby College Museum of Art), a nearly identical painting, the jacklight stands upright in the bow of the canoe.

29. Terrie, *Forever Wild*, 48.

30. "William Chase, Marksman," *New York Herald*, November 25, 1894, 3.

31. The quotation is Lloyd Goodrich paraphrasing sportswriter Clarence Cranmer. Lloyd Goodrich, *Thomas Eakins* (Cambridge, Mass.: Harvard University Press for the National Gallery of Art, 1982), 220. Harrison S. Morris notes Chase's "skill with a pistol" in *Confessions in Art* (New York: Sears, 1930), 95. See also Keith L. Bryant, Jr., *William Merritt Chase: A Genteel Bohemian* (Columbia: University of Missouri Press, 1991), 191.

32. "A Rabble Hunting Deer," *New York Times*, November 15, 1894, 15.

33. "Deer Shooting on Long Island," *New York Times*, March 8, 1896, 25.

34. Caspar Whitney, "The Sportsman's View-Point," *Outing*, September 1900, 676. For the problem of pot hunters on Long Island, see also "Pot Hunting on Long Island," *Forest and Stream*, October 8, 1874, 137; and "Sport for the Hunters," *New York Times*, November 2, 1891, 10.

35. For Homer's watercolor, see, among others, Helen A. Cooper, *Winslow Homer Watercolors* (Washington, D.C.: National Gallery of Art, 1986), 186; Eleanor Lewis Jones, "*Deer Drinking*: Reflections on a Watercolor by Winslow Homer," *Smithsonian Studies in American Art* 2 (Autumn 1988): 61–64; and Tatham, *Winslow Homer*, 111.

36. Alfred Trumble, "Notes for the New Year," *Collector*, January 1, 1892, 71.

37. I rely principally on Nicolai Cikovsky, Jr., "Something More than Meets the Eye," in Cikovsky and Kelly, *Winslow Homer*, 251–53, 275; and Randall C. Griffin, *Homer, Eakins, and Anshutz: The Search for American Identity in the Gilded Age* (University Park: Pennsylvania State University Press, 2004), 117–19.

38. "Deer in the Adirondacks," *New York Times*, March 16, 1890, 17.

39. "Art Notes," *Critic*, April 16, 1898, 271. For an overview of Homer's travels to the region, see David Tatham, "Winslow Homer in Quebec," in *Winslow Homer: Artist and Angler*, by Patricia Junker and Sarah Burns (Fort Worth, Tex.: Amon Carter Museum, the Fine Arts Museums of San Francisco, and Thames and Hudson, 2002), 125–59.

40. Lloyd Goodrich, *American Watercolor and Winslow Homer* (Minneapolis, Minn.: Walker Art Center, 1945), 43.

41. Charles G. D. Roberts, "Poet and Buckboard on the Saguenay River," *Outing*, July 1887, 336.

42. George Bird Grinnell, "The Antelope," in *Sport with Gun and Rod in American Woods and Waters*, ed. Alfred M. Mayer (New York: Century, 1883), 309.

43. Geo. McAleer, "Trees and Men," *Forest and Stream*, January 12, 1893, 29.

44. Grinnell features prominently in John F. Reiger, *American Sportsmen and the Origins of Conservation*, 3rd ed. (Corvallis: Oregon State University Press, 2001).

45. "Field Sports," *New York Times*, January 12, 1874, 2.

46. Alf Evers, *The Catskills: From Wilderness to Woodstock* (Garden City, N.Y.: Doubleday, 1972), 64–65.

47. Fred Mather, "Our Fishes," *Forest and Stream*, June 23, 1881, 403.

48. Charles Hallock, *The Fishing Tourist: Angler's Guide and Reference Book* (New York: Harper and Brothers, 1873), 26–27.

49. Teresa A. Carbone, *American Paintings in the Brooklyn Museum: Artists Born by 1876*, vol. 1 (Brooklyn, N.Y.: Brooklyn Museum in association with D. Giles, London, 2006), 326.

50. Martingale [Charles White], *Sporting Scenes and Country Characters* (London: Longman, Orme, Brown, Green, and Longmans, 1840), 299, 301, 303.

51. John I. H. Baur, ed., *The Autobiography of Worthington Whittredge (1820–1910)* (New York: Arno Press, 1969), 42.

52. Ibid., 60.

53. For Whittredge's painting, see Kevin Sharp, *Poetic Journey: American Paintings from the Grey Collection* (New Britain, Conn.: New Britain Museum of American Art, 2007), 25.

54. Henry David Thoreau, *A Week on the Concord and Merrimack Rivers, Walden and Other Writings* (New York: Bantam, 2004), 41.

55. "Worthington Whittredge," *Aldine*, December 1, 1879, 373.

56. Baur, *Autobiography*, 42.

57. T. Addison Richards, "The Catskills," *Harper's New Monthly Magazine*, July 1854, 153.

58. T. Addison Richards, *Appletons' Illustrated Hand-Book of American Travel* (New York: Appleton, 1857), 12–13.

59. David Stradling, *The Nature of New York: An Environmental History of the Empire State* (Ithaca, N.Y.: Cornell University Press, 2010), 35.

60. Alf Evers, *The Catskills: From Wilderness to Woodstock* (Garden City, N.Y.: Doubleday, 1972), 335.

61. Ibid., 338.

62. "The Pollution of Rivers," *Forest and Stream*, March 27, 1884, 169. For some mid-1870s sources addressing the pollution of waterways, see "Pollution of Rivers," *Forest and Stream*, February 5, 1874, 409; "Fish

Culture: Wholesale Pollution of Rivers," *Forest and Stream*, April 29, 1875, 182; "Scientific and Sanitary: The Pollution of Rivers," *Christian Union*, June 23, 1875, 540; "Fish Culture: Pollution of Rivers," *Forest and Stream*, August 10, 1876, 2; and J. H. Batty, "Fish Culture: Pollution of New York Waters," *Forest and Stream*, August 31, 1876, 51.

63. Evers, *Catskills*, 588. For discussions of fish restocking during this decade, see, for example, A. S. Collins, "Fish Culture—No. IV: Stocking Streams with Trout," *New York Observer*, September 19, 1872, 304; and "Progress in Fish Culture," *Scientific American*, August 2, 1879, 71.

64. Fred Mather, "Our Fishes," *Forest and Stream*, June 23, 1881, 403.

65. *Ellenville Journal*, September 1, 1899, quoted in Evers, *Catskills*, 677. In the early 1900s, efforts of the newly established New York State Fisheries, Game, and Forest Commission focused on stream and river pollution in the interest of protecting fish. Enforcement of laws was stricter when fishermen lodged complaints about the quality of mountain water. Water quality in the Catskills would continue to be an ongoing issue with the construction of the Catskill Aqueduct, completed in 1916, and its subsequent integration into New York City's larger water supply system. See Stradling, *Nature of New York*, 149–50.

66. David Soll, *Empire of Water: An Environmental and Political History of the New York City Water Supply* (Ithaca, N.Y.: Cornell University Press, 2013), 22.

67. Michael Kudish, *The Catskill Forest: A History* (Fleischmanns, N.Y.: Purple Mountain Press, 2000), 71.

68. For Gifford's painting, see the entries by Kevin J. Avery in *Hudson River School Visions: The Landscapes of Sanford R. Gifford*, ed. Kevin J. Avery and Franklin Kelly (New York: Metropolitan Museum of Art), 175–78; and in *American Paradise: The World of the Hudson River School*, ed. John K. Howat (New York: Metropolitan Museum of Art, 1987), 229–31.

69. See Joseph A. Arnold, "James Wallace Pinchot," *Yearbook of the United States Department of Agriculture, 1907* (Washington, D.C.: Government Printing Office, 1908), 495–97; and Nancy P. Pittman, "James Wallace Pinchot (1831–1908): One Man's Evolution toward Conservation in the Nineteenth Century," *Yale Forestry and Environmental Studies Centennial News* (Fall 1999): 4–7. His son, Gifford Pinchot—named for the artist, his godfather—was a leading figure in forestry conservation. He served as the first head of the United States Forest Service under President Theodore Roosevelt and is credited with coining

the phrase "conservation of natural resources." See Gifford Pinchot, *The Conservation of Natural Resources* (Washington, D.C.: U.S. Department of Agriculture, 1908); and Char Miller, *Gifford Pinchot and the Making of Modern Environmentalism* (Washington, D.C.: Island Press, 2001).

70. "A Catskill Brook," *Aldine*, April 1873, 82.

71. James Owen, *Trout* (London: Reaktion Books, 2012), 67–68.

72. Baur, *Autobiography*, 55.

73. Anthony F. Janson, *Worthington Whittredge* (New York: Cambridge University Press, 1989), 105. For the forest interiors of the 1870s, see 142–51.

74. "American Landscape Painters," *New Englander*, January 1873, 151.

75. John McPhee, *The Founding Fish* (New York: Farrar, Straus and Giroux, 2002), 156.

76. John Gay, "The Shad Streams of Pennsylvania," in *Report of the State Commissioners of Fisheries for 1888–1891* (Harrisburg, Penn.: State Printer, 1891), 182–83.

77. For Eakins and polluted waters around Philadelphia, see Alan C. Braddock, "Bodies of Water: Thomas Eakins, Racial Ecology, and the Limits of Civic Realism," in *A Keener Perception: Ecocritical Studies in American Art History*, ed. Alan C. Braddock and Christoph Irmscher (Tuscaloosa: University of Alabama Press, 2009), 129–50.

78. "The Fine Arts," *Philadelphia Evening Telegraph*, October 17, 1881, 4. On the photographic sources for these paintings, see Kathleen A. Foster, *Thomas Eakins Rediscovered: Charles Bregler's Thomas Eakins Collection at the Pennsylvania Academy of the Fine Arts* (New Haven, Conn.: Yale University Press, 1997), 163–77; and Mark Tucker and Nica Gutman, "Photographs and the Making of Paintings," in *Thomas Eakins*, ed. Darrel Sewell (Philadelphia: Philadelphia Museum of Art in association with Yale University Press, 2001), 227–34.

79. Of Eakins's paintings, Marc Simpson has noted: "Men working out-of-doors was a peculiarly modern subject"; Marc Simpson, "The 1880s," in Sewell, *Thomas Eakins*, 111.

80. For a discussion of Weir at Branchville, see H. Barbara Weinberg, Doreen Bolger, and David Park Curry, *American Impressionism and Realism: The Painting of Modern Life, 1885–1915* (New York: Metropolitan Museum of Art, 1994), 59–61.

81. *The Century Dictionary and Cyclopedia*, vol. 8 (New York: Century, 1897), 6872.

82. Charles H. Townsend, "The Cultivation of Fishes in Small Ponds," in *Transactions of the American Fisheries Society at Its Thirty-sixth Annual Meeting* (Appleton, Wisc.: Post Publishing, 1907), 128.

83. C. H. Townsend, "The Private Fish Pond: A Neglected Resource," in *Ponds, Pond Fish, and Pond*

Fish Culture, by Lewis Lindsay Dyche (Topeka: Kansas State Printing Office, 1914), 189.

84. C. H. Townsend, "Cultivating Fishes in Your Own Pond," *Outing*, June 1907, 376.

85. See Dorothy Weir Young, ed., *The Life and Letters of J. Alden Weir* (New Haven, Conn.: Yale University Press, 1960), 8–9. For a reminiscence of Weir's fishing prowess, see H. de Raasloff, "Weir the Fisherman," in *Julian Alden Weir: An Appreciation of His Life and Works* (New York: Dutton, 1922), 89–97.

86. Quoted in Young, *Life and Letters*, 242.

87. Ibid., 243.

88. See Duncan Phillips, "Julian Alden Weir," in *Julian Alden Weir*, 34.

89. Quoted in Young, *Life and Letters*, 247.

90. James Huneker, "The Seven Arts," *Puck*, October 30, 1915, 10.

91. "Art Notes of the Month," *Independent*, January 31, 1907, 259.

92. See Doreen Bolger Burke, *J. Alden Weir: An American Impressionist* (Newark: University of Delaware Press, 1983), 237.

93. Duncan Phillips, "Julian Alden Weir," in *Julian Alden Weir*, 33–34.

94. Cindy S. Aron, *Working at Play: A History of Vacations in the United States* (New York: Oxford University Press, 1999), 27.

95. Ibid., 80, 88.

96. See ibid., 69–100. Relatedly, regarding the fishing woman in the French artist Georges Seurat's *A Sunday on La Grande Jatte* (1884–86; Art Institute of Chicago), Hajo Düchting notes: "Fishing ladies (unaccompanied) were at the time considered to be 'easy' women, as is also suggested by the similarity between the French words *pêcheuse*, meaning 'fisherwoman,' and *péché*, 'sin,' and *pécher*, 'to sin.'" Hajo Düchting, *Seurat* (New York: Taschen, 1999), 36.

97. Arthur F. Rice, "The Sportswoman," *Forest and Stream*, January 26, 1895, 62.

98. Mabel Percy Haskell, "Trout Fishing for Women," *Town and Country*, June 11, 1904, 22. See also W. R. Gilbert, "Women and Sport," *Health*, January 1910, 8.

99. Lorinda Munson Bryant, "Our Great Painter John Singer Sargent and Some of His Child-Portraits," *St. Nicholas*, November 1923, 5.

100. Quoted in Lauren Lessing and Sally Mills, "George Wesley Bellows (1882–1925)," in *The Collection of the Nelson-Atkins Museum of Art: American Paintings to 1945*, vol. 1, ed. Margaret C. Conrads (Kansas City: The Nelson-Atkins Museum of Art, 2007), 47. For a discussion of Bellows and manliness, see Marianne Doezema, *George Bellows and Urban America* (New Haven, Conn.: Yale University Press, 1992), 67–122.

101. Charles L. Buchanan, "George Bellows: Painter of Democracy," *Art and Decoration*, August 1914, 370.

102. Wayne M. O'Leary, *Maine Sea Fisheries: The Rise and Fall of a Native Industry, 1830–1890* (Boston: Northeastern University Press, 1996), 222–23, 231. For hardship and deprivation in the lives of Maine fishermen generally, see 215–51.

103. Hermann Grimm, *Das Leben Raphaels von Urbino* (Berlin: Dummler, 1872), 295, quoted in Michael Hatt and Charlotte Klonk, *Art History: A Critical Introduction to Its Methods* (New York: Manchester University Press, 2006), 72.

104. O'Leary, *Maine Sea Fisheries*, 9.

105. Ibid., 6.

106. Helen Rolfe Holmes, "Monhegan Island," *Granite Monthly*, May 1912, 147.

107. Marsden Hartley, "On the Subject of Nativeness—A Tribute to Maine," in *Marsden Hartley: Exhibition of Recent Paintings, 1936* (New York: An American Place, 1937), 5.

108. Edward Alden Jewell, "2 Art Exhibitions Open at Museum," *New York Times*, October 25, 1944, 27.

109. Laura Meixner, "Marsden Hartley," in *American Paintings and Sculpture to 1945 in the Carnegie Museum of Art*, by Diana Strazdes (New York: Hudson Hills Press in association with the Carnegie Museum of Art, 1992), 232.

110. For a discussion of Hartley's affinity for Germany in the 1910s, see Jonathan Weinberg, *Speaking for Vice: Homosexuality in the Art of Charles Demuth, Marsden Hartley, and the First American Avant-Garde* (New Haven, Conn.: Yale University Press, 1993), 141–62.

111. See Donna M. Cassidy, *Marsden Hartley: Race, Region, and Nation* (Lebanon, N.H.: University Press of New England, 2005), esp. 235. On race and German folk culture in his art from this period, see also Donna M. Cassidy, "Localized Glory: Marsden Hartley as New England Regionalist," in *Marsden Hartley*, ed. Elizabeth Mankin Kornhauser (Hartford, Conn.: Wadsworth Atheneum in association with Yale University Press, 2002), 186–87. On Hartley's attitude toward Nazi Germany in particular, see Weinberg, *Speaking for Vice*, 172–74.

112. Cassidy, *Marsden Hartley*, 195; and Cassidy, "Localized Glory," 192n67.

113. Quoted in Bruce Robertson, *Marsden Hartley* (New York: Abrams in association with the National Museum of American Art, Smithsonian Institution, 1995), 125.

114. William Carlos Williams, unpublished review, April 1940, in Archives of American Art, Smithsonian Institution, Washington, D.C., quoted in Elizabeth Mankin Kornhauser, "Marsden Hartley: 'Gaunt Eagle from the Hills of Maine,'" in Kornhauser, *Marsden Hartley*, 11.

115. For the spiritual associations of Hartley's painting, see Cassidy, *Marsden Hartley*, 275.

116. "Sportsmen in the War," *Hunting and Fishing*, February 1942, 19. See also "Ex-Duck Hunter Downs Jap Plane with Rifle Shot," *Los Angeles Times*, April 22, 1943, A2; and Art Ryon, "Southlanders Find Bagging Nazis Like Duck Shooting," *Los Angeles Times*, August 27, 1944, 13.

117. For example, see "Lone Eagle's Feathers Ruffled: Lindbergh Quits Army, Cites Roosevelt's Implied Criticism," *Washington Post*, April 29, 1941, 1; and "Lindbergh's Views Dumb, Says President," *Washington Post*, April 26, 1941, 2. For a comprehensive recent account of these events, see Nicholas Wapshott, *The Sphinx: Franklin Roosevelt, the Isolationists, and the Road to World War II* (New York: Norton, 2015).

118. Quoted in Doris Kearns Goodwin, *No Ordinary Time: Franklin and Eleanor Roosevelt: The Home Front in World War II* (New York: Simon and Schuster, 1994), 47.

119. The Pittman-Robertson Wildlife Restoration Act of 1937, for example, taxed the sale of guns and ammunition to fund the restoration of wildlife and the acquisition of wildlife habitat. See, for example, Brian Black, "The Complex Environmentalist: Franklin D. Roosevelt and the Ethos of New Deal Conservation," in *FDR and the Environment*, ed. Henry L. Henderson and David B. Woolner (New York: Palgrave Macmillan, 2005), 22; and Paul Sutter, "New Deal Conservation: A View from the Wilderness," in Henderson and Woolner, *FDR and the Environment*, 96. Berryman's image recalls his most famous 1902 *Washington Post* cartoon *Drawing the Line in Mississippi*, in which then-president Theodore Roosevelt refuses to shoot a woeful bear cub; it subsequently inspired the Teddy bear children's toy.

120. Geoffrey Household, *Rogue Male* (New York: New York Review Books Classics, 2007), 1.

121. Robert L. McLaughlin and Salley E. Parry, *We'll Always Have the Movies: American Cinema during World War II* (Lexington: University of Kentucky Press, 2006), 49, 54–58. See also Lutz Koepnick, "Not the End: Fritz Lang's War," in *A Companion to Fritz Lang*, ed. Joe McElhaney (Malden, Mass.: Wiley-Blackwell, 2015), 415–29.

122. Quoted in Richard Meryman, "Andrew Wyeth: An Interview," *Life*, May 14, 1965, 110.

123. Aline B. Louchheim, "Wyeth—Conservative Avant-Gardist," *New York Times Magazine*, October 25, 1953, 28.

124. Quoted in Edward Sozanski, "Looking Beneath the Surface," *Philadelphia Inquirer*, September 7, 1997. Relatedly, Charles Brock asserts that both World Wars "played a powerful role in his emotional and creative life" in his essay, "Through a Glass: Windows in the Art of Wyeth, Sheeler, and Hopper," in *Andrew Wyeth: Looking Out, Looking In*, ed. Nancy K. Anderson and Charles Brock (Washington, D.C.: National Gallery of Art, 2014), 42. Two other recent essays discuss how the World War II years factor in Wyeth's art in different ways. See Alexander Nemerov, "The Glitter of *Night Hauling*: Andrew Wyeth in the 1940s"; and Randall C. Griffin, "Andrew Wyeth's *Christina's World*: Normalizing the 'Abnormal' Body," in *Rethinking Andrew Wyeth*, ed. David Cateforis (Berkeley: University of California Press, 2014), 101–11, 112–27.

125. For example, though dating to World War I, the word "foxhole"—a typically body-length protective shelter dug into the ground or some variant field entrenchment—was increasingly used in the 1940s. See Alan Alexrod, *Encyclopedia of World War II*, vol. 1 (New York: Facts on File, 2007), 347; and Paul Dickson, *War Slang: American Fighting Words and Phrases Since the Civil War*, 2nd ed. (Washington, D.C.: Brassy's, 2004), 159. Michael R. Taylor briefly notes the "sinister" connotations of the "unseen sniper" in his essay "Between Realism and Surrealism: The Early Work of Andrew Wyeth," in *Andrew Wyeth: Memory and Magic*, by Anne Classen Knutson (Atlanta, Ga.: High Museum of Art and Philadelphia Museum of Art in association with Rizzoli International, 2005), 35.

126. These include Mackinlay Kantor, "Flying Sweet and Low"; Joseph Marshall, "War Is Unfair to Lovers"; Henry F. Pringle, "My Thirty Days in the Pentagon"; George Smedal, "Fighting Words"; and "Soldiers Must Help Make Peace," *Saturday Evening Post*, October 16, 1943.

127. "Patriotic Duty to Go Duck and Goose Hunting this Year," *Boston Globe*, October 15, 1943, 37.

128. Frank L. Kluckhohn, "West and East—Two Kinds of Warfare," *New York Times Magazine*, October 17, 1943, 12.

129. Ibid. The choice of words by one critic is telling: "'The Hunter' by Andrew Wyeth is a magnificent piece of painting." The Latin root of "magnificent" means to enlarge or magnify—a function of the sniper's scope. Eleanor Jewett, "56th American Painting Exhibit Is Diversified," *Chicago Tribune*, October 24, 1945, 24.

130. Comparisons to Homer abound. Examples include Howard Devree, "Four Good First Shows," *New York Times*, October 24, 1937, 11; "Andrew Wyeth: An American Realist Paints What He Sees," *Life*, May 17, 1948, 102; John Wilmerding, *Andrew Wyeth: The Helga Pictures* (New York: Abrams, 1987), 18; Taylor, "Between Realism and Surrealism," 28–30.

131. Quoted in Meryman, "Andrew Wyeth," 100.

132. Paul Virilio, *War and Cinema: The Logistics of*

Perception, trans. Patrick Camiller (London: Verso, 1989), 70.

133. Quoted in Richard Meryman, *Andrew Wyeth: A Secret Life* (New York: HarperCollins, 1996), 358.

134. To the chagrin of his father, N. C. Wyeth, Andrew Wyeth did not include anecdotal hunting details in *The Turkey Pond* the following year (Farnsworth Art Museum). His father advised, "You've got to put a gun in that man's hand and you ought to have a dog going beside him." Just as he economizes to avoid blatant "drama" in that painting, Wyeth privileges an ambiguous tone in *The Hunter*. Quoted in James H. Duff, "An American Vision," in *An American Vision: Three Generations of Wyeth Art*, by James H. Duff, Andrew Wyeth, Thomas Hoving, and Lincoln Kirstein (Boston: Little, Brown in association with the Brandywine River Museum, 1987), 39. A related watercolor is Andrew Wyeth's *The Coot Hunter*, usually dated to 1941 (Art Institute of Chicago).

135. For a period discussion of camouflage, see William McK. Spierer, "The Fine Art of Camouflage," *New York Times Magazine*, January 24, 1943, 7–9. On how camouflage in battle evolved from hunting, see Tim Newark, *Camouflage* (London: Imperial War Museum and Thames and Hudson, 2007), 37–50.

136. On U.S. camouflage uniforms during World War II, see Newark, *Camouflage*, 129–33; and Hardy Blechman, *Disruptive Pattern Material: An Encyclopedia of Camouflage* (Richmond Hill, Canada: Firefly Books, 2004), 188–89.

137. For example, "the sycamore is easily recognized . . . because of the 'camouflage' or mottled appearance of the bark"; Stephen Collins, "Streamside Plans Can Make or Break Your Fishing," *Pennsylvania Angler*, January 1953, 7. The sycamore looks "as if it had been painted to match army camouflage patterns"; Dorothy Sterling, *Trees and Their Story* (New York: Doubleday, 1953), 102.

138. Maury Klein, *A Call to Arms: Mobilizing America for World War II* (New York: Bloomsbury Press, 2013), 216. For copper use in ammunition and the copper crisis, see also Paul A. C. Koistinen, *Arsenal of World War II: The Political Economy of American Warfare, 1940–1945* (Lawrence: University of Kansas Press, 2004), 144–48.

139. *Conservation of Wildlife: Report of the Select Committee on Conservation of Wildlife Resources, House of Representatives* (Washington, D.C.: Government Printing Office, 1943), 12.

140. Ibid., 13.

141. Ibid.

142. "Ammunition was always a problem," recalled undersecretary of war Robert P. Patterson. "Material shortages forced the use of steel cartridge cases in place of brass. Ammunition was packed in cardboard and wood when tin and steel were not to be had." At one point, "it was necessary to ration some guns to seventeen shells a day, when fifty might have been fired." Robert P. Patterson, *Arming the Nation for War: Mobilization, Supply, and the American War Effort in World War II*, ed. Brian Waddell (Knoxville: University of Tennessee Press, 2014), 178, 199.

143. Lincoln A. Werden, "Wood, Field and Stream," *New York Times*, October 13, 1943, 32. For hunters "who have 'stocked up'" on ammunition before the shell shortage, see also Lincoln A. Werden, "News of Wood, Field and Stream," *New York Times*, July 25, 1943, S2.

144. "Sportsmen Still Interested in Wild Life Despite War," *Boston Globe*, January 4, 1945, 6.

145. Klein, *A Call to Arms*, 451.

146. Ibid. In at least one instance, "Planes were used to 'bomb' farm areas with printed scrap appeals and to locate scrap piles"; Russell W. Davenport, "The Nebraska Plan: Some Plain Citizens Find a Way to Help Lick Hitler," *Life*, October 5, 1942, 20.

147. For accounts from Britain, see James MacDonald, "London Bomb Sites Grow Vegetables," *New York Times*, June 1, 1942, 4; Laurence L. Winship, "British Farmers Defy Bombs, Lick Shortages," *Boston Globe*, August 29, 1943, 1, 16; and "3,281,953 Claims for Bomb Loss Filed in Britain," *Chicago Tribune*, September 11, 1945, 8. A related connection is articulated in Millard C. Faught, "Seeds Are Bullets for the Allies," *New York Times Magazine*, September 5, 1943, 12, 35. For the difficulties of rural life at home, see Douglas Ensminger, "The Impacts of the War on the Rural Community," *Social Forces* 22 (October 1943): 76–79.

148. Louise Ault, *Artist in Woodstock, George Ault: The Independent Years* (Philadelphia: Dorrance, 1978), 97.

149. Alexander Nemerov, *To Make a World: George Ault and 1940s America* (Washington, D.C.: Smithsonian American Art Museum in association with Yale University Press, 2011).

150. Matthew B. Ridgway, *The Korean War* (New York: Doubleday, 1967), 79.

151. See, for example, Atherton's *Fishing Still Life* of the April 15, 1944, issue.

152. For the competition, see "Defense Posters Go on View Today," *New York Times*, July 16, 1941, 5; and William L. Bird, Jr., and Harry R. Rubenstein, *Design for Victory: World War II Poster on the American Home Front* (New York: Princeton Architectural Press, 1998), 23–25.

153. *Allocations and Priorities Guide* (Chicago: Coordinators Corporation, 1943), 388. The order went into effect April 1942.

154. Atherton opens his book with the rapport between art making and fly fishing: "The study of art brings

with it a new regard for visual things, a sharpened observation. This goes well in angling. The angler is necessarily observant and, if successful, has usually succeeded in putting his findings to practical use. ... Tying flies, like painting, is a constant series of experiments"; John Atherton, *The Fish and the Fly* (New York: Macmillan, 1951), 2. For his death, see "John Atherton, 52, Artist and Writer," *New York Times*, September 18, 1952, 29; and "John C. Atherton," *Boston Globe*, September 19, 1952, 31.

155. Along similar, more explicit lines, Atherton's *Patient Dog* cover of the December 12, 1942, issue of the *Saturday Evening Post* features guns and other hunting paraphernalia adjacent to a dog gazing longingly at a photograph of his absent master in military uniform.

156. "Gain in Fishing Tackle: WPB Authorizes More Production of Anglers' Equipment," *New York Times*, November 3, 1944, 26. For the lifting of additional "war-imposed restrictions on fishing," see John Rendel, "Wood, Field and Stream," *New York Times*, May 11, 1945, 15. On the supposed therapeutic benefits of hunting and fishing "for the frayed nerves of returning veterans," see also "Wants Veterans to Fish and Hunt," *New York Times*, December 25, 1944, 14.

157. For a recent discussion of Suba's watercolor, see Robin Jaffee Frank, ed., *Coney Island: Visions of an American Dreamland, 1861–2008* (Hartford, Conn.: Wadsworth Atheneum Museum of Art in association with Yale University Press, 2015), 121.

158. C. Ward Crampton, "The Killer Throw," *Boys' Life*, March 1943, 15.

159. See Stephen Polcari, *Abstract Expressionism and Modern Experience* (New York: Cambridge University Press, 1991), 167–68.

160. Ernest Hemingway, "On the Blue Water," *Esquire*, April 1936, 31.

Selected Bibliography

Ames, Kenneth L. *Death in the Dining Room and Other Tales of Victorian Culture*. Philadelphia: Temple University Press, 1992.

Aron, Cindy S. *Working at Play: A History of Vacations in the United States*. New York: Oxford University Press, 1999.

Atherton, John. *The Fish and the Fly*. New York: Macmillan, 1951.

Ault, Louise. *Artist in Woodstock, George Ault: The Independent Years*. Philadelphia: Dorrance, 1978.

Avery, Kevin. *Hudson River School Visions: The Landscapes of Sanford R. Gifford*. New York: Metropolitan Museum of Art.

Bantel, Linda, and Peter H. Hassrick. *Forging an American Identity: The Art of William Ranney, with a Catalogue of His Works*. Cody, Wyo.: Buffalo Bill Historical Center, 2006.

Baur, John I. H., ed. *The Autobiography of Worthington Whittredge (1820–1910)*. New York: Arno Press, 1969.

Bender, Thomas. *Community and Social Change in America*. Baltimore, Md.: Johns Hopkins University Press, 1978.

Benjamin, S. G. W. *Our American Artists; Our American Artists, Second Series*. Boston: Lothrop, 1879 and 1881. Reprint, New York: Garland, 1977.

Boehme, Sarah E. *John James Audubon in the West*. New York: Abrams in association with the Buffalo Bill Historical Center, 2000.

Bowditch, Nancy Douglas. *George de Forest Brush: Recollections of a Joyous Painter*. Peterborough, N.H.: Noone House, 1970.

Buchhart, Dieter, and Mark Dion. *Mark Dion: Concerning Hunting*. Ostfildern, Germany: Hatje Cantz, 2008.

Burrows, Edwin G., and Mike Wallace. *Gotham: A History of New York City to 1898*. New York: Oxford University Press, 1999.

Cadbury, Warder H., and Patricia C. F. Mandel. *A. F. Tait: Artist in the Adirondacks*. Blue Mountain Lake, N.Y.: Adirondack Museum, 1974.

Carbone, Teresa A. *American Paintings in the Brooklyn Museum: Artists Born by 1876*. Vol. 1. Brooklyn, N.Y.: Brooklyn Museum in association with D. Giles, London, 2006.

Cassidy, Donna M. *Marsden Hartley: Race, Region, and Nation*. Lebanon, N.H.: University Press of New England, 2005.

Cateforis, David, Janice Driesbach, and Norman A. Geske. *Sculpture from the Sheldon Memorial Art Gallery*. Edited by Karen O. Janovy. Lincoln, Neb.: Bison Books, 2006.

Catlin, George. *The Last Rambles Amongst the Indians of the Rocky Mountains and the Andes*. London: Sampson Low, Son, and Marston, 1868.

Cikovsky, Nicolai, Jr., and Franklin Kelly. *Winslow Homer*. Washington, D.C.: National Gallery of Art, 1995.

Clark, Carol. *Charles Deas and 1840s America*. Norman: University of Oklahoma Press, 2009.

Clark, Carol Lea. "Indians on the Mantel and in the Park." In *The American West in Bronze, 1850–1925*, edited by Thayer Tolles and Thomas Brent Smith, 26–29. New York: Metropolitan Museum of Art, 2014.

Conrads, Margaret C., ed. *The Collection of the Nelson-Atkins Museum of Art: American Paintings to 1945*. Vol. 1. Kansas City, Mo.: Nelson-Atkins Museum of Art, 2007.

Cooper, Helen A. *Winslow Homer Watercolors*. Washington, D.C.: National Gallery of Art, 1986.

Craven, Wayne. "Henry Kirke Brown: His Search for an American Art in the 1840s." *American Art Journal* 4, no. 2 (November 1, 1972): 44–58.

Cutchins, Dennis, and Eric Eliason, ed. *Wild Games: Hunting and Fishing Traditions in North America*. Knoxville: University of Tennessee Press, 2009.

Driskel, Michael Paul. *Representing Belief: Religion, Art, and Society in Nineteenth-Century France*. University Park: Pennsylvania State University Press, 1991.

Dryfhout, John H. *The Work of Augustus Saint-Gaudens*. Hanover, N.H.: University Press of New England, 1982.

Evers, Alf. *The Catskills: From Wilderness to Woodstock*. Garden City, N.Y.: Doubleday, 1972.

Frank, Stephen M. *Life with Father: Parenthood and Masculinity in the Nineteenth-Century American North*. Baltimore, Md.: Johns Hopkins University Press, 1998.

Frankenstein, Alfred. *William Sidney Mount*. New York: Abrams, 1975.

Furness, William Henry. *The Power of Spirit Manifest in Jesus of Nazareth*. Philadelphia: Lippincott, 1877.

Gasset, Jose Ortega. *Meditations on Hunting*. Bozeman, Mont.: Wilderness Adventures Press, 1996.

Glanz, Dawn. *How the West Was Drawn: American Art and the Settling of the Frontier*. Ann Arbor, Mich.: UMI Research Press, 1982.

Goodrich, Lloyd. *Thomas Eakins*. Cambridge, Mass.: Harvard University Press for the National Gallery of Art, 1982.

Grace Museum and Dallas Museum of Art. *Loren Mozely: Structural Integrity*. Dallas, Tex.: McKinney Avenue Contemporary, 2012.

Griffin, Randall C. *Homer, Eakins, and Anshutz: The Search for American Identity in the Gilded Age*. University Park: Pennsylvania State University Press, 2004.

Haltman, Kenneth. *Looking Close and Seeing Far: Samuel Seymour, Titian Ramsay Peale, and the Art of the Long Expedition, 1818–1823*. University Park: Pennsylvania State University Press, 2008.

Hamilton, Edith. *Mythology*. New York: New American Library, 1969.

Hawthorne, Charles Webster. *Hawthorne on Painting*. New York: Dover, 1960.

Henry, O. *The Complete Works of O. Henry*. Garden City, N.Y.: Doubleday, 1911.

Herman, Daniel Justin. *Hunting and the American Imagination*. Washington, D.C.: Smithsonian Institution Press, 2001.

Herrigel, Eugen. *Zen in the Art of Archery*. New York: Vintage, 1989.

Holliman, Jennie. *American Sports, 1785–1835*. Durham, N.C.: Seeman Press, 1931. Reprint, Mansfield Center, Conn.: Martino, 2003.

Hoppin, Martha. *The World of J. G. Brown*. Chesterfield, Mass.: Chameleon Books, 2010.

Hureaux, Alain Daguerre, ed. *Augustus Saint-Gaudens, 1848–1907: A Master of American Sculpture*. Paris: Somogy Editions D'Art, 1999.

Irving, Washington. *Rip Van Winkle and The Legend of Sleepy Hollow*. New York: Macmillan, 1893.

Janson, Anthony F. *Worthington Whittredge*. New York: Cambridge University Press, 1989.

Johns, Elizabeth. *American Genre Painting: The Politics of Everyday Life*. New Haven, Conn.: Yale University Press, 1993.

Johnson, Deborah J. *William Sidney Mount: Painter of American Life*. New York: American Federation of the Arts, 1998.

Junker, Patricia, ed. *Winslow Homer: Artist and Angler*. New York: Thames and Hudson, 2003.

Junker, Patricia A., and Will Gillham. *An American Collection: Works from the Amon Carter Museum*. New York: Hudson Hills, 2001.

Kasson, John F. *Civilizing the Machine: Technology and Republican Values in America, 1776–1900*. New York: Hill and Wang, 1999.

Klein, Maury. *A Call to Arms: Mobilizing America for World War II*. New York: Bloomsbury Press, 2013.

Knutson, Anne Classen, John Wilmerding, Christopher Crosman, Kathleen A. Foster, and Michael R. Taylor. *Andrew Wyeth: Memory and Magic*. Atlanta, Ga.: High Museum of Art and Philadelphia Museum of Art in association with Rizzoli International, 2005.

Kornhauser, Elizabeth Mankin, ed. *Marsden Hartley*. Hartford, Conn.: Wadsworth Atheneum in association with Yale University Press, 2002.

Kudish, Michael. *The Catskill Forest: A History*. Fleischmanns, N.Y.: Purple Mountain Press, 2000.

Lears, Jackson. *Rebirth of a Nation: The Making of Modern America, 1877–1920*. New York: Harper Collins, 2009.

Leja, Michael. *Looking Askance: Skepticism and American Art from Eakins to Duchamp*. Berkley: University of California Press, 2004.

Lubowsky, Susan. *George Ault*. New York: Whitney Museum of Art, 1988.

MacKillop, James. *Myths and Legends of the Celts*. London: Penguin UK, 2006.

Maclean, Norman. *A River Runs through It and Other Stories*. 25th anniversary ed. Chicago: University of Chicago Press, 2001.

McCoubrey, John W., ed. *American Art, 1700–1960: Sources and Documents*. Englewood Cliffs, N.J.: Prentice-Hall, 1965.

McPhee, John. *The Founding Fish*. New York: Farrar, Straus and Giroux, 2002.

Merritt, Howard S. *Thomas Cole*. Rochester, N.Y.: Memorial Art Gallery of the University of Rochester, 1969.

Miller, Angela. *The Empire of the Eye: Landscape Representation and American Cultural Politics, 1825–1875*. Ithaca, N.Y.: Cornell University Press, 1992.

Miller, Char. *Gifford Pinchot and the Making of Modern Environmentalism*. Washington, D.C.: Island Press, 2001.

Mühlberger, Richard. *Charles Webster Hawthorne*. Chesterfield, Mass.: Chameleon Books, 1999.

Nemerov, Alexander. *To Make a World: George Ault and 1940s America*. Washington, D.C.: New Haven, Conn.: Yale University Press, 2011.

Newark, Tim. *Camouflage*. London: Imperial War Museum and Thames and Hudson, 2007.

Norris, Thaddeus. *The American Angler's Book: Embracing the Natural History of Sporting Fish and the Art of Taking Them*. Philadelphia: Porter and Coates, 1865.

O'Leary, Wayne M. *Maine Sea Fisheries: The Rise and Fall of a Native Industry, 1830–1890*. Boston: Northeastern University Press, 1996.

Ovid. *Metamorphoses*. Books 1–8. Edited by G. P. Goold. Translated by Frank Justus Miller. Cambridge, Mass.: Harvard University Press, 1977.

Owen, James. *Trout*. London: Reaktion Books, 2012.

Palmer, George H. *The Exhaustion of Food Fishes on the Seacoast of Massachusetts*. Boston: Addison C. Getchell, 1887.

Phillips Collection. *Julian Alden Weir: An Appreciation of His Life and Works*. New York: Dutton, 1922.

Powell, Earl A. *Thomas Cole*. New York: Abrams, 1990.

Rand, Harry. *Paul Manship*. Washington, D.C.: Smithsonian Institution Press, 1989.

Rather, Susan. *Archaism, Modernism, and the Art of Paul Manship*. Austin: University of Texas Press, 2014.

Reiger, John F. *American Sportsmen and the Origins of Conservation*. 3rd ed. Corvallis: Oregon State University Press, 2001.

Reuter, F. Turner, Jr. *Animal and Sporting Artists in America*. Middleburg, Va.: National Sporting Library, 2008.

Reynolds, Sir Joshua. *The Discourses of Sir Joshua Reynolds*. London: J. Carpenter, 1842.

Richards, T. Addison. *Appleton's Illustrated Hand-Book of American Travel*. New York: Appleton, 1857.

Roberts, Jennifer L. *Transporting Visions: The Movement of Images in Early America*. Berkeley: University of California Press, 2014.

Robertson, Bruce. *Reckoning with Winslow Homer: His Late Paintings and Their Influence*. Cleveland, Ohio: Cleveland Museum of Art in association with Indiana University Press, 1990.

Rotundo, E. Anthony. *American Manhood: Transformations in Masculinity from the Revolution to the Modern Era*. New York: Basic Books, 1993.

Schweizer, Paul D., ed. *Masterworks of American Art from the Munson-Williams-Proctor Institute*. New York: Abrams, 1989.

Sewell, Darrel, ed. *Thomas Eakins*. Philadelphia: Philadelphia Museum of Art in association with Yale University Press, 2001.

Shapiro, Michael Edward. *Bronze Casting and American Sculpture, 1850–1900*. Newark: University of Delaware Press, 1985.

Shields, Scott A. *The Exoticized Woman and Her Allure in American Art, 1865–1917*. San Francisco: Fine Arts Museums of San Francisco, 1996.

Simpson, Marc. *Winslow Homer: Paintings of the Civil War*. San Francisco: Fine Arts Museum of San Francisco, 1988.

Soll, David. *Empire of Water: An Environmental and Political History of the New York City Water Supply*. Ithaca, N.Y.: Cornell University Press, 2013.

Staal, Julius D. *The New Patterns in the Sky: Myths and Legends of the Stars*. Blacksburg, Va: McDonald and Woodward, 1996.

Stein, Judith E. *I Tell My Heart: The Art of Horace Pippin*. New York: Universe, 1993.

Stradling, David. *The Nature of New York: An Environmental History of the Empire State*. Ithaca, N.Y.: Cornell University Press, 2010.

Tatham, David. *Winslow Homer in the Adirondacks*. Syracuse, N.Y.: Syracuse University Press, 1996.

Terrie, Philip G. *Forever Wild: A Cultural History of Wilderness in the Adirondacks*. Syracuse, N.Y.: Syracuse University Press, 1994.

Thompson, Maurice. *The Witchery of Archery*. New York: Scribner, 1878.

Thoreau, Henry David. *A Week on the Concord and Merrimack Rivers, Walden and Other Writings*. New York: Bantam, 2004.

Tolles, Thayer, ed. *American Sculpture in the Metropolitan Museum of Art*. New York: Metropolitan Museum of Art, 1999.

Tolles, Thayer, Thomas Brent Smith, Carol Clark, Brian W. Dippie, Peter H. Hassrick, Karen Lemmey, and Jessica Murphy. *The American West in Bronze, 1850–1925*. New York: Metropolitan Museum of Art, 2013.

Truettner, William H., and Alan Wallach, eds. *Thomas Cole: Landscape into History*. New Haven, Conn.: Yale University Press in association with the National Museum of American Art, 1994.

Uruburu, Paula. *American Eve*. New York: Penguin, 2008.

Verner, William K., ed. *Adventure in the Wilderness, by William H. H. Murray*. Syracuse, N.Y.: Adirondack Museum and Syracuse University Press, 1989.

Virgil. *The Aeneid*. Translated by Robert Fitzgerald. New York: Vintage, 1990.

Weigley, Russell F., ed. *Philadelphia: A 300-Year History*. New York: Norton, 1982.

Weinberg, H. Barbara, Doreen Bolger, and David Park Curry. *American Impressionism and Realism: The Painting of Modern Life, 1885–1915*. New York: Metropolitan Museum of Art, 1994.

Weinberg, Jonathan. *Speaking for Vice: Homosexuality in the Art of Charles Demuth, Marsden Hartley, and the First American Avant-Garde*. New Haven, Conn.: Yale University Press, 1993.

Welsh, Caroline M. *The Adirondack World of A. F. Tait*. Blue Mountain Lake, N.Y.: North Country Books, 2011.

Whitman, Walt. *The Complete Writings of Walt Whitman*. New York: Putnam and Knickerbocker Press, 1902.

Young, Dorothy Weir, ed. *The Life and Letters of J. Alden Weir*. New Haven, Conn.: Yale University Press, 1960.

Photography Credits

Fig. i.8 (Cat. 57). Photograph by Andy Duback

Fig. 1.3. Photograph by Hervé Lewandowski, © RMN-Grand Palais/Art Resource, New York

Fig. 1.12. Photograph courtesy Scala/Art Resource, New York

Fig. 1.13. © Tate, London 2015

Fig. 1.15 (Cat. 9). Photograph by Bruce Schwarz

Fig. 1.17 (Cat. 17). Photograph courtesy Bridgeman Images

Fig. 1.19 (Cat. 65). Photograph by Bruce Schwarz

Fig. 1.24 (Cat. 48). Digital image © Whitney Museum of American Art, New York

Fig. 2.1 (Cat. 20). Photograph by Bruce Schwarz

Fig 2.2 (Cat. 63). Photograph by Andy Duback

Fig. 2.6 (Cat. 64). Photograph by Amon Carter Museum of American Art, Fort Worth, Texas

Fig. 2.7. Image courtesy Old Print Shop, Inc., New York, New York

Fig. 2.16 (Cat. 36). Photograph by Andy Duback

Fig. 2.17 (Cat. 24). Photograph © Terra Foundation for American Art, Chicago, Illinois

Fig. 2.19 (Cat. 25). © 2015 Christie's Images Limited

Fig. 3.6 (Cat. 44). Photograph by Richard Walker

Fig. 3.7. Photograph by David Stansbury

Fig. 3.12 (Cat. 66). Photograph by Baxter Buck

Fig. 3.14 (Cat. 11). Photograph courtesy Bridgeman Images

Fig. 3.18 (Cat. 22). Photograph by Katherine Wetzel, © Virginia Museum of Fine Arts, Richmond, Virginia

Fig. 3.20 (Cat. 34). Digital image © Whitney Museum of American Art, New York

Fig. 3.25 (Cat. 61). Photograph courtesy Bridgeman Images

Fig. 4.1 (Cat. 17). Photograph courtesy Bridgeman Images

Fig. 4.3. Photograph courtesy Bridgeman Images

Fig. 4.5. Photograph courtesy Detroit Institute of Arts, Detroit, Michigan/Bridgeman Images

Fig. 4.9. Photograph by Richard Nicol

Fig. 4.11. Photograph © 2016 Museum of Fine Arts, Boston, Massachusetts

Fig. 4.16 (Cat. 16). Photograph © 2016 Museum of Fine Arts, Boston, Massachusetts

Fig. 4.19. Photograph © Terra Foundation for American Art, Chicago, Illinois

Fig. 4.22 (Cat. 61). Photograph courtesy Bridgeman Images

Fig. 4.23. © 2014 Christie's Images Limited

Fig. 4.25. © Victoria and Albert Museum, London

Fig. 4.26. Photograph © 2015 Carnegie Museum of Art, Pittsburgh, Pennsylvania

Fig. 4.29 (Cat. 73). © Andrew Wyeth/Artists Rights Society (ARS), New York

Fig. 4.31 (Cat. 5). Photograph © 2016 Museum of Fine Arts, Boston, Massachusetts

Fig. 4.35. Image provided by the Wadsworth Atheneum Museum of Art, Hartford, Connecticut

Fig. 4.36. By permission of the Marcus family

Cat. 49. Photograph by Andy Duback

Cat. 50. Photograph by Andy Duback

Cat. 51. Photograph by Andy Duback

Cat. 52. Photograph by Andy Duback

(detail facing, and left)
Cat. 49
Ogden Minton Pleissner
Duck Hunting, 1957
Watercolor on paper,
19¼ × 29¼ inches
Collection of Shelburne Museum,
Shelburne, Vermont. Gift of
Ann M. Leonard, 2013-14.2

Exhibition Checklist

Cat. 1 (Fig. 4.34)
John Atherton
American, 1900–1952
Fisherman's Paradise, 1941
Oil on canvas, 24 × 30 inches
The John and Susan Horseman Collection
 of American Art

Cat. 2 (Fig. 3.22)
Gifford Reynolds Beal
American, 1879–1956
The Fisherman, 1922
Oil on canvas, 37 × 46 inches
Brooklyn Museum, Brooklyn, New York.
 Samuel E. Haslett Fund, 23.72

Cat. 3 (Fig. 3.24)
Gifford Reynolds Beal
American, 1879–1956
Fishermen with Nets, 1920s
Oil on canvas, 20¼ × 30 inches
Joslyn Art Museum, Omaha, Nebraska.
 Mr. and Mrs. Edwin S. Miller Bequest Fund,
 1951.660

Cat. 4 (Fig. 4.24)
George Wesley Bellows
American, 1882–1925
Cleaning Fish, 1913
Oil on panel, 13¼ × 19½ inches
The Nelson-Atkins Museum of Art, Kansas City,
 Missouri. Gift of Mrs. Logan Clendening
 through the Friends of Art, 47-31

Cat. 5 (Fig. 4.31)
Frank Weston Benson
American, 1862–1951
Pintails Decoyed, 1921
Oil on canvas, 36⅛ × 44⅛ inches
Museum of Fine Arts, Boston, Massachusetts.
 Gift of Frederick L. Jack, 35.1230

Cat. 6 (Fig. 3.10)
Albert Bierstadt
American, b. Germany, 1830–1902
The Trappers, Lake Tahoe, ca. 1890
Oil on canvas, 19½ × 27¾ inches
Joslyn Art Museum, Omaha, Nebraska.
 Gift of Mrs. Harold Gifford, 1961.430

Cat. 7
George Caleb Bingham
American, 1811–1879
Watching the Cargo by Night, 1854
Oil on canvas, 24 × 29 inches
Joslyn Art Museum, Omaha, Nebraska.
 Gift of Foxley and Co., 1997.33

Cat. 8 (Fig. 4.15)
Walter M. Brackett
American, 1823–1919
Trout, 1867
Oil on canvas, 14 × 20¹⁄₁₆ inches
Brooklyn Museum, Brooklyn, New York.
 Bequest of Caroline H. Polhemus, 06.321

(*detail facing, and left*)
Cat. 42
George L. K. Morris
Indians Hunting #4, 1935
Oil on canvas, 35½ × 40 inches
University of New Mexico Art
Museum, Albuquerque, New
Mexico. Museum purchase,
National Endowment of the Arts
grant with matching funds from
the Friends of Art, 74.319

Cat. 9 (Fig. 1.15)
Albertus Del Orient Browere
American, 1814–1887
Rip Van Winkle in the Mountains, 1880
Oil on canvas, 30 × 44 ¼ inches
Collection of Shelburne Museum, Shelburne,
 Vermont. Museum purchase, acquired
 from Maxim Karolik, 1959-265.9

Cat. 10 (Fig. 3.15)
John George Brown
American, 1831–1913
Portrait of William Brand, 1864
Oil on canvas, 16 × 12 inches
Judith and James Pizzagalli Collection

Cat. 11 (Fig 3.14)
John George Brown
American, 1831–1913
*Claiming the Shot: After the Hunt in the
 Adirondacks*, 1865
Oil on canvas, 32 × 50 inches
Detroit Institute of Arts, Detroit, Michigan.
 Founders Society purchase, R. H. Tannahill
 Foundation Fund, 73.226

Cat. 12 (Fig 1.10)
Henry Kirke Brown
American, 1814–1886
The Choosing of the Arrow, 1848
Bronze, 21 ¼ × 6 ¼ × 5 ½ inches
Amon Carter Museum of American Art,
 Fort Worth, Texas. Purchase with funds
 from the Ruth Carter Stevenson Acquisitions
 Endowment, 1997.143

Cat. 13 (Fig. 1.9)
George de Forest Brush
American, 1855–1941
A Celtic Huntress, 1890
Oil on canvas, 20 × 17 ¼ inches
Fine Arts Museums of San Francisco,
 San Francisco, California. Museum purchase,
 partial gift of Roderick McManigal and funds
 from The Fine Arts Museums Foundation,
 Art Trust Fund, and the Ethel M. Copelotti
 Estate, 1987.28

Cat. 14 (Fig. 2.9)
George Catlin
American, 1796–1872
The Rattle Snakes Den (Fountain of Poison), 1852
Oil on canvas, 18 × 26 ¾ inches
Gilcrease Museum, Tulsa, Oklahoma,
 GM 0176.2167

Cat. 15 (Figs. 3.11 and 4.10)
William Merritt Chase
American, 1849–1916
*The Pot Hunter (The Road through the Fields;
 The Hunter)*, ca. 1894
Oil on canvas, 16 ¼ × 24 ⅛ inches
Parrish Art Museum, Water Mill, New York.
 Purchase fund and gift of Mr. Frank Sherer,
 1974.5

Cat. 16 (Fig. 4.16)
James Goodwyn Clonney
American, b. England, 1812–1867
The Happy Moment, 1847
Oil on canvas, 27 × 22 inches
Museum of Fine Arts, Boston, Massachusetts.
 Gift of Martha C. Karolik for the
 M. and M. Karolik Collection of American
 Paintings, 1815–1865, 47.1222

Cat. 17 (Figs. 1.17 and 4.1)
Thomas Cole
American, 1801–1848
Daniel Boone at His Cabin in Great Osage Lake,
 ca. 1826
Oil on canvas, 38 ½ × 42 ⅝ inches
Mead Art Museum, Amherst College, Amherst,
 Massachusetts. Museum purchase

Cat. 18 (Figs. 1.27, 3.1, and 4.33)
Thomas Cole
American, 1801–1848
The Hunter's Return, 1845
Oil on canvas, 40 ⅛ × 60 ½ inches
Amon Carter Museum of American Art,
 Fort Worth, Texas, 1983.156

Cat. 19 (Fig. 2.18)
Astley D. M. Cooper
American, 1856–1924
The Buffalo Head, Relics of the Past, before 1910
Oil on canvas, 40 × 36 inches
Buffalo Bill Center of the West, Cody, Wyoming.
 Bequest in memory of the Houx and Newell
 families, 4.64

Cat. 20 (Fig. 2.1)
Charles Deas
American, 1818–1867
The Death Struggle, 1840–45
Oil on canvas, 30 × 25 inches
Collection of Shelburne Museum, Shelburne,
 Vermont. Museum purchase, acquired from
 Maxim Karolik, 1959-265.16

Cat. 21 (Fig. 3.19)
Thomas Eakins
American, 1844–1916
Pushing for Rail, 1874
Oil on canvas, 13 × 30 1/16 inches
Metropolitan Museum of Art, New York,
 New York. Arthur Hoppock Hearn Fund,
 1916, 16.65
Shelburne and Amon Carter venues only

Cat. 22 (Fig. 3.18)
Thomas Eakins
American, 1844–1916
*The Artist and His Father Hunting Reed-Birds
 on the Cohansey Marshes*, ca. 1874
Oil on canvas laid on composition board,
 17 1/8 × 26 1/2 inches
Virginia Museum of Fine Arts, Richmond,
 Virginia. Paul Mellon Collection, 85.638

Cat. 23 (Fig. i.2)
Alvan Fisher
American, 1792–1863
Under the Bridge, 1828
Oil on canvas, 30 × 25 inches
Collection of Phoenix Art Museum, Phoenix,
 Arizona. Museum purchase with gifted
 restricted funds from Mr. Edwin Q. Barbey,
 2011.174

Cat. 24 (Fig. 2.17)
Richard La Barre Goodwin
American, 1840–1910
Two Snipes, between 1880 and 1902
Oil on canvas, 20 1/8 × 17 1/8 inches
Terra Foundation for American Art, Chicago,
 Illinois. Gift of Mr. and Mrs. John Estabrook,
 C1982.2

Cat. 25 (Fig. 2.19)
Philip R. Goodwin
American, b. England, 1881–1935
The Northwood King—Calling the Moose, n.d.
Oil on canvas, 25 × 36 inches
Foxley Collection

Cat. 26 (Fig. 2.13)
William Michael Harnett
American, b. Ireland, 1848–1892
After the Hunt, 1884
Oil on canvas, 55 × 40 inches
The Butler Institute of American Art,
 Youngstown, Ohio. Museum purchase, 1954

Cat. 27 (Fig. 4.26)
Marsden Hartley
American, 1877–1943
Lobster Buoys and Nets, 1936
Oil on canvas, 18 1/2 × 24 inches
Albritton Collection

Cat. 28 (Fig. 1.21)
Charles Webster Hawthorne
American, 1872–1930
The Calling of St. Peter, ca. 1900
Oil on canvas, 60 × 48 inches
Collection of The Newark Museum, Newark,
 New Jersey. Gift of Bernard Rabin in memory
 of Nathan Krueger, 1962, 62.170

Cat. 29 (Fig. i.6)
Martin Johnson Heade
American, 1819–1904
Thunder Storm on Narragansett Bay, 1868
Oil on canvas, 32 1/8 × 54 3/4 inches
Amon Carter Museum of American Art,
 Fort Worth, Texas, 1977.17

Cat. 30 (Fig. 1.18)
Thomas Hill
American, b. England, 1829–1908
Fishing on the Merced River, 1891
Oil on canvas, 36 × 54 inches
The Thomas H. and Diane DeMell Jacobsen
 Ph.D. Foundation

Cat. 31 (Figs. 2.4 and 4.12)
Winslow Homer
American, 1836–1910
A Huntsman and Dogs, 1891
Oil on canvas, 28 1/8 × 48 inches
Philadelphia Museum of Art, Philadelphia,
 Pennsylvania. The William L. Elkins
 Collection, 1924, #E1924-3-8
Shelburne and Amon Carter venues only

Cat. 32 (Fig. 4.13)
Winslow Homer
American, 1836–1910
Guides Shooting Rapids, 1895
Watercolor and charcoal, 11 3/16 × 20 1/16 inches
Davis Museum at Wellesley College, Wellesley,
 Massachusetts. Bequest of Samuel G.
 Houghton (husband of Edda Kriender
 Houghton, Class of 1934), 1976.14
Dixon venue only

Cat. 33 (Fig. 4.7)
Thomas Hovenden
American, 1840–1895
The Favorite Falcon, 1879
Oil on canvas, 53⅝ × 38¾ inches
Pennsylvania Academy of the Fine Arts,
 Philadelphia, Pennsylvania. Gift of
 Mrs. Edward H. Coates (The Edward H.
 Coates Memorial Collection), 1923.9.1

Cat. 34 (Fig. 3.20)
Rockwell Kent
American, 1882–1971
The Trapper, 1921
Oil on canvas, 34⅛ × 44⅛ inches
Whitney Museum of American Art, New York,
 New York. Purchase, 31.258

Cat. 35 (Fig. 2.8)
William R. Leigh
American, 1866–1955
A Close Call, 1914
Oil on canvas, 40½ × 60½ inches
Gilcrease Museum, Tulsa, Oklahoma,
 GM 0127.2232

Cat. 36 (Fig. 2.16)
Luigi Lucioni
American, b. Italy, 1900–1988
Fowl and Glass of Red Wine, 1940
Oil on canvas, 23 × 30 inches
Collection of Shelburne Museum, Shelburne,
 Vermont. Bequest of Electra Havemeyer
 Webb, 1961-1.35

Cat. 37 (Fig. 1.9)
Paul Manship
American, 1885–1966
Indian Hunter and Pronghorn Antelope, 1914
Bronze, Indian: 13 × 10⅛ × 8 inches;
 Antelope: 12 × 10⅛ × 8¼ inches
Amon Carter Museum of American Art,
 Fort Worth, Texas. Purchase with funds
 from the Ruth Carter Stevenson Acquisitions
 Endowment, 1997.3.a-b

Cat. 38 (Fig. 1.8)
Paul Manship
American, 1885–1966
Diana and Actaeon (#1), 1925
Bronze on onyx base, Diana: 49 × 43 inches;
 Actaeon: 48 × 52 inches
Smithsonian American Art Museum,
 Washington, D.C. Gift of the artist,
 1965.16.32A-B and 1965.16.33

Cat. 39 (Fig. 2.10)
Alfred Jacob Miller
American, 1810–1874
Buffalo Hunt, ca. 1838–42
Oil on wood panel, 9³⁄₁₆ × 13¹¹⁄₁₆ inches
Amon Carter Museum of American Art,
 Fort Worth, Texas, 2003.10

Cat. 40 (Fig. 2.11)
Alfred Jacob Miller
American, 1810–1874
The Surround, ca. 1840
Oil on canvas, 66 × 94½ inches
Joslyn Art Museum, Omaha, Nebraska.
 Museum purchase, 1963.611

Cat. 41 (Fig. 4.2)
Alfred Jacob Miller
American, 1810–1874
Portrait of Captain Joseph Reddeford Walker,
 ca. 1845–50
Oil on canvas, 24 × 20 inches
Joslyn Art Museum, Omaha, Nebraska.
 Museum purchase, 1963.610

Cat. 42
George L. K. Morris
American, 1905–1975
Indians Hunting #4, 1935
Oil on canvas, 35½ × 40 inches
University of New Mexico Art Museum,
 Albuquerque, New Mexico. Museum
 purchase, National Endowment of the
 Arts grant with matching funds from the
 Friends of Art, 74.319

Cat. 43 (Fig. 1.20)
William Sidney Mount
American, 1807–1868
Catching Rabbits, 1839
Oil on panel, 18⅛ × 21¼ inches
The Long Island Museum of American Art,
 History, and Carriages, Stony Brook,
 New York. Gift of Mr. and Mrs. Ward
 Melville, 1954, 0000.001.0026

Cat. 44 (Fig. 3.6)
William Sidney Mount
American, 1807–1868
Eel Spearing at Setauket, 1845
Oil on canvas, 28½ × 36 inches
Fenimore Art Museum, Cooperstown, New York.
 Gift of Stephen C. Clark, N0395.1955

Cat. 45 (Fig. 1.25)
Loren Mozely
American, 1905–1989
Skull and Powder Horn, 1941
Oil on canvas, 40 × 30 inches
Albritton Collection

Cat. 46 (Figs. 2.14 and 4.6)
David Neal
American, 1838–1915
After the Hunt, 1870
Oil on canvas, 62⁵⁄₁₆ × 46¾ inches
Los Angeles County Museum of Art,
 Los Angeles, California. Gift of
 Mr. and Mrs. Will Richeson, Jr., M.72.103.1

Cat. 47 (Fig. i.10)
Robert Jenkins Onderdonk
American, 1852–1917
Still Life of Fish, 1889
Oil on canvas with painted frame, 30 × 20 inches
Albritton Collection

Cat. 48 (Fig. 1.24)
Horace Pippin
American, 1888–1946
The Buffalo Hunt, 1933
Oil on canvas, 21⁵⁄₁₆ × 31⁵⁄₁₆ inches
Whitney Museum of American Art, New York,
 New York. Purchase, 41.27
Joslyn, Shelburne, and Amon Carter venues only

Cat. 49
Ogden Minton Pleissner
American, 1905–1983
Duck Hunting, 1957
Watercolor on paper, 19¼ × 29¼ inches
Collection of Shelburne Museum, Shelburne,
 Vermont. Gift of Ann M. Leonard, 2013-14.2
Dixon and Joslyn venues only

Cat. 50
Ogden Minton Pleissner
American, 1905–1983
October Snow, Vermont, 1952
Watercolor on paper, 19 × 28⅞ inches
Collection of Shelburne Museum, Shelburne,
 Vermont. Gift of Morton Quantrell, 1996-42.15
Dixon and Joslyn venues only

Cat. 51
Ogden Minton Pleissner
American, 1905–1983
Ruffed Grouse Shooting, n.d.
Watercolor on paper, 20⅛ × 27⅞ inches
Collection of Shelburne Museum, Shelburne,
 Vermont. Bequest of Ogden M. Pleissner, 1984-
 17.18
Shelburne and Amon Carter venues only

Cat. 52
Ogden Minton Pleissner
American, 1905–1983
The Broadbill Gunner, 1957
Watercolor on paper, 19⅜ × 29⅛ inches
Collection of Shelburne Museum, Shelburne,
 Vermont. Gift of Ann M. Leonard, 2013-14.1
Shelburne and Amon Carter venues only

Cat. 53 (Fig. 2.12)
Alexander Pope
American, 1849–1924
Trophies of the Hunt, 1899
Oil on canvas, 37¼ × 43 inches
The Manoogian Collection

Cat. 54 (Fig. 2.15)
Alexander Pope
American, 1849–1924
The Wild Swan, 1900
Oil on canvas, 57 × 44½ inches
Fine Arts Museums of San Francisco, San
 Francisco, California. Museum purchase, gifts
 from members of the Boards of Trustees, the
 M. H. de Young Museum Society, the Patrons
 of Art and Music, Friends of the Museums,
 and by exchange, Sir Joseph Duveen, 72.28

Cat. 55 (Fig. 3.10)
William Tylee Ranney
American, 1813–1857
The Retrieve, 1850
Oil on canvas, 30⅛ × 40⅜ inches
National Gallery of Art, Washington, D.C.
 Corcoran Collection. Gift of William Wilson
 Corcoran, 2014.79.29

Cat. 56 (Fig. i.3)
Frederic Remington
American, 1861–1909
An Indian Trapper, 1889
Oil on canvas, 49 × 34⅛ inches
Amon Carter Museum of American Art,
 Fort Worth, Texas. Amon G. Carter
 Collection, 1961.229

Cat. 57 (Fig. i.8)
Carl Rungius
American, 1869–1959
Caribou's Death Struggle, 1906–1908
Oil on canvas, 30¾ × 46¾ inches
Collection of Shelburne Museum, Shelburne,
 Vermont. Gift of the Sheldon Family in
 memory of Mr. and Mrs. Charles Sheldon,
 1966-194.1

Cat. 58 (Fig. i.4)
Charles M. Russell
American, 1864–1926
The Buffalo Hunt [No. 39], 1919
Oil on canvas, 30⅛ × 48⅛ inches
Amon Carter Museum of American Art,
 Fort Worth, Texas. Amon G. Carter
 Collection, 1961.146

Cat. 59 (Fig. 1.7)
Augustus Saint-Gaudens
American, b. Ireland, 1848–1907
Diana of the Tower, 1899
Bronze, 36 × 14¼ × 11 inches
Amon Carter Museum of American Art,
 Fort Worth, Texas. Ruth Carter Stevenson
 Acquisitions Endowment, in honor of all who
 worked on the expansion of the Amon Carter
 Museum of American Art, 1999–2001, 2001.2

Cat. 60 (Fig. i.1)
John Singer Sargent
American, b. Italy, 1855–1925
A Young Salmon Fisher, ca. 1901
Oil on canvas, 28 × 22 inches
Private collection, New York
Shelburne and Amon Carter venues only

Cat. 61 (Figs. 3.25 and 4.22)
John Singer Sargent
American, born in Italy, 1855–1925
Two Girls Fishing, 1912
Oil on canvas, 22 × 28¼ inches
Cincinnati Art Museum, Cincinnati, Ohio. John J.
 Emery Fund, 1918.39
Dixon and Joslyn venues only

Cat. 62 (Fig. 1.14)
Joshua Shaw
American, b. England, 1776–1860
Dido and Aeneas Going to the Hunt, 1831
Oil on canvas, 26⅛ × 38½ inches
Munson-Williams-Proctor Arts Institute
 Museum of Art, Utica, New York. Museum
 purchase, 60.197

Cat. 63 (Fig. 2.2)
Arthur Fitzwilliam Tait
American, 1819–1905
The Hunter's Dilemma, 1851
Oil on canvas, 33¾ × 44¼ inches
Collection of Shelburne Museum, Shelburne,
 Vermont. Gift of William H. Scoble, 1961-2

Cat. 64 (Fig. 2.6)
Arthur Fitzwilliam Tait
American 1819–1905
*A Tight Fix—Bear Hunting, Early Winter
 [The Life of a Hunter: A Tight Fix]*, 1856
Oil on canvas, 40 × 60 inches
Crystal Bridges Museum of American Art,
 Bentonville, Arkansas

Cat. 65 (Fig. 1.19)
Arthur Fitzwilliam Tait
American, 1819–1905
Mink Trapping Prime, 1862
Oil on canvas, 20⅛ × 30 inches
Collection of Shelburne Museum, Shelburne,
 Vermont. Gift of Richard H. Carleton, 1969-1

Cat. 66 (Fig. 3.12)
Arthur Fitzwilliam Tait
American, 1819–1905
Hard Hit, 1883
Oil on canvas, 20⅛ × 30⅛ inches
Collection of Mr. and Mrs. Joseph Orgill III

Cat. 67 (Fig. 1.22)
Henry Ossawa Tanner
American, 1859–1937
The Miraculous Haul of Fishes, ca. 1913–14
Oil on canvas, 38 × 47½ inches
National Academy Museum, New York,
 New York, 1236-P

Cat. 68 (Fig. 1.11)
John Quincy Adams Ward
American, 1830–1910
The Indian Hunter, 1857–59
Bronze, 16 × 14¹⁵⁄₁₆ × 8½ inches
Amon Carter Museum of American Art,
 Fort Worth, Texas. Purchase with funds
 provided by the Council of the Amon Carter
 Museum of American Art, 2000.16

Cat. 69 (Fig. 3.23)
Max Weber
American, b. Poland, 1881–1961
The Fisherman (Fisherman, Fish and Sea Gulls), 1919
Gouache on canvas, 23⅛ × 17 inches
Private collection

Cat. 70 (Figs. 3.26 and 4.21)
Julian Alden Weir
American, 1852–1919
The Return of the Fishing Party, 1906
Oil on canvas, 22⅞ × 27¹⁵⁄₁₆ inches
High Museum of Art, Atlanta, Georgia. Gift of
 Miss Mary E. Haverty for the J. J. Haverty
 Collection, 61.65

Cat. 71 (Figs. 3.17 and 4.17)
Worthington Whittredge
American, 1820–1910
Trout Stream, ca. 1870s
Oil on canvas, 12 × 15 inches
David and Laura Grey Collection

Cat. 72 (Fig. 3.21)
N. C. Wyeth
American, 1882–1945
Deep Cove Lobster Man, ca. 1938
Oil on gessoed board (Renaissance panel),
 16¼ × 22¾ inches
Pennsylvania Academy of the Fine Arts,
 Philadelphia, Pennsylvania. Joseph E. Temple
 Fund, 1939.16

Cat. 73 (Fig. 4.29)
Andrew Wyeth
American, 1917–2009
The Hunter, 1943
Tempera on Masonite, 33 × 33⅞ inches
Toledo Museum of Art, Toledo, Ohio.
 Elizabeth C. Mau Bequest Fund, 1946.25
 © 2016 Andrew Wyeth/Artists Rights Society
 (ARS), New York
Amon Carter venue only

Index

(detail facing, and left)
Cat. 50
Ogden Minton Pleissner
October Snow, Vermont, 1952
Watercolor on paper,
19 × 28⅞ inches
Collection of Shelburne Museum,
Shelburne, Vermont. Gift of
Morton Quantrell, 1996-42.15

fishing (*cont.*)
 individualism, 115; as leisure activity, 135, 138, 140; Maine sea fisheries, 148–49; myth of the "big one" in, 20; of Pope, 76; private fishponds, 142; and religion, 21–22, 45–46, 49, 57n78, 146; in *Rip Van Winkle and the Legend of Sleepy Hollow*, 56n49; trout, 135, 138, 140–41; and "true sportsman," 97; and war, 154, 156; women, 87, 115, 117, 144, 146, 163n96. *See also* community; family; water pollution; *titles of individual illustrations on fishing*
Fishing on the Merced River (Hill), 41, 42, 175
Flidais (Irish goddess), 31
Forest and Stream, 117, 135, 140
Forester, Frank. *See* Herbert, Henry William
Fowl and Glass of Red Wine (Lucioni), 17, 76, 78, 176
foxholes, 164n125
Fragonard, Jean-Honoré, 7
From the Top of Kaaterskill Falls (Cole), 160n8
Fuertes, Louis Agassiz, 7
Fulton, New York, 65
"Future of America: The Search for Realities, The" (Wells), 115

Gainsborough, Thomas, 7
Gall, Chief, 17
Genesis, 45
Germany, 149, 150, 152, 158
Gérôme, Jean-Léon, 14, 29, 109, 120n67
Gifford, Sanford Robinson, 138; *Hunter Mountain, Twilight*, 140–41, 141
Girl Fishing at San Vigilio (Sargent), 144, 146
Girl Hunter (Pellegrini), 17
Glanz, Dawn, 119n26
Glass, Hugh, 67, 82n13
Gleason's Pictorial Drawing-Room Companion, 94
Goodrich, Lloyd, 104
Goodwin, Philip R., *The Northwood King—Calling the Moose*, iv, xiv–1, 81, 82, 175
Goodwin, Richard La Barre, *Two Snipes*, 14, 76, 79, 175
Gordon, Robert, 103
Gottlieb, Adolph: *Hunter and Hunted*, 158–59; *Omen for a Hunter*, 158–59
Grimm, Hermann, 148
Grinnell, George Bird, 7, 135
Grouard, Frank, 17
Guides Shooting Rapids (Homer), 134, 135, 175
Guthrie, R. Dale, 4, 17
Gyrfalcons Striking a Kite (Wolf), 10, 10

Hackensack, New Jersey, 97
Hallowell, William R., 109
Hals, Franz, 46

Happy Moment, The (Clonney), 137, 138, 174
Hard Hit (Tait), 99, 100, 178
Harnett, William Michael, 52, 73, 76; *After the Hunt*, 14, 75, 175
Harper, Fletcher, 90
Harper's Weekly, 24, 25, 90, 100, 109
Hart, James M., 83n17
Hart, Rachel Holland, 94
Hartley, Marsden, 52; *Lobster Buoys and Nets*, 147, 148–49, 175; *Young Hunter Hearing Call to Arms*, 148, 148–49
Hawthorne, Charles Webster, 57n78; *The Calling of St. Peter*, 14, 46, 47, 49, 175
Heade, Martin Johnson, *Thunder Storm on Narragansett Bay*, 11, 12, 175
Hector (Mount family servant), 94
Hemingway, Ernest, 20, 49, 159
Henri, Robert, 109
Henry, O., 25
Herbert, Henry William, 63
Here Lies Hugh Glass (Coleman), 67
Herman, Daniel Justin, 63, 86, 88, 89
Herring Net, The (Homer), 57n78
Hickock, Wild Bill, 17
Hill, Thomas, *Fishing on the Merced River*, 41, 42, 175
H is for Hawk (Macdonald), 17
Hitler, Adolf, 150
Home in the Woods (Cole), 90, 91, 119n26
Home Journal, 55n35
Homer (Greek poet), 37
Homer, Winslow, 7, 110; *An Adirondack Lake*, 131, 131–32, 135; *The Fallen Deer*, 132, 133; *Guides Shooting Rapids*, 134, 135, 175; *The Herring Net*, 57n78; *Hound and Hunter*, 12, 12, 63, 65, 65, 82n10; *A Huntsman and Dogs*, 63, 64, 133, 133, 175; *Right and Left*, 49, 49, 52; *Sharpshooter*, 152, 152; *The Trapper*, 160n28
Hopper, Edward, 109
Hornaday, William T., 7, 10
Houdon, Jean-Antoine, 25
Hound and Hunter (Homer), 12, 12, 63, 65, 65, 82n10
hounding, 63, 65
Household, Geoffrey, 150
Hovenden, Thomas, *The Favorite Falcon*, 7, 127, 129, 130, 176
Hudson River school, 3, 39, 104
Huffington Post, 17
Humphrey, Heman, 91, 119n25
Hunt, Gather, Cook (Shaw), 17
Hunter, The (Wyeth, A.), 10, 122, 123, 150, 151, 152, 154, 164n129, 165n134, 179
Hunter and Hunted (Gottlieb), 158–59
Hunter Angler Gardener Cook (Shaw), 17
Hunter Mountain, Twilight (Gifford), 140–41, 141